Heartwarming Bible Illustrations

Heartwarming Bible Illustrations

Compiled and Edited by
Richard A. Steele, Jr. and Evelyn Stoner

AMG
PUBLISHERS
Chattanooga, TN 37422

Unless otherwise noted, all scripture references are from the HOLY BIBLE,
KING JAMES VERSION.

Scripture taken from the HOLY BIBLE, NEW INTERNATIONAL VERSION®.
NIV®. Copyright © 1973, 1978, 1984 by International Bible Society. Used by
permission of Zondervan Publishing House. All rights reserved.

Scripture Taken from the NEW AMERICAN STANDARD BIBLE, © 1960, 1962,
1963, 1968, 1971, 1972, 1973, 1975, 1977, by The Lockman Foundation. Used
by Permission.

Scripture taken from THE HOLY BIBLE, NEW KING JAMES VERSION, Copyright
© 1982, 1983, 1985 by Thomas Nelson, Inc.

ISBN 0-899572-224-3

Library of Congress Catalog Card Number: 98-86101

Printed in the United States of America
03 02 01 00 99 98 -R- 6 5 4 3 2 1

This book of illustrations is dedicated to all those who have faithfully and sacrificially served as volunteers at AMG International, and who were honored for their service in a special luncheon at AMG International headquarters on Thursday, April 23, 1998

Contents

Admonition .1
Age .3
Atonement .4
Attitude .6
Bible .14
Character .27
Christ .30
Christian .54
 Spurgeon on Christian Living .67
Christian Living .71
Christianity .78
Church .83
Commitment .92
Compassion .97
Complaining .101
Death .102
Decisions .106
Discernment .111
Disciples .114
Doctrine .116
Duty .117
Example .119
Faith .121
Family .136
Fear .142
Fellowship .144
Forgiveness .148
Giving .152
God .158
 God's Guidance .176
 God's Protection .177
 God's Providence .177
 God's Sovereignty .179
 God's Will .180
Grace .182

Growth .184
Heaven .187
Holy Spirit .193
Hope .202
Humility .203
Hypocrisy .205
Judgment .206
Kindness .212
Knowledge .220
Love .221
Marriage .235
Obedience .238
Pastors .243
Prayer .246
 Spurgeon on Prayer .262
Preaching .265
Pride .273
Priorities .275
Promises .278
Quotes .280
Repentance .282
Salvation .287
Satan .310
Self .312
 Self-Deception .312
 Self-Control .313
 Self-Indulgence .314
Sin .317
Soul .327
Spiritual .329
Stewardship .336
Temptation .340
Tests and Trials .344
Thankfulness .352
Tongue .357
Treasure .359
Trust .361
Truth .367
Unbelief .369
Unity .370
Will .372
Wisdom .374
Witness .377
Witnessing .381

Works and Service .385
Worldliness .390
Worship .393

General Index .399
Scripture Index .411
Bibliography .417

Foreword

Heartwarming Bible Illustrations is AMG Publisher's fourth release of valuable nuggets of illustrations, quotes and anecdotes. We would like to think that we improved in quality with the release of each volume. However, compiling an illustration volume of this magnitude is never an easy task, and this particular volume is no exception. Work began on this project more than a year before the press date, as many illustrations were culled from a number of public domain sources from our library here at AMG International Headquarters.

Although there are quite a few contemporary illustrations in this volume (most coming from a feature section of our magazine *Pulpit Helps)* there are also many illustrations from out-of-print sources. Illustrations coming from these sources are excellent illustrations that would be useful to any generation; however much editorial work was necessary. We have updated some of the outdated language and sentence structure to make the reading more enjoyable to modern readers. A handy bibliography can be found at the back of the book which gives a list of the sources used for this compilation.

A good variety of illustrations exist in this volume. Some will make you laugh. Some may even bring tears to your eyes. Some are inspirational in nature, and, yes, some illustrations are convicting. These illustrations may be used for sermons, Sunday-school lessons, public devotional readings, or simply for personal reading enjoyment. We trust that you will truly find these illustrations to be—well, heartwarming!

It is our hope that as you read this edition of illustrations, you will find the gospel of Jesus Christ to be the central focus. This is our chief objective at AMG Publishers and the numerous ministries of AMG International—to promote Jesus Christ and His message of salvation through faith in Him alone.

—THE EDITORS

Admonition

1 An Unanswerable Question

Many years ago a Welsh minister, a man of God, while beginning his sermon, leaned over the pulpit and said with a solemn air: "Friends, I have a question to ask. I cannot answer it. You cannot answer it. If an angel from heaven were here, he could not answer it. If a devil from hell were here, he could not answer it." Death-like silence reigned. Every eye was fixed on the speaker. He proceeded: "The question is this, How shall we escape if we neglect so great salvation?"

—C. H. Spurgeon

2 One Testimony Lacking

It is said that once, when Sir Michael Costa was having a rehearsal with a vast array of performers and hundreds of voices, as the mighty chorus rang out with thunder of the organ, roll of drums, ringing horns and cymbals clashing, some man who played the piccolo far away up in some corner, said within himself: "In all this din it matters not what I do," and so he ceased to play. Suddenly the great conductor stopped, flung up his hands, and all was still—and then he cried aloud: "Where is the piccolo?" The quick ear missed it, and all was spoiled because it failed to take its part. O my soul, do your part with all your might! Little you may be, insignificant and hidden, and yet God seeks your praise. He listens for it, and all the great music of His universe is made richer and sweeter because you give Him thanks. "Bless the Lord, O my soul."

3 Look Out for the Media

Two farm boys in jail at Watertown, New York, confessed that they attempted to hold up and rob a lady in her own home. They gave as the reason for beginning a life of crime that they had both been persistent readers of dime novels, and had become so enamored of the masked heroes in the vile sensational stories that, securing masks and pistols, they started out to win fame and fortune. Parents cannot be too careful what their children read. The companionship found in their books, video games and television shows has a more persistent influence on them than that which they meet in flesh and blood on the street. Let us watch the door into the inner sanctuary of our children's minds and hearts. This is one of the cases where the positive treatment is much more effective than the negative. Bright, cheery, wholesome videos, full of positive images and healthy lifestyles, and good books,

are better defenses against bad media than any amount of "don'ts."

4 Wear Your Colors

A young lady, a member of the church who felt very responsive in regard to her Christian life, found herself frequently in the society of a young man who was not a Christian. One evening she went with him to a service where great religious interest was being manifested. On the way home he remarked:

"After all, I don't know but that you and I are as well off as these church people."

"But I am one of the church people myself," she stammered.

The young man made a polite attempt at an apology, but the arrow had hit the mark. A private Christian life is an essential thing, but the one who has no public life is not likely to have a private one that is worth taking account of.

5 Mammon-Worshipers

There are two perils connected with wealth: one is the abuse of it when it is possessed; the other is the seeking of it as the portion of one's soul. Our Lord outlines the contrast between treasures on earth and treasures in heaven, and urges the remembrance of this, as a rule of life, in His servants. What multitudes need this teaching! But, as the Searcher of hearts, He suggests another reason for laying up treasure in heaven. Where the treasure is the heart will also be. Oh, if we could only get mammon-worshipers to examine themselves! Reader, where is your treasure?

6 If It's Doubtful, It's Dirty

A boy was dressing to go out for the evening. He called to his mother who was in the adjoining room. "Mom, is this shirt dirty?" Without so much as looking she replied, "Yes, it's dirty. Get a clean one."

When he had dressed he entered his mother's room and inquired how she knew the shirt was dirty when she had not even looked at it. "If it had been clean," she replied, "you would have known it and would not have asked me. Remember son, if it's doubtful, it's dirty."

In this little incident there is a sermon. It applies to all of us who flirt with temptation and seek approval of others for the things we desire to do. In many cases in our Christian living, if it looks doubtful, you better leave it alone.

Age

7 *Sowing and Reaping*

Talmage tells the story of a young man who came to a 90 year old man and said to him, "How have you managed to live so long and be so well?" The old man took the youngster to an orchard, and, pointing to some large trees full of apples, said, "I planted these trees when I was a boy, and do you wonder that now I am permitted to gather the fruit of them?" We gather in old age what we plant in our youth. Sow to the wind, and you reap the whirlwind. Plant in early life the right kind of a Christian character, and you will eat luscious fruit in old age, and gather these harvest apples in eternity.

8 *Elderly Disciples Useful*

You who are advanced in years, do not grow weary in well doing! Christ's cause is still in need of you. Alexander conquered the world 334 years before Christ, and he conquered it with old men. When he set out from Macedon his army only numbered 32,000 foot soldiers, 5,000 horses, and nearly all the officers and men were aged persons. History tells us that when drawn up in camp, they had the appearance of a venerable Senate. O, aged Christians, the Master needs you yet! When your work is done He will call you home.

Atonement

9 Doctrine of the Atonement

Nothing could be clearer than the teaching of the New Testament as to the effect of the death of our Lord on the cross. According to it, that death is the means of eternal salvation to believing people; through that sacrifice they obtain the Divine forgiveness; Christ did something on the cross which was of vital importance for mankind and which we could never have done for ourselves. I take it for granted that we all believe and preach this as the Gospel of God. Christ is to us the supreme and infallible Master in all spiritual things. His word about the eternal realities is to us final. He said that He came to give His life a ransom for many and that His blood was shed for many for the remission of sins (Matt. 26:28). We accept the words of His servants who declare that He bore our sins in His own body on the tree, that He is the propitiation for our sins and not for ours only, but also for the whole world. We say after His apostle Paul with devout thankfulness and joy, "He loved me and gave Himself for me"(Gal. 2:20).

10 Christ the Sin-Bearer

An old servant was once carrying a large bough of a tree to have it cut into pieces to make a fire. A little boy, one of the family, seeing the end of it dragging along the ground and making it very heavy, came and took hold of the end, and the burden grew light. Then said the servant, "Ah! Master Frank, I wish you could take hold of one end of the greater burden that I have to carry; I have a burden of sin; the more I drag it about, the heavier it becomes. I wish Jesus Christ would take hold of one end of it." The little boy said, "My mother told me, yesterday, that Jesus Christ carries all our sins; therefore, you do not want Jesus Christ to drag one end of it; he will take the whole of it." The poor woman, who had been long seeking rest, found it by that remark of the child. Yes, Jesus does take your sins. If you trust Christ, this is the evidence that all your sins are laid on him.

—C. H. Spurgeon

11 Cross of Refuge

Sir Arthur Conan Doyle, of *Sherlock Holmes* fame, in his history of the Boer War, tells us how on one occasion a comparatively small detachment of the British army was

surprised by a force of the enemy twice its own strength. The British were driven back upon their camp, and the Boers occupied a commanding position from which they were enabled to pour volley after volley into the English lines. The British wounded in the earlier part of the action found themselves in a terrible position, laid out in the open under a withering fire. One of this number, a corporal in the Ceylon Mounted Infantry, tells the story himself: "We must get up a red flag or we shall be blown from the face of the earth." He says, "We had a pillow but no red paint. Then we saw what to do instead. So they made an upright with my blood and the horizontal with Paul's." This grim flag, the blood red cross upon the white background, was respected by the Boers. Those lying beneath it were safe. Even so—beneath the blood stained Cross of Christ we find our sure refuge.

Attitude

12 The Importance of a Smile

In the window of a small store in Gettysburg, PA, was a sign with these words, "If you can't stop in, smile as you go by." It takes 73 muscles to frown—14 to smile. No wonder the grouchy people are always tired. It has been said if you laugh every day it is equal to 10 minutes of exercise.

13 Saintly Conduct

Alexander Maclaren once said that, "more souls are won for Jesus Christ by saintly conduct than by any argument."

14 Mirrors

A little street girl fell ill one Christmas and was taken to the hospital. While there she heard the story of Jesus' coming into the world to save us. One day the nurse came around at the usual hour, and "Little Broomstick" (that was her street name) held her by the hand and whispered, "I am having real good times here, ever such good times. S'pose I'll have to go 'way from here just as soon as I get well; but I'll take the good time along—some of it, anyhow. Did you know about Jesus being born?"

"Yes," replied the nurse, "I know. But you must not talk any more."

"You did? I thought you looked as if you didn't, and I was going to tell you."

"Why, how did I look?" asked the nurse, forgetting her orders in her curiosity.

"Oh, just like most o' folks—kind o' glum. I shouldn't think you'd ever look glum if you knowed about Jesus being born."

15 Good for Evil

A good story is told of the magnanimous William McKinley, which shows his kindness to a political enemy. During one of his congressional campaigns he was followed from place to place by a reporter for a paper of opposite political opinion, who is described as being one of those "shrewd, persistent fellows who are always at work, quick to see an opportunity, and skilled in making the most of it."

While Mr. McKinley was annoyed by the misrepresentations to which he was almost daily subjected, he could not help admiring the skill and persistence with which he was assailed. His admiration, too, was not unmixed with compassion, for the reporter was ill, poorly clad, and had an annoying cough. One night Mr. McKinley took a closed carriage for a nearby town, at which he was billed to speak. The weather was wretchedly raw and cold, and what followed is

thus described: He had not gone far when he heard that cough, and knew that the reporter was riding with the driver in the exposed seat. McKinley called the driver to stop, and alighted. "Get down off that seat, young man," he said. The reporter obeyed, thinking the time for the politician's vengeance had come. "Here," said Mr. McKinley, taking off his overcoat, "you put on this overcoat and get into that carriage."

"But, Mr. McKinley," said the reporter, "I guess you don't know who I am. I have been with you through the whole campaign, giving it to you every time you spoke, and I am going over tonight to rip you to pieces if I can."

"I know," said Mr. McKinley, "but you put on this coat and get inside and get warm so you can do a good job."

16 One Smile

Someone gave me a smile today,
I tried my best to give it away
To everyone I chanced to meet
As I was going along the street,
But everyone that I could see
Would give my smile right back
 to me.
When I got home, besides one
 smile,
I had enough to reach a mile.

The Bible Friend

17 Sir Eardley Wilmot's Advice

A gentleman who had filled many high stations in public life, with the greatest honor to himself and ad-vantage to the nation, once went to Sir Eardley Wilmot in great anger at a real injury he had received from a person high in the political world, which he was considering how to resent in the most effectual manner. After relating the particulars to Sir Eardley, he asked if he did not think it would be manly to resent it. "Yes," said Sir Eardley, "it would doubtless be manly to resent it, but it would be Godlike to forget it." This the gentleman declared had such an instantaneous effect upon him that he came away quite another man, and in temper entirely altered from that in which he went.

18 Retaliation Repudiated

An incident well worth noting is told of General Robert E. Lee, the Confederate officer during the American Civil War. Jefferson Davis once asked him what he thought of a certain officer in the army, as he had an important place he wanted filled by a trustworthy man. Lee gave the officer an excellent recommendation, and he was immediately promoted to the position. Some of Lee's friends told him that the officer had said some very bitter things against him, and were surprised at the General's recommendation. "I was not asked," said Lee, "for the officer's opinion of me, but my opinion of him." Only a noble heart could prompt such action. In praying we are told to love our enemies, but in our everyday life we too often love only those who love us.

19 It's No Use

Doctor Brown was surprised to find Jack home so early from school. "Isn't there any football practice today, Jack?" he asked.

"Oh, yes, Father, but I'm not going out any more," Jack answered. "I haven't any chance to make the team. I've been out for a month, and tried hard, but it's no use."

Doctor Brown seemed disappointed. "It doesn't matter whether you make the team or not, Jack," he said, "but it does matter a great deal whether you tried with all your might to do something you set out to do."

"Well, I tried all right," said Jack uneasily.

"I don't believe it," answered his father with energy. "You wanted to make that team, but you found that you were competing with boys a bit heavier or with more natural aptitude for the game than you had, and because you saw that the odds were against you, you quit. The odds may always be against you in everything you undertake in life. Does that mean that you are always going to quit? Every man who ever accomplished anything really worthwhile did it in spite of tremendous odds. It doesn't matter whether or not you ever accomplished anything that the world deems great, but it does matter whether or not you are going to lie down in the face of difficulty or whether you are going to develop the character that keeps on trying and never admits defeat. Just 'trying' never got a man anywhere. It's trying even when it seems no use to keep on. That's the way to win the victories of life."

Jack was heading for the door. "It isn't too late yet, father. Maybe I won't make the team, but it won't be my fault if I don't."

Doctor Brown smiled. "That's the way for a man to talk," he said.

20 The Medicinal Value of Cheerfulness

Scientists have been discussing the question of happiness as an agent for the cure of disease, or of states of mind which favor the progress of certain diseases. Some very novel views have been advanced on the subject of happiness as a therapeutic, and the case was recalled of a victim of gout, who, on the approach of an attack, began dancing, not as if from a spasm of pain, but with the lightness of joy, and thus escaped the worst effects of the painful twitch. That sort of mirth seems quite artificial, though no doubt even that sort would be better than tamely submitting to the bondage of pain. The Bible proverb, "A merry heart doeth good like a medicine" (Prov. 17:22), has more logic in it. The healing beams of sunshine in a Christian's hope sustain many an invalid, and soothe the spirit, making the heart strong to bear if it cannot heal the disease.

21 Goodness

How many people would like to be good, if only they might be good without taking trouble about it! They do not like goodness well

enough to hunger and thirst after it, or to sell all that they have that they may buy it; they will not batter at the gate of the Kingdom of Heaven; but they look with pleasure on this or that aerial castle of righteousness, and think it would be rather nice to live in it.

22 New Standards for Old

To be a Christian means, or ought to mean, to be transported into a new world, a world with new ways of looking at things and new standards of worth and importance, where the things that seemed most urgent cease to count, and the things that hitherto appeared commonplace or impracticable become for us the only realities that matter. It has always worked out so in the deepest Christian experience. The things that had been counted gain are now found to be mere loss, and the things that were counted loss are now gain for the sake of Christ. And just that change in our standards of values and ways of looking at things was the primary demand of Jesus. "The kingdom of God is at hand. Change your mind and believe the good news." He said that this is what is wrong with our world, behind all its tyranny, its injustice, and its pain, was simply a wrong attitude to life. Men were living for the wrong things. And behind that wrong attitude to life there lay something still more dangerous—a wrong attitude to God, or perhaps no attitude to God at all. And He said that if men would put God in the center of their vision, and would see their lives measured against that background, reckoning both its grandeur and its littleness in the light of the great spiritual realities, then our whole aim would be redirected, and we should live no longer for the things that perish, and so our lives would no longer clash with one another. That new quality of life which comes where God is supreme in the heart, that He called the kingdom of heaven; but only by being converted can people enter it. And we shrink from facing the fact that repentance means first of all a revolution in our thinking, a changed philosophy of life, a new overturning of our standards of worth, schooling ourselves to see things from God's standpoint and not merely from the point of view imposed upon us by the conventions of our own social groove.

23 The Attitude of Today

We are hearing much today about the tremendous importance of young people. We are all impressed by that importance, but the attitude adopted today—that it is impossible to do anything with grown-up people, is very discouraging. It is a gospel of despair. If you cannot teach grown-up people anything, how are you going to get at the child, who is in their hands and so much under their influence?

24 No Room in the Inn

Can you not feel the chilly atmosphere of that inn? "No room; there is only the stable!" This part of the story of Christ's nativity foreshadows His

later experience. Men have continued to echo that cry, "No room!" Jesus should have the supreme place, but He is constantly made a secondary consideration. He should dominate our lives, but we have crowded Him out. I often feel the chilling atmosphere of that inn as I read the Gospel story. I feel it in the house of the rich Pharisee (Luke 7:45, 46). Jesus was a guest there, but not a supreme one. There was no water, no kiss, no oil. He was tolerated, patronized, not worshiped. I feel that atmosphere in the world today. I fear lest I find it in the Church and my own soul.

25 Noble Aspiration

I have often used an illustration taken from a person who teaches the art of growing taller. I do not believe in that art: we shall not add a cubit to our stature just yet. But part of this professor's exercise is that in the morning, when you get up, you are to reach as high as ever you can, and aim a little higher every morning, though it be only the hundredth part of an inch. By that means you are to grow. This is so with faith. Do all you can, and then do a little more; and when you can do that, then do a little more than you can. Always have something in hand that is greater than your present capacity. Grow up to it, and when you have grown up to it, grow more. By many little additions a great house is built. Brick by brick up rose the pyramid. Believe and yet believe. Trust and have further trust. Hope shall become faith, and faith shall ripen to full as-

surance and perfect confidence in God Most High.

—C. H. Spurgeon

26 Seek the Higher Things

Another account told by Spurgeon is about a street sweeper in Dublin, who, "with his broom, at the corner, and in all probability his highest thoughts were to keep the crossing clean, and look for pocket change. One day, a lawyer put his hand upon his shoulder, and said to him, "My good fellow, do you know that you are heir to a fortune of ten thousand pounds a year?" "Do you mean it?" said he. "I do," he said. "I have just received the information; I am sure you are the man." He walked away, *and he forgot his broom.* Are you astonished? Why, who would not have forgotten a broom when suddenly made possessor of ten thousand a year? So, I pray that some poor sinners, who have been thinking of the pleasures of the world, when they hear that there is hope, and that there is heaven to be had, will forget the deceitful pleasures of sin, and follow after higher and better things.

27 Refusing the Prize

"There's a man that once offered me ten thousand dollars, and I didn't take it," a young man said of a gentleman who passed down the street.

"Why didn't you?"

"Because I didn't know it was ten thousand dollars," he answered.

The fact was the gentleman had come to him and given him a bit of advice, to which no heed was given.

It turned out afterward that if he had taken the advice it would have made him ten thousand dollars. I think you and I have had a good many experiences like that, only the riches we might have won are imperishable. That day when Christ said, "Go," and you said, "Oh, I can't go," you missed a prize that would have been yours through all eternity.

28 High Aspirations

A gentleman relates overhearing a conversation between a father and his son who was an architectural student in a certain university. The father told him that he must study to please the people if he would succeed in building up a profitable profession. The boy replied: "I cannot consent to try to please people who have no artistic knowledge or natural sense of beauty. I would rather be great than be rich. Millionaires there are in plenty, some of them both useless and vulgar. I am willing to be poor all my life if I can do something toward educating the people to high ideals for their homes and public buildings." That young man could not have paid a higher compliment to his teacher. There is no grander work in the world than to put high ideals into the minds and hearts of young men and women. The youth with high ideals will in the end rise far above the one who has low ones.

29 Forbearance

I once lived by the side of a very excellent man who, nevertheless, had his infirmities which, of course surprised me! And I recollect an oc-casion on which he became angry and manifested his displeasure in a very striking manner. I wanted a place to hang up a dipper in my yard, and drove a nail into the fence between him and me, which went through on the other side. One day I heard a racket in my yard, and looking to see what was the occasion of it, I found my dipper ringing over the pavement. This man had got a hammer, and hit the nail a rap, and sent the nail, dipper, and everything else flying. My feeling was to fire the dipper over at him and give him as good as he sent, but my second thought was, "Well, this man was made so, I suppose; he is a passionate man by nature; he was taken by surprise; he is a very good fellow, a kind neighbor, and I won't say anything about it. I was going to be satisfied so; but then I said, "I guess I had better say something to him," and I stepped in and said, "I ask your pardon for driving the nail through the fence, and I am glad you reminded me of it." He shook hands with me, and said, "Well, well, well, let us not say anything more about it." The result showed the wisdom of treating the matter in a spirit of simple kindness.

—Beecher

30 What a Little Boy Could Do

A boy in Boston, rather small for his years, worked in an office as errand boy for four gentlemen who did business there. One day they were chaffing him a little about being so small, and said to him,

"You never will amount to much—you never can do much business—you are too small."

"Well," said he, "small as I am I can do something which none of you four men can do."

"Oh, and what is that?" they asked.

"I don't know as I ought to tell you," he replied.

But they were eager to know and urged him to tell them what he could do that none of them were able to do.

"I can keep from swearing," said the little fellow.

There were some blushes on four manly faces, and there seemed to be very little anxiety for further information on the point.

31 Sowing and Reaping

The following words of advice were penned by the late John Hall:

"Men when thoughtless are easily deceived. A thing is done, and they count it 'done with.' This is to mock God, who is Ruler and Judge, and who calls every human being to account. We are sowing in all that we say and do, and the harvest will be as the seed. If we are guided only by fallen human nature, we can only reap corruption. If we are guided by the Spirit, we trust, love, and imitate the Savior, and through Him we shall reap life everlasting. What is influencing us in the details of life—'the flesh' or the Spirit?

32 Start with Yourself

The following words were written on the tomb of an Anglican bishop in the crypts of Westminister Abbey:

"When I was young and free and my imagination had no limits, I dreamed of changing the world. As I grew older and wiser, I discovered the world would not change, so I shortened my sights somewhat and decided to change only my country. But it, too, seemed immovable.

"As I grew into my twilight years, in one last desperate attempt, I settled for changing only my family, those closest to me, but alas, they would have none of it.

"And now as I lie on my deathbed, I suddenly realize: If I had only changed myself first, then by example I would have changed my family.

"From their inspiration and encouragement, I would then have been able to better my country and, who knows, I may have even changed the world."

33 Beyond the Call of Duty?

A wise king ruled over a people who always expected others to do for them. To teach his subjects an important lesson, he put a large boulder in the narrowest part of the road with steep banks on either side.

First a farmer came by with his cart. He grumbled because someone had left a large stone in the road which caused him great difficulty; painstakingly he skirted the stone but did not remove it.

Such occurrences went on repeatedly, day after day. The stone, however, remained where it was and nobody attempted to move it.

Finally, the king called for a meet-

ing of his townspeople at the site of the stone. The king himself moved the stone over with some difficulty, picked up something beneath it. It was a pouch which he opened; from it he took several pieces of gold and a note which read "To him who moved the stone."

Bible

34 Searching the Scriptures

As diligent bees fill their cells with honey unseen and unknown to others, so may we search the Word of God, which is sweeter than honey in the honeycomb, for hidden delights. As men seek riches, laboring through days and nights, so may we search for that precious truth which shall give to us a new manhood, a nobler aspiration, a nearer alliance to God and more blessed joy.

35 Living Gospels

I had a letter only this week, as I have every week, from some young person starting out in life, asking, "What is the best commentary I can have on the Bible?" Well, I cannot send them this, because the only commentary of the Bible that is really of much value is a person that is living the Bible; and, really, a Christian is the best commentary on the New Testament that anybody can have. But there are not enough of such commentaries to send out. The edition is small.

36 The Bible First of Books

One day Luther's wife seems to have been a little out of temper. She got tired of his prolonged reading in the Psalms, said she had heard enough, and added impa-tiently that she "read a great deal for herself every day, and knew very well how to talk about it, too." "Ah, Kate," replied her husband, with a sigh, "this is the way weariness of God's word begins; beware lest new books come and take its place, and the Scriptures be driven into the corner."

37 Influence of Spreading the Bible

An Appalachian frontiersman relates the following story:

"One day a man entered my room, wearing a hunting-shirt and moccasins, with a gun in his hand, and a long knife hanging to a belt at his side, and asked me if I was the man that gave books to the poor people in the mountains. I told him I was engaged in that business. 'Well,' said he, 'we live in an out-of-the-way place, where we have neither schools nor preaching; and we met together last Sunday, to see if we could not raise a Sunday School, and teach our children to read, but all the books we could find was one New Testament; and someone said there was a man that was giving books to the poor, and so I have come to see you about it.' I gave him all the light I could as to forming and conducting a Sunday School, and added twenty Testa-

ments with fifty small volumes of Tract Society books and some tracts. He soon had them all in the bosom of his hunting-shirt, and I have seldom seen a happier man. The next Sabbath the school was started. In six months a church was organized, and soon after a little church built, and a man of God was preaching to them once each month. That bosomful of books was the means God blessed to this result."

38 Restraining Power of the Bible

The Rev. Charles Vince, of Birmingham, told the following incident at a meeting of the Bible Society, in 1863—

The Hill-top Auxiliary, in "the Black Country," determined to send around two or three Christian men every Saturday evening, with packages of Bibles, to visit the public-houses, and persuade the miners of the district, while they had their money, to spend some part of it in buying the word of God. While they were carrying out this plan, a miner said: "Wouldn't it be a good thing for us to have a copy to read down in the pit at dinner-time?" The proposition met with general approval, and they agreed to buy a copy for this purpose. Of the first copy handed to them, the landlord said the print was too small to read down in the pit, and offered to give a shilling towards the cost of a better type. This was bought, and one of the men said with great simplicity: "If we have the Bible at dinner-time, we mustn't have no swearing." This, too, was carried, and a fine imposed upon the man that should break the rule. Is there any other book in the world that you could carry into the company of men and make them say, "If we open this, and begin to look at it, we must begin to put away some of our sins"?

39 Study the Bible, Not About It

Much that is called Bible study is not Bible study at all. Satan kept men for years from any interest in Bible study, but now that there is a great and growing interest in it he keeps them from real Bible study. Questions about the authorship, date, etc., of the various books of the Bible are both interesting and important; but studying these things is not studying the Bible. Mr. Moody once asked a recent graduate of a great university why he did not give his life to teaching the English Bible. The young man replied, "I don't know anything about the Bible." "Why," Mr. Moody said, "you have a high priced professor employed in your university just to teach the English Bible." The young man said, "Mr. Moody, would you like to know how we study the Bible? We have spent the last six months trying to find out who wrote the Pentateuch, and we know less about it now than when we began." That was not Bible study.

—R. A. Torrey

40 "So Shall My Word Go Forth and Not Return Void"

It is related that "an old peasant in Northwest India learned by heart the first chapter of John's Gospel. After his harvest was over he would go out year by year into the villages nearby and repeat what he had learned. It is stated that in eight years he had brought some four hundred of his countrymen to embrace Christianity and receive baptism."

We know that it is written: "As the rain cometh down, and the snow, from heaven, and returneth not thither, but watereth the earth, and maketh it bring forth bud, that I may give seed to the sower and bread to the eater; so shall my word be that goeth forth out of my mouth; it shall not return unto me void, but it shall accomplish that which I please, and it shall prosper in the thing whereto I sent it" (Is. 55:10, 11).

41 Can a Society Long Survive without the Bible?

It is generally accepted as an axiom that the only justification of the State in undertaking popular education is its own preservation and upbuilding. It is a measure of public safety. The aim, so far as the State is concerned, is to make good citizens, and the scope of its effort is limited by that necessity. The question with which the State has to do is one of public morals; for it is upon the morality of the people that the progress of the nation and its civilization depend. The great nations of the past all perished, not of poverty, nor of lack of culture, but of immorality. Some of them went down at the height of literary, artistic, or material greatness. Few will dispute the impressive teaching of history, as well as of philosophy, that the great duty of the State is the cultivation of the moral nature of its children. It is a question, therefore, which every citizen ought to weigh, whether a system, not of ethical maxims, but of vital aggressive morality, can be successfully cultivated without the aid of the Bible.

42 Influence of the Bible

Wherever God's law is supreme, life and property are safe. Wherever the Bible is despised or discarded, neither life nor property is secure. When worldly friends were discussing theories around the dining table one day, Voltaire said: "Hush, gentlemen, till the servants are gone. If they believed as we do, none of our lives would be safe." The influence of the Bible in restraining sin and promoting righteousness is one of the evidences that it is a supernatural and divine revelation.

43 Became a Christian Reading the Bible

According to a report of the British and American Bible Society, at Manila, a Filipino who assisted in 1908 in translating the Tagalog Bible gave this testimony:

"I became a Christian through reading the Bible. When I saw in John 4:24 that 'God is a spirit, and they that worship him must worship in spirit and truth,' I began to think that worshiping God through idols must be wrong, and from this I was gradually led on to the truth. At first my father and brothers were very bitter against me; I said but little to them, but gave each of them a Bible and asked them to read for themselves; in time they, too, became convinced, and are now Christians."

44 Unseen Beauty

"As it is written, eye hath not seen, nor ear heard, neither have entered into the heart of man, the things which God hath prepared for them that love him. But God hath revealed them unto us by his Spirit . . ." (1 Cor. 2:9, 10).

His parents had sent the young boy to Florida to spend the winter, but he was disgusted with the area of Florida he had been in. Then a few months later he met a botanist who kindled the boy's interest in his favorite study. The boy became fascinated with the orchid and its strange life.

Looking at the orchids in the greenhouse one day, the botanist said enthusiastically: "You should see them in Florida, they are much better there; but these will give you some idea."

The boy looked at him in amazement.

"I have been in Florida," he said, "but I never noticed any of them."

"Perhaps you did not look for them," answered his friend, "but they will not escape you the next time."

That is the way it often is with the Bible. A person sees no beauty in it, but the Holy Spirit is ready to open the eyes of our understanding, and to teach us. It may be by some sermon or book which will lift a truth out of its hiding place and give it an application to our life which it never seemed to have before.

45 Quality over Quantity

"Blessed is the man . . . his delight is in the law of the Lord, and in his law doth he meditate day and night."—Psalm 1:1, 2

At one time I would read so many chapters of the Bible a day, and if I did not get through my usual quantity, I thought I was getting cold and backsliding. But, mind you, if a man had asked me two hours afterwards what I had read, I could not tell him; I had nearly forgotten it all.

When I was a boy I used to hoe the garden of corn; and I would hoe it so badly, in order to get over so much ground, that at night I had to put a stick in the ground, so as to know next morning where I had left off.

That was somewhat the same manner as running through so many chapters every day. A man will say, "Honey, did I read that chapter?"

"Well," she says, "I don't remember."

And neither of them can recollect. Perhaps he reads the same chapter over and over again; and they call that "studying the Bible." I do not think there is a book in all the world we treat in that fashion.

Someone has well said, "If you have only three minutes a day to devote to Bible reading, devote one minute to reading, and two minutes to thinking about what you have read."

The word "meditate" really means "to chew the cud." And any who have watched the cow chew her cud understand what God means when He tells us to meditate upon His Word. It is to first take the Word, and then carefully mull it over in our minds until it reaches our hearts.

46 *The Most Valuable Thing the World Affords*

As Queen Victoria was crowned in Westminster Abbey, three presents were made to her: first, the Sword of the State; second, the Imperial Robe; and, lastly, the Bible; these words accompanying the gift: "Our gracious queen, we present you with this book, the most valuable thing the world affords. Here is wisdom; this is the royal law; these are the timely oracles of God. Blessed is he that readeth, and they that hear the words of this book; that keep and do the things contained in it. For these are the words of eternal life, able to make you wise and happy in this world, nay, wise unto salvation, and so happy forevermore, through faith which is in Christ Jesus, to whom be glory forever. Amen." Words as true as they are beautiful!—and by few monarchs have they been put to a fuller test than by the royal lady to whom they were addressed.

47 *The Power of the Bible*

In "Unbeaten Tracts in Japan," Isabella L. Bird relates a remarkable instance of the power of the Scriptures over criminals. A portion of the New Testament, the only parts then translated and printed in Japanese, was given to the keeper of the prison at Otsu, a place in the interior of Japan, beyond the reach of missionary instruction. The officer of the prison gave it to a scholarly convict, incarcerated for manslaughter. Time passed, and nothing was heard from this precious gift. It seemed to have been thrown away on these heathen. But not so. A fire finally broke out in the Otsu prison. "Now is your opportunity," would be the natural thought to each of the hundred prisoners. But when all were looking to see them attempt an escape, every one of the prisoners helped to put out the flames, and voluntarily remained to serve the rest of his sentence. Such honorable conduct mystified the heathen authorities, and led to a careful investigation. This investigation developed the fact that the manslaughterer had become so impressed with the truth of Christianity by studying the Scriptures which the officer had given him, that he had embraced the life-giving truth and

then had devoted himself to teaching his fellow-prisoners. Thus the power of the Word of God produced in these men. The circumstances led to the release of the manslaughterer, but he preferred to remain in Otsu, that he might teach more of the "new way" to the prisoners.

48 Testimony to the Bible

The leading skeptical statesman of America, Thomas Jefferson, was wise enough to make this confession: "I have always said, and always will say, that the studious perusal of the sacred volume will make better citizens, better fathers, and better husbands." The words explain the source of America's prosperity. The Christian statesman, Edward Everett, said: "All the distinctive features and superiority of our republican institutions are derived from the teachings of Scripture."

49 Truth-Seekers

"Why did God not make the Bible so plain that everyone could understand it?" asked one. "If God made coal as fuel, why did he not put it on the top of the ground instead of burying it deep underneath the surface?" was the reply.

50 Gospel the Power of God

Some years ago a woman delivered a lecture in Lancashire against Christianity, in which she declared that the gospel narrative of the life of Christ is a "myth." One of the mill-hands who listened to her ob-

tained permission to ask a question. "The question I want to ask the lady is this: 'Thirty years ago I was a curse to this town, and everybody shrank from me that had any respect for himself. I often tried to do better, but could not succeed. The teetotalers got hold of me, but I broke the pledge so often that they said it was no use trying me any longer. Then the police got hold of me, and I was taken before the magistrate, and the wardens of the prison all tried me in vain. Then Christ took hold of me, touched my heart, and made me a new man. And now I am an honored and respected fellow-worker in gospel and Sunday school work with many dear to me. And I ask, if Christ is a myth, how is it that this myth is stronger than all the others put together?'" The lady was silent. "No, miss," he said, "say what you will, the gospel is the power of God unto salvation" (Rom. 1:16; 1 Pet. 1:5).

51 Bible—The Newspaper

A story is told of a minister who taught an old man in his parish to read. He proved to be a proficient scholar. After the teaching had come to an end the minister was not able to come to the cottage for some time, and when he did he only found the wife at home. "How's John? he said. "He's canny, sir," said the wife. "How does he get on with his reading?" "Nicely, sir." "Ah! I suppose he will read his Bible very comfortably now." "Bible, sir! Bless you! He was out of the Bible and into the newspaper long

ago." There are many other persons who, like this old man, have long been out of the Bible and into the newspaper. They have forsaken the fountain of Living Waters, and have gone about among muddy pools and stagnant morasses to seek something which might slake their thirst.

52 Bible—Half Read

A certain wayward young man ran away from home and was not heard of for years. In some way, hearing that his father had just died, he returned home and was kindly received by his mother. The day came for the reading of the will; the family were all gathered together, and the lawyer commenced to read the document. To the great surprise of all present the will told in detail of the wayward career of the runaway son. The boy in anger arose, stamped out of the room, left the house, and was not heard from for three years. When eventually he was found he was informed that the will, after telling of his waywardness, had gone on to bequeath to him $15,000—which was quite a sum of money in those days. How much sorrow he would have been saved if he had only heard the reading through! Thus many people only half-read the Bible and turn from it dissatisfied. The old Book says: "The wages of sin is death," yea, verily, but it says more, it says, "but the gift of God is eternal life" (Rom. 6:23).

53 Bible—Best Recommendation

A youth looking for a job came to New York City, and, on inquiring at an investment firm if they wished to hire a clerk, was told that they did not. He then spoke of the recommendation he had, one of which was from a highly respectable citizen. In opening his briefcase to find his letters, a book rolled out on the floor. "What book is that?" said the merchant. "It is the Bible, sir," was the reply. "And what are you going to do with that book in New York?" The young man looked seriously into the merchant's face, and replied, "I promised my mother I would read it every day; and I shall do so." The merchant at once took him into his service.

54 God's Word Powerful

A Jewish woman of wealth and position noticed an advertisement of some article which she fancied, that would accompany the purchase of a Bible. She sent an order for the sake of what she wanted, and tossed the unwelcome book aside; but in an idle hour, later, picked it up and turned its pages. The New Testament was unfamiliar and she glanced at it curiously, becoming interested before she knew.

She fought against belief, but it gradually forced itself upon her, and she found herself in deep trouble. Confessing her faith meant the loss of property and home, the heartbreak of father and mother, even separation from her husband, but she could not remain silent.

All that she feared was threatened in those awful days, but because they loved her, and to prove her error, her family also read the despised Gospel. Earth's unending miracle was repeated; they found what she had found, and looked wondering into each other's faces, a Christian household.

55 Sword of the Lord

We are told that the gray heron has a very singular mode of defense. When attacked by the eagle or falcon it simply stands quiet and firm, using its bill as a sword, allowing the enemy to pierce himself through by his own force. The Christian's method of defense is very similar. We have the sword of the Spirit which is the Word of God. When attacked by the enemy, without or within, stand firm and display the Word, hold it forth. The more fiercely the foe attacks the more surely shall they pierce themselves with it. His Word is a fire, all that cross it shall be burned. "Stand therefore, having your loins girt about with truth" (Eph. 6:14).

56 Loving the Author of the Bible

A young lady asked to explain devotional reading of the Bible, answered:

"Yesterday morning I received a letter from one to whom I have given my heart and devoted my life. I freely confess to you that I have read that letter five times, not because I did not understand it at the first reading, nor because I expected to commend myself to the author by frequent reading of his epistle. It was not with me a question of duty, but simply one of pleasure. I read it because I am devoted to him who wrote it. To read the Bible with that motive is to read it devotionally, and to one who reads it in that spirit it is indeed a love letter."

This young Christian's explanation is beautifully clear. The heart has not a little to do in interpreting God's word.

57 Following the Bible

Well over 100 years ago, much of northern Michigan was entirely new country, covered with dense forests. The best woodsman was liable to lose his way unless he carried a pocket compass. A settler of those days tells this story: "One day I had been walking in the woods, when though I could not see the sun or sky, I knew by the settling darkness that night was coming on, and started, as I thought, for home. I was so certain of my direction that for some time I did not look at my compass. On doing so, however, I was greatly surprised to find that, whereas I thought I was going east, in reality I was bound due west. Not only was I surprised, but I was so sure of my own judgment and so disgusted with my compass that I raised my arm to throw it away. Then pausing, I thought, "You have never lied to me yet, and I'll trust you once more." I followed it and came out all right. The Bible is a compass that has guided millions

to heaven. Some would throw it away, but those who follow it always come out safely.

58 Comfort in the Bible

The bishop of Rochester was being led to the scaffold. As the cruel framework loomed grimly on his sight, he bowed his head and prayed, "Now, O Lord direct me to some passage which may support me through the awful scenes." He forthwith opened his Testament and his eye lighted on the words, "This is life eternal, that they might know thee, the only true God, and Jesus Christ whom thou hast sent" (John 17:3). Closing the Book, he said, "Praised be the Lord, this is sufficient for time and for eternity."

59 Blind Eyes Opened

A little boy was born blind. At last an operation was performed; the light was let in slowly. When one day his mother led him outdoors and uncovered his eyes, and for the first time he saw the sky and the earth, "O mother!" he cried, "why didn't you tell me it was so beautiful?" She burst into tears, and said, "I tried to tell you, dear, but you could not understand me," So it is when you try to tell what is in the Bible. Unless the spiritual sight is opened we cannot understand. In the light of this fact how blessed, how to be desired, is the work of the Holy Spirit! No wonder that the Psalmist prayed—"Open thou mine eyes, that I may behold wondrous things out of they law" (Ps. 119:18). Ask, and receive!

60 Perpetuity of the Bible

It has often been reviled; but it has never been refuted. Its foundations have been examined by the most searching eyes. In Hume, and Gibbon, and Voltaire, and La Place, not to mention a multitude of vulgar assailants, the Bible has had to sustain the assaults of the greatest talent, the sharpest wit, and the acutest intellects. To make it appear a cunningly devised fable, philosophers have sought arguments amid the mysteries of science, and travelers amid the remains of antiquity; for that purpose, geologists have ransacked the bowels of the earth, and astronomers the stars of heaven; and yet after having sustained the most cunningly devised and ably executed assaults of 2,000 years, it still exists—a glorious fulfillment of the words of its Founder—"On this rock have I built my Church and the gates of hell shall not prevail against it" (Matt. 16:18).

—Dr. Guthrie

61 Bible—Its Authorship Wonderful

The authorship of this book is wonderful. Here are words written by kings, by emperors, by princes, by poets, by sages, by philosophers, by fishermen, by statesmen; by men learned in the wisdom of Egypt, educated in the Schools of Babylon, trained at the feet of rabbis in Jerusalem. It was written by men in exile, in the desert, and in shepherds' tents, in "green pastures" and beside "still waters." Among its au-

thors we find the fishermen, the tax-gatherer, the herdsman, the gatherer of sycamore fruit; we find poor men, rich men, statesmen, preachers, exiles, captains, legislators, judges—men of every grade and class. The authorship of this book is wonderful beyond all other books.

It required fifteen hundred years to write it, and the man who wrote the closing pages of it had no communication with the man who commenced it. How did these men, writing independently, produce such a book? Other books get out of date when they are ten or twenty years old; but this book lives on through the ages, and keeps abreast of the mightiest thought and intellect of every age.

62 All Scripture Profitable

I have sometimes had persons ask me, "What portions of the Bible are most delightful to you?" I am reminded of the answer to a question once propounded to Daniel Webster. He was a great reader of Shakespeare's plays, and was asked which he liked best. He replied, instantly, "The one that I read last." It is very much so with Scripture. That portion which distills as the dew from heaven upon the thirsty soul, seems for the time the most precious of all Scripture; and which part it is, will depend very much upon the need of the man's own feeling, or heart-life.

63 The Bible to be Practiced

A traveler to France once remarked:

"I was convicted when I went to Paris! I had learned French. I could read newspapers in the French language almost as easily as in my own, and I thought I understood French very well, but when I went to Paris and heard it talked, it seemed like jargon, they talked so fast, and ran the words into each other so! I went into the shops, and undertook to talk French, and the shopkeepers could not understand me any better than I could them. I came near starving to death because I could not ask for what I wanted! I could take up French books and newspapers and read what was in them, but I came to understand, very soon, that I did not know very much about French."

Many a man reads the Bible, and reads it well; but let him undertake to talk in the language of Zion, and see whether he does not stagger.

64 The Power of the Word

A few years before the war, a humble villager in eastern Poland received a Bible from an evangelist who visited his small hamlet. He read it, was converted, and passed the book on to others. Through that one Bible two hundred more became believers. When the evangelist, Michael Billester, revisited the town in the summer of 1940, the group gathered to worship and listen to his preaching. Billester suggested that instead of giving the customary testimonies they all recite verses of Scripture.

Thereupon a man arose and asked, "Perhaps we have misun-

derstood. Did you mean verses or chapters?"

"Do you mean to say there are people here who can recite chapters of the Bible?" asked Mr. Billester in astonishment.

That was precisely the case. Those villagers had memorized not only chapters but entire books of the Bible. Thirteen knew Matthew and Luke and half of Genesis. One had committed all the Psalms to memory. Together, the two hundred knew virtually the entire Bible. Passed around from family to family and brought to the gathering on Sundays, the old Book had become so worn with use that its pages were hardly legible.

65 Meeting the Authors

Many years ago Dr. Bonar was speaking on heaven and the great reunion of loved ones there, and in his eloquent way he pictured the believer newly come from the earth walking along the golden street and suddenly coming right up against a group of Old Testament sages and prophets. In a moment he recognized them and said, "Why, this is Ezekiel, isn't it?"

"Yes," said Ezekiel. "I am so glad to meet you."

"And this is Micah, and Zechariah, and Amos."

And then Andrew Bonar said, "And just imagine Ezekiel's saying, 'Oh, you knew about me, did you? How did you like the book I wrote?'

"'Book? What book was that? I am sorry to say I never read it.'

"And then Micah would say, 'And what did you think of my book?'

"'Let me see, was that in the Old Testament or in the New Testament? It seems to me I remember there was such a book.'

"How would you feel to have to meet these men and never have read their books"

Some of you had better get busy. There is far too much time spent in reading novels and in reading the newspapers and too little time given to the Word of God. Good literature is fine; reading the newspaper is all right, but these things should not crowd out time for reading God's Word.

66 How to Enjoy the Bible

Dr. Howard W. Pope tells the story of a young lady who read a book, and, having completed it, remarked that it was the dullest book she had read in many a day. Not long after this experience she met a young man and in the course of time their friendship ripened into love and they became engaged. When he was visiting at the home of his fiancée one evening, she said to him, "I have a book in my library which was written by a man whose name and even initials are precisely the same as yours. Is that not a singular coincidence?"

"I do not think so," he replied."

"Why not?"

"For the simple reason that I wrote the book."

Dr. Pope concludes the story by remarking that the young lady sat up until the early morning hours

to read the book again, and when it was completed it seemed to her the most interesting book she had ever read. It wasn't dull at all. She found it fascinating. The secret? She knew and loved the author!

You will enjoy the greatest of all books, the Bible, God's Word, if you love the Author. "We love him, because He first loves us."

67 God's Word is Always Right

J. H. McConkey writes: "We said to a physician friend one day, "Doctor, what is the exact significance of God's touching Jacob upon the sinew of his thigh?" He replied, "The sinew of the thigh is the strongest in the human body. A horse could scarcely tear it apart." Ah, I see. God has to break us down at the strongest part of our self-life before He can have His own way of blessing with us.

68 A Good Answer

A New Hebrides chieftain sat peacefully reading the Bible, when he was interrupted by a French trader. "Bah," he said in French, "why are you reading the Bible? I suppose the missionaries have got hold of you, you poor fool. Throw it way! The Bible never did anybody any good."

Replied the chieftain calmly, "if it wasn't for this Bible, you'd be in my kettle there by now!"

69 Get Out What You Put In

What we experience today, hear today, and read today will help us and become the tools of our mind, or the way we think tomorrow. Because of this process we can see the importance of teaching a child the Word of God and right thinking while they are young. Proverbs 22:6 says: *"Train up a child in the way he should go; and when he is old, he will not depart from it."*

I can remember a teacher in Jr. High saying, "J. F., read good books. We get out what we put in!" I would have said it like this, "Read the Good Book. We get out what we put in!"

A Christian is a person that does not have a sin nature and also puts into himself what is needed to make the right decisions.

"Study to show thyself approved unto God, a workman that needeth not to be ashamed, rightly dividing the word of God" (2 Tim. 2:15).

—J. F. Carter

70 Revival for Survival

As my wife and I have been raising our four children, we've always lived on a busy street or highway. Like most other parents, when our kids were small, we gave them strict orders not to play near or in the street. For their own safety, we gave them boundaries. Our children are still alive today because of the grace of God and because they stayed within the boundaries and did not play in the street.

In many ways the U.S. is still a great country, and we're grateful and thankful to be Americans. But our nation is troubled, and we are reeling from the shock and grief of

the Oklahoma City bombing. At first we thought it was the work of another foreign terrorist. Then we were horrified to find this dastardly deed came from within our own ranks. The tragedy in our nation's heartland is a grim reminder of the fact that we are a society in moral and spiritual decline. We cannot blame Saddam Hussein or other foreign entities this time. We are slowly self-destructing and we must shoulder our own blame.

It is this writer's opinion that our official decline began in 1962-63 when we allowed our Supreme Court to remove prayer and Bible reading from our public schools. Ten years later, we legalized abortion, and when we sanction the murder of our society's most innocent and helpless citizens, then none of us is safe! We have discarded the sanctity of human life and are reaping the bloody results. We have ignored the boundaries our loving heavenly Father gave us and are "playing in the street," and it is killing us! Profanity, desecrating the Lord's Day, disobedience to parents, murder, adultery, stealing, lying, and coveting are all forbidden in the Ten Commandments, but Americans are acting like those were only "ten suggestions." There is a high price for "playing in the street" and every day we file for more divorces and lawsuits, increase our welfare rolls, build more jails and hospitals, bury more dead and shed more tears.

What is the remedy? The Bible says in 2 Chronicles 7:14, "*If my people, who are called by my name, shall humble themselves and pray, and seek my face, and turn from their wicked ways; then will I hear from heaven, and will forgive their sin, and will heal their land.*" In other words, there must be "Revival for Survival." We must return to the God who loves us and who in His wisdom and mercy set boundaries for our safety and enjoyment. God said in Deuteronomy 30:19, "*I have set before you life and death, blessing and cursing; therefore choose life, that both you and your descendants may live.*" It's up to us.

—Don Johnston

Character

 71 *Character Made Known*

"Thy speech betrayeth thee." Speech is the index of the soul. Utterance is the open door through which the character is known. Words are the fruit of the lips, and by their fruits we know them.

72 *The Glory of a Stainless Life*

An Arabian princess was once presented by her teacher with an ivory casket, not to be opened until a year had passed. The time, impatiently waited for, came at last, and with trembling haste she unlocked the treasure; and behold—on the satin linings lay a *shroud of rust*; the form of something beautiful, but the beauty gone. A slip of parchment contained these words: "Dear pupil, learn a lesson in your life. This trinket, when enclosed, had upon it only a spot of rust; by neglect it has become the useless thing you now behold, only a blot on its pure surroundings. So a little stain on your character will, by inattention and neglect, mar a bright and useful life, and in time leave only the dark shadow of what might have been. Place herein a jewel of gold, and after many years you will find it still as sparkling as ever. So with yourself; treasure up only the pure, the good, and you will be an ornament to society, and a source of true pleasure to yourself and your friends."

73 *Character Develops in Silence*

What a silent but awful work is character building! We understand now why "there was neither hammer, nor ax, nor any tool of iron heard in the house while the temple was in building" (1 Kgs. 6:7). It has been discovered that the quarries where the stones were made ready were under the city. All the preparations were made in silence and secrecy down beneath the tread of busy life; and then, when the great blocks were cleft from their bed, hewn, shaped, polished, and fitted for their place, they were hoisted through a shaft to the temple platform and lifted to their exact position. So all the preparations for character go forward in silence and secrecy; but the results are manifest in the structure which, for glory or shame, mysteriously grows before our eyes.

74 *Incomplete Character*

What becomes of those who reach high on the plane of morality, but do not touch the yet higher plane of spirituality? You might just as well ask me what becomes of a

marksman who almost hits the mark, but does not hit it. You might just as well ask me what becomes of an anchor that is let out of a ship, and reaches almost to the bottom, but stops short without touching it. You might as well ask me what becomes of a portrait which is splendidly painted, and is almost like the man that it is designed to represent, and yet is not like him.

75 The Real Man

It is with a man as it is with corn. You may take away the stalk, but that is not the corn; you may strip all the husks, one after another, and yet the corn has lost nothing. The kernel remains, and that is the corn. The stalk and husks are good to protect the corn, and carry the sap to it while it is growing; but when it is grown they are of no use to it. And a man has lost nothing when his surroundings are taken away.

76 Blessing in Trouble

When tender grasses start in the spring on the meadows along the Connecticut, the farmers rejoice. But the snows melt, the rains pour, the burdened river cannot carry all its treasure, and it overflows its banks, and submerges the fields. When the waters subside a deposit of mud has blotted out every spear of grass. But, behold! In a few weeks the blades shoot up through, and never was there such burden on fields as in the harvest day there is on these, that seemed to have been destroyed; for the slime and mud fed the fields instead of destroying them.

And so has it often been in the world's history, that torrents which seemed to be destruction, in the end enriched rather than destroyed what they submerged.

77 Nobility before Decoration

The habit of acting from the highest considerations is that which makes a man noble. The recognition of nobility may be conferred upon men, but not nobility itself. The king lays a sword on a man's shoulder and calls him a knight; but he was a knight before he was knighted, or he would not have received the title. It was the heroic endurance, the death-defying courage, the skill and coolness with which he achieved his notable deeds, that made him a knight. He was in himself royal and noble, and the king said to all men, "I see it," when he laid his sword on his shoulder.

78 Silence of Modesty

The late Stowell Scott, known in literary circles as Henry Seton Merriman, had a father who severely repressed his son's literary aspirations, compelling the young man to publish his earlier efforts under the pseudonym which afterwards became so famous. One day the old man picked up one of these books and said, "If you could write as well as this Seton Merriman, now, it might be worthwhile going on with it." The father never learned his

son's secret; he kept it with lowly modesty until the father's death. How few could have done this. How hard not to let the left hand know what the right has been doing (see Matt. 6:3).

Christt

79 Missing the Opportunity

Several years ago, in one of our Western cities, the church was preparing to entertain a conference of Christian workers. Among those who were expected, was a man whose reputation was almost worldwide. Because of his saintliness, and because of his splendid powers of mind, even the great had delighted to do him honor. When it was known that he would honor the conference with his presence, there was a sharp strife among the good women as to who should have the privilege of entertaining the distinguished guest. By and by, it was decided that he should stay in the home of the wealthiest man in the church.

Late on the night before the opening of the conference, there came a ring at the door of the rich man. Upon opening the door, the mistress of the house found a plainly dressed old man, who explained that he had been told he was to be entertained at this place. The lady replied somewhat sharply that it was a mistake, as she had no room, other than for those she had promised to take. Seeing the hurt look on the old man's face, she told him he might try the house across the street, as she knew they had promised to accommodate several of the delegates. The stranger did as she suggested, but with like result. As there was no hotel in this suburb, there was nothing for him to do but to return to the little waiting-station and there pass the night. Imagine the chagrin of the rich woman and her neighbor when they learned that the man they had turned away was the one they had so desired to honor. If the faithful Jews in the town of Bethlehem could have known that they were missing the opportunity of taking into their homes him whom they had longed to honor, there would have been many open doors to the weary pilgrims that memorable night.

80 Coming Deliverer

During the dark days of the struggle for Italian liberty the people generally looked upon Garibaldi as their invincible deliverer. Prisoners, hurried away to loathsome dungeons, would be cheered as they passed along the streets by friends whispering in their ears, "Courage, Garibaldi is coming!" Men would steal out at night and chalk on the walls and pavements, "Garibaldi is coming!" And when the news of his approach near to a city was announced the people

broke out into the rapturous shout, "Garibaldi is coming!" He came and Italy broke her political and religious fetters, never to be so enslaved again. A greater than Garibaldi is coming to God's people. The Desire of all nations is on the way. Jesus is coming, coming to reign, and His kingdom is joy, peace, blessing eternal.

—H. O. Mackey

81 Queen Victoria's Heart

Though Dean Farrar was the privileged friend of Queen Victoria, he seldom referred to this distinction. But he did so on the occasion of the first anniversary of the accession of Edward VI to the throne of England, during the service in Canterbury Cathedral, when he related that Queen Victoria, after hearing one of her chaplains preach at Windsor on the second advent of Christ, spoke to the dean about it and said: "Oh, how I wish that the Lord would come during my lifetime." "Why does your majesty feel this very earnest desire?" asked the great preacher. With her countenance illuminated by deep emotion the Queen replied, "Because I should so love to lay my crown at His feet."

82 Watch

McCheyne, the Scottish preacher, once said to some friends, "Do you think Christ will come tonight?'

One after another they said, "I think not."

When all had given this answer, he solemnly repeated this text:

"The Son of Man cometh at an hour when ye think not."

83 Come as You Are

An artist wanted a man for a model who would represent the prodigal. One day he met a wretched beggar, and he thought: "That man would represent the prodigal." He found the beggar ready to sit for his painting if he would pay him. The man appeared on the day appointed, but the artist did not recognize him. He said: "You made an appointment with me." "No," responded the artist, "I never saw you before." "You are mistaken; you did see me, and made an appointment with me." "No; it must have been some other artist. I have an appointment to meet a beggar here at this hour." "Well," said the beggar, "I am the man." "You the man?" "Yes." "What have you been doing?" "Well, I thought I would get a new suit of clothes before I got painted." "Oh," replied the artist; "I don't want you."

And so if you are coming to God, come just as you are. Do not go and put on some garments of your own. Do not try to make yourself more acceptable to God. All your "put on" righteousness will not avail. Come just as your are. Come with all your crimes. Come with your broken vows. Come with your lost opportunities. Come with your hardened heart. Come with your crushing burden. Come, come just as you are.

84 Christ Dwelling in the Heart

A widow woman lives by herself in a little cottage by the seashore. Of all whom she loved, only one survives—a lad at sea; all the rest have passed "from sunshine to the sunless land." She has not set her eyes on him for years. But her heart is full of him. She thinks of him by day, and dreams of him by night. His name is never left out from her prayers. The winds speak about him; the stars speak about him; the waves speak about him, both in storm and in calm. No one has difficulty in understanding how her boy dwells in her heart. Let that stand as a parable of what may be for every believer in the Lord and Savior Jesus Christ.

85 Christ-like Life

A Scottish missionary, home on furlough from her work in India, told this story. She had been teaching a group of children one day, telling them the story of Jesus, bringing out bit by bit incidents showing His character. As she was talking, one child, listening intently, grew excited, and then more excited. At last she was unable to restrain herself and blurted out: "I know him; he lives near us." Was there ever such praise of a human?

86 Pleasing Men or Serving Christ

A railway gatekeeper, who one cold night required every passenger to show his ticket before passing through to the train, and was re-warded with considerable grumbling and protesting, was told: "You are a very unpopular man tonight." "I only care to be popular with one man," was the reply, "and that is the superintendent." He might have pleased the passengers, disobeyed orders, and lost his position. He was too wise for that; his business was to please one man—the man who hired him, gave him his orders, and rewarded him for faithfulness, and who would discharge him for disobedience. The servant of Christ has many opportunities to make himself unpopular. There are multitudes who would be glad to have him relax the strictness of his rules. If he is their servant, they demand that he should consult their wishes. But if he serves them, he cannot serve the Lord. "No man can serve two masters." He who tries to be popular with the world, will lose his popularity with the Lord. He will make friends, but he will lose the one Friend who is above all others. He will win plaudits, but he will not hear the gracious words: "Well done!"

87 We Shall Be like Him

Gustavus Adolphus, King of Sweden, being killed in the battle of Lutzen, left only a daughter, Christina, six years of age. A general assembly, consisting of deputations from the nobles, the clergy, the burghers and the peasants of Sweden, was summoned to meet at Stockholm. Silence being proclaimed, the Chancellor rose. "We desire to know," said he, "whether

the people of Sweden will take the daughter of our dead King Gustavus Adolphus to be their Queen."

"Who is this daughter of Gustavus?" asked an old peasant. "We do not know her. Let her be shown to us."

Then Christina was brought into the hall and placed before the old peasant. He took Christina up in his arms and gazed earnestly into her face. He had known the great Gustavus well, and his heart was touched when he saw the likeness which the little girl bore to that heroic monarch. "Yes," cried he, with the tears gushing down his furrowed cheeks; "this is truly the daughter of our Gustavus! Here is her father's brow! Here is his piercing eye! She is his very picture! This child shall be our Queen!"

—Nathaniel Hawthorne

88 *Example of Life*

When Jesus makes our souls alive, then the one thing we have to do is to try to be like Jesus. A little girl went to a writing school. When she saw the copy set before her, she said: "I can never write like that." But she took up her pen and put it timidly on the paper. "I can but try," she said. "I'll do the best I can." She wrote half a page. The letters were crooked. She feared to have the teacher look at her book. But when the teacher came, he looked and smiled. "I see you are trying, my little girl," he said kindly, "and that is all I expect." She took courage. Again and again she studied the beautiful copy. She wrote

very carefully, but the letters straggled here, were crowded there, and some of them seemed to look every way. She trembled when she heard the step of the teacher. "I'm afraid you'll find fault with me," she said. "I do not find fault with you," said the teacher, "because you are only a beginner. Keep on trying. In this way, you will do better every day, and soon get to be a very good writer." And this is the way we are to try to be like Jesus. But when we read about Jesus, and learn how holy, and good, and perfect He was, we must not be discouraged if we do not become like Him at once. But, if we keep on trying, and ask God to help us we shall "learn of Him to be meek and lowly in heart" (see Matt. 11:29); and we shall become daily more and more like Him.

89 *Light Your Lamp*

Many years ago there was a little church on a lonely hillside which had no lamps, and yet on darkest nights they held divine services. Each worshiper, coming a great distance from village or moorland home, brought with him a taper and lit it from the one supplied and carried by the minister of the little church. The building was always packed, and the scene was said to be "most brilliant." Let each one of our lives be but a little taper—lighted from the life of Christ, and carrying His flame—and we shall help to fill this great temple of human need and human sin with the light of the knowledge of the

glory of God. The life of Christ will be the new sunshine of the world. "Men shall be blessed in Him; all nations shall call Him blessed"; universal man shall receive "God's Living Light."

90 The Inevitable Christ

The story has come down to us from the early centuries that when the storm of persecution broke over the Christian church in Rome, the little company of the believers besought Peter to seek refuge in flight. His sense, both of loyalty and of honor, rose up to protest. But his friends pleaded that their deaths would be only the loss of a few sheep of the fold, his would be the loss of the shepherd. He set out by night along the Appian Way. But as he traveled a vision flashed upon him of a figure clothed in white and a face crowned with thorns. "Quo vadis, domine?" "Whither goest thou, Lord?" Peter cried to Christ. "To Rome, to be crucified instead of Thee."

Into the night the vision ebbed
 like breath
And Peter turned and rushed on
 Rome and death.

That is a parable of the inevitable Christ. Whether we seek him or seek him not, whether we are in the way of our duty or out of it, the vision of Christ shall meet us face to face.

91 Jesus Shut Out

I remember hearing some years ago of an incident which occurred near Inverness. A beautiful yacht had been sailing in the Moray Firth. The owners of it—two young men—landed at Inverness, purposing to take a walking tour through the Highlands. But they lost their way, and darkness found them wandering aimlessly about in a very desolate spot. At last, about midnight, they fortunately came upon a little cottage, at the door of which they knocked long and loudly for admittance. But the inmates were all in bed, and curtly the young men were told to go elsewhere, and make no more disturbance there. Luckily, they found shelter in another house some distance away. But next morning the inhospitable people heard a rumor that filled them with chagrin, and gave them a lesson which they would not be likely to soon forget. What do you think it was? Just this: that the two young men who knocked in vain at their door the previous night were Prince George and his brother, the late Duke of Clarence—the most illustrious visitors in the kingdom. You can fancy the shame the people must have felt thus unconsciously to have shown themselves so inhospitable to the noblest persons in all the land. But are we any better? Are we not, indeed, much worse if we shut Jesus Christ, the greatest of all Kings, out of our hearts?

92 Royal Mediator

Sometimes there were more kings than one at Sparta, who governed by joint authority. A king was occasionally sent to some neigh-

boring state in character of a Spartan ambassador. Did he, when so sent, cease to be a king of Sparta, because he was also an ambassador? No, he did not divest himself of his royal dignity, but only added to it that of public deputation. So Christ, in becoming man, did not cease to be God; but though He ever was, and still continued to be, King of the whole creation, acted as the voluntary Servant and Messenger of the Father.

93 Trusting in Christ a Sign of Life

Suppose there is a person who does not exactly know his age, and he wants to find the register of his birth, and he has tried and cannot find it. Now, what is the inference that he draws from his not being able to tell the day of his birth? Well, I do not know what the inference may be, but I will tell you one inference he does not draw. He does not say, therefore, "I am not alive." If he did, he would be an idiot, for if the man is alive he is alive, whether he knows his birthday or not. And if the man really trusts in Jesus, and is alive from the dead, he is a saved soul, whether he knows exactly when and where he was saved or not.

—C. H. Spurgeon

94 A Story of the Christ Child

Tradition tells us that a century after the first Christmas a missionary stood on the banks of the Arno, telling the story of the Christ Child.

That night a Roman prince returned to his stone mansion, to feast. Suddenly in the dark he heard a tap on the window and beheld a child's face, a face beautiful enough to have been a model for Raphael's cherubs, and lo, a voice like music in the air whispered "The Christ Child is hungry." Irritated, the prince sent his soldiers to drive the child away, but from that moment his rich viands became tasteless and as ashes and sand. Once more he looked up, startled by a tap upon the window, and beheld the radiant child, standing at the window, in the darkness and the storm. Then came the voice saying, "The Christ Child is cold." In his selfishness again he bade the soldiers drive the child away, and told his servants to draw the curtains close. In that moment the very fire grew cold, and the blazing embers threw off darkness, and a chill crept to the heart of the selfish prince. And then the ice began to melt. Springing up, he flung wide the door and plunged into the darkness, calling for the child. Faster and faster fled the vision, until it came to a house, where a widow was dead, and a group of little orphan children were sobbing in the night. Obedient to the Child's command, the prince and his servants took them to his stately house, and brought other hungry children in, and feasted them, and henceforth his table was their table, his house their home, his sword their shield, his feet their wings. Some had thought that happiness was not for him, but in giving

happiness to Christ's children, his heart became the very citadel of joy and gladness.

95 *The Divinity of Christ*

If I were to attempt to prove the divinity of Christ, instead of beginning with mystery or miracle or the theory of the atonement, I should simply tell you the story of His life and how He lived and what He said and did and how He died, and then I would ask you to explain it by any other theory than that He is divine. Reared in a carpenter's shop, having no access to the wisdom of the other races and people, He yet, when about thirty years of age, gave to the world a code of morality, the likes of which the world had never seen before, the likes of which the world has never seen since. Then He was put to death. He was nailed to the cross in shame, and those who followed him were scattered or killed. And then, from this little beginning, His religion spread until hundreds of millions have taken his name upon their lips, and millions have been ready to die rather than surrender the faith that He put into their hearts. To me it is easier to believe Him divine than to explain in any other way what He said and did.

96 *Standing in Our Place*

A New York merchant who is very wealthy is afflicted with blindness, caused by the atrophy of the optic nerve. He so greatly desires to recover his sight that he has offered a reward of a million dollars to anyone that will restore him the use of his eyes. A very poor young man, who is afflicted in the same way, has been hired by this wealthy merchant to permit the experiments which are suggested to him to be tried on his eyes. He stands in the rich man's place with the added interest that if the experiments are successful, he will recover his own sight, as well as lead to the recovery of his employer. But suppose it were turned around, and the rich man were to give up his wealth, and his own sight, and his life even, to stand in the place of this poor man, and bring recovery and comfort to him, how infinitely more striking and interesting it would be! But Christ did more than that for us. He had the glory of heaven, and riches beyond our dreams; and yet He became poor and lonely and outcast, and suffered and died upon the cross in our stead; went down into the grace for us; but, blessed be God— He broke the bands of death asunder, and stands glorified in heaven, the pledge that all who sleep in Jesus shall have similar victory!

97 *Giving Our Best to Christ*

While there was pending a bill which had been introduced into Congress to preserve as a military park the splendid and picturesque Palisades of the Hudson, the work of their destruction went forward with great rapidity. The snorting drills which pounded all day long, eating holes in the cliff-top for the explosives, were operated by a large engine, protected by an un-

painted shed. This unsightly building added to the hideousness of the scarred and mournful scenery. Within a month the force of men employed was increased from seventy-five to one hundred and eighty, and the demolition went on at a disheartening rate. Heavy boulders, torn from the crags above, were blasted into fragments every few hours, and scores of men were employed loading and sending to the crusher carloads of the rock to be pulverized for road-making. A spot which should be one of nature's most beautiful pictures became an eyesore, a sordid scene of desolation. How sad that Congress waited so long! But it is sadder still to see a young man or a young woman permitting the best years of youth and hope to be eaten up in frivolity and sin instead of giving to Christ the strength and beauty of their young souls.

98 Christ's Trust in Us

No great leader ever left his followers less equipped to carry on his work than Jesus did. He left them with no written manual, no prestige, no money, no army, no organization. He left them His memory and His spirit, and trusted them to win the kingdom of God. Such a trust in the people is the world's hope.

99 The Cross of Christ Transforms

One of the things that differentiates Christianity from all other religions is that it offers more. Alchemy, the practice that supposedly transforms all the baser metals into gold—at least, it would if we could discover it—the only real alchemy is the cross of our Lord Jesus Christ. I once heard somebody say that it made plain faces beautiful. So it does. It makes commonplace people majestic. I have thought sometimes where would William Carey have been—one of our great pioneers and national heroes—if he had not given his heart to Jesus Christ? A cobbler in Northampton. And Bunyan was worse, he would have stayed tinker, and not much of a tinker at that, but for the fact that he gave himself to Jesus Christ. One of the most surprising men of the nineteenth century was Dwight L. Moody, just the hard old New England type. Somebody said of him that the world had yet to see what God would do with a man who gave himself unreservedly to Jesus Christ; and he said, "I will try."

100 Jesus' Method of Teaching

Jesus chose this method of extending the knowledge of Himself throughout the world; He taught His truth to a few men, and then He said, "Now go and tell that truth to other men."

101 Love of Christ

The love of Christ hath a height without a top, a depth without a bottom, a length without an end and a breadth without a limit.

102) A Better Example

To the laws of God and nature, our Savior added the testimony of His own example. Surely no man ever lived a busier life. He crowded His ministry into three and a half years, yet He always took time to rest. When He told His disciples to come apart into a desert place and rest, He did not mean a place barren of all shrubbery, trees, or grass. He meant a deserted place, a place deserted by the throng. Jesus' idea of a holiday was to get out of a crowd, not to get into one. He went to a place where grass and trees abounded, but where the throng came not; and when the throng crowded on Him, He fled into the coasts of Tyre. When He could be no longer hid there, He found refuge in the mountains of Cæsarea, Philippi, and from the labor and excitement of His later life, He sought retirement in the quiet home at Bethany at different times. When anyone says that the devil never takes a vacation, we may answer that we follow a better example.

103) Christ's Yoke

Did you ever stop to ask what a yoke is really for? Is it to be a burden to the animal which wears it? It is just the opposite. It is to make its burden light. Attached to the oxen in any other way than by a yoke, the plows would be intolerable. Worked by means of a yoke, it is light. A yoke is not an instrument of torture; it is an instrument of mercy. It is not a malicious contrivance for making work hard; it is a gentle device to make hard labor light. It is not meant to give pain, but to save pain. And yet men speak of the yoke of Christ as if it were a slavery, and look upon those who wear it as objects of compassion. Christ's yoke is simply His secret for the alleviation of human life, His prescription for the best and happiest method of living.

—Henry Drummond

104) Power of Christ

There are two kinds of magnets, steel magnets and soft iron magnets. The steel magnet receives its magnetism from the load stone, and has it permanently; it can get along very well alone in a small way; it can pick up needles and do many other little things to amuse children. There is another kind of magnet, which is made of soft iron, with a coil of copper wire round it. When the battery is all ready, and the cups are filled with the mercury, and the connection is made with the wires, this magnet is twenty times as strong as the steel magnet. Break the circuit, and its power is all gone instantly. We are soft iron magnets; our whole power must come from the Lord Jesus Christ; but faith makes the connection, and while it holds we are safe.

105) Suffering for Christ

There was a certain king whose son was sent upon an errand to a far country, and when he came into that country, although he was the lawful prince of it, he found that the citizens would not acknowledge

him. They mocked at him, jeered at him, and took him and set him in the pillory, and there they scoffed at him and pelted him with filth. Now, there was one in that country who knew the prince, and he alone stood up for him when all the mob was in tumult raging against him. And when they set him on high as an object of scorn, this man stood side by side with him to wipe the filth from that dear royal face; and when from cruel hands missiles in scorn were thrown, this man took his full share; and whenever he could he thrust himself before the prince to ward off the blows from him if possible, and to bear the scorn instead of him. Now it came to pass that after awhile the prince went on his way, and in due season the man who had been the prince's friend was called to the king's palace. And on a day when all the princes of the court were around, and the peers and nobles of the land were sitting in their places, the king came to his throne and he called for that man, and he said, "Make way, princes and nobles! Make way! Here is a man more noble than you all, for he stood boldly forth with my son when he was scorned and scoffed at! Make way, I say, each one of you, for he shall sit at my right hand with my own son. As he took a share of his scorn, he shall now take a share of his honor." And there sat princes and nobles who wished that they had been there—they now envied the man who had been privileged to endure scorn and scoffing for the prince's sake! You need not that I interpret the parable. May you make angels envious of you, if envy can ever pierce their holy minds. You can submit for Christ's sake to sufferings which it is not possible for seraphim or cherubim to endure.

—C. H. Spurgeon

106 The True Shepherd

Another illustration from the pen of Spurgeon:

" 'The sheep follow him, for they know his voice; and a stranger will they not follow, for they know not the voice of strangers' (John 10:5). I remember hearing a brother tell how he disproved the notion that sheep only know the shepherd by his dress. When in Palestine he asked a shepherd to allow him to put on his clothes. Then he began to call the sheep, but never a one would come, not even a lamb. The most sheepish of the flock had sense enough left to know that he was not the shepherd, and even the youngest kept aloof, heedless of the stranger's voice. He might have called till he was hoarse, but they would not come. So God's people know their Lord, and they know the kind of food which he gives them."

107 Christ's Ownership in His People

Spurgeon also wrote:
"If I possess a love-token that some dear one has given me, I may rightly desire to have it with me. Nobody can have such a right to your wedding ring, good sister, as

you have yourself; and are not Christ's saints, as it were, a signet upon his finger, a token which his Father gave him of his good pleasure in him? Should they not be with Jesus where he is, since they are his crown jewels and his glory? We in our creature love lift up our hands and cry, 'My Lord, my Master, let me have this dear one with me a little longer. I need the companionship of one so sweet, or life will be misery to me.' But if Jesus looks us in the face, and says, 'Is thy right better than mine?' we draw back at once. He has a greater part in his saints than we can have."

108 The Humiliation of Christ

Still another illustration by Spurgeon:

"Never was there a poorer man than Christ; he was the prince of poverty. . . . *Christ* stood in the lowest vale of poverty. Look at his clothing, it is woven from the top throughout, the garment of the poor! As for his food, he oftentimes did hunger; and always was dependent upon the charity of others for the relief of his wants! He who scattered the harvest over the broad acres of the world, had not sometimes wherewithal to reverse the pangs of hunger? He who dug the springs of the ocean, sat upon a well and said to a Samaritan woman, 'Give me to drink' (John 4:7, 10). He rode in no chariot, He walked his weary way, footsore, over the flints of Galilee! He had nowhere to lay his head. He looked upon the fox as it hurried to its burrow, and the fowl as it went to its resting-place, and he said, 'Foxes have holes, and the birds of the air have nests; but I, the Son of man, have nowhere to lay my head' (Matt. 8:20; Luke 9:58). He who had once been waited on by angels, becomes the servant of servants, takes a towel, girds himself, and washes his disciples' feet! He who was once honored with the hallelujahs of ages, is now spit upon and despised! He who was loved by his Father, and had abundance of the wealth of affection, could say, 'He that eateth bread with me hath lifted up his heel against me' (John 13:18; cf. Ps. 41:9). Oh, for words to picture the humiliation of Christ!

109 Christ Seeking the Lost

"I am lost," said Mr. Whitefield's brother to the Countess of Huntington. "I am delighted to hear it," said the Countess. "Oh," cried he, "what a dreadful thing to say!" "Nay," said she, "'for the Son of man is come to seek and to save that which was lost' (Matt. 18:11; Luke 19:10); therefore, I know he is come to save *you*." O sinner, it would be unreasonable to despair. The more broken you are, the more ruined you are, the more vile you are in your own esteem, so much the more room is there for the display of infinite mercy and power.

110 The Elder Brother

It is saying a great thing to affirm that "there is a friend that sticketh closer than a brother" (Prov. 18:24);

for the love of brotherhood has produced most valiant deeds. We have read stories of what brotherhood could do, which, we think could hardly be excelled in the annals of friendship. Timoleon, with his shield, stood over the body of his slain brother, to defend him from the insults of the foe. It was reckoned a brave deed of brotherhood that he should dare the spears of an army in defense of his brother's corpse. And many such instances have there been, in ancient and modern warfare, of the attachment of brethren. There is a story told of a Highland regiment, who, while marching through the Highlands, lost their way; they were overtaken by one of the terrible storms which will sometimes come upon travelers unawares, and blinded by the snow, they lost their way upon the mountains. Well nigh frozen to death, it was with difficulty they could continue their march. One man after another dropped into the snow and disappeared. There were two brothers, however, of the name of Forsythe; one of them fell prostrate on the earth, and would have lain there to die, but his brother, though barely able to drag his own limbs across the white desert, took him on his back, and carried him along, and as others fell, one by one, this brave, true-hearted brother carried his loved one on his back until at last he himself fell down overcome with fatigue and died. His brother, however, had received such warmth from his body that he was enabled to reach the end of his journey in safety, and so lived. Here we have an instance of one brother sacrificing his life for another. I hope there are some brothers here who would be prepared to do the same if they should ever be brought into the same difficulty. It is saying a great thing, to declare that "there is a friend that sticketh closer than a brother."

—C. H. Spurgeon

111 Yoked with Christ

Here is yet another illustration by Spurgeon:

"When bullocks are yoked, there are generally two. I have watched them in Northern Italy, and noticed that when two are yoked together, and they are perfectly agreed, the yoke is always easy to both of them. If one were determined to lie down and the other to stand up, the yoke would be very uncomfortable; but when they are both of one mind you will see them look at each other with those large, lustrous, brown eyes of theirs so lovingly, and with a look they read each other's minds, so that when one wants to lie down, down they go, or when one wishes to go forward, forward they both go, keeping step. In this way the yoke is easy. Now I think the Savior says to us, 'I am bearing one end of the yoke on my shoulder; come, my disciple, place your neck under the other side of it, and then learn of me. Keep step with me, be as I am, do as I do. I am meek and lowly in heart; your heart must be like mine, and then we will work to-

gether in blessed fellowship, and you will find that working with me is a happy thing; for my yoke is easy to me, and will be to you. Come, then, true yoke-fellow, come and be yoked with me, take my yoke upon you, and learn of me' (Matt. 11:29, 30)."

112 Linked to the Savior

Two travelers, who fancied they were abundantly able to take care of themselves, entered a railway carriage when the train was being made up and found comfortable seats. They had dropped into conversation when a porter looked in and told them to go to another coach. "What is the matter with this coach?" they asked. "Nothing," he grinned, "only 'taint coupled on to anything that'll take you anywhere." That is the trouble with many beautiful creeds and theories—they sound good, but they do not take you anywhere. The soul that would journey heavenward must make sure of the coupling. This is it: "Whosoever shall call upon the name of the Lord shall be saved" (Rom. 10:13).

113 Putting on Christ

It is told of a Roman youth who, notwithstanding a mother's unwearied prayers, had lived a life of self-seeking and sinful indulgence. Then one day, as he sat in the garden, in the cloudless beauty of an autumn day, a great struggle took place in his mind. Throwing himself on his knees he prayed earnestly to God, "O Lord, how long—how long—

how long wilt thou be angry with me? Must it be forever, tomorrow, and tomorrow, and tomorrows? Why should it not be today?" Suddenly in his agony he seemed to hear the voice as of a little child repeating, "Take up and read"; "Take up and read." And taking up the Epistles of St. Paul which he had happened to be reading, and opening the book at random, his eye caught these words: "Not in rioting and drunkenness, not in chambering and wantonness, not in strife and envying. But put ye on the Lord Jesus Christ, and make not provision for the flesh, to fulfill the lusts thereof (Rom. 13:13, 14). The words came to him as a direct message from God, and in one instant strong resolve, he determined forever to break with his old life and in the might of Christ to enter on the new. Augustine put on Christ.

114 Fellowship with Christ

The president of one of the largest banks of New York City said that after he had served for several years as an office boy in the bank, the then president called him into his office one day and said, "I want you to come into my office and be with me." The young man replied, "But what do you want me to do?" "Never mind that," said the president; "you will learn about that soon. I just want you to be in here with me." "That was the most memorable moment of my life," said the great banker. "Being with that man made me all that I am today." What must the disciples have received by being with Jesus?

115 How Christ Draws

(John 12:32)

A gentleman who was being urged to accept Christ, said to the preacher, "There are some things in the Bible that seem to me to be highly contradictory. Christ must have overestimated himself. Once he declared that he would draw all men unto him, and yet he hasn't done it. I know you will remind me that he hasn't yet been lifted up before all men, but even that does not alter the case. Men go to church and listen to you; they even read the Bible, and then go away and live worldly lives. They devote themselves to money-making and sensuality, and are not drawn to your Christ—at least, not more than one of them in a hundred is."

"Do you believe that there is such a thing as gravitation?" the preacher asked.

"Certainly I do."

"Well, what is it?"

"I believe philosophers define it as being an invisible force by which all matter is drawn to the center of the earth."

The preacher stepped to the window. "Come here," he said. "Do you see those gilt balls?" pointing to the pawnbroker's sign across the street.

"Yes."

"How about the power of gravitation now? You say that it draws all matter to the center of the earth, and yet those balls have been hanging there for three years."

"Oh, well!" said the young man, his face flushing, "they are fastened to that iron rod."

"Yes," replied the preacher, "and it is so with the men of whom you speak. One is bound fast by the lusts of the flesh; another is anchored by his ambitions, and still another finds his business an iron rod that holds him fast."

Christ draws men wherever he is lifted up to their view, but they can resist him if they will.

116 Christ Waiting

A man once stopped a preacher in a street of London, and said, "I once heard you preach in Paris, and you said something which has, through God, been the means of my conversion." "What was that?" said the preacher. "It was that the latch was on our side of the door. I had always thought that God was a hard God, and that we must do something to propitiate him. It was a new thought to me that Christ was waiting for me to open to him."

117 The Inner Life

Christ came that men might have more abundant life than they had ever known before. No man has ever known from any other source a life so sweet and rich and full as that which comes to him whose life is "hid with Christ in God" and who sups daily with Jesus at the head of the table of his heart. How beautifully James McLeod characterizes the richness of such fellowship:

Purer than the purest fountain,
Wider than the widest sea,

Sweeter than the sweetest
music,
Is God's love in Christ to me.
Why love me ?
I do not know;
I only know
That nothing less than love
divine
Could save this sinful soul of
mine.

118 The Shepherd and the Lost Sheep

In the life of Dr. Moody Stewart the story is told that, when a boy, he was greatly surprised one day to find all the sheep in the field standing close in a circle with their faces outward. Two foxes had run off with two lambs and the sheep at once drove the lambs together and formed a circle around them for their defense. A gentleman commenting on this story recalls the fact that wild horses and wild deer do that when attacked by wolves. Sheep were probably once quite wild, and in their wild state they were far stronger and braver than they are now. In great danger their original nature rushes upon them and arms them for the defense of their lambs. If the sheep risk their lives for the sake of their lambs, surely the Good Shepherd will defend His own. Again and again He tells us that He laid down His life for the sheep. His sheep were lost in the wilderness, ready to perish, and He went into the wilderness to seek and to save them. And He considers even one sheep well worth saving.

He leaves the ninety and nine in the fold, and goes after the one that has strayed. He cares for each as if it were His one ewe lamb.

119 Shining for Christ

Elsie Lyle took a journey by rail. As the train was starting her pastor said to her: "I am glad you have a holiday, and traveling will give you a good opportunity to shine for Jesus." She wondered how in a railway-carriage she could do anything for Jesus. In front of her was a poor woman with three ragged, untidy children. They did not look very inviting, but she said: "I am one of Christ's disciples and I must be careful how I treat one of his little ones." She read to them and gave them some of her lunch, and was so occupied in entertaining them that she came to the end of her journey before she realized it. When she reviewed the day's work she said to herself: "Mr. Wardwell said traveling gave good opportunity to shine for Jesus and I have not spoken a word for Christ all day." A few days later Mr. Wardwell said to her, "Mr. Smith, the lawyer, who sat on the opposite side of the carriage you traveled in the other day, says he wishes to become a Christian. He said: 'I traveled lately with Elsie Lyle, who had just confessed her love for Christ, and for a half-day she proved an angel of mercy to a worn-out mother and three fretful children and never appeared to think of herself for a moment. What the Spirit of Christ has done for her I want done for me.' And the best of it all is, Elsie,

he is now a Christian and your shining face led him to Christ."

120 Christ Knows How to Feel for Us

Marjo sat on the upper stair listening. Every time a fresh wail reached her ears she groaned softly in loving sympathy. She had her little scalloped handkerchief squeezed together in one hand, and it was quite damp.

"Oh, dear me! I wish he'd been a good boy; then mamma wouldn't have put him to bed, and he wouldn't be feeling so dredf'ly," Marjo murmured. "I wish he had been good. Poor Bobby! It hurts in my heart when he cries so."

New reinforced wails drifted out to the stairway. They were growing more heart-rending all the time. Marjo's little mouth corners dropped more and more, and the scalloped handkerchief got still damper.

"Marjorie! Marjorie! Why don't you come down and play, dear?" mamma called.

"I guess I can't, mamma; I feel so sorrowful for Bobby!" Marjo called back.

"You mustn't feel too bad, dear. Bobby was naughty, and ought to cry."

"Yes'm, I know it," the sweet, shaky little voice called down to mamma; "but—but—you see, I have to feel bad. You can't do it well's I can, for I've been there and know how it feels."

How much it meant that Christ came and tasted our human grief for 33 years, and was tempted in all points like as we are (Heb. 4:15), so that when we carry to Him our sorrows we know that He has a fellow-feeling for us.

121 Debt—Christ Has Paid It

A dissipated Russian officer having become hopelessly involved in debt, sat down in desperation and wrote out a list of his indebtedness. Summing up the whole, he wrote in despair at the bottom, "*Who can pay such a debt as this?*" That night the emperor passed through the barracks in disguise and seeing the paper beside the sleeping man, read it, and wrote at the end of the question the one word *Nicholas!* In the morning the officer wondered who had done it, but all doubts vanished when at ten o'clock the emperor sent the cash necessary for the heavy payment. Unsaved reader, you are in debt also. Think of your sins, how much you owe your Lord, and when in despair you say, "Who can pay such a debt?" then whisper the name of Jesus. He can pay it. He has paid it.

Jesus paid it all,

Yes, all the debt you owe!

122 Christ—A Refiner

"For he is like a refiner's fire. And he shall sit as a refiner and purifier of silver" (Mal. 3:2, 3).

A Lady in Dublin became interested in the meaning of this text and called upon a silversmith and asked him to explain the process of refining, which he did. "But do you *sit*, sir, while you are refin-

ing?" she asked. "Oh, yes, madam, I must sit, with my eye steadily fixed on the furnace, since if the silver remain too long it is sure to be injured." She at once saw the beauty of the text. Christ sees it needful to put His children into the furnace, but He is seated by the side of it, and will permit them to remain in it no longer than is best. The lady was leaving, and got as far as the door of the shop, when the man called her back and said he had forgotten to tell her how he knew when the process of purifying was complete—*it was when he saw his own image reflected in the silver.* O, yes, when Christ sees His own image in His people, then His work of purifying is accomplished.

123 The Great Refiner

In the great iron foundries in making Bessemer steel, the process of purification is watched through a spectroscope, in which the changing colors of the flames show exactly when the metal is perfectly ready for its uses. When the flame becomes a certain precise shade of color then the great crucible is tilted and the metal poured into molds. So the great Divine Refiner, the loving Christ sits down by the crucible of our discipline and chastening, watches intently to see when the fire has done its work; and when this is reached, the metal is removed from the flames. Not a pang, a pain, or a sorrow that is not necessary to our purifying will He permit.

124 A Slave for Christ's Sake

Many years ago Lough Fook, a Chinese Christian, moved with compassion for the workers in the South American mines, sold himself into slavery for a term of five years and was transported to Demerara that he might carry the gospel to his countrymen there. He toiled in the mines with them and preached Christ as he toiled, until there were scores of whom he could say, as Paul of Onesimus, "whom I have begotten in my bonds" (Phile. 1:10), He died some time ago, but not until he had won to the Savior nearly two hundred disciples, whom he left behind in membership with Christian churches. To a Christian Chinaman belongs the honor of coming nearest to his Master in actual deed for *"He took upon Him the form of a slave"* (see Phil. 2:7).

125 To See Christ

A sculptor wrought a beautiful statue, and a man who saw it said, "I do not understand your statue. You can care, I know, but your statue is all out of proportion. Can't you see it?"

"You cannot see it as I see it," remarked the sculptor. "You will find at the foot of the statue a place to kneel, and when you kneel at the foot of my image of Christ, you will see it in its true proportion."

The man knelt there, and he saw at once the statue in its true proportion and glory. There are things in Christ which you can never learn or see until you have knelt at His feet.

126 "Then to the Dogs!"

"The Lord shall fight for you" (Ex. 14:14).

The Turks, having tortured and slain the parents of a little Armenian girl before her eyes, turned to the child and said, "Will you renounce your faith in Jesus, and live?" She replied, "I will not." "Then to the dogs!" she was thrown into a kennel of savage and famished dogs and left there. The next morning they came and looked in, to see the little girl on her knees praying, and beside her the largest and most savage of all the dogs, snapping at every dog that ventured near, thus protecting the child. The men ran away terrified, crying out, "There is a god here; there is a god here."

127 The Name That Made the Difference

At the close of a battle a young man was found dying on the battlefield. A soldier stopped to render him assistance, and as his comrade moistened his lips and made his head rest easier the dying man said, "My father is a man of large wealth in Detroit, and if I have strength I will write him a note and he will repay you for this kindness."

And this is the letter he wrote: "Dear Father, the bearer of this note made my last moments easier, and helped me to die. Receive him and help him for Charlie's sake."

The war ended, and the soldier, in tattered garments, sought out the father in Detroit. He refused to see him at first because of his wretched appearance. "But," said the stranger, "I have a note for you in which you will be interested." He handed him the little soiled piece of paper, and when the great man's eyes fell upon the name of his son, all was instantly changed. He threw his arms about the soldier, and drew him close to his heart, and put at his disposal everything that wealth could make possible for him to possess. It was the name that made the difference. And thus we stand on redemption ground, before God in the Name of Jesus Christ, and He speaks for us as did Paul for the Roman slave Onesimus.

—J. Wilbur Chapman

128 He Understands

"How do you know that Christ is risen?" Someone asked an old fisherman whose faith in Jesus seemed very simple and sure. "Do you see those cottages near that high cliff?" he replied, pointing to the shore. "Well, sometimes, when I am far out at sea, I know that the sun is risen by the reflection in those windows. How do I know that Christ is risen? Because I see His light reflected from the faces of some of my fellows every day, and because the light of His glory shines into my own life. And I hope that I am reflecting that light to others." That is the way it was with the disciples on the day of Pentecost. They were reflecting the light of the risen Christ, and so the people were filled with amazement. Only as we reflect a risen Christ in our lives will the world know that He is risen indeed.

129　The Solid Rock

A street preacher in London was preaching to a crowd that had gathered around him. It was at the time of the Shamrock races, and everyone was talking of the event. A ruffian on the edge of the crowd thought he would have a little fun, so he called three times, "Mr. Preacher! What do you know about the Shamrock?" Finally, the fourth time, not to be silenced, the ruffian called again, "Mr. Preacher! I'm asking you what you know about the Shamrock." This time the preacher paused. The crowd became very still. Pointing upward with one hand, he said, so clearly and distinctly that everyone could hear him, "On Christ, the solid Rock, I stand; all other rocks are—sham rocks!"

130　Work Done for Christ

Both in belief and in duty this is the work of the Holy Spirit—to make belief profound by showing us the hearts of the things that we believe in, and to make duty delightful by setting us to doing it for Christ. Oh, in this world of shallow believers and weary, dreary workers, how we need that Holy Spirit! Remember, we may go our way, ignoring all the time the very forces that we need to help us do our work. The forces still may help us. The Holy Spirit may help us—will surely help us—just as far as He can, even if we do not know His name, or ever call upon Him. But there is so much more that He might do for us if we would only open our hearts and ask Him to come into them.

—Phillips Brooks

131　"Show Us the Father"

A. T. Pierson has this to say about communion with God:

"A word is the manifestation of a thought. If I wish to communicate a thought to you, that thought takes shape in words. You cannot see my thought, but what is there comes through the channels of speech, and so travels through your ear to your mind, and becomes part of your thought. Now Christ became the Word to take the thought out of the mind and heart of God, and translate that thought so that we could understand it, so that what was before invisible and inaudible and beyond the reach of our senses comes into our minds and hearts as something that was in God's mind and heart, but now is in ours. Beautiful indeed is this as an expression of what Christ is to us. You want to know God; well, then, study Christ, and you will know all about Him. 'He that hath seen me hath seen the Father' (John 14:9), said Jesus.

132　Refreshment

Are you weary, dear friend, in the struggle with the world without and sin within? Here is One who can refresh you. Have you come to Christ? If so, you will be cared for in all the future in the degree in which you are learning of Him. We are often thoughtless and forgetful students, and for our good we are

chastened. But in the toils and troubles and bereavements of the present we can have rest in a trusted Savior, and when the sorrows are over we shall have rest in heaven.

—John Hall

133 The Cross and the Crown

The following illustration is by Phillips Brooks:

"In all of Christ's associations the same inevitable mingling of the sad and glad appears. There was a little family at Bethany in which He often made His home, and the last time He left the hospitable door He carried out with him two memories— the memory of how the eyes of Mary had looked up into His face, eager with the desire to understand all His sacred truth, and the memory of how the same eyes had streamed with tears beside her brother's tomb. The same voices of the populace at Jerusalem which cried, 'Hosanna!' cried, 'Crucify him!' before the week was done.

134 Treading the Wine Press

Here is another fine illustration by Phillips Brooks:

"The Savior Himself, surely He is never so dear, never wins so utter and so tender a love, as when we see what it has cost Him to save us. . . . Not merely has he conquered completely and conquered in suffering; He has conquered *alone*. As anyone reads through the Gospels, he feels how hopeless the attempt would be to tell of the loneliness of that life which Jesus lived. 'I have trodden the winepress alone; and of the people there was none with me. I looked, and there was none to help: therefore mine own arm brought salvation' (Is. 63:5). He had friends, but we always feel how far off they stood from the deepest center of His heart. He had disciples, but they never came into the inner circles of His self-knowledge. He had fellow-workers, but they only handed around the broken bread and fishes in the miracle, or ordered the guest chamber on the Passover night. They never came into the deepest work of His life. With the mysterious suffering that saved the world they had nothing to do.

135 Common Things Glorified

The great devotional writer J. R. Miller has this to say about serving God to the best of our abilities:

"Our Lord calls His people always to be helpers in blessing this world. We cannot do much. The best we can bring is a little of the common water of earth; but if we bring that to Him, He can change it into the rich wine of heaven, which will bless weary and fainting ones. If we take simply what we have and use it as He commands, it will do good. Moses had only a rod in his hand, but with this he wrought great wonders. The disciples had only five barley-loaves, but these, touched by Christ's hand, made a feast for thousands. The common water, carried by the servants, under the Master's benediction became wine for the wedding."

136 "Careful for Nothing"

Philippians 4:6

How many need a cure for care! The burdened man of business, the anxious parent, the struggling toiler, the perplexed man of affairs—all need some counselor that can be trusted, and some helper that can be relied upon. God is the One to whom to go "in everything." Thanksgiving is to be joined with the prayer, for even the most burdened have blessings here and hereafter. Pray in faith; then comes peace, different from what the world gives, with its pleasures, its promises, and its opiates, and that peace keeps the heart as brave soldiers keep the citadel. And all "through Christ Jesus"— blessed be His name!

—John Hall

137 At the Door

In Holman Hunt's great picture, called "The Light of the World," we see One with a patient, gentle face, standing at a door which is ivy-covered, as if long closed. He is girt with the priestly breastplate. He bears in His hand the lamp of truth. He stands and knocks. There is no answer, and He still stands and knocks. His eye tells of love; His face beams with yearning. You look closely, and you perceive that there is no knob or latch on the outside of the door. It can be opened only from within.

Do you not see the meaning? The Spirit of God comes to your heart's door and knocks. He stands there while storms gather and break upon His unsheltered head, while the sun declines, and night comes on with its chills and its heavy dews. He waits and knocks, but you must open the door yourself. The only latch is inside.

—J. R. Miller

138 In the Bright Days

Another illustration from J. R. Miller:

"We need Christ just as much in our bright, prosperous, exalted hours as in the days of darkness, adversity, and depression. We are quite in danger of thinking that religion is only for sickrooms and funerals, and for times of great sorrow and trial—a lamp to shine at night, a staff to help when the road is rough, a friendly hand to hold us up when we are stumbling. This is not true. Jesus went to the marriage-feast as well as to the home of sorrow. His religion is just as much for our hours of joy as for our days of grief. There are just as many stars in the sky at noon as at midnight, although we cannot see them in the sun's glare. And there are just as many comforts, promises, divine encouragements, and blessings above us when we are in the noons of our human gladness and earthly success, as when we are in our nights of pain and shadow. We may not see them in the brightness about us, but they are there, and their benedictions fall upon us as perpetually, in a gentle rain of grace."

139 Hurry! He Is Coming!

I had an opportunity to work in a bakery while going to high school.

I remember one particular day when the telephone rang and one of the ladies went to answer it. She put down the phone like it was hot and yelled, "He's coming!" I wondered what in the world was going on? The ladies ran for their hair nets and men ran for clean aprons and clean caps. The boss told me to sweep the floor, and cover all the containers. There was a wild and excited look in his eyes. Everyone was running around like chickens with their heads cut off. I thought to myself, "Who is coming?"

Suddenly through the front door entered a man in a suit with a case under his arm. As I observed him he began to walk around and check the bakery for any health hazards. I then realized that he was the state inspector for the Board of Health. After he left everyone breathed a sigh of relief and went back to work. One of the ladies told me that all the places of business always watched out for each other. The first one to see the inspector coming would then call the other business. They had a system of warning.

When Jesus comes again there won't be time to prepare a speech on all the good things we have been involved in. There won't be time to tell Him how our neighbors and friends hindered us in His service. There will be judgment, "*So then each one of us shall give an account of himself before God.*" God will not accept our excuses nor will He give us time to repent. Today is the time to prepare ourselves for His coming.

Remember, "He is coming!"

—John A. Boor

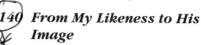

140 From My Likeness to His Image

My, how I love them, these sons
 God gave me,
But there's a great problem,
My likeness I see.

I hear their groanings, I hear
 their plea,
And I know the reason,
They're the likeness of me.

They cannot help it, they can't
 seem to see,
They have my nature,
They're the likeness of me.

Born with my likeness, with
most of my need,
Born with my weakness
They're the likeness of me.

In all that they do, I see, I can tell,
They are just like me,
I know them right well.

Oh God, hear my prayer as I
 plead now for them,
That they be changed from my
 likeness,
To the image of **Him.**

Changed from my likeness, made
 after His plan,
And grant them real strength,
In the deep, inner man.

From my likeness to His image,
conformed to His plan,
For to be like the Savior,
Is to be the best man.

—George Mills
The Wilderness

141 My Vacation

I love to sit beside the sea
And think of Jesus of Galilee.
How on a pillow in a boat He
 slept,
And how the waves the boat
 overswept.
His, *"Peace, be still,"* brought the
 calm,
Soothing the storm like a balm.

I see the boats with their nets
 stretched out,
And watch them slowly move
 about
Making a living from the sea
As the apostles did on Galilee.
I think of them fishing all the
 night,
And catching nothing before
 daylight.

Then Jesus told them where to
 cast
To get their nets filled up at last.
And now I take another look
To see Jesus on the shore—a cook.
A charcoal fire He had made
To cook some fish, and then He
 bade
His friend to come and dine
On fish and bread, a meal so
 fine.
I sit and think and "drink it in,"
And hope soon to return again!

—Mary Lee Lyons
Gospel Light

142 Angels and Their Love
 for Christ

Elizabeth Barrett Browning, in one of her poems, has pictured with rare beauty the effect of Christ's death upon two seraphim who lingered a little behind the hosts of heaven who had gathered that day round the cross. One of them, as he thinks of the meaning of the wonderful sacrifice, is troubled by the thought that men will now have more reason to love God than even the angels have. The other remonstrates, saying, "Do we love not?" "Yes, but not as man shall," he answered:

Oh! not with this blood on us—
 and this face,
Still, haply, pale with sorrow that
 it bore
In our behalf, and tender ever
 more
With nature all our won, upon
 us gazing
Nor yet with these forgiving
 hands upraising
Their reproachful wounds, alone
 to bless!
Alas, Creator! shall we love Thee
 less
Than mortals shall?

142 Rejected Love

Her mother and daddy disowned her. She did all she could do. When Elizabeth Barrett married the famous poet Robert Browning, her parents were so upset they disowned her. She and her husband settled far from home in Florence, Italy. Elizabeth loved her mother and father and did everything she could to be reconciled with them. Several times a month she wrote expressive, loving letters. After 10 years without any response, finally,

a package came from her parents. It was a happy moment for Elizabeth as she opened it. But inside she found all of the letters she had sent—unopened. Like her husband, Elizabeth was a poet and her letters of reconciliation were eloquent. They have been called "some of the most beautiful and expressive in all English literature." But her parents never read them. Jesus Christ, like Elizabeth, went to extreme measures in a reconciliation attempt. He died so sinful men could be reconciled to God. It breaks His heart that many refuse to even read the letter of Calvary's love.

Moody Adams Update

Christian

144 Buttonhole Christians

An incident is related which occurred during Charles Finney's meetings in New York City, and which will illustrate the value of a little tact in the great struggle for souls. The big cutlery firm of Sheffield, England, had a branch house in New York. The manager was a partner of the firm and very worldly. One of his clerks, who had been converted in the meetings, invited his employer to attend. One evening he was there and sat across the aisle from Mr. Arthur Tappan. He appeared affected during the sermon, and Mr. Tappan kept his eye on him. After the dismissal, Mr. Tappan stepped quickly across the aisle, introduced himself, and invited him to stay to the after-service. The gentleman tried to excuse himself and get away, but Mr. Tappan caught hold of the button on his coat and said: "Now, do stay; I know you will enjoy it," and he was so kind and gentlemanly that the cutlery man could not well refuse. He stayed and was led to Christ. Afterwards he said: "An ounce of weight upon my coat-button saved my soul." More "buttonhole Christians" are needed.

145 Evading Duty

Bishop Frodsham relates: "Sir William MacGregor, whose unflagging zeal for humanity in many parts of the globe has done so much for the cause of Christianity, once discussed with me the relatively rapid progress of Islamic belief in West Africa, as compared with that of Christianity. 'It's just this,' he said, 'every Muslim regards himself as a missionary; the majority of Christians think it is another man's work.'"

146 Individual Effort

There is a great rage nowadays for large congregations and for prominent work; but do not forget individual souls. Roland Hill used to say that if he had a number of bottles before him, and he were to dash water over them, a drop might go into this one and a drop into that; but he said, "If I take one bottle and pour water into it, I fill it up to the brim." And so it is with individual souls. There is a personality in the application which cannot be estimated if we are speaking face to face in an honest, manly way. Is not this the best way to do Christian work?

147 "Thou Art the Finger"

A writer in the *Sunday School Times* tells how, during a season of revival, a friend was praying one evening for a certain unconverted neighbor. After this manner he

prayed: "O Lord, touch him with Thy finger, Lord!"

The petition was repeated with great earnestness, when something said to him:

"You are the finger of God. Have you ever touched your neighbor? Have you ever spoken a single word to him on the question of salvation? Go now and touch that man, and your prayer shall be answered."

It was a voice from the throne. God's servant arose from his knees self-condemned. He had known the man to be impenitent for a quarter of a century, yet he had uttered not a word of warning. Hundreds of opportunities had come and gone, but the supreme question of life had been set aside for such topics as "the weather," "the latest news," "politics," "trade," etc. His first duty as a Christian had been left undone.

"As we, therefore, have opportunity, let us do good unto all men."

148 Drawing Daily

A man can no more take in a supply of grace for the future than he can eat enough today to last him for the next six months; or take sufficient air into his lungs at once to sustain life for a week to come. We must draw upon God's boundless stores of grace from day to day, as we need it.

—D. L. Moody

149 Effective Reproof

There was a boy at Norfolk Island who had been brought from one of the rougher and wilder islands, and was consequently rebellious and difficult to manage. One day Mr. Selwyn spoke to him about something he had refused to do, and the boy, flying into a passion, struck him in the face. This was an unheard of thing for a Melanesian to do. Mr. Selwyn, not trusting himself to speak, turned on his heel and walked away. The boy was punished for the offense, and, being still unsatisfactory, was sent back to his own island without being baptized, and there relapsed into heathen ways. Many years afterwards Mr. Bice, the missionary who worked on that island, was sent for by a sick person who wanted him. He found this very man in a dying state and begging to be baptized. He told Mr. Bice how often he thought of the teaching on Norfolk Island and when the latter asked him by what name he should baptize him, he said, "Call me John Selwyn, because he taught me what Christ was like that day when I struck him; and I saw the color mount in his face, but he never said a word except of love afterwards." Mr. Bice then baptized him, and he died soon after.

Life of Bishop John Selwyn

150 Skeptical Artist Convinced

"Irenaeus," in one of his graceful sketches in the New York *Observer*, gives a striking account of the conversion of the artist who painted one of the beautiful national pictures that adorns the rotunda of the Capitol at Washington. When he selected his theme he was an

utter unbeliever in Christianity. As a subject relating to American history was required, he chose the embarkation of the Pilgrim fathers, without a thought of its religious associations. After outlining his characters as grouped on the deck of the *Mayflower*, the question arose, why were they there? He saw that they were animated by some principle he could not comprehend. He studied their times, their lives, their deeds, their sacrifices, their plans and hopes; and as he studied the truth gradually stole into his own soul, till he had learned to believe in their God and Savior. He found that the secret spring of all their actions was their religion; that their lives were hidden with Christ in God, and that they could abandon home, country, wealth, for freedom to live for Christ. Not till he became a Christian could he understand their motives or characters, or was he fitted to put his immortal work upon canvas.

151 Take Time

Dr. James Hamilton once related an anecdote which illustrates a vital question in the Christian life. A writer recounts it as follows: "A gallant mounted police officer was pursued by an overwhelming force, and his followers were urging him to greater speed, when he discovered that his saddle-girth was becoming loose. He coolly dismounted, repaired the girth by tightening the buckle, and then dashed away. The broken buckle would have left him on the field a prisoner; the wise delay to repair damages sent him on in safety amid the huzzas of his comrades." The Christian who is in such haste to get about this business in the morning that he neglects his Bible and his season of prayer rides with a broken buckle.

152 Freezing Christians

Years ago a woman, with her little baby, was riding in a stagecoach in western Montana. The weather was bitter cold, and, in spite of all the driver could do to protect her, he saw that the mother was becoming unconscious from the cold. He stopped the coach, took the baby, and wrapping it warmly, put it under the seat, then seized the mother by the arm, and dragging her out upon the ground, drove away, leaving her in the road. As she saw him drive away, she ran after him, crying piteously for her baby. When he felt sure that she was warm, he allowed her to overtake the coach and resume her place by her baby. Can we not imagine her gratitude when she realized that he had saved her life? He had done as God sometimes does, to shake us out of soul-lethargy and moral sleep which would end in death.

153 Dropping Behind

Professor Hugh Black, in "Christ's Service of Love," says: "A young Jewish woman who is now a Christian asked a lady who had instructed her in the Gospel to read history with her, 'Because,' said she, 'I have been reading the Gospels and I am puzzled. I want to know

when Christians began to be so different from Christ.'"

154 Trembling Saints

In the early days of emigration to the West a traveler once came, for the first time in his life, to the banks of the mighty Mississippi. There was no bridge. He must cross. It was early winter, and the surface of the mighty river was sheeted with ice. He knew nothing of its thickness, however, and feared to trust himself to it. He hesitated long, but night was coming on, and he must reach the other shore. At length, with many fears, and infinite caution, he crept out on his hands and knees, thinking thus to distribute his weight as much as possible, and trembling with every sound. When he had gone in this way painfully halfway over he heard a sound of singing behind him. There in the dusk was a man driving a four-horse load of coal across upon the ice and singing as he went! Many a Christian creeps tremblingly out upon God's promises where another, stronger in faith, goes singing through life upheld by the same word. Have faith in God. Whoever puts his trust in Jehovah shall be safe.

155 Christian Treatment of Enemies

A poor widow, who was a washerwoman, partly depended for support upon the produce of her garden. In it was a peach tree, the fruit of which was coveted by some boys of the village. Accordingly, one night they entered the garden to rob the tree. The widow had, however, made a timely gathering of her fruit that day. In revenge for their disappointment, the wicked lads turned some swine into the garden, who, by morning, had wrought havoc among the poor woman's vegetables and made her suffer in consequence through the winter. In looking at the desolation, she picked up a knife with a name engraved on the handle. It was the name of a village boy whom she knew, and whom she thus recognized as the cause of her loss. However, nothing was said about the matter. During the ensuing months, a revival took place in the village in question, and among those who became convicted of sin was the owner of the knife. Becoming converted, he obeyed his conscience by going to the widow and confessing the wrong he had done her. Thereupon she told him she had long known it, and showed him his knife. "But why did you not inform the authorities about me, and make me pay the damage?" he asked. "There was a more excellent way," she said; "I took that." "What was it?" asked the lad. "To pray for you, in accordance with the Master's directions." So the widow had her revenge.

156 Let Your Light Shine

"Let your light so shine before men, that they may see your good works, and glorify your Father which is in heaven" (Matt. 5:16).

Many years ago New England newspapers carried the story of a lighthouse keeper and the tragic loss

of his son. His son had been on a whaling voyage and the father was expecting him home on this particular night. But that very night the father fell soundly asleep, and while he slept a terrific gale swept up the coast and the light in the lighthouse was extinguished. When he awakened he looked toward the shore and there saw a vessel had been wrecked by the storm. Rushing to the beach he was horrified to see the body of his son washed ashore by the angry waves.

That father had been waiting for his son for months to come home once again, but when the boy was within sight of home he was lost, because the father had carelessly permitted his light to go out!

157 A Good Testimony

"And it came to pass, as Jesus sat at meat in the house, behold, many publicans and sinners came and sat down with him and his disciples" (Matt. 9:10).

D. L. Moody tells the following interesting ways in which believers in London brought their friends under the sound of the Gospel.

"One of the wealthiest young men in London, the son of the city's leading banker, and a student at Cambridge University, felt that he could not go to the inquiry room to do personal work. So one night he went to a cabman and said: 'I will pay you your regular fee by the hour if you will go in and hear Mr. Moody preach. I will act as cabman, and take care of your horse.' "

Upon another occasion Moody asked a man to speak to a certain young man whom he felt was interested in Christ. He was a great Christian manufacturer but confessed, "Mr. Moody, for some reason I just cannot do that kind of witnessing."

"Well, go speak to him for a little while then," urged Moody.

The man did and discovered the younger man wanted to accept Christ, had even confessed Him as Savior, but a strong desire for drink defeated him. "Every payday I stop at the saloon and spend all my earnings," he complained bitterly.

"When do you get paid?" asked the manufacturer.

"Saturday noon," was the reply.

"Then I shall meet you every Saturday noon until with God's help you gain the victory over this sin."

And he did. The great manufacturer and the humble laborer walked home together every payday. They would have dinner, and then spend the rest of the afternoon visiting. Through that fellowship God brought victory over sin to the laborer, and joy for the opportunity to rescue a soul from destruction to the other.

Not all of us can readily talk to others about Christ, but we may be able to render some service that God will bless unto salvation of a precious soul.

158 Noble Confessions

"For I am not ashamed of the gospel of Christ: for it is the power of God unto salvation to every one that

believeth; to the Jew first, and also to the Greek" (Rom. 1:16).

Revival meetings were being held in a certain town, and as is often the case, opposition made itself felt. But one day one of the town's most prominent men rose to his feet and said: "I want it to be known that I am a disciple of Christ Jesus; and if there is any odium to be cast on this cause, I am prepared to take my share of it."

His testimony went through the meeting like an electric current, and God's blessing at once attended the meetings as never before.

Under somewhat different circumstances, but with just as telling effect a young street preacher rebuked some of his critics. He could not preach very well, but he was doing the best he could when someone interrupted him and said, "Young man, you cannot preach; you ought to be ashamed of yourself."

Said the young man, "So I am, but I am not ashamed of my Lord."

And that is certainly an excellent defense. We need never to be ashamed of the One who purchased us with His own blood upon Calvary's Cross. Yet how often, because of the weakness of the flesh, we are prone to permit the sneers and jeers of the unbelieving world to silence our tongues, render us into fearful rather than faithful witnesses of our Lord Jesus Christ.

159 Think Well; Speak Well

"A good man out of the good treasure of the heart bringeth forth good things; and an evil man, out of the evil treasure, bringeth forth evil things" (Matt. 12:35).

There is a certain condition of the nervous system termed "aphasia" in which the patient is unable to express his thoughts in speech. The connection between his mind and tongue has been severed. How many Christians are afflicted with this malady? They may *think* well of Christ, but they never *speak* for Him.

Such folk are graciously reminded that *truth* is not man's property, which he may keep to himself; it is confided to him as a steward, and woe to him if he does not utter it, and give it all the breadth of which he and it are capable.

But perhaps the best exhortation any of us can pass on to other believers is that of the Scottish mother who was bidding her preacher-son farewell: "Always have a good word to say for Jesus, laddie, and He will always bless ye." Let our thoughts be of Him, let Him be the Truth we treasure in our hearts, and let Him ever be the theme of our songs, the topic of our conversation.

160 Diamond Christians

"The Lord looketh down from heaven; he beholdeth all the sons of men . . . he fashioneth their hearts alike; he considereth all their works" (Ps. 33:13, 15).

Every diamond does not shine alike; neither does every Christian's testimony receive the same evaluation by men. The reason some di-

amonds *cannot* shine is due to the fact that they were never cut. The brilliancy of their light depends largely upon the character of its facets. These three things are necessary in making Christians shine as diamonds: (1) We must be diamonds, that is, we must be saved ones, precious in His sight through the faith we have reposed in Christ. (2) We must be cut, fashioned after His will, chastened and refined as by fire. (3) We must abide in the light. Our shining is but the reflection of His Light.

161 Disappointing People

"Woe unto you . . . ye also outwardly appear righteous unto men, but within ye are full of hypocrisy and iniquity" (Matt. 23:27, 28)

Some time after World War II you could walk along the much bombed Queen Victoria Street in London and come upon a lovely Georgian doorway which had been left standing. The walls had been blasted or knocked down and carted away as rubble. Only the beautiful mahogany door, standing half open, was left of what was once a prosperous business establishment. Glazed glass doors were visible within, and one could imagine large rooms filled with busy people beyond. But there was nothing beyond—nothing but a huge hole torn up by the enemy's bomb.

That door was a beautiful facade—every promise of something within, but belying that promise with an awful emptiness and ruin.

Perhaps that door without a house is similar to some people we meet. The door is so beautiful. Their words, their looks, and their manners are delightful. We long to walk through the half opened door, and into their minds and heart and be enriched by our friendship with them.

But, alas, we soon discover that the door is all. They have never bothered to develop their spiritual life. Beyond the flashing smile there is boredom and dullness. They put up a good front, but it conceals a horrible hypocrisy and life of iniquity. Jesus says unto all such, "Woe unto you!"

162 Death to the Christian

There is a very fine illustration of the power of military discipline to strengthen a man's nerve and sense of honor in time of deadly peril. This particular story relates to the conduct of those who survived the explosion of the battleship *Maine*. After the awful catastrophe, when the ship was torn and reeling like a drunken man, enveloped in smoke, as Captain Sigsbee came out of his cabin, he was met by his orderly who was on guard there, and who had not moved from his place. Saluting his commander, the man said, "Sir, I have the honor to report that the ship has been blown up and is sinking." There was something splendid about that which one cannot choose but admire; however, there is something not only just as splendid, but with an added touch of infinite joy, in the

case of a Christian who feels that his body is failing him, but his spirit is mounting up to a victorious life. Hear Paul saying: "For we know that if our earthly house of this tabernacle were dissolved, we have a building of God, an house not made with hands, eternal in the heavens" (2 Cor. 5:1).

163 Enriching Others While Enriching Ourselves

The death of Sir Henry Bessemer called attention to the business career of a man who succeeded in making an immense fortune, and yet did it in a way to bless everybody else in the civilized world. As the result of long and laborious scientific investigation and experiments he came to the conclusion that it was possible to convert iron ore into steel, so that the latter material could be sold at a mere fraction of its then cost. The patents which he took out to cover his invention enabled him for a series of years to obtain a royalty from the use of his apparatus, and meanwhile the price of steel was reduced to about one tenth of its old quotations. While the inventor made a great fortune, he benefited the world many hundreds of millions of dollars a year—a benefit which has been shared, both directly and indirectly, by every person in every civilized country on the earth. The career of this man is a signal illustration of the universal blessing of Christian character. Every person who finds salvation in Jesus Christ and enters into the joy of communion with God, not only enriches his own soul beyond comparison, but enriches everybody else that comes in contact with him. And every sinner whom he can lead into the same blessed experience becomes endowed with spiritual wealth, which also adds to the joy of the one who won him to Christ.

164 Preventing Common from Becoming Commonplace

I know only one infallible way of preventing the common from becoming commonplace, of preventing the small from becoming trivial, of preventing the familiar from becoming contemptible, and it is to link it all to Jesus Christ, and to say, "For Thy sake, and unto Thee, I do this." Then, not only will the rough places become plain, and the crooked things straight, and not only will the mountain be brought low, but the valleys of the commonplace be exalted.

—Alexander Maclaren

165 A Christian's Measure

A river is measured by the water it brings to the sea, a fountain by its overflow, a Christian by his helpfulness to others.

—Isaac Edwardson

166 The Happiest Christian

The happiest and most useful Christians are those whose outflow is spontaneous and commensurate with their intake, whose giving in substance and service is proportionate to their receiving. They are

channels of blessing. Having received the Holy Spirit in fullness, out from within them there flow rivers of living water. Every blessing received makes a new opportunity to pass a blessing on. Increased ability calls for larger service. As riches increase, the opportunity to help spread the gospel increases. As one's contacts with people multiply and become more intimate, the opportunities to influence them in right directions, to help them to better lives and above all to point them to the Lamb of God who takes away the sin of the world, multiply. He who socially, in the business world, or any way, moves in a larger orbit in life, has the wider opportunity to let the light God has given him shine upon other lives to their eternal good. Using life's opportunities enlarges life's orbit.

—Charles A. Cook
The Larger Stewardship
(Judson Press)

167 *Paradoxes of Christian Life*

Lord Bacon says, in his essays on the "Different Characters of the Christian":

"A Christian is one that believes things his reason cannot comprehend and hopes for things which neither he nor any man alive ever saw; he believes three to be one, and one to be three; a father not to be older than his son, and a son to be equal with his father. He believes himself to be precious in God's sight, and yet loathes himself in his own; he dares not justify himself even in those things wherein he can find no fault with himself, and yet believes that God accepts him in those services wherein he is able to find many faults. He is so ashamed as that he dares not open his mouth before God, and yet comes with boldness to God, and asks him anything he needs; he has within him both flesh and spirit, and yet he is not a double-minded man. He is often led captive by the law of sin, yet it never gets dominion over him; he cannot sin, yet can do nothing without sin. He is so humble as to acknowledge himself to deserve nothing but evil, and yet he believes that God means him all good, . . ."

This whole essay is so remarkable that even some devout Christians could not comprehend it, and thought Bacon must have fallen into a sudden fit of skepticism or mental aberration.

168 *Equality before Him*

It has been said of the Duke of Wellington, that once, when he remained to take the sacrament at his parish church, a very poor old man went up the opposite aisle, and, reaching the communion table, knelt down close by the side of the Duke. Someone came and touched the poor man on the shoulder and whispered to him to move farther away, to rise and wait until the Duke had received the bread and wine. But the eagle eye and the quick ear of the great commander caught the meaning of that touch

and that whisper. He clasped the old man's hand and held him to prevent his rising; and in a reverential undertone, but most distinctly, said, "Do not move: all are equal here."

169 The Beginning of a Gentleman

Some boys were playing ball in a shady street. Among their number was a little fellow, seemingly about twelve years old—a pale, sickly looking child, supported on two crutches, and who evidently found much difficulty in walking even with such assistance. The lame boy wished to join the game, for he did not seem to see how much his infirmity would be in his way, nor how much it would hinder the progress of such an active sport. "Why, Jimmie," said one, "you cannot run, you know." "Oh, hush!" said another, the tallest in the party, "Never mind, I will run for him"; and he took his place by Jimmie's side, preparing to act. "If you were lame like him," he said to the other boys, "you would not want to be told of it all the time." There was the beginning of a true gentleman.

170 Luther's Conversion—Its Relation to His Work

It was at one time not unusual to consider that Luther, as a reformer, was born into life, so to speak, in connection with that outrageous business, the sale of indulgences through Germany, by the command of Leo X, with a view ostensibly to obtain money for the completion of St. Peter's in Rome. It was previous to this, however, that he made that memorable journey to the Papal City which was disclosed to him in the nearer view afforded, the enormous corruption of the Papacy, and in which, as he was painfully climbing the *scala sancta* in Rome, those words came to him with such power, "The just shall live by His faith." And it was still earlier than this that, in the library of the monastery at Erfert, he had taken in his hand for the first time a copy of the Bible, and there at its very source found the water of life. It was still earlier that, seeing a companion slain at his side by a stroke of lightning, he was roused to think of death and eternity, becoming from that hour an anxious seeker until he found peace in believing. Thus he was first a Christian before he was a reformer, and we do not reach the momentous lesson of his whole history if we fail to realize the fact that he was a reformer *because* he was a Christian.

171 A Double Life

A man who is attempting to live a Christian life on one side, and a worldly life on the other, is like a sick man who has made up his mind that what the doctor says is all folly, and that, since he does not like the medicine and regimen, he will do that which is most agreeable to him. When the nurse and physician are out, he steals into the pantry, and loads his stomach with things aggravating to his disease.

He deceives everybody but Nature; Nature is never deceived. You may call food what you please, but if it is contrary to the law of digestion, when the stomach takes it, Nature knows it. You may call your course in life what you please, but when your conscience takes it, and its effects are evolved, its real character is disclosed.

172 My Place

God seeks to mold us by circumstances, and you must believe that God has put you down just where you are because your present position is the very best place in the universe to make you what He wants you to become. He could have made you a king or a bishop, a millionaire or a statesman; but He passed all these by, and has put you just where you are. You may be a stableman, a cook, or a housemaid; but God had the whole universe to choose from, and He wanted to do His best for you and He put your soul just where it is, because He knew that there you would be surrounded by the best conditions to make you what He wanted you to become.

—F. B. Meyer

173 Many Mansions

Christ had to prepare the disciples for parting with Him. He did this by the promise of reunion. It will not be in a strange land, but in His Father's house. There will be ample room— "many mansions." He has gone into that house—is there now, in His glory, and with His mediatorial power. In due time He will come and take us to be with Him, our spirits to be at home with the Lord, and in due time our bodies to be raised up and glorified. Oh, what a future is before the believer, though he be as poor and as despised by the world as the fishermen of Galilee!

174 Saved by Words

Have you been described as a person of many words?

On October 14, 1912, the life of outspoken and energetic presidential candidate, Theodore Roosevelt was saved by his many words.

Roosevelt had just served one term as president, and was reapplying for the job. As he left his hotel in Milwaukee on that day, he stuffed his thick, wordy campaign speech in his breast pocket. He was soon confronted by a gun-toting bartender. The angry assailant fired at Teddy, hoping that Roosevelt would suffer the same fate as his predecessor, President McKinley. The bullet did crack one of Roosevelt's ribs, but the thickness of his speech probably saved him from death.

While many words were life-saving in this one incident, generally the more words you spit out, the more trouble you bring to yourself. Jean Paul Sartre once said, "Words are loaded pistols." And, your Creator dispensed this sage perspective: *"When words are many, sin is not absent, but he who holds his tongue is wise"* (Prov. 10:19 NIV). Words—choose them carefully. And make sure you err on the side of

saying too little than too much. Your life might be at stake.

Remember: An "absent" word shows prudent "presence."

Reflections

175 No Laughing Matter

Are you one of those who believes that "pain is gain?"

At Massachusetts General Hospital, in October, 1846, Dr. William Morton employed ether for a surgical amputation and the science of anesthesiology officially began. Painless surgery quickly became the norm that it is today.

Actually, itinerant performers had been using nitrous oxide for years as a party gag. In 1842, Dr. Crawford Long of Jefferson, Georgia, attended an "ether party." He was very mystified at how participants stumbled around laughing, yet feeling no pain. Crawford convinced a friend to try it for the removal of a tumor. The procedure was a success, but Crawford didn't publish his findings ahead of Morton, thus losing the credit.

Today there are more sophisticated anesthetic methods to eliminate the pain. But when it comes to emotional pain, there's no relief. In fact, suffering that is incurred as the result of following Christ is essential. God inspired: *"If you suffer for doing good and you endure it, this is commendable before God"* (1 Pet. 2:20 NIV). God's Son, Jesus Christ, endured enormous pain to pave our way back to God. We should be willing to do no less.

Remember: Christian wanna-bees should know this: "no pain, no reign."

Reflections

176 Brick Streets

"Other foundation can no man lay than that is laid, which is Jesus Christ" (1 Cor. 3:11).

Do you like brick streets? If you live in Liberal, Kansas, or my home town in Oklahoma, I hope the answer is yes, but it may not be. Many people do not like the noise of driving down brick streets. In this country we do not know how to keep them up. A few years ago I went to Holland to visit my brother and what did I see? The green country and the great old buildings and the roads. Some of the streets dated back to the fifteenth and sixteenth centuries. The streets were all brick.

A brick is just a small and unimpressive thing. But when bricks are put side by side they make a street or a great structure that can last for a long time. A Christian is like a brick, in that a Christian by one's self is not very impressive and sometimes may be used in a destructive way. Bricks, however, that are put together in a good and proper way, can and will last for generations. In Holland we visited a building site of a town where a street was being built. The people working made sure the ground or foundation for the brick was strong and right before the first brick came into hand. Today, we as Christians can last but we need to be on the foundation that is Christ Jesus.

—J. F. Carter

177 *Fire and Smoke*

I've taught the Book of Revelation many times in my decades of ministry, but never as realistically as the last time around.

We were in the famous "thousand year" verses in chapter 20. About 9 o'clock that Tuesday night, I was reading to my adult students the account of Satan's rampage when he and his cohorts are unchained at the end of the thousand years. *"They marched across the breadth of the earth and surrounded the camp of God's people, the city he loves,"* John wrote, *"But fire came down from heaven and devoured them."*

Just as I intoned the Scripture about heavenly fire, the smell of burning wood wafted down from the air conditioner grates above our heads. "Does anybody else smell what I smell?" I asked. They did. A quick check verified that none of the neighbors' houses was ablaze. By now the smoke smell was stronger, so we put Revelation on hold and got serious about seeking the smoke smell source. A quick peek into the church attic let us know we were close. It was filled with acrid smoke.

Three minutes later our church building was invaded by a small army of firemen in protective yellow coats with oxygen bottles strapped to their backs. Thus the study of Revelation ended that night. Memorably.

I don't suppose I need to confess that not even with my most grandiose efforts could I have arranged for the bird's nest in that light fixture to ignite on cue to provide special effects for a Bible lesson on fire and brimstone. But I can't keep from wondering about us church folk, when the scent of a charred two-by-four galvanizes us to urgent action while the promise of eternal flames evokes hardly a yawn these days.

—Gene Shelburne

178 *A Virtue That Needs Reviving*

It is a simple command: "Practice hospitality." The great English Bible translator William Tyndale said that Christians should have a "harborous" disposition, a willingness to share house and heart with others.

But we live in a time of isolation. Houses are islands where their residents frantically emerge to shop, conduct their business, and work and then impatiently return home. It is an age when we do not know our neighbors or anyone else outside our own family. Unfortunately, this spirit has infiltrated the ranks of God's people.

The church exists as a counter-culture to the prevailing mood. In a society that can be brutally individualistic, followers of Jesus should cut across the grain and become community oriented. In an ocean full of little islands of families, we should open our homes and hearts to other families. We need to connect.

Here are some suggestions for encouraging hospitality:

• **Invite one new family into**

your home every month.

Play games, talk, study the Bible, or pray. We need to widen our horizons and make new friends. If we do not do this, we are, by neglect, implementing loneliness.

• **Plan Sunday dinner at your house once a quarter with a new family.**

This is an old custom worth reviving. Few things draw people together better than a shared meal around a common table.

• **Visit a neighbor.**

Neighborhoods aren't neighborhoods anymore. They are just collections of houses where people move in and out. Reach out and introduce yourself to a neighbor with a platter of cookies or other sign of good will.

A home can never be happy if it is selfish. Let's learn to open our door to the stranger. Chances are, that stranger is lonely.

—Paul Woodhouse
Family Newsletter

179 Wanted...

FATHERS like Abraham: "*He will command his children and his household after him, and they shall keep the way of the Lord*" (Gen. 18:19).

MOTHERS like Hannah: "*As long as he* (her son) *liveth he shall be lent to the LORD*" (1 Sam. 1:28).

BOYS like Jesus: He returned with His parents to Nazareth and "*was subject unto them*" (Luke 2:51).

GIRLS like the little maid who told her mistress that God could heal Naaman's leprosy (2 Kings 5:1-3).

BROTHERS like Nehemiah and Hanani, who served God together (Neh. 7:1, 2).

SISTERS like Mary and Martha, who received Jesus into their home and lives (Luke 10:38, 39).

PREACHERS like Paul, who "in weakness, and in fear, and in much trembling" (1 Cor. 2:3) presented the truth in the power of the Spirit.

SERVANTS OF GOD like Barnabas: "*He was a good man, and full of the Holy Ghost and of faith*" (Acts 11:24).

LOVERS OF THE BIBLE like the Bereans: "*They received the word* (message) *with all readiness of mind, and searched the scriptures daily*" (Acts 17:11).

Spurgeon on the Christian Walk

The remaining illustrations in the **Christian** Category are written by C. H. Spurgeon

180 The Riches of Christian Faith

This week I had my faith much strengthened in visiting a sick woman. I would fain change places with her. Glad enough should I be to lie upon that sick bed and die in her room; for though she has been long on the borders of the grave, and knows it—knows that each hour may probably be the last—her joy is so great, her bliss is so abundant, that you have only to speak with her and her joy overflows. She said to me, "I prayed that if God would spare me, he would give me

one soul, and he has given me five converts while I have been on this bed"; and I did not wonder at it, as I saw the five dear friends sitting in the room; I did not wonder at it— it was enough to make one a Christian to see her joy and her peace, and hear her talk so confidently about the time when she should see her Lord and be in his embrace forever. "Ah!" says the devil to the Christian, "I will give you so much if you sin." Our reply is, "What could you give me compared with my inheritance? O fiend, you bring me counterfeit riches, but I can count down ten thousand times as much in real solid gold! You offer me your paste gems, but here are diamonds and pearls of the first water and of the rarest value!"

181 True to His Conscience

I know a man whose master had tried to make him go against his conscience; but he said, "No, sir." And the master thought, "Well, he is a very valuable servant; but I will beat him, if I can." So he threatened that if he did not do as he wished he would turn him away. The man was dependent on his master, and he knew not what he should do for his daily bread. So he said to his master honestly at once, "Sir, I don't know of any other situation; I should be very sorry to leave you, for I have been very comfortable, but if it comes to that, sir, I would sooner starve than submit my conscience to anyone." The man left, and the master had to go after him to bring him back again. And so it will be

in every case. If Christians are but faithful, they must win the day.

182 The Rooted Christian

I saw one day a number of beech trees which had formed a wood; they had all fallen to the ground through a storm. The fact was they leaned upon one another to a great extent, and the thickness of the wood prevented each tree from getting a firm hold of the soil. They kept each other up and also constrained each other to grow up tall and thin, to the neglect of root growth. When the tempest forced down the first few trees, the others readily followed, one after the other. Close to that same spot I saw another tree in the open, bravely defying the blast, in solitary strength. The hurricane had beaten upon it but it had endured all its force unsheltered. That lone, brave tree seemed to be better rooted than before the storm. I thought, "Is it not so with professors?" They often hold together, and help each other to grow up, but if they have not firm personal roothold, when a storm arises they fall in rows. A minister dies, or certain leaders are taken away, and over go the members by departure from the faith and from holiness. I would have you be self-contained, growing each man into Christ for himself, rooted and grounded in love and faith and every holy grace. Then when the worst storm that ever blew on mortal man shall come, it will be said of your faith, "It could not shake it."

183 Quarreling with God

I was greatly struck with a story a dear sister told me yesterday. She was very nearly being removed from the church; she had quarreled with the Lord for taking away her husband, and she would not go to any place of worship, she felt so angry about her loss. But her little child came to her one morning, and said, "Mother, do you think Jonah was right when he said, 'I do well to be angry, even unto death'?" She replied, "O child, do not talk to me," and put the little one away, but she felt the rebuke, and it brought her back to God, and back to her church again, humbly rejoicing in him who has used this instrumentality to set her right with her Lord.

184 Making Idols of Children

A mother who had lost her baby fretted and rebelled about it. She happened to be in a meeting of the Society of Friends, and there was nothing spoken that morning except this word by one female Friend, who was moved, I doubt not, by the Spirit of God, to say, "Verily, I perceive that children are idols." She did not know the condition of that mourner's mind, but it was the right word, and she to whom God applied it knew how true it was. She submitted her rebellious will, and then, as if it were magic, was at once comforted.

185 Vagrant Thoughts

I remember a certain narrow and crooked lane in a certain country town, along which I was walking one day, while I was seeking the Savior. All of a sudden the most fearful oaths that any of you can conceive rushed through my mind. I put my hand to my mouth to prevent the utterance. I had not, that I know of, ever heard these words; and I am certain that I had never used in my life, from my youth up, so much as one of them, for I had never been profane. But these things sorely beset me; for half an hour together the most fearful imprecations would dash through my brain. Oh, how I groaned and cried before God. That temptation passed away; but ere many days it was renewed again; and when I was in prayer, or when I was reading the Bible, these blasphemous thoughts would pour in upon me more than at any other time. I consulted with an aged godly man about it. He said to me, "Oh, all this many of the people of God have proved before you. "But," said he, "do you hate these thoughts?" "I do," I truly said. "Then," said he, "they are not yours; serve them as the old parishes used to do with vagrants—whip them and send them on to their own parish. Groan over them, repent of them, and send them on to the devil, the father, to whom they belong—for they are not yours." Do you not recollect how John Bunyan illustrates this idea? He says, when Christian was going through the valley of the shadow of death, "There stepped up one to him, and whispered blasphemous thoughts into

his ear, so that poor Christian thought they were his own thoughts; but they were not his thoughts at all, but the injections of a blasphemous spirit." So when you are about to lay hold on Christ, Satan will ply all his engines and try to destroy you. He cannot bear to lose one of his slaves; he will invent a fresh temptation for each believer, so that he may not put his trust in Christ."

Christian Living

186 Stepping-Stones

There are three grades of Christian life. There is, first of all, the dissatisfied life—the life that knows there is something which it does not possess; the life that is perpetually discontented, and rightly so, with itself. There is, second, the life that is half and half, that now and then rises up to the Mount of Transfiguration, and then paces for long seasons over weary wastes of whitened ashes. There is a third life of satisfaction and contentment, of peace and power and rest; the life that has made Jesus Christ its one object; the life that every man lives who is able to say, in the fine phrase of Ignatius, "O Christ, thou art 'my inseparable life.' " The soul that has made Christ its one object has entered into rest, and has entered into power; it has entered into a life of activity which no foe can withstand, and of contentment which no storm can ruffle; for over all the seas where it voyages speaks that Voice which quieted the turbulent waves of the Tiberian sea: "Peace, be still." Nothing can overcome or disturb the soul that is hid with Christ in God and has made Christ the one object of its life.

187 You're a What?

Are you very impressed with high sounding titles?

If you receive a business card in the course of your employment today, you'll probably find a very important-looking title listed. It seems that the longer the title, the less important the job.

Here are some of these new titles: "Wannabillies" are people who hope to succeed in Nashville. A "Jargonaut" is an editor in cyberspace. An "Abracadabbler" has an avocation in magic. "Redumbants" are employees who stupidly keep making the same mistake. Those who are involved in "Grubterfuge" are definitely finding new ways to sneak snacks. And "Faxcident Specialists" can expertly repair your facsimile machine paper jam.

What if every time you handed someone your business card, it read "Christian"? Would the cause of Christ be advanced or set back? The Bible says: *"We are therefore Christ's ambassadors, as though God were making his appeal through us"* (2 Cor. 5:20 NIV). We are the only advertisement Christ has for His life-changing gospel. And regardless of our "very reverend" title, if we are not reflective of his positive characteristics—HE LOOKS BAD!

Remember: Performance can drown out the most impressive of titles.

Reflections

188 Who Said "Broad-Mindedness?"

There is no room for broad-mindedness in the chemical laboratory. Water is composed of two parts hydrogen and one part oxygen. The slightest deviation from that formula is forbidden.

There is no room for broad-mindedness in music. The skilled director will not permit his first violin to play even so much as one-half note off the written note, chord, and key.

There is no room for broad-mindedness in the mathematics classroom. Neither geometry, calculus, nor trigonometry allows any variation from exact accuracy, even for old time's sake. The solution of the problem is either right or it is wrong (no tolerance there).

There is no room for broad-mindedness in biology. One varying result out of a thousand experiments will invalidate an entire theory.

There is no room for broad-mindedness on the athletic field. The game is to be played according to the rules with no favors shown for "charity's sake."

There is no room for broad-mindedness in the garage. The mechanic there says the piston rings must fit the cylinder walls within one-thousandth part of an inch. Even between friends there cannot be any variation if the motor is to run smoothly.

How then shall we expect that broad-mindedness shall rule in the realm of Christianity and morals?

He that forsakes the truth of God, forsakes the God of truth.

189 Perspective

At the 1988 Olympics in Calgary, Dan Jansen was given a good chance to win gold medals in speed-skating. In his best event, the 500 meters, he crashed and fell coming out of the first turn. Later, in the 1,000 meters, skating a gold-medal pace and two-thirds through the event, he caught a skate blade in the ice on a straightway and tumbled into a heap.

Years of discipline, training, and hoping went sprawling on the ice with him. He must have been devastated. But he handled it with such grace. "What's happened in the last week has absolutely put things in a different perspective," Jansen said, "and I don't feel as bad as I would have."

You see, his 27-year old sister had died earlier on the day of his first race. It put his failure to win an Olympic medal in perspective for him. His failure to win an Olympic gold medal in Albertville, France in 1992 spurred him to go for one last attempt for gold at the Lillehammer, Norway Olympic Games in 1994. It was in Lillehammer that Dan's quest for Olympic success was finally realized when he took home the gold medal.

Gold medal or no gold medal, whatever you have done is probably neither as wonderful nor as dreadful as you are tempted to think it is. Someone else can do better. Many others have done

worse. God is still on His throne, and life goes on.

—Adapted from an illustration by Rubel Shelly

190 Empty Houses—Empty Lives

There is something about a ghost town that captures the imagination. As you walk the streets you can almost hear the echoes of the past. But the buildings stand empty as mute reminders of life that is gone. With every passing season more buildings collapse, more weeds grow up, more animals take over the ruins where a thriving town once stood. A ghost town is nature's testimony that once something has been emptied, destruction and death follow, unless the void is filled.

Some people are like ghost towns—shallow, hollow, empty. They are like hollow shells—voids looking to be filled—aimless, meaningless, hopeless.

In the parable of the empty house, Jesus tells us that it is not enough for a man to be freed from the power of Satan. He must come under the rule of God or Satan will get hold of him again. No one walks around empty for long. If his life is not filled with Jesus, it will be filled with something—or someone—else. Like the ghost town, if a person is not filled with life in Christ, there's nothing left but decay and death.

—Dale Wells

191 Hey, Soldier! Whose Side Are You On?

The world in which we live is quickly approaching a time of divine judgment; a time when the Lord will make that ultimate pronouncement of blessing upon those who have stood with Him, and of condemnation upon those who have stood against Him. As the age-old spiritual battle between good and evil draws ever closer to its preordained climax, it becomes essential that the soldiers of Christ display their banner and declare their loyalty. The world must know whose side we are on!

Joshua was not a spiritual "fence-rider" in the battle for eternal life. He publicly declared his loyalty to the Lord. *"And if it is disagreeable in your sight to serve the LORD, choose for yourselves today whom you will serve: whether the gods which your fathers served which were beyond the River, or the gods of the Amorites in whose land you are living; but as for me and my house, we will serve the LORD"* (Josh. 24:15).

Like Joshua, we today must let the world know whose side we are on. The world about us is promoting tolerance, and even acceptance, of the homosexual lifestyle and agenda, for example. Whose side are you on? "As for me and my house, WE are on the Lord's side!" The slaughter of unborn babies has reached unprecedented levels. Precious lives are snuffed out with a callous casualness that defies

comprehension. Whose side are you on?!

Some things are simply much too important, much too vital to the survival of our godly heritage, not to take a stand. The soldiers of Christ must arise, put their armor on, and fight for Truth.

The tale is told of a soldier during the Civil War who simply could not make up his mind which side of the conflict he supported. Thus, he dressed in a blue coat and gray pants, and walked down the center of the battlefield confident of his approval by both sides...and was immediately shot by both sides! Jesus tells us we can't be "fence riders" when the issues involve matters of eternal consequence. We must choose. "You are either with Me, or against Me," our Lord declares, "but you cannot be both!"

A story is related of an elderly German woman who, as her village was being entered by an American unit during the final days of the second world war, stood in the middle of the street holding a small U.S. flag. Her friends told her she was crazy; she should hide and wait to see who would win. She replied, "I already know who's going to win, and I want them to know which side I'm on!"

Soldiers of Christ, it is time for us to stand bravely before the enemy and declare our loyalty in a loud, clear voice. After all, we're on the winning side!

—Al Maxey
The Aloha Spirit

192) It's About Time

This very minute—do you know what time it is?

Charles Dowd, a schoolteacher from Connecticut, proposed the time zone plan currently in use in the United States. It was on this day in 1883 that it was first implemented.

If you were to give an answer to the opening question, your answer would be relative. What is 9 a.m. Saturday morning for one person, may be 8 a.m. Sunday morning for someone else on another continent. A half-a-century ago, Albert Einstein made us aware of the relativity of time. As we have gained more scientific knowledge, we have also learned that if one travels at the speed of light, time essentially stands still.

Time is a relative measurement that was created by God to assist the human race. However, he is timeless. That is why we have these inspired words: *"With the Lord a day is like a thousand years, and a thousand years are like a day"* (2 Pet. 3:8 NIV). When your "time" on earth is over, unmeasured time will begin. You will either spend it with your Creator or with Satan. God wants you to know that "NOW" is the time to choose him. If you delay, your choices may be very limited.

Remember: How you spend your measured time determines where you'll spend your unmeasured time.

Reflections

193 In Disguise

Does the avalanche of media "bad news" drive us to insensitivity?

Twenty-six years ago, after a week of counting the devastation from a cyclone and tidal wave in Pakistan, government officials put the death toll at 150,000.

Granted our memories aren't that great, but if Americans had experienced a catastrophe that had wiped out a third of the state of Wyoming or all of Fort Lauderdale, Florida, they would not have forgotten. Does the constant media bombardment of death and destruction make us devoid of human sympathy?

Perhaps there is a way back to compassion. Jesus once said, *"For I was hungry and you gave me something to eat, I was thirsty and you gave me something to drink, I was a stranger and you invited me in, I needed clothes and you clothed me, I was sick and you looked after me, I was in prison and you came to visit me."* When he was asked the where and when of those charities, he replied, *"Whatever you did for one of the least of these brothers of mine, you did for me"* (Matt. 25:35-40 NIV). So look for a hungry, thirsty, foreign, tattered, or sick person in need. Then treat him or her as you would Jesus Himself.

Remember: If you can't see God in everybody, you have an "image" problem.

Reflections

194 Foul Fowl

"The kingdom of heaven is like a mustard seed, which a man took and sowed in his field; and this is smaller than all other seeds; but when it is full grown, it is larger than the garden plants, and becomes a tree, so that the birds of the air come and nest in its branches" (Matt. 13:31, 32 NASB). Christ's reference to birds can be interpreted either positively or negatively. From the former perspective, the kingdom provides a place of shelter, a place to nest and call home, a source of food and nourishment. From the latter perspective, these birds may represent that undesirable element in the world which flocks to the kingdom merely to rob it of its fruit, peck holes in its structure, or drive away those who genuinely seek a place to nest. Such foul fowl do more damage than good, and need to be driven away. Consider carefully the following feathered felons. Are any nesting among our branches?

• The Parrot—This bird has a talent for repeating what someone else has said. One must exercise great caution around a parrot, for what you say may be repeated when you least expect it. "Don't tell anyone, but have you heard. . . ." is a phrase that can lead to "fruit & seed robbing" in the kingdom.

• The Fan-Tail Pigeon—This is a strutting bird, one which loves to show off. This "church bird" must always be the center of attention. When denied the spotlight it will

generally fly to another tree where it is more greatly appreciated.

• The Hawk—This bird has an extremely sharp eye. It can spot a flaw a mile away. He can list every error the preacher made in a sermon, every song incorrectly pitched or led, every failing of every member. The hawk is a bird of prey which looks for weaknesses…and then swoops in for the kill.

• The Jay Bird—Often called the fussing bird, they feel the "divine call" to sound the alarm and raise a ruckus whenever they spot something that doesn't suit them. Most of their time is spent squawking over matters of little or no consequence.

• The Bat—Though not really a bird, from a distance it may appear to be one. Viewed up close it can be seen to be another species: "A rat with wings!" A pretender, a hypocrite.

• The Crow—This bird is a thief. It slips into a field another has planted and cultivated, and steals the grain, thus robbing another of the fruit of his labor. It always squawks loudly when caught.

• The Swan—This is a very beautiful bird, but very flighty. It calls no particular pond home, but wanders from pond to pond. Never satisfied with where it's at, it searches ceaselessly for that perfect pond…never finding it!

See Isaiah 40:30, 31 for the type of bird God would want us to be.

—Al Maxey

195 Try Your Patience

Can you truthfully say that you are a patient person?

Robert Kearns had to be patient. In 1962, Kearns was tinkering in his shop and in the process invented a phased windshield wiper that was just the ticket for intermittent light rain. You probably enjoy his invention in your car today.

Kearns, a Detroit native, was sure that the "Motor City's" Big Three would be ecstatic over his find. But to his surprise, American cars began appearing on sales floors with his device, without his permission. Gaining no satisfaction from auto executives, in 1978 he decided to take his case to court. Twelve years later, Kearns' patience paid off when a court ruled in his favor to the tune of $10 million (and that was just from one of the Big Three).

A prolonged ordeal is enough to test anyone's patience. However, the Christian enjoys the guarantee that one day God will not only make all things right, but also deliver an eternal payoff. Meanwhile, the Bible suggests that we: "*Be joyful in hope, patient in affliction, faithful in prayer*" (Rom. 12:12 NIV). That Big Three is a key to your earthly peace of mind.

Reflections

196 How We Act

Bowing before the "god of openmindedness," this generation has been slow to admit that what we

believe determines how we act. PBS film critic and columnist Michael Medved recently shared this anecdote out of his Jewish heritage:

"A few years ago, the illustrious Rabbi Jacob Kamenetzky made a trip to Israel accompanied by his teenage grandson. Ironically, these two deeply religious people had been seated in the airplane next to a prominent Israeli socialist leader and outspoken atheist, who had spent his whole life fighting against Orthodox values.

"After the plane reached its cruising altitude, the cynical atheist traveler couldn't help noticing the way the teenage boy attended to the needs of his aged, bearded grandfather. He got up to get the old man a glass of water, helped him remove his shoes and put on some slippers, and otherwise demonstrated that the rabbi's comfort represented his primary concern.

"At one point, as the boy got up for yet another errand on behalf of the old man, the skeptical stranger could contain himself no longer.

'Tell me something,' he asked the rabbi. 'Why does your grandson treat you like some kind of a king? I have a grandson, too, but he wouldn't give me the time of day.'

" 'It's very simple,' the old man replied. 'My grandson and I both believe in a God who rules the universe and created all things, including the first man. That means that in the boy's eyes, I'm two generations closer to the hand of God Himself. But in the eyes of your grandson, you're just two generations closer to a monkey.' "

Medved told this story as if it were true. I can't vouch for that. But it certainly reflects truth. A person's theology (what they think about God) determines what they think, and therefore what they do, about everything else. It should not surprise us that the behavior of people who don't believe in God is so often ungodly. Could it be that to make our streets safe again, we need to be building more churches instead of more jails?

—Gene Shelburne

Christianity

197 *Emotion and Christianity*

To the Editor of *The Sun*—Sir:

In your editorial on the "Glory of the Christian Year," you say the idealism of Christianity still stirs the religious emotions of Christendom.

Now, I don't think I know just what that means, but somehow it reminds me that years ago when I was fast becoming a drunkard I used to attend services at a church in Newark, just to hear a lady sing, and as she sang she must have stirred the religious emotions in me, for I always felt very pious, and "mine eyes became a very fountain of tears." Could I have remained under that spell I don't believe I could have done an evil thing; but when I got out on the street again I made for the nearest saloon, every time, and spent the next hour or more filling myself with beer, which also must have stirred my religious emotions, for I remember on one of these occasions of quarreling with the barkeeper because he did not believe in God.

Whether this illustrates your point or not I don't know, but it shows how a man may have religious emotions, yet not be a Christian.

Twenty-three years ago tonight, and some years after attending the church meeting referred to, and after years of hard drinking and evil courses generally, I attended a little Woman's Christian Temperance Union meeting in Newark, and there without any religious emotions, but with an awful sense of my exceeding sinfulness, I surrendered to Jesus Christ, and a spirit was put within me that has been with me ever since, and I have been as free from my old way of living as though I had never lived at all. "Old things have passed away and behold all things have become new" (see 2 Cor. 5:17).

The idealism of Christianity is Jesus Christ and eternal life.

198 *Holy Influence*

Many years ago a young fellow by the name of Wray, a student at Princeton College, applied for appointment as a foreign missionary. He was a thoroughly good man, but not very quick in respect to learning, and when he reached the field of his prospective labors he found it difficult to master the language. But though the simple natives could not understand his talk, they could understand his walk. One day when they, according to the custom in those countries, were seated in a circle on the ground, listening to the instruction

78

of one of their teachers, the question was asked, "What is it to be a Christian?" And none could answer. But finally one pointed to where this young man sat, and replied: "It is to live as Mr. Wray lives." Not one of them could read the Gospel according to Matthew, to Mark, to Luke, or to John; but everyone there could read the Gospel according to Wray.

199 Race Set Before Us

In Athens, long ago, games used to be held in honor of the Grecian gods and heroes. One of these was a torch race—that is, a race of torch bearers—which was run at night in honor of Prometheus. The starting point was a mile and a half out of the city, in the olive grove where Plato had his "Academy," this spot being chosen because Prometheus had a sanctuary there. The winning-post was within the city; and the runner who reached it first with his torch still burning gained the prize. In like manner our Christian life here on earth is "the race that is set before us" (Heb. 12:1) We shall have run that race well if, when we come at last into God's presence, our lights are still burning. "They that be wise shall shine as the brightness of the firmament; and they that turn many to righteousness as the stars forever and ever."

200 Without Religion Nothing

Who would want to live in any city if you took the Christians out of it? Some wicked men formed a town in Minnesota many years ago, in order to have a community in which the name of God or Christ should never be mentioned except in terms of profanity or vulgarity. They hung Jesus Christ in the streets in effigy, and the place was full of blasphemy. The town was destroyed by fire, and they tried to build it up again. Then came an Indian massacre, with an awful retribution of bloodshed, and they tried to build it up again. It was again partially destroyed by fire; and at last, after there had been riot and bloodshed and anything but purity and peace for years, the citizens of that town sent to the American Home Missionary Society and said, "Can you send us a minister of Jesus Christ?" And if you were to go there today you would not know that community, with its church spires pointing heavenward, and its children going to Sunday School and learning about Christ. It is almost as orderly there today as in any town in the land, because of the influence of the church. Your property would not be worth having if it were not for Christianity in this city.

201 Kindness and Justice in the Labor World

The proverb of Solomon that a soft answer turneth away wrath is not more true in personal relations than in the larger affairs of social interaction. In these days, when the papers are filling up with the rumors of strikes, and strife between labor and management, it is very comforting as well as interesting to

notice the splendid success which attended Commissioner Waring's "Labor Senate," which he organized in the Street-Cleaning Department of New York City. Under this arrangement all complaints, grievances, petitions, or suggestions for improvement came before a committee of forty-one, which was selected by the men themselves. The result was that the streets never were so clean in the history of the city, and that peace and mutual respect reigned throughout the department. Nothing works so well as applied Christianity in human affairs.

202 Christianity and X-Rays

Wonderful things happen every day in surgery by the aid of X-rays. In a hospital in Bridgeport, Connecticut, a woman who was born blind was given her sight through a surgical operation which was only made possible by the aid of X-rays. When John's disciples came to Jesus asking for proof of His Messiahship, He told them to go back and tell John that the blind had received sight at His touch. The world was never so full of evidence of the divinity of Christianity as it is now. Every hospital and every invention to relieve human suffering bears testimony to the divine mission of the "Great Physician."

203 The Healing Power of a Happy Heart

I know a man who not long ago gave his heart to Christ, and has since lived a very happy Christian, who for a long time prior to his conversion had been so eaten up by care and anxiety that he had been ill-natured on account of it. His religion had the happy effect of healing not only his mind and heart, but his body as well. When he became happy in the consciousness of the forgiveness of his sins and rejoiced in peace with God, his mind was at rest. He quit worrying. He did not fret any more. He slept well, had a good appetite, and digested his food without difficulty. He had a friend who was an unbeliever, who did not believe in the Bible nor in Christ, but who was also ill-natured. They had been accustomed to meet and lunch together in a restaurant. When the skeptic saw that his friend's temper was gone, he was anxious to know what had cured him. And when he was told, with a happy, sincere face behind it, that it was the joyous heart that had come to him through Jesus Christ, you may be sure that it aroused that man's attention as a thousand sermons from the pulpit never could have done, and the skeptic was glad to go with his Christian friend to hear the message which had so transformed him. The greatest evidence of Christianity is a transformed life.

204 Magnetism of a Great Personality

William Wetmore Story was fond of telling an interesting tale of James Russell Lowell and himself. It was when they were young men, and they were very angry with Daniel

Webster for staying in Tyler's cabinet, and, as Webster was to speak in Faneuil Hall one evening, they determined to go in from the Harvard Law School and heckle him, and show him that he had incurred their displeasure. The house was packed with people, and the young men felt sure that the crowd would hoot with them, young as they were. But they reckoned without their host. Mr. Story says: "Mr. Webster, beautifully dressed, stepped forward. His great eyes looked, as I shall always think, straight at me. I pulled off my hat; James pulled off his. We both became as cold as ice, and I saw James turn pale; he said I was livid. And when the great statesman began that most beautiful exordium, our scorn turned to deepest admiration, from abject contempt to belief and approbation." Christianity encourages the power of individual personality. It is the very essence of the Christian teaching that a man's greatness does not consist in what he has, nor in his position, but in what he is. Men poor in purse, and of no physical authority, are often splendid in influence, because of the subtle power of character which men feel in their presence. Paul said his bodily presence was insignificant, but men feel him yet, after all these centuries.

205 Promised Peace

The deepest want of man is not a desire for happiness, but a craving for peace; not a wish for the gratification of every desire, but a craving for the repose of acquiescence in the will of God: and it is this which Christianity promises. Christianity does not promise happiness, but it does promise peace.

206 A Test of Sinfulness

If you want to know whether you are sinful or not, just take any of the characteristic commands of Jesus Christ; take any point of example in him, any of his conduct, anywhere, and try it on yourself. A man goes into a store and says to his tailor, "Look here, how do I know what size I want?" He looks at him a moment, then goes on with him trying on coats and finds that they do or do not fit the man. Try moral qualities in the same way. You have one text that leads to this very analogy or figure: "Put ye on the Lord Jesus Christ," as a garment. Put it on your conscience. Put on the Lord Jesus Christ as an element of love. Try on these Christian graces, and see whether they fit you.

207 Seeing the Gospel

"Let your light so shine before men, that they may see your good works, and glorify your Father which is in heaven" (Matt. 5:16).

"Have you ever heard the Gospel?" a missionary asked a Chinaman.

"No," was the reply, "but I have seen it. I know a man who was the terror of the whole district. He was at times as fierce as a wild animal, and was also an opium-smoker. When he accepted the Jesus religion, he became quite changed.

Now he is meek, and is no longer wicked, and has given up opium-smoking. I can see by that, that the Gospel and the service for Jesus are good."

Someone has said: "Lamps do not talk, but they illuminate. Light-houses make no noise, but they give light." Thus must the walk of a Christian be a living sermon. Actions speak louder than words.

208 Failure is Success

A Moravian missionary named George Smith went to Africa. He had been there only a short time and had only one convert, a poor woman, when he was driven from the country. He died shortly after, on his knees, praying for Africa. He was considered a failure. But a company of men stumbled onto the place where he had prayed and found a copy of the Scriptures he had left. Presently they met the one poor woman who was his convert.

A hundred years later his mission counted more than 13,000 living converts who had sprung from the ministry of George Smith.

209 Lest We Forget

As Christianity is the most vivid of all religions, with its personally-manifested God, there is a more perfect unity in a Christian life than in any other. It keeps all its parts, and from its consummations looks back with gratitude and love to its beginnings. The crown that it casts before the throne at last is the same that it felt trembling on its brow in the first ecstatic sense of Christ's forgiveness, and that has been steadily glowing into greater clearness as perfecting love has more and more completely cast out fear. The feet that go up to God into the mountain at the end are the same that first put off their shoes beside the burning bush. This is why the Christian, more than other men, not merely dares but loves to look back and remember.

—Phillips Brooks

Church

210 Forum without Power

Some years ago the captain of a Greenland whaling vessel found himself at night surrounded by icebergs. He expected any moment to be ground to pieces. As the morning dawned he sighted a ship at no great distance. Getting into a boat with some of his men he carefully picked his way through the lanes of open ice towards the mysterious-looking craft. Coming alongside he hailed the vessel with a loud, "Ship ahoy!" but there was no response. He looked through the porthole and saw a man, evidently the captain, sitting at a table as if writing in a log-book. He again hailed the vessel, but the figure moved not. It was dead and frozen. On examination the sailors were found, some frozen among the hammocks, others in the cabin. From the last entry in the log-book it appeared this vessel had been drifting about the Arctic seas for thirteen years—a floating sepulcher, manned by a frozen crew. And there are souls today who have refused the Divine offer of life, forsaken the centers where they were warmed with hallowed influences, and drifted into the chilling regions of Arctic darkness and frost. Many of these have certain appearance of Christian life, and a name to live.

211 Church without Power

When Thomas Aquinas visited Rome, and was shown the gorgeousness of the papal palace, the pope, it is said, remarked to him—"Well, Thomas, the church in our day cannot say, 'Silver and gold have I none.'" "No," replied Aquinas, "neither can she say, 'In the name of Jesus Christ of Nazareth, rise up and walk.'" Ah! how often has it been the case, that when the church has been increased in riches and worldly wisdom, she has correspondingly decreased in spiritual power and piety.

212 Two Kinds of Church Members

A rich nobleman was once showing a friend a great collection of precious stones whose value was almost beyond counting. There were diamonds and pearls and rubies and gems from almost every country, and they had been gathered by their possessor at the greatest labor and expense. "And yet," he remarked, "they yield me no income." His friend replied that he had two stones which had cost him only five pounds each, but which yielded him a very considerable income, and he led him down to the

mill and pointed to two toiling gray millstones.

213 Imperfect Church

The following anecdote is by Dr. E. Y. Mullins:

"I teach students for the ministry. Some of them grow impatient in their preparation, and I have often said to them: When God builds a tree, it takes Him about three generations, but when He builds a squash, it takes Him about three weeks. A man can choose which He will be—a tree or a squash. We misjudge children, we misjudge church members, we misjudge the church itself, when we forget that the Christian life is progressively realized, that it comes slowly. I once saw in Pilgrim Hall at Plymouth, Massachusetts, the restored ribs and keel of an old ship that was dug up from the sands of Cape Cod. They were worm-eaten and moldy. As I gazed upon them I reflected that when the ship was built, hundreds of years ago, these ribs and this keel were in the same position. Then, however, it was a prophecy of a ship that was to be. When I saw it, it was a reminiscence of a ship that had been. The imperfect Christian is a prophecy, not a reminiscence. The imperfect church is a prophecy of the glorious church that is to be, not a reminiscence."

214 The Need of an 'Up-to-Date' Church

A man digging a well in Minnesota discovered an old Spanish gunboat which has since been completely unearthed. The impression is that the boat was run up into that region by the early Spanish discoverers about the year 1600, when a much larger part of the State was under water than now. Five cannons and two mortars and a large number of cannon-balls were found on board. The gunboat was found in the bed of a creek, which was no doubt in the old time a navigable river. As the years have passed by, it has been covered over completely by the soil, until thus discovered by accident. It is interesting as a curiosity, but worthless as a gunboat. A good many churches are in that condition. They belong to another age. Instead of keeping pace with the current of the world, floating on the bosom of its life, keeping in touch with its living heart, they have been covered over with its drift and forgotten. They are interesting relics of a dead past, but are worthless as allies in the capture of the world for Christ. Almost every church has some members in the same condition.

215 The Church's Quarry

An architectural magazine is responsible for the statement that the members of a Presbyterian church in Waterloo, Iowa, have constructed a new church building out of a single large rock. Stone was scarce, and while looking about for a possible quarry their attention was called to this huge boulder which stood in the middle of a plain about eight miles from the town.

This mass of rock was like an island in the midst of a vast sea. About eight feet of it projected above ground. The work of excavating this gigantic boulder was at once begun. When exposed to view, it was found to be twenty-eight feet high, thirty feet long, and twenty feet wide. On this monolith the workmen began their labors with drill, hammer, and dynamite, and the enormous rock was converted into building-stones, which were removed to the town and built into a beautiful church. The sinful world about us is our quarry. With the hammer of God's Word, the dynamite of the Holy Spirit, and earnest human hearts we are to convert the stony natures about us into beautiful building-stones for the temple of God.

216 The Church a Fortress

The recent removal of thick incrustations of dirt and varnish from the old woodwork above the outer central doors of the northern porch of Westminster Abbey shows that the wood is thickly penetrated with a great quantity of small shot, and bears many bullet-marks. The old doors beneath were removed several years ago to admit a freer method of egress, and they were riddled in a similar manner. The abbey workmen engaged in cleaning the woodwork say it is four or five hundred years old. It is very thick oak and is studded with large iron bolt-headed nails, and it and the old doors have filled a space about fifteen feet in height by seven feet in width. These bullet marks come from a long past date, perhaps several hundred years. But wicked men have not ceased to shoot at God's church. Many a flying bullet is hurled at the church doors in our own time, but it is a safe sanctuary inside, and those who trust God and do their duty will find that there is protection and peace for every one who seeks refuge at those sacred altars.

217 Christian Fellowship

Christianity is a social religion. It loses power whenever the social element is left out. I have heard many people say that they did not care to go to a certain church because the people were not sociable, but I have never heard anyone say yet that they stayed away from the church because the people were so friendly and sociable they could not stand it. Rich or poor, learned or unlearned, we all have a craving for fellowship. The saloon has much of its power in this hunger of the heart to find some sort of fraternal greeting. I asked a man the other night why he went to the saloon and put himself in the way of drinking, when he really desired to stop it, and his answer was: "All the people who are willing to talk to me are there. I must go where my friends are." Let us make the church so full of social kindness that the people who come in will find friends with us.

218 Build Yourself into the Church

Build yourself into the church. If you give of your means to defray its expense, you are a pillar, supporting God's house. If you wel-

come people into its membership, you are a door in the house of the Lord. If you teach a class in its school, you are a window, letting in the light.

219 Lowering the Standard

The unjust steward, liable to be thrust out of his stewardship, curries favors with his lord's debtors *by reducing the face of their bills* of obligation. What an illustration of the so-called preachers of the gospel who venture to make concessions to unbelievers and disbelievers and worldly-minded hearers, changing the terms of the Word of God and catering to the demands of the carnal nature!

220 The Power of a Live Church

A healthy church kills error, and tears in pieces evil. Not so very long ago England tolerated slavery in her colonies. Philanthropists endeavored to destroy slavery; but when was it utterly abolished? It was when Wilberforce roused the church of God, and when the church of God addressed herself to the conflict, then she tore the evil thing to pieces. I have been amused with what Wilberforce said the day after they passed the Act of Emancipation. He merrily said to a friend when it was all done, "Is there not something else we can abolish?" That was said playfully, but it shows the spirit of the church of God. She lives in conflict and victory; her mission is to destroy everything that is bad in the land.

See the fierce devil of intemperance how it devours men! Earnest friends have been laboring against it, and they have done something for which we are grateful, but if ever intemperance is put down, it will be when the entire church of God shall arouse herself to protest against it. When the strong lion rises up the giant of drunkenness shall fall before him. "He shall not lie down until he eat of the prey, and drink the blood of the slain" (Num. 23:24). I anticipate for the world the best results from a fully aroused church. If God be in her there is no evil which she cannot overcome.

—C. H. Spurgeon

221 The Church in Business

A church member was remonstrated by the preacher for the way in which he made his living. While it was not what is generally called gambling, even the man himself did not deny that it was that. "There is nothing unfair about it," said the man; "men know the risks when they go into it."

"Then you wouldn't object to the other members of the church making their money in the same way?"

"No, except that the business would be apt to be overcrowded."

"Suppose we raise a fund and go into it as a church?" The man hesitated.

"That would be different," he said. "I think a church ought to be religious, and has no business meddling with such things."

"Then neither have you," the minister replied. "The church is simply the men and women who belong to it."

222 A Prayerless Church

A worthy minister of the gospel, was pastor of a flourishing church. He was a popular preacher, but gradually became less to his hearers, and his congregation very much decreased. This was solely attributed to the minister; and matters continuing to get worse, some of his hearers resolved to speak to him on the subject. They did so; and when the good man had heard their complaints, he replied, "I am quite sensible of all you say, for I feel it to be true; and the reason of it is that I have lost my prayer book." They were astonished at hearing this, but he proceeded; "Once my preaching was acceptable, many were edified by it, and numbers were added to the church, which was then in a prosperous state. But we were then a praying people. . . ." They took the hint. Social prayer was again renewed and punctually attended. Exertions were made to induce those who were without to attend the preaching of the Word. And the result was that the minister became as popular as ever, and in a short time the church was again as flourishing as ever.

223 Lack of Christian Sympathy in Churches

Everyone has a right to feel that when he goes into the church of Christ he goes into an association, a brotherhood, where the principle of gentleness and kindness is carried to a higher degree than it is outside of the church. But the Church is keyed, often, very low in the matter of sympathy. Formality, and separations into classes, and divisions by a great many worldly distinctions, break up the sense of brotherhood. Too frequently people who go into the church are like those who go at night to a hotel. Each lodger has his own room, and calls for what he himself needs, and does not feel bound to take care of any of the other lodgers. And a church, frequently, is nothing but a spiritual boarding-house, where the members are not acquainted with each other, and where there is but very little sympathy.

224 The True Church Welcomes All

Some astronomers are studying the nebulae, some Jupiter, some Saturn, some the sun, and so on; and they bring together all the results of their investigations, and unite them; and the sum total makes the one astronomy. The true church is that which takes the gifts of all its members, and instead of quarreling with and persecuting and treading under foot each the peculiar views of any other, unites them as far as possible.

225 Only Christians

John Wesley was much troubled in regard to the disposition of various sects, and the chances of each in reference to future happiness or

punishment. A dream one night transported him in its uncertain wanderings to the gates of hell.

"Are there any Roman Catholics here?" asked thoughtful Wesley.

"Yes," was the reply.

"Any Presbyterians?"

"Yes," was the answer.

"Any Congregationalists?"

"Yes."

"Any Methodists?" by way of a clincher, asked the pious Wesley.

"Yes," was the answer, to his great indignation.

In the mystic way of dreams there was a sudden transition, and he stood at the gates of heaven. Improving his opportunity, he again inquired.

"Are there any Roman Catholics here?"

"No," was the reply.

"Any Presbyterians?"

"No."

"Any Congregationalists?"

"No."

"Any Methodists?"

"No."

"Well, then," he asked, lost in wonder, "who are they inside?"

"Christians!" was the jubilant answer.

226 Morbus Sabbaticus

Morbus Sabbaticus, or Sunday sickness, is a disease peculiar to church members.

1. The symptoms vary, but it never interferes with the appetite.

2. It never lasts more than twenty-four hours.

3. No physician is ever called.

4. It always proves fatal in the end—to the soul!

5. It is becoming fearfully prevalent, and is destroying thousands every year.

The attack comes on suddenly every Sunday; no symptoms are felt on Saturday night; the patient sleeps well and wakes feeling well; he eats a hearty breakfast; but about church time the attack comes on and continues until services are over for the morning. Then the patient feels easy and eats a hearty dinner. In the afternoon he feels much better and is able to take a walk and read the Sunday papers; he eats a hearty supper, but about church time he has another attack and stays at home. He wakes up Monday morning refreshed and able to go to work, and does not have any symptoms of the disease until the following Sunday.

The remedy—"Be not deceived; God is not mocked" (Gal. 6:7).

227 Always New

Old John was a man of God and loved his village chapel. One day he was stopped by an acquaintance, who, by the way, was an ardent angler. "I say, John," said the angler, "I have often wondered what attraction there is up at the village chapel. You go week after week to the same old chapel, see the same folks, sing the same old hymns—" "Wait a minute," interrupted John. "You fish very often at

the same spot, and in the same water, do you not?" "Yes, that's true," agreed the other. John smiled, and then exclaimed, "Well, actually, you do not, for the water you fished in yesterday has passed on to the sea, and every time I go up to the chapel the Lord has something fresh for me."

228 Aim High

In these days there is a great deal of lowering the standards. Businessmen say that business standards have been lowered, and now a good deal of business runs into gambling. In politics the standards have been lowered. There has been a lowering of standards in theology and in reference to the supreme authority of God's blessed Book. We must keep the standard up to the very tip-top peak of God's flagstaff. Be careful, my brother, about lowering your standard of right, obedience, and holiness. You remember, perhaps, that scene in the days of conflict when a color-sergeant had carried the colors so near to the enemy's redoubt that the regiment shouted to him to bring them back, or they would be captured. The color-sergeant said, "No, no; bring your men up to the colors!" With a magnificent dash they carried the colors themselves into the rampart. The commandment of the Captain of our salvation to us ministers is, "Bring my church up to my colors, and then we will go forward and capture the enemy."

229 The User-Friendly Church

People often ask me "How is your church going?" and I generally respond by saying that "We started from scratch and we're still scratching." When you start a group with no denominational affiliation and no financial backing it is not only evangelistic but also entrepreneurial, and it is not easy.

But I wouldn't have it any other way.

When you simply teach and preach the Bible with no entertainment or promotion, it is not easy. When you disregard traditions and battle the infiltration of errors and outright paganism while never passing an offering plate, it is not easy.

But I wouldn't have it any other way.

Yet, I would welcome more people and so I have come up with the idea of the user-friendly church and "No-Excuse Sunday."

We are putting out cots for the people who say that Sunday is their only day to rest. And for those who say "If I go to church, the roof will fall in," we have hard hats that meet OSHA specifications. The people who say the church is too cold will be asked to change places with the people who say the church is too hot, and that should solve those problems. The people who don't like the hypocrites who attend church will be given stones to throw, and sin will never be mentioned in the service, only love.

Cotton balls will be provided for the use of those people who complain that the pastor is too loud, and hearing aids will be given to those who complain that the pastor speaks too softly.

Microwave dinners will be given to those who say that they cannot attend church and cook too. The subject of money will never be mentioned, no offering plates will be passed, and the concept that the church may have needs will never be presented. Much of the service will be music of the Top 40's style, with lots of very attractive people getting extremely emotional. There will be a special area with grass and trees and a pond for the people who only feel close to God when they are fishing or surrounded by nature.

Stenographers will be provided for the people who say the pastor goes too fast, and Bibles that have only pictures without words will be given to those who find the Authorized Version too difficult. And for those who stayed up too late Saturday night, the lights will be dimmed and a wooden frame will be put around the pulpit to give the illusion that you are watching television. Most of the messages will be about how wonderful we all are, except for some messages about all the wonderful things that God is going to do for us because we are so worthy.

Now what more could a church do to be user-friendly? These accommodations should make it possible for everyone to attend and to have a great time.

Except, of course, for those precious people who really care and want to do it right.

—Terence D. McLean

230 Writing Out Loud

Do you recall the young lady who, as valedictorian of her high school graduating class, testified for Jesus Christ? At first the principal flat-out said, "No." Only a threatened lawsuit changed that. Then she was asked to rewrite her speech and tone it down. She did not. The speech was given as she had originally planned.

This clearly demonstrates once again that Christianity is under attack. She could have quoted Buddha, Confucius, or Shirley MacClaine, but not God! Others have free speech. Christians don't! Consider the following observations:

Christians (that's us) are more into tolerance than truth. Even Christians act ashamed. Truth has been sold out for popularity and acceptance. Preachers are encouraged to "tone it down" and not to "be so negative."

The girl's speech was evangelistic. Perhaps even my wisdom would have changed it. Then it hit me. We have lost our zeal and our aggressiveness. We are totally passive, defeated. The early church was militant. We are trying to be righteous without being too religious. It is not going to happen.

The media shout "courage" when the abortionists, homosexuals, rad-

ical feminists, etc., "shove it in our faces." They whine when a little Christian girl discusses her faith and priorities. The world is not listening to the church because the church is not talking. We have ceased preaching because we no longer have fire in our bones. Pulpits deliver feel-good sermonettes to Christianettes while the church dies. Should not someone rattle our cages? Everything we believe in is offensive. God is offensive. Jesus is offensive. Truth is offensive. Preaching is offensive. The Bible is offensive.

Good morning, church! Is anyone reading? Let's wake up before our meeting houses become our tombs. Movements begin in caves and die in cathedrals. We cannot settle for life-support Christianity. What has become of the Great Commission? Thank God for the little girl in DeSoto, Texas!

—Steven Clark Goad
Blythe Banner

Commitment

231 Careful Thinking

"More than an hour has passed away," said the aunt of James Watt to her nephew, angrily, "and you have not uttered a single word. Do you know what you have been doing all the time? You have been taking off and putting on the lid of the saucepan, and catching the drops of water formed by vapor on a saucer and spoons. It's a shame for you to waste your time so!" But was it time wasted? He was musing over that mighty force of steam, which he was by and by to enlist in the world's service, and which eventually changed the whole commercial life of the world. Time spent in thought that aims at practical usefulness is not wasted, but finely invested. To "rest a while" at Our Lord's invitation is to be recruited and re-invigorated for the higher and best service.

232 Previous Engagement

Major General O. O. Howard was once stationed on the Pacific Coast, and some friends of his wanted to honor him by having a reception. They decided to have it on Wednesday night. It was to be a great affair, and the President had given it his sanction. Then someone said, "We had better let him know, so that he will be ready on Wednesday evening," and so they went and told him, "General, Wednesday night we want to see you on a matter of business." "Well, gentlemen, you cannot see me on that night; I have a previous engagement." Finally they said, "It is a reception, and the President of the United States has given it his sanction." And the old veteran, his eyes flashing, stood up and said: "You know I am a church member, and I promised the Lord when I united with His church that every Wednesday night I would meet Him in the prayer meeting, and there is nothing in the world that would make me break my engagement." They had the reception, but they had it on a Thursday evening. When I was out there, I asked, "Where is the man who has the greatest influence?" and they said, "It is not a minister of the gospel; it is Major General Howard."

—J. Wilbur Chapman

233 Doing Good

An skilled surgeon, who was also a devout Christian, visited a lady who was a professed believer in Christ, but who, like some ladies I have heard of, was frequently troubled with imaginary diseases. The good doctor was frequently called

92

in, until at last he said to her: "Madam, I will give you a prescription which I am certain will make a healthy woman of you, if you will follow it." "Sir," she said, "I shall be so glad to have good health that I will be sure to follow it." "Madam, I will send you the prescription this evening." When it arrived it consisted of these words, "Do good to somebody." She roused herself to relieve a poor neighbor, and then sought out others who needed her help, and the Christian woman, who had been so constantly despondent and nervous, became a healthy, cheerful woman, for she had an object to live for, and found joy in doing good to others.

—C. H. Spurgeon

234 Our Dead Level Best

Some years ago in Northwestern University, near Chicago, a rescue crew was organized. Their purpose was the rescue of the drowning on the lake. One day the news came that a magnificent vessel was wrecked just off the shore. The young men hurried at once to the scene of the disaster, and plunged into the angry waters to rescue those who were going down. Soon they all returned, but one. Finally he came in bringing one man with him. Immediately he returned, and soon brought another, and then another, and so on until he had rescued ten. During this time his mates had built a fire and were warming themselves, all the time trying to persuade the young hero against

his conviction of duty. By the time he had brought the tenth man he was completely exhausted, and had to rest for a while. Regaining sufficient strength, he again plunged into the water and brought another man. Now he was completely overcome. During the night he died from exposure. It was a sad scene. While friends stood around weeping, and his fellow students were regretting that they had not forced him to do as they had, he called one of them to his bedside, and said in a low subdued tone, just before he died:

"Did I do my best?"

Instantly his friend said: "Yes, I should think you did do your best. You saved eleven, but you have lost your life."

"But," said he, "did I do my best, my dead level best?"

"Yes, you did your dead level best."

Then a smile seemed to come over his face as if to say: "Then I am satisfied to die."

Oh, my friends, this will be something of our experience when we are in the presence of God in eternity! "Did I do my best, my dead level best?"

235 Little Things Lead to Great

The world-famous evangelist, D. L. Moody, before he had discovered his special gift, went to a Sunday-school superintendent and asked if he could use him for service. The answer was, if he could gather a class for himself, he might

teach it in the school. On the first Sunday he picked up eighteen boys from the streets, and continued in this work till all the boys in the streets seemed to run after him. He soon filled up two or three schools with boys of this class, and then started a school for himself. Obtaining the use of the City Hall in Chicago, he filled it with 800 boys, and taught them himself, with no help but that of a singer, and nearly all of them were converted.

236 Faith's Commitment to God

"I know whom I have believed, and am persuaded that He is able to keep that which I have committed *unto Him"* (2 Tim. 1:12).

On the point of faith's committal to God, Russell Sturgis has told a very beautiful story in illustration. A party of visitors at the national mint were told by a workman in the smelting-works that if the hand be dipped in water the ladle of molten metal might pour its contents over the palm without burning it. A gentleman and his wife heard the statement. "Perhaps you would like to try it?" said the workman. The gentleman said, shrinking back, "No, thank you. I prefer to accept your word for it!" Then turning to the lady, he said: "Perhaps, Madame, you would make the experiment." "Certainly," she replied; and suiting the action to the word, she bared her arm and thrust her hand into a bucket of water, and calmly held it out while the metal was poured over it. Turning to the man, the workman quietly said: "You, sir, *believed*; but your wife *trusted*.

How long shall we be in learning that in all true faith there is this element of entrustment—venture, *committal?*

237 True Greatness

At the close of the Civil War, stockholders of the infamous Louisiana Lottery, approached General Robert E. Lee and tendered him the presidency of the company. Lee was without position, property, or income, but regarded this offer as the gain of oppression, and on the ground that he did not understand the business and did not care to learn it, he modestly declined the proposition. They then said, "No experience is needed. We know how to run the business. We want you as president for the influence of your name. Remember the salary is twenty-five thousand dollars a year." Lee arose and buttoned his old gray coat over his manly breast and replied, "Gentlemen, my home at Arlington Heights is gone, I am a poor man, and my people are in need. My name and influence are all I have left, and they are not for sale at any price." Rather than receive the gain of oppression, he taught the young men of the South the principles of right living at a salary of one thousand dollars a year.

238 How to Shine for Jesus

Two plowshares were made from the same pig iron. One was sold to

a farmer who used it constantly. The other remained on the shelf of the hardware store, unsold until it was covered with rust. The farmer brought his worn-out share to get another like it. The rusty share was brought out, and there was its brother shining like a silver mirror. "How is it," the rusty one asked, "that your life has been so wearing and yet has made you so beautiful? Once we were alike: I have grown ugly in spite of my easy life." "That is it," replied the shining share, "the beautiful life is the sacrificial life."

239 Decision of Character of Strong Men

At Harper's Ferry on one occasion the flood in the Potomac was so great that it threatened the destruction of the costly railroad bridge, which was seen to shake in its unsteadiness. When everybody present was looking each moment to see the bridge go down, President John W. Garrett, of the Baltimore & Ohio Railroad, arrived upon the scene. Appreciating the necessity of instant action, he gave an abrupt order for a loaded train of freight cars standing on a side track to be run with the locomotive on to the bridge and kept there. "But, Mr. Garrett, that is a train-load of silk," said the local superintendent. "I don't care; run out the cars!" commanded the great master of railroads. "It would be easier to pay for the silks than to build a new bridge." The silk-train was run on to the bridge and the structure was saved. The difference between the success of one man and the disaster which comes to another often lies just at that point. The one is vacillating and uncertain, and the other bold to dare whatever is necessary in order to win. A certain holy boldness and audacity of faith is necessary to great triumph in spiritual matters.

240 Growing a Character

Human life is character-building; for remember that character means exactly what we are, while reputation is only what other people think we are. Every man builds his own character. Fix one fact in your mind, however, and that is, the better and stronger Christian you are, the more dearly you must pay for it. All the best things are costly. Jesus Christ laid down His life to redeem you from sin and death. "Free grace" for you meant Calvary for Christ. A strong, godly character is not to be had without cost.

241 What is Consecration?

Consecration is only possible when we give up our will *about everything*. As soon as we come to the point of giving ourselves to God, we are almost certain to become aware of the presence of one thing, if not of more, out of harmony with His will. Every room and cupboard in the house, with the exception of one, is thrown open to the new Occupant; every limb in the body but one is submitted to the practiced hand of the good Physician. But that small reserve spoils the whole. To give

ninety-nine parts and to withhold the hundredth undoes the whole transaction. Jesus will have all or none. Who would live in a fever-stricken house so long as one room was not exposed to disinfectants, air, and sun? Who would become responsible for a bankrupt person so long as one ledger was kept back? The reason that so many fail to attain the blessed life is that there is some one point in which they hold back from God, and concerning which they prefer to have their own way and will rather than His. This one little thing mars the whole, robs them of peace, and compels them to wander in the desert.

—F. B. Meyer

242 God Wants Our Best

Christ never asks for anything we cannot do.

But let us not forget that He always does expect and require of each of us the best we can do. The faithfulness Christ wants and approves implies the doing of all our work, our business, our trade, our daily toil, as well as we can. Let no one think that religion does not apply to private life. It applies to the way you do your most common work just as readily as to your praying and keeping of the commandments. Whatever your duty is, you cannot be altogether faithful to God unless you do your best. To slur any task is to do God's work badly; to neglect it is to rob God. The universe is not quite complete without your work well done, however small that work may be.

—J. R. Miller

243 Making a Choice

The moment that Moses came to years of discretion, we read that he "refused to be called the son of Pharaoh's daughter." Take that as the starting-point of the life of service. If your circumstances are making it impossible for you to carry out what would otherwise be the will of God, then drop your circumstances as Moses did; it rests with you to do it. Refuse any longer to be called the son of Pharaoh's daughter. You have been in the courts of men; you may have stood high in the favor of the people of this world, and your heirship may look exceedingly brilliant: you must chose whether you will take the heavenly inheritance or the earthly.

Compassion

244 Self-Denial for Others

A friend told me that he was visiting a lighthouse lately, and said to the keeper: "Are you not afraid to live here? It is a dreadful place to be constantly in." "No," replied the man, "I am not afraid. We never think of ourselves here." "Never think of yourselves! How is that?" The reply was a good one. "We know that we are perfectly safe, and only think of having our lamps burning brightly, and keeping the reflectors clear, so that those in danger may be saved." That is what Christians ought to do. They are safe in a house built on a rock, which cannot be moved by the wildest storm, and in a spirit of holy unselfishness they should let their light gleam across the dark waves of sin, that they who are imperiled may be guided into the harbor of eternal safety.

245 Adoption, Example of

A young man left the Confederate army and joined the Union. One day letters came for everyone except him. He said: "I wish I was dead; no one cares for me. My mother is dead, and my father would not own me now, because I've joined the Northern cause." Another young man wrote and told his own mother of this, and in a few days a letter came from Wisconsin, addressed to the stranger. He told the chaplain who brought it: "It isn't for me; nobody would write to me." But it was for him, and it began, "My dear son." The mother of his comrade wrote him that she wanted him to be her son, and she would be his mother. He cried, "Boys, I've got a mother!" and when the war was over, no one was more eager to go and see his mother than that friendless boy.

Thousands of dear young men want a mother. What are you Christians doing?

—D. L. Moody

246 Our Duty to Our Neighbor

A lost person once met a Christian, and said, "I know you do not believe your religion." "Why?" asked the Christian. "Because," said the other, "for years you have passed me on my way to my house of business. You believe, do you not, there is a hell, into which men's spirits are cast?" "Yes, I do," said the Christian. "And you believe that unless I believe in Christ I must be sent there?" "Yes." "You do not, I am sure, because if you did, you must be a most inhuman wretch to pass me, day by day, and never tell me about it or warn me of it."

—C. H. Spurgeon

97

247 Saving a Child

In a remote district of Wales a baby boy lay dangerously ill. The widowed mother walked five miles in the night through drenching rain to get a doctor. The doctor hesitated about making the unpleasant trip. Would it pay? he questioned. He would receive no money for his services, and, besides, if the child's life were saved, he would no doubt become only a poor laborer. But love for humanity and professional duty conquered, and the little life was saved. Years after, when this same child—David Lloyd-George—became Prime Minister of England, the doctor said, "I never dreamed that in saving the life of that child on the farm hearth I was saving the life of the leader of England." This is a good Children's Day lesson. In working for the little ones we never know how much we are doing.

248 Little Deeds

The Alpine strawberry is no larger than a pea, and yet is the sweetest of all the fruits of the field. And many of the most precious deeds of a true Christian are the small acts of his life, as the giving of a cup of cold water to a weary disciple, or the speaking of a word in due season.

There is an old adage that says "the smaller the gift or the service, in certain circumstances, the greater the evidence of love." To fetch the donkey for Jesus was a truer test of love than to drive furiously like Jehu (see 2 Kgs. 9). To wash the feet of Jesus, like Mary, is an evidence of greater love than to spread a feast for Him like Simon the Pharisee. Mary with her alabaster box of ointment, the widow with her two mites, Peter forsaking his fishing tackle—these are truer acts of benevolence than the gifts of a Vanderbilt, DuPont, Getty, Hearst, Ted Turner, or Bill Gates. A little boy gave six cents for charity and wrote on the envelope: "Fasted a meal to give a meal."

249 Compassion of Christ

At a railway station in New Jersey a little girl stepped up to a shackled criminal, and looking tenderly into his face, said: "Oh, man, I am so sorry for you." It made him very angry, and he tried to strike her. Her mother forbade her to go near him again. But as they all waited for the train the mother's eyes were turned away, and once more the little tot stole up to the wretched man and tenderly whispered to him: "Poor man, Jesus Christ is so sorry for you." He started and gave a low groan and offered no violence. Suddenly the train came, the officers led him away, and the two parted forever. But years afterwards the man came forth from prison a Christian and an evangelist, and he loved to tell how the compassion of the Lord Jesus from the lips of a little child broke his heart, subdued his spirit, saved his soul. It is not *our* sympathy men want, but *His!*

250 Rescue Work

A large steamer was voyaging homeward. In wild weather and

growing darkness a black man fell overboard. Instantly the vessel was stopped, the engines reversed, the boats lowered, and the energy of every officer and man of the crew devoted to the man's rescue. A native Indian prince was on board, and, seeing all this, broke out in surprise to the captain: "What! You delay the passage of His Majesty's mails, lose hours of your run, and your boats and men, for that Negro fireman?" "Certainly," replied the captain, "and I would risk the loss of my propeller and smokestack to pick up the poorest laborer in my company. But Jesus laid down His own life to save you and me."

251 The Transfigured Life

An old legend tells of two men who entered the celestial portals. The white robes of the first one were stainless; and when asked by the warder where he had come from and how his garments were so clean, he told how he had just passed a poor, struggling traveler on earth, whose cart had become entangled in a swamp. The traveler had begged him to help him extricate it, and he explained with what difficulty and pain he had escaped the urgent call, and kept his garments spotless to meet his Lord.

The second pilgrim followed. His robes were soiled with mire and grime. Flushing crimson and shame, he explained that he had tried his best to keep his garments clean, but that he could not refuse to put his shoulder to the wheel when a struggling wayfarer was trying to get his cart out of the quagmire. "So," he added, "the marks are still on my once spotless robes."

The angel smiled and said, "My brother, these stains will not hinder your welcome here, for even as we speak, they are transformed into jewels of glory as the badge and recompense of that love which is the highest glory of our sanctity and the brightest jewel in our crown."

Let us not only climb the Mount of Transfiguration with the Master, but let us live the transfigured life of love here below.

252 "It Really Happened"

At Schults Lewis Children's Home in northern Indiana, where the corn is so tall and plentiful, we always had a devotional before school began. We adults had many friends in our mission fields, and always included them in our prayers by asking, "Lord, please bless all the workers we know, especially those in the foreign fields."

Eight-year-old Robert kept asking us to let him say the prayer one morning. The time came and Robert did a masterful job until he came to that part, and he said, "Lord, please bless all our brothers and sisters that are working so hard out in all those corn fields."

—Lester Allen
Bulletin Digest

253 The Kindness of John Wesley

Mr. Wesley, one winter day, met a poor girl in one of the schools

under his care. She seemed almost frozen. He asked her if she had no clothing but the thin garments she was wearing. She said she had not. His hand was in his pocket in an instant, but there was no money there. He went to his room, but the pictures on it seemed to upbraid him. He took them down, saying to himself: "How can the Master say to thee, 'Well done, good and faithful servant'? Thou hast adorned thy walls with the money which might have screened this poor creature from the bitter cold! O justice! O mercy! Are not these pictures the blood of the poor maid?" So he sold the pictures to get money to relieve the girl's distress.

254 Seek and Find

The shepherd whose ninety and nine sheep were safe did not wait for the one astray to return; he went forth and sought and found it, and when he did find it he did not maul or kick or pound it; he took it to his bosom, and comforted and rescued and healed it.

—D. L. Moody

Complaining

255 An Impertinent Question

On a train one summer a young girl was boiling over with indignation at a preacher who had been asking her some plain questions about her soul. "Why, he even asked me if I were sure I was really on the road to heaven," she said. "He had no right to talk like that to me, and to make me feel perfectly dreadful."

"What did the brakeman say to you when you boarded the train?" her friend asked.

"Why, he only asked me where I was going."

"And you didn't mind it at all. You knew that he was asking you to save you from a possible mistake. The preacher had the same motive, only the case was a good deal more serious."

The young woman is only one of a very large class, who consider it an intrusion when you concern yourselves about their lack of concern. There is one thing here worth noting: whenever questions like these are disturbing us, it is pretty conclusive proof that we are shutting our eyes to danger.

256 God's Bounty to Men

For a long time a gentleman used to drop a penny into the hat of a poor beggar who sat by a church door in Madrid. For a week, however, the gentleman was confined to his house by illness. When he was able to return to business he put the usual coin into the hat of the beggar. "Pardon me, señor," said the latter; "have you not a little account to settle with me? You have not been this way for more than a week. You owe me at least seven pence." "Be gone!" replied the gentleman. "My gifts are alms, not salary. I owe you nothing." Let us beware lest the regularity with which God sends His gifts to us causes us to look upon them as our lawful right instead of the unmerited bounty of our Heavenly Father.

Death

257 Unpreparedness for Death

"One should think," said a friend to the celebrated Dr. Samuel Johnson, "that sickness and the view of death would make men more religious." "Sir," replied Johnson, "they do not know how to go about it. A man who has never had religion before no more grows religious when he is sick than a man who has never learned figures can count when he had need of calculation."

258 Deliverance through Sacrifice

On the 10th of June, 1770, the town of Port-au-Prince, Haiti, was utterly devastated by an earthquake. From one of the destroyed servant's housing buildings the slaves had fled, except a black woman, the nurse of her master's infant child. She would not desert her charge, though the walls were even then giving way. Rushing to the child's bedside, she stretched forth her arms to protect the babe. The building rocked to its foundation; the roof fell in. Did it crush the hapless pair? The heavy fragments fell indeed upon the woman, but the infant escaped unharmed, for its noble protectoress extended her bended form across the body, and at the sacrifice of her own life, preserved her charge from destruction.

259 The Comfort of Christ

"Come unto me all ye that labor and are heavy laden, and I will give you rest" (Matt. 11:28)

The story is told of a little Welsh girl who lay dying of a dread disease. The doctor had told the mother she could not live throughout the night. Whereupon the mother sought to console the little girl with thoughts of heaven.

"Darling, you know you will soon hear the music of heaven?" she said. "You will hear a sweeter song than you have ever heard on earth. You will hear them sing the song of Moses and the Lamb. You are so fond of music; won't it be sweet, dear?

The tired little girl turned her head slowly, and said, "Oh, Mother, I am so sick, I think it would make me feel terrible to listen to such music." "Well," continued her mother, "you will soon see Jesus, and the streets all paved with gold. Why, think of it, you will see all the beautiful angels!" And again the sick little child turned to her mother mournfully, "Oh, Mother, I am too sick to even think of such things."

Then desperately the mother offered still one more suggestion. "Darling, come let me hold you quietly in my arms!" "Oh, Mama, that is what I want! If Jesus will only take me in His arms and let me rest!"

Dear friend, where will you find a better picture of the invitation of Christ to yourself? He said, "Come unto me all ye that labor and are heavy laden, and I will give you rest."

260 Dedicated Unto Death

"And they stoned Stephen, calling upon God, and saying, Lord Jesus, receive my spirit" (Acts 7:59).

In a Chinese town an angry mob was stoning a Chinese Christian to death. "Are you sorry," asked the missionary, "that you must die like this?" "Oh, no," he replied. "How glad! Only sorry that I have done so little for Jesus, my Lord."

And David Livingstone, when found dead upon his knees in Central Africa, had his diary open before him, and its last entry was, "My Jesus, my Savior, my Life, my all, anew I dedicate myself to Thee."

Not all dedications lead to death as in these two cases, but they are poorly consecrated who are not willing to renew their vows *even unto death*.

261 Smothered to Death

A sad thing happened in Henderson, Kentucky, when two little girls who were playing hide-and-seek with three other children went into the cellar to find a hiding place. Seeing a large, old-fashioned trunk in one corner, they raised the lid and jumped inside. The top fell and closed with a tight spring lock, and before they were found they had been smothered to death. Sad as it is, this heartbreaking incident is only a fitting type of the smothering to death of spiritual life by men and women all about us. The heart that does not worship God, but twines its affections about things of the world, will soon smother to death its noblest life.

262 Spiritual Death

The following picture of spiritual death is told by Henry Ward Beecher:

"A man is taken out of the water into which he has fallen. It is feared that he is past recovery. He is brought in. He no longer hears, nor speaks, nor sees, nor breathes, nor moves, nor shows any evidence of feeling. And you say, "He is dead." Why is he said to be dead? Because he lacks sensibility.

"Now, take a man that is spiritually dead. Pinch his conscience; he does not start. Bring before him the law, and let it thunder in his ears; it makes no impression upon him. Pierce him with the sword of the Spirit; he does not feel it; he is not susceptible to fear; he has no moral sensibility. And you say that that man is spiritually dead because he is not alive to Divine influences."

263 Death a Kindly Messenger

A preacher once said that we must recover from some of our

blind prejudices concerning death, and must come to understand that it is not an enemy, but a messenger of God, and such a messenger can never be other than kindly. To Christ it must have been an infinite relief, and to us who follow in his footsteps it is the inn in which we sleep on the last night before we reach home. In the morning when we wake from slumber, we find ourselves on the brighter shore in the presence of the loved who have gone before. Such faith makes us peaceful, contented, and happy, glad to live as long as we may, and glad to go when the Father summons us.

264 Life under Death

In the winter and early spring there seems to be no life in the garden and field and forest. Everything looks dead—twice dead. But it is not so really. Under the surface, roots are full of ferment, seeds are swelling, and within the bark of the trees is as much movement as in a city's noisy streets. Every fiber is tingling with vital force, and the sap is coursing along the minute channels, and all that is needed is the breath of the south wind, the warmth of the smiling sun, and the branches will burst into buds, and the earth will break out with laughing flowers. So in souls that seem dead, twice dead, the Spirit of God is often at work, and one earnest heaven-sent message calls out the buds of penitence and faith, and it is seen as a very garden of the Lord. Spiritual winter may hold a springtide of blessing and resurrection glory in its chill grasp, but He who commands both can easily transform the one into the other.

265 The Dying Child and his Guardian Angel

The only child of a poor woman, a little boy of three years old, one day fell into a fire by accident, during his mother's absence from the cottage, and was so badly burned that he died after a few hours' suffering. The clergyman of the parish did not hear of the accident until the child was gone; but as soon as he knew of it, he went down to see the mother, who was known to be dotingly fond of the child, in order that he might comfort and console her. To his great surprise, he found her very calm, and patient, and resigned. After a little conversation, she told him how that God had sent her wonderful comfort. She had been weeping bitterly as she knelt beside her child's cot, when suddenly the boy exclaimed, 'Mother, don't you see the beautiful man who is standing there and waiting for me!' Again and again the child persisted in saying that 'the beautiful man' was waiting for him; and seemed ready and even anxious to go to him. And, as a natural consequence, the mother's heart was strangely cheered. She told her clergyman that she thought it must have been the Lord Jesus Himself; but he reminded her that it was more probably one of His heavenly host, seeing that we have our Blessed Lord's own war-

rant for believing that the angels in heaven care for, and wait upon, and minister unto Christ's little ones below.

266 Live the Life

Paul tells of Christians who "through fear of death were all their lifetime subject to bondage" (Heb. 2:15). There are some men and women who haunt their lives and make them cheerless for fear they will not be able to meet the king of terrors when he comes. Dear friends, learn from your Savior that no duty reveals itself till we approach it. The duty of death, when you approach it, will light itself up, you may be sure, and seem very easy to your soul. Till then do not trouble yourself about it. To live, and not to die, is your work now. When your time comes, the Christ who conquered death will prove Himself its Lord, and pave the narrow river to a sea of glass for you to cross. The work of life is living, and not, as we are so often told, preparing to die, except by living well.

—Phillips Brooks

267 Death Is Checking Out of a Temporary Hotel

The Roman Cicero, who lived before Christ, was a very respected orator and politician. Without the insight of Christ's revelation, he said something very important concerning life and death: "I am sure that my friends who died before me did not cease to live. In reality, only their present state can be called life. I believe this because I am duty bound to do so by my logic and because of my respect for the greatest philosopher of the past. I consider this world as a place which was never meant to be our abode forever. I never considered my departure from this world as being chased out of my permanent residence, but rather as a checking out from a temporary abode such as a hotel or an inn."

268 Money Won't Buy Heaven!

Mark 8:36

The losing of one's life is an irreparable loss. Whatever we may seem to get in exchange, we really get nothing. For if we gain the whole world, we can keep it but for a little while, and it will have no power to deliver us from death or give us the blessing of eternal life. The world cannot give peace of conscience or comfort in sorrow. It cannot purchase heaven. All we can do with the world is to keep it until death comes. We cannot carry even the smallest portion of it with us into the other world. "How much did he leave?" asked a neighbor, referring to a millionaire who had just died. "Every cent," was the reply. So it is easy to see that there is no profit, but rather a fearful and eternal loss in gaining even all the world at the price of one's soul.

—J. R. Miller

Decisions

269 *Pretexts of Indecision*

When duly examined, the pretexts of indecision are absurd; unless we submit to the great appeal, nothing is left but speechlessness. What are the undecided ones waiting for? Some are stopped by a variety of presuppositions. Much mystery and many questions must be cleared up. There are difficulties with regard to the Bible: the great question of Noah's ark, of Baalam's ass, of the Gadarene swine. How shall we reconcile sin, suffering and death with the goodness of God? Are not the birth and death of Christ wrapped in mystery? Now, it is true that revelation presents great problems; but does this justify our hesitation? Spots appear on the sun, yet it gives more light than any other luminary, therefore we rejoice to walk in its light; and although dark places occur in revelation, it is still "the master-light of all our seeing," and our common sense bids us follow its guidance. We have to judge between Christ and other masters, and there need not be one moment's hesitation between the glorious liberty, the godly comfort, the high character, the sweet service, the benign influence, and the splendid hope of the Christian life and the life of sin.

Many wait for a more powerful impulse. They wait for something practically supernatural that will agitate, stimulate or master them; but in reality the appeal of conscience is not less the voice of God than the vision that smote Saul (see Acts 9).

Others wait for a convenient season. "Convenient" is a word that has no place in serious life. When seriously ill, we do not defer going to the doctor until it is convenient. How much rather, then, shall we promptly deal with the crisis of the soul!

270 *Meant to Surrender*

McIan of Glencoe meant to surrender, no doubt about it, when in 1691 William III gave the word that all royalists must take the oath or take the consequences. McIan meant to surrender, to go to the place where all the Highland chieftains were to go, and take the oath of allegiance, but he said, "I will be the last. I will go at just the last moment. The others have gone ahead, the others have been at Inverness weeks ago, to take the oath," and he started a few days before the thirty-first of the previous month, really meaning to take the oath: but a snowstorm came on and detained him, caus-

ing him struggle and stumble through the snows.

McIan arrived three days behind the time fixed, and the king's messenger had gone. There was the tramp of the government army northward to Glencoe, and in the morning the valley that had been so peaceful the night before ran red with blood. Too late! Some of you mean to be saved. Do you know, hell is full of those who meant to be saved, meant to give themselves to Christ, meant to do it, yet are lost? Oh, see to it that you get Christ while there is opportunity given! Why risk eternity?

271 Bad Advice

A revival swept through the university at Princeton, New Jersey. Aaron Burr came to the president of the university and said: "Mr. president, I have made up my mind to consider the claims of Christ. Now, Mr. President, what would you do?" And the old president of the university gave him this advice: He said, "Burr, if I were you, I would wait until the excitement of the revival had subsided, and then I would think it out carefully." Aaron Burr bowed his head a moment, and then he said, "Mr. President, that is exactly what I will do." And, it is stated as a fact, that never again in his life did he express a desire to be a Christian, and they say he died without such an expression.

272 Habit Hard to Stop

A few years ago I was living in a suburban town about twelve miles west of St. Louis, Missouri. One night I ran to catch a train to take me there and just managed to swing up on the back platform of the last car as it was pulling out. Feeling lucky that I had just caught it, I settled down for a nap till I reached my station. After about twenty minutes I looked out of the window to see where I was, and found the train was running right by the station at which I wished to get off. So I hurriedly found the conductor and told him I wanted to get off. He looked at me in surprise and said: "Why, what do you think you are on, anyhow? You didn't get the right train. The local was on the next track. This is the through express and doesn't stop until it gets to Jefferson City, one hundred and fifty miles from here." So I went on to Jefferson City and stayed all night.

A great many men have awakened to find themselves in something of the same fix I was in that night. They have started in with some habit without thinking very much about it, supposing they could stop whenever they wanted to, and then have discovered that they were on a "through" train, a force that was carrying them farther than they ever meant to go.

—H. E. Luccock

273 Settled in Time

A young fellow heard a preacher from the olden days, and was greatly moved, and the preacher said: "When you have a religious impression, the time to act upon it is

right then. The time when you hear God's call, in which you ought to respond is right then." And the young fellow walked down the aisle and publicly made his surrender to Christ, saying: "It shall be right now that I take Christ as my Savior." He went back to the sawmill in the mountains where he worked, and the boys said that next morning he sang continually. Religion in the heart makes men sing. The boys said that he sang all the morning, and they moved the great logs to the sawmill, and as he went singing all that morning—the first morning that he had ever known what it was to be Christ's trusting disciple and follower—about noon his body was caught somehow in the machinery and crushed and mangled, so that a little while thereafter he went away into dusty death. When they got him out he faintly said: "Send for the preacher, that preacher in the church at the foot of the mountains that I talked to last night." The preacher fortunately was soon found and hurried up the mountain to the mill, and he bent down by the side of the dying fellow and took his hand and said: "Charley, I have come. What would you like to say?" And with a smile on his face that was never on land or sea, he faintly pressed the minister's hand and said: "Wasn't it a glorious thing that I settled it in time?" Oh, men and women, my men and women, I beg you, in the great Savior's name, turn your boat upstream before it is too late! "Now is the ac-cepted time. Now is the day of salvation" (2 Cor. 6:2).

—George W. Truett

274 Timely Decision

When Moody and Sankey were conducting services in the mining region of England, coming out of the services one night, they noticed a man sitting just underneath the gallery. Although everybody else had left the church, he still remained. Mr. Moody sat down beside him, and found that he had been a constant attendant upon the services, and that he had determined this night that he would not leave the building until he had settled the question of his soul's salvation. After prayer and the study of the Bible the matter was settled.

He returned to his home, and the next day entered the mine, where there was a terrific explosion. He was taken out more nearly dead than alive, and carried a little way from the entrance to the mine. One of his friends stooped down to moisten his lips; he was too weak to speak, but they saw his lips moving, and finally they could make out his speech. Over and over again he was saying: "It's a good thing I settled it last night."

So it would be for everyone; when God calls, it is dangerous to wait. Today we may yield to His voice; tomorrow may be eternally too late.

—J. Wilbur Chapman

275 The Great Decision

Charles Spurgeon relates:

"I can scarcely recall the details of a little incident in Russian history

which might illustrate the emergency; but the fact, as far as my memory serves, was this. The Czar had died suddenly, and in the dead of night one of the counselors of the empire came to the Princess Elizabeth and said to her, 'You must come at once and take possession of the crown.' She hesitated, for there were difficulties in the way, and she did not desire the position. But he said, 'Now, sit down, Princess, for a minute.' Then he drew her two pictures. One was the picture of herself and the Count thrown into prison, racked with tortures, and presently both brought out to die beneath the axe. 'That,' he said, 'you can have if you like.' The other picture was of herself with the imperial crown of all of Russia on her brow, and all the princes bowing before her, and all the nation doing her homage. 'That,' said he, 'is the other side of the question. But, tonight, your Majesty must choose which it shall be.' With the two pictures vividly depicted before her mind's eye she did not hesitate long, but cast in her choice for the crown. Now, I would wish to paint to you such pictures, only I lack the skill. You will either sink forever down in deeper and yet deeper woe, filled with remorse because you brought it all upon yourself, or else, if you decide for Christ, and trust in him, you shall enter into the bliss of those who forever and forever, without admixture of grief, enjoy felicity before the throne of God. To my mind, there ought to be no halting as to

the choice. It should be made. I pray God's Holy Spirit to help you to make it today. On this winged hour eternity is hung. The choice of this day may be the cooling of the wax which now is soft. Once cooled, it will bear the imprint throughout eternity. God grant it may be a resolve for Christ, for His cause, for His cross, for His crown.

276 Terrace of Indecision

Travelers tell us that there is, near the Jaffa gate at Jerusalem, a small terrace on the top of a hill, called the "Terrace of Indecision." The ground is so level that the rain, falling upon it, seems at a loss which way to go. Part of it is carried over the west side, where it flows into the Valley of Roses, and gives life, fertility, beauty, and fragrance to the Sharon lilies and roses. The rest flows down the east side into the Valley of Tophet and onward to the Dead Sea. Every life has its terrace of indecision. On the decision of each one hangs his future of helpful life or of death.

277 Decision—Immediate

Spurgeon tells a tale of a young man who made an open profession of the gospel. His father, greatly offended, gave him this advice: "James, you should first get yourself established in a good trade, and then think of the matter of religion." "Father," said the son, "Jesus Christ advises me differently; He says, 'Seek ye first the kingdom of God' " (Matt. 6:33).

278 The Accepted Time

There trudged along a Scottish highway years ago a little, old-fashioned mother. By her side was her boy. The boy was going out into the world. At last the mother stopped. She could go no farther. "Robert," she said, "promise me something?" "What?" asked the boy. "Promise me something?" said the mother again. The boy was as Scottish as his mother, and he said: "You will have to tell me before I will promise." She said: "Robert, it is something you can easily do. Promise your mother?" He looked into her face and said: "Very well, mother, I will do anything you wish." She clasped her hands behind his head and pulled his face down close to hers, and said: "Robert, you are going out into a wicked world. Begin every day with God. Close every day with God." Then she kissed him, and Robert Moffat says that that kiss made him a missionary. And Joseph Parker says that when Robert Moffat was added to the Kingdom of God, a whole continent was added with him. There are critical times in the history of souls. "Now is the accepted time; now is the day of salvation."

—J. Wilbur Chapman

279 The Wise Use of Money

Some time ago a New York millionaire sat by his window, knowing that the hour of his death was drawing near, and, seeing a street-sweeper at work below, said; "I would give every penny of my fortune if I could change places with that man—if I could have my health back again. I have worked hard during my life and have saved every dollar that I could. And now it is hard to think that I have got to die and leave it all behind." Evidently this man was in the same condition as that rich farmer whom Jesus tells us about, who meant to store up his goods to feed his soul on, and whom God declared to be a fool (see Luke 12:16–21). If this man had made wise and loving use of his money to bless the world during his lifetime, he would not have had this lament at his death, "How hard it is to think I have to die and leave it all behind."

Discernment

280 Think More Than You Speak

An amusing story is told of Ulysses S. Grant. One day during his Presidency he came into the room where his Cabinet was assembling, quietly laughing to himself. "I have just read," said he, "one of the best anecdotes I have ever met. It was that John Adams, after he had been President, was one day taking a party out to dinner at his home in Quincy, when one of his guests noticed a portrait over the door and said, 'You have a fine portrait of Washington there, Mr. Adams.' 'Yes,' was the reply, 'and that old wooden head made his fortune by keeping his mouth shut.' " And Grant laughed again with uncommon enjoyment. It is a great thing to know when to keep still. As we look back over our lives there are comparatively few times when we regret having not spoken, but a great many of us have numerous reminiscences of trouble and sorrow that have come from unguarded and ill-advised speech. It is important to do a great deal more thinking than speaking.

281 The World Growing Smaller

In 1850 India was over a month's journey from America via clip-per ship. Now one can fly to India from the U.S. in a day. In the early 1800's travel from New York to California involved months of riding on horseback through large tracts of unsettled wilderness. Now a man can cross the continent in a jet airliner within hours. Many years ago it took two weeks at the quickest to get news from London to New York. Today, with computer technology involving the Internet's World Wide Web, and E-mail, as well as fax machines, satellite communication, and high-tech phone lines, it requires only seconds. The Christian, if he is thoughtful, must not fail to feel the emphasis this puts on the marching order which Christ gave his disciples: "Go ye, therefore, and teach all nations, baptizing them in the name of the Father, and of the Son, and of the Holy Ghost." As the world grows smaller our power to fulfill the great command of our Master rapidly increases.

282 False Lights

Of olden times on the coast of Cornwall there were wreckers. These men tied a lantern on the head of an ass, and drove the animal along the heights that fringe the shore. Ships at sea saw this light, and thinking them to be guides

where there was open water, ran towards them, fell on rocks, and were dashed to pieces. Then the wreckers came down to the shore, and took from the wrecked ship all that could be saved. There are a host of these false signals about in the religious world, leading men to destruction. What, then, are we to do? Look to the lighthouse of the Church, built by the hands of Jesus Christ. In it He has set the clear, steady light of revealed truth.

283 Looking Unto Jesus

Two boys were playing in the snow one day, when one said to the other, "Let us see who can make the straightest path in the snow." His companion readily accepted the proposition, and they started. One boy fixed his eyes on a tree, and walked along without taking his eyes off the object selected. The other boy set his eyes on the tree also, and, when he had gone a short distance, he turned, and looked back to see how true his course was. He went a little distance farther, and again turned to look over his steps. When they arrived at their stopping place, each halted and looked back. One path was true as an arrow, while the other ran in a zigzag course. "How did you get your path so true?" asked the boy who had made the crooked steps. "Why," said the other boy, "I just set my eyes on the tree, and kept them there until I got to the end; while you stopped and looked back and wandered out of your course." This is a perfect picture of the Christian life. If we fix the eyes of our hope, our trust, and our faith upon Jesus Christ, and keep them continually fastened thereon, we will at last land at the desired haven, with flowers of immortal victory at our feet.

284 God Omniscient

While the Americans were blockading Cuba, several captains endeavored to elude their vigilance by night, trusting that the darkness would conceal them as they passed between the American warships. But in almost every case the dazzling rays of a searchlight frustrated the attempt, and the fugitives' vessel was captured by the Americans. The brilliant searchlight sweeping the broad ocean and revealing even the smallest craft on its surface is but a faint type of the Eternal Light from which no sinner can hide his sin.

285 God Sees Us

In the American Civil War, one of the officers of the Southern armies was taken a prisoner, and kept for quite awhile in a Federal prison. In his memoirs he recounts his prison experiences. He tells us that he was guarded day and night, and that he could not look up, neither to the right, nor to the left, night or day, but that eyes were watching his every movement. He tells us that if he started in his dreams and was rudely awakened from his sleep, standing over him and watching him were eyes that never ceased to observe his every movement. He tells us that of all the experiences, torturing and ter-

rible, through which he passed in that fearful, fratricidal war, that one experience of eyes watching him all the time was the most torturing experience of all.

Oh, my brethren, if the truth could only come home to us properly, this very hour, that God sees us and knows us altogether, and that for everything in our lives, whether public or secret, He will bring us into judgment at last, what a difference such fact would make in our conduct before Him!

—George W. Truett

286 Light Enough

A boy was walking with his father along a lonely road at night, carrying a lantern. He told his father he was afraid, because the lantern showed such a little way ahead. The father answered, "That is so, but if you walk straight on, you will find that the light will reach to the end of the journey." God often gives us light for only a little way ahead, but He always gives at least that, and so He always gives us light enough for the whole journey.

287 Flesh Cannot Discern Spirit

The natural man cannot discern the things of the spirit. We see this every day, not only as applied to imagination in its highest reaches, but in the ordinary interaction of men. A man in a rage cannot understand the emotions of peace. A man that is grasping and unfair is not in a state to consider justice and equity between man and man. All prejudices and all emotions inspired by hatred or by selfishness twist the mind. It gets awry. You are obliged to discharge these influences before you can form an equitable judgment of what is truth in any case of controversy or conflict.

288 Our Task

Our task is not to condemn, or to judge another's superficial unloveliness, but to look for underlying beauty. That is what we would have others do to us, and that is what we must do to others.

Discipline

289 Secret Disciples

The boy was expressing the opinion of many older than himself when he said to his mother: "I should like to be just such a Christian as father is, for no one can tell whether he is a Christian or not." This father is like the clock attached to a certain church, which possessed neither face nor hands, but which was wound up by the sexton on Sundays and continued to tick year after year, affording an apt illustration of the religion which many are content to possess. The movements of the clock were as regular and accurate as anyone could desire, but, inasmuch as it kept the time to itself, no one was the better for its existence.

290 The Power of Discipline

The power of discipline was not long ago illustrated at the House of Refuge on Randall's Island. But for it, 600 young boys would have been thrown into a panic and many lives lost. Although they were aroused out of slumber at two o'clock in the morning, the signal for fire drill was given and the well-disciplined lads fell to their places and were marched out of the building in safety. If we are to do good work for humanity, we must discipline ourselves to regular effort. It is the steady onward push of the disciplined purpose that counts in the struggle of life.

291 Example—Reproducing

When Peter speaks of Jesus having left us an "example" (1 Pet. 2:21), he chose for "example" the Greek word signifying "the headline of a copybook." Jesus is for our imitation; he is our "copy." And a test of discipleship is the progress we make in the reproduction of the copy he has set.

292 Discipline a Blessing

Some prayers Christ does not answer, we may say, because they ask Him to do our work for us. Tell me, is there a kinder thing that you can do for your pupil who comes up to you with his slate, asking you to work out for him his problem, than to bid him go back to his seat and do his task himself, and get that discipline and learning which is really the object of his having his task set to him at all? You ask Christ to show you with a flash of lightning what your sorrow means. You ask Him to reveal to you by some supernatural illumination which path of life you ought to take, which friendship you shall cultivate, what profes-

114

sion you can most successfully pursue. There comes no answer to those prayers. And why? Those are your problems. It is by hard work of yours, by watchful vigilance, by careful weighing of consideration against consideration, that you must settle those things for yourself.

—Phillips Brooks

Doctrine

293 Only One Doctrine

An aged Christian minister said: "When I was a young man I knew everything; when I got to be thirty-five years of age, in my ministry I had only a hundred doctrines of religion; when I got to be forty years of age I had only fifty doctrines of religion; when I got to be sixty years of age I had only ten doctrines of religion; and now I am dying at seventy-five years of age, and there is only one thing I know, and that is that Christ Jesus came into the world to save sinners."

294 Perverting the Gospel

If, at the tent door, the Arab offers to the thirsty passerby a cup of water, clear, cool, and sparkling in the cup, but in which he has cleverly concealed a painful and deadly poison, he would deserve and receive the anathema of all honest men. Much more terrible shall be the doom of him who, pretending friendship with the souls of men, and offering them in their need, instead of the pure water of life the deadly poison of false doctrine, shall bring down upon himself the righteous and unerring anathema of God.

295 Old Doctrines Enduring

J. Halsey comments:

"In the Kent region of England, is an old church. Walking round it on one occasion, I observed a portion of the roof falling to decay and needing to be propped up with a timber stay. On closer investigation, however, I discovered that the decaying portion was none of the old structure, but a modern addition. We need not fear for the ancient fabric of Christian truth. The new-fangled doctrines will fall to the ground, while the old Gospel 'endureth forever.' "

Duty

296 Duty Performed in Love

The most beautiful sight this earth affords is a man or woman so filled with love that duty is only a name, and its performance the natural outflow and expression of the love which has become the central principle of their life.

297 Feebleness and Duty

Feeble are we? Yes, without God we are nothing. But by faith, every man may be what God requires him to be. This is the only Christian idea of duty. Measure obligation by inherent ability? No, my brethren, Christian obligation has a very different measure. It is measured by the power that God will give us, measured by the gifts and possible increments of faith. And what a reckoning it will be for many of us, when Christ summons us to answer before Him under the law, not for what we are, but for what we might have been.

298 Duty of Man

The duty of every man is to ask himself two questions: "What is my place?" and, "Am I in it?". There are people who from lack of thought or because of unsettling circumstances, drift about uncertainly, anchoring nowhere, bearing no cargoes, and guarding nothing. It is pathetic to meet individuals of middle age who never yet have found their niche. But, once in a situation of opportunity, there comes the urgent demand, Am I measuring up to it? No one is negligible; and even one cog, if broken, will mar the running of the social machine. Nothing is unimportant in the economy of God. The Lord has a place for us, and, if we have the high aim of a holy enterprise, it will prove to be no narrow one. Let us get the right spirit, and we shall have all the "sphere" we want.

299 Courage on Quiet Days

There are a great many helps to courage in numbers and display. The music of marching feet, the brilliancy of uniform and flag, and, above all, the military band with its martial tunes which make the air vibrate with martial feeling. A woman in an American town hurried to the window not long ago at the sound of the band, to see the soldiers marching. "If I were a man," she exclaimed, "I should be a soldier myself! I know I could shoot if they kept the band playing all the time." How many who can fight the battle of life while the band plays faint by the wayside when they must go out in cold blood and sternly struggle with the hard duties of quiet days! But the

noblest heroes among men and women are those who in silence and in quiet, in unreported battles do their duty for Christ's sake and for the love of their fellow men. The newspapers may not herald their bravery, but God recognizes it, and they shall have something better than the medal of the Legion of Honor in God's good time.

Example

300 Example Counts

While holding meetings in Egypt among some soldiers I asked a big sergeant in a Highland regiment how he was brought to Christ. His answer was: "There is a private in our company who was converted in Malta before the regiment came on to Egypt. We gave that fellow an awful time. One night he came in from sentry duty, very tired and set, and before going to bed he got down to pray. I struck him on the side of his head with my boots, and he just went on with his prayers. Next morning I found my boots beautifully polished by the side of my bed. That was his reply to me. It just broke my heart, and I was saved that day."

—Rev. J. Stuart Holden

301 Work While It Is Day

During the period of rainy weather, a London city missionary became discouraged through inclemency of the weather and the hard-heartedness of the people. One evening he wandered through his district in a very despondent mood, and stepped into a hallway to rest and gain shelter from the rain. Through an open doorway he saw a seamstress at her work by candlelight. So busily was she working that

he had trouble to follow the fast flying needle with his eye. She stopped a moment to rest, but then, casting a look at her candle, she murmured, "I must hasten, for my candle is burning low, and I have no other," and busily applied herself to her work. The missionary says: "These words entered my heart as a warning from above. In a moment my despondence was gone, and I said, 'I too, must hasten and work while it is day; the night comes apace when no man can work.'"

Do YOU feel discouraged, brother or sister? Work on, your labor is not in vain in the Lord! You cannot know how long your light will shine, so do not hide it even for a moment, but let every ray count in an effort to dispel the darkness of sin! God will take notice and bless you for it.

302 A Religious Experience

Hezekiah Butterworth, in writing about the Christian faith of Abraham Lincoln, tells this story: "One day Mr. Lincoln met an army nurse, a woman of true Christian character. 'I have a question to ask you,' he said, in effect. 'What is a religious experience?' It was the most important question that one can ask in the world. The woman answered: 'It is to feel one's need of

divine help and cast one's self on God in perfect trust and know his presence,' or words to that effect. 'Then I have it,' he answered. 'I have it, and I intend to make a public profession of it.' About the same time, or later, he said to Harriet Beecher Stowe: 'When I entered the White House I was not a Christian. Now I am a Christian.' In this period of divine trust he made a vow to God to free the slaves by a proclamation. At a cabinet meeting he said: 'The time has come to issue a proclamation of emancipation; the people are ready for it, and I promised God on my knees I would do it.'"

Faith

303 Faith: The Evidence of Things Unseen

Now faith is the substance of things hoped for, the evidence of things not seen (Heb. 11:1).

It was rumored that underneath a certain piece of ground there was iron to be found, and two men were appointed to go and inspect the land and see whether there was really iron there. One man, a scientist and mineralogist, was very conscious of his own limitations; and knowing his own weaknesses, he took with him some scientific instruments. The other man, who was buoyant and self-confident, said, "I believe what I can see, and what I can't see I won't believe"; and so he walked over the field, and got over it in no time. He said, "Iron? nonsense! I see no iron; there is no iron here." This man went to the syndicate and said, "There is no iron there: I walked all over the field and I could not see a trace of it." The other man did not trust to his eye at all. He carried in his hand a little crystal box, and in that little crystal box there was a needle, and he kept watching that needle. He paused, for the needle in that crystal box had pointed down like the very finger of God, and he said, "There is iron there." He passed on, until again that needle pointed down, and he said, "There is iron there," and when he handed in this report he said, "From one end of the field to the other there is iron." "Oh!" said one of the adherents of the first man, "how do you know, when you did not see it?" "Because," he said, "that which cannot be seen with the eye can be magnetically discerned."

304 Never Give Up

A long time ago an old woman tripped and fell from the top of a stone stairway in Boston as she was coming out of the police station. They called the patrol and carried her to the hospital and the doctor examining her said to the nurse, "She will not live more than a day." And when the nurse had won her confidence the old woman said, "I have traveled from California, stopping at every city of importance between San Francisco and Boston, visiting two places always—the police station and the hospital. My boy went away from me and did not tell me where he was going, so I have sold all my property and made this journey to seek him out. Some day," she said, "he may come into this hospital, and if he does tell him that there were two who never gave him up." When the night came and the doctor standing

121

beside her said, "It is not but a question of a few minutes," the nurse bent over her to say, "Tell me the names of the two and I will tell your son if I see him." With trembling lips and eyes overflowing with tears she said, "Tell him that the two were God and his mother."

—J. Wilbur Chapman

305 Faith in Men

Some years ago an airtight vase was found in a mummy-pit in Egypt, by the English traveler Wilkinson, who sent it to the British museum. The librarian there, having unfortunately broken it, discovered in it a few grains of wheat and one or two peas, old, wrinkled and hard as stone. The peas were planted carefully under glass on the 4th of June, 1844, and at the end of thirty days these old seeds were seen to spring up into new life. They had been buried probably about three thousand years ago, perhaps in the time of Moses, and had slept all that long time, apparently dead, yet still living in the dust of the tomb.

306 Growing Faith

I have read that, when the first cable of the suspension-bridge that now spans the Niagara was about to be laid, a thin thread was attached to a kite and both sent, on a favoring wind, to the other side of the river. By means of that thread, a heavier string was pulled across, and by it a heavier one still, and then a rope, and then a tow, and then the cable, and the other parts of that mighty bridge that enables the people to pass in safety, from one side to the other, over the roaring cataract beneath. Let but those who doubt or disbelieve fasten the tiny thread of faith that still lingers in them to the spiritual side of life, and gradually it will become stronger and stronger until it will grow into a mighty bridge that will carry them safely, over the seething and hissing abyss of doubts and perplexities, unto the yonder peaceful shore.

307 It Takes Courage

To refrain from gossip when others about you delight in it.

To stand up for the absent person who is being abused.

To live honestly within your means and not dishonestly on the means of others.

To be a real man, a true woman, by holding fast to your ideals when it causes you to be looked upon as strange and peculiar.

To be talked about and remain silent when a word would justify you in the eyes of others, but which you cannot speak without injury to another.

To refuse to do a thing which is wrong, though others do it.

To live according to your own convictions.

To dress according to your income and to deny yourself what you cannot afford to buy.

The Fountain

308 Faithfulness Rewarded

The son of a widow in difficult financial circumstances was on his

last journey to Oxford. His mother had made a great, and a last effort, as she hoped it might be, to raise the money to enable her son to take his degree. The coach was within two stages of Oxford, when a little before it reached the inn where they stopped, the young scholar missed the money which his mother had given him. He had been a good and careful son, and such a sickness of heart as he felt at that moment some can guess. He tried to recollect whether he had taken out his purse, and remembered that he had done so a few miles back. Almost without hope, and yet feeling it to be his duty to try and recover this large sum that he had lost, he told the coachman to let his luggage be sent on as directed, and walked back towards the place where he thought it possible that he might have dropped the note. He had gone about three miles, when there met him, working his way slowly and wearily, a poor creature whose appearance arrested his attention. He had often read of leprosy, but had never seen a leper. This poor man was one. Shall he stop to speak to him? If the lost note *is* on the road, some passenger may see and take it up, and he may lose it. Yet conscience told him to speak a word of comfort to the poor sufferer before him, and he obeyed. Learning the man's sad history, and his vague hope of getting some advice in Oxford, the student remembered a gentleman in the University whose residence in the East had brought him into contact with lep-

ers, who was well qualified to do any possible good in such a case, besides being ever ready to assist distress. He offered to write a line for the leper, who thankfully accepted the proposal. The student searched his pocket for a piece of paper, but could not find any. Suddenly the poor leper stooped, picked up from the road a piece of paper, and asked if he could not write on that? It was his lost note, given into his own hand by the very man towards whom he was endeavoring to do what he felt to be present duty.

309 Faith and Self-Confidence

Confucius, when he learned that an enemy, named Hwan-to was attempting to kill him, said: "As heaven has produced such virtue in me, what can Hwan-to do?" Contrast with this: "If God be for us, who can be against us?"

310 Consecration of the Poor

A poor widowed laundry woman lost her daughter and only child. A few days after the funeral, she called on the clergyman who had attended her in her illness, and, handing him a packet containing 20 pounds, asked that it might be conveyed to some missionary society. The clergyman, well knowing her circumstances, naturally hesitated; but with great modesty she urged him to take it, and said: "When my child was born, I thought, 'She'll live to get married some of these days,' and I thought I would begin to put by a little sum to be a store for her then, and I began that day with sixpence.

You know what happened last week. Well, I thought to myself, the heavenly Bridegroom has come, and He has called her home to be His bride; and I thought, as He has taken the bride, it is only right He should have the dowry."

311 A Mother's Faith

"I call to remembrance the unfeigned faith that is in thee, which dwelt first in thy grandmother Lois, and thy mother Eunice; and I am persuaded that in thee also"—(2 Tim. 1:5).

Lois and Eunice are not irrelevancies in the story of Timothy. What they were had much to do with what he was, or they would not have been named with this honor. As one missionary put it, "To make a sound Christian of a Hindu you have got to convert his grandmother."

Nowhere will we find a more wonderful example of such feminine spiritual aristocracy than in the life of Abraham Lincoln. When he was a baby his mother said that she would rather have him learn to read the Bible than to have him own a farm. While the boy was still young, in forlorn poverty that mother died and was buried without religious services at her grave. Afterwards came a step-mother—a most understanding woman. She also desired that Abraham learn to read, and to read the Bible. He did.

So the two women of the backwoods and the cabin of the dirt floor had ambition for the boy and gave him guidance. Who knows how much they contributed to what he became? It may be that some of us who wish we had greater opportunity fail to recognize those we have in the nurturing of faith in our children.

312 Landmark of Faith

A strong faith in God: this was another of our founding fathers' landmarks. They trusted God. Like Abraham they believed God. We are not bound to believe all that our fathers believed. There are many things we cannot accept, but when we recollect the firmness with which the old men clung to the broad doctrines of Scripture, of the strength they gained, of the rest, peace and joy of soul they obtained, these memories should check that mania for fashionable doubting which is so much abroad today, and lead us to keep this landmark firmly in its place. Faith in God is our safeguard in temptation; it saves us from despair; it gives prevalence to prayer; it brings deliverance; it is the secret of all heroic enterprises; it ennobles the whole life, and without it no church can succeed.

313 Forward Look of Faith

How happy is the forward look of faith! It meets all doubt with confidence in the living Christ. It looks beyond all present disappointment to the completion of His work. It counts itself His fellow-workman in all efforts toward the bettering of the world.

314 Keeping Our Faith

This substitute of discriminating admiration for embracing faith and personal love, if pressed, will be one of the strongest elements in dividing those who profess to be followers of the blessed Redeemer. We cannot divide the foundation and maintain the superstructure: we cannot divide Christ and keep our faith. No mere admiration of Jesus will anchor the soul. "The life I now live I live by faith in the Son of God, who loved me and gave himself for me" (Gal. 2:20). "Faith is the victory that overcometh the world" (1 John 5:4).

315 God Honors Our Faith

Sir William Napier was one day taking a long walk, when he met a little girl about five years old, sobbing over a broken bowl. She had dropped and broken it in bringing it back from the field to which she had taken her father's dinner in it, and she said she would be beaten on her return for having broken it; then, with a sudden gleam of hope, she innocently looked into his face and said: "But you can mend it, can't you?" Sir William explained that he could not mend the bowl; but the trouble he could mend by the gift of a sixpence to buy another. However, on opening his purse, it was empty of silver, and he had to make amends by promising to meet his little friend in the same spot at the same hour next day, and to bring the sixpence with him, bidding her, meanwhile, tell her mother she had seen a gentleman who would bring her the money for the bowl next day. The child, entirely trusting him, went on her way comforted. On his return home he found an invitation awaiting him to dine in Bath the following evening, to meet someone whom he especially wished to see. He hesitated for some little time, trying to calculate the possibility of honoring the meeting to his little friend of the broken bowl, and of still being in time for the dinner party in Bath; but, finding that this could not be, he wrote to decline accepting the invitation, on the plea of a "pre-engagement," saying to one of his family members as he did so, *"I cannot disappoint her, she trusted me so implicitly."*

316 Experience of Aged Christians

I recollect in a time of great despondency deriving wonderful comfort from the testimony of an aged minister who was blind, and had been so for twenty years. When he addressed us, he spoke of the faithfulness of God, with the weak voice of a tremulous old man, but with the firmness of one who knew what he said, because he had tasted and handled it. I thanked God for what he had said. It was not much in itself. If I had read it in a book, it would not have struck me; but as it came from him, from the very man who knew it and understood it, it came with force and with unction. So you experienced Christians, if any others are silent, you must not be. You must tell the young ones of what the Lord has done for you. Why, some of you

good old Christian people are apt to get talking about the difficulties, troubles, and afflictions you have met with more than about the succors, the deliverances, and the joys you have proved; not unlike those persons in *Pilgrim's Progress*, who told poor Pilgrim about the lions, and giants, and dragons, and the sloughs, and hills, and all that could terrify and dishearten him. They might have mentioned all this, but they should also have told of Mr. Greatheart, and they should not have forgotten to speak of the eternal arm that sustains Christian in his pilgrimage. Tell the troubles, that is wise; but tell the strength of God that makes you sufficient, that is wiser still. Empty yourselves. If you have got experience, empty yourselves upon the earth.

—C. H. Spurgeon

317 Won by His Wife's Faith

Spurgeon relates:

"I have read the story of a man who was converted to God by seeing the conduct of his wife in the hour of trouble. They had a lovely child, their only offspring. The father's heart doted on her perpetually, and the mother's soul was knit up in the heart of the little one. The baby lay sick upon her bed, and the parents watched her night and day. At last the infant died. The father had no God; he rent his hair, he rolled upon the floor in misery, wallowed upon the earth, cursing his being, and defying God in the utter casting down of his agony. There sat his wife, as fond of the child as

ever he could be; and though tears would come, she gently said, 'The Lord gave, and the Lord hath taken away; blessed be the name of the Lord.' 'What,' said he, starting to his feet, 'you love that child! I thought that when that child died it would break your heart. Here am I, a strong man; I am mad: here are you, a weak woman, and yet you are strong and bold; tell me what it is that possesses you?' She said, 'Christ is my Lord, I trust in him; surely I can give this child to him who gave himself for me.' From that instant the man became a believer. 'There must,' said he, 'be some truth and some power in the gospel, which could lead you to believe in such a manner, under such a trial.'

318 The Rope of Faith

Another illustration on faith from the "prince of preachers," C. H. Spurgeon:

The stupendous falls of Niagara have been spoken of in every part of the world; but while they are marvelous to hear of, and wonderful as a spectacle, they have been very destructive to human life, when by accident any have been carried down the cataract. Some years ago two men, a bargeman and a collier, were in a boat, and found themselves unable to manage it, it being carried so swiftly down the current that they must both inevitably be taken down and dashed to pieces. Persons on the shore saw them, but were unable to do much for their rescue. At last, however, one man was saved by floating a rope to him, which he

grasped. The same instant that the rope came into his hand a log floated by the other man. The thoughtless and confused bargeman instead of seizing the rope laid hold on the log. It was a fatal mistake; they were both in imminent peril, but the one was drawn to shore because he had a connection with the people on the land, while the other, clinging to the log, was swept irresistibly along and never heard of afterward. Do you not see that here is a practical illustration? Faith is a connection with Christ. Christ is on the shore, so to speak, holding the rope of faith, and if we lay hold of it with the hand of our confidence he pulls us to shore; but our good works, having no connection with Christ, are drifted along down the gulf of utter despair. Grapple them as tightly as we may, even with hooks of steel, they cannot with all our efforts avail us in the least degree.

319 Won by Faith

The providence of God sent across my path some years ago a thief who had been in prison over twenty times. I could find no work for him here, because he was well known, and therefore I sent him across the ocean to America, but his character followed him, and he was returned to England. At length we obtained work for him out of Manchester; and he turned out to be a faithful employee. One day the manager of the business was removing his goods to a new house, and the mistress—who did not know what the man had been—

called him, saying, "John, this basket contains all our silver; will you please be very careful about it, and carry it to the new house." I said to the man, "And what did you do?" He said, "When I got outside, I looked into the basket and saw the silver shining. I lifted it up, and it felt very heavy." "Well, what did you do then?" He replied, "I cried, because I was trusted." Of course, he carried it safely.

320 Upward Look of Faith

John Wesley was walking one day with a troubled man who expressed his doubt of God's goodness. "I don't know what I shall do with all this worry and trouble," he said. At that moment Wesley noticed a cow looking over a stone wall. "Do you know," asked Wesley, "why that cow is looking over that wall?" "No," replied his troubled companion. "I will tell you," said Wesley—"because she cannot see through it. That is what you must do with your wall of trouble—look over it and above it." Faith enables us to look over and above every trouble, to God, who is our help.

321 Faith and Character

A. J. Gordon while traveling on a train fell into debate with a fellow passenger on the subject of justification by faith. Said the man to Dr. Gordon: "I tell you, God deals with men, not with a little bit of theological scrip called faith; and when the Almighty admits one to Heaven he makes rigid inquiry about his character, and not

about his faith." Presently the conductor came along and examined the tickets. When he had passed, Dr. Gordon said, "Did you ever notice how the conductor always looks at the ticket, and takes no pains at all to inspect the passenger? A railway ticket, if genuine, shows that the person presenting it has complied with the company's conditions and is entitled to transportation. Faith entitles a man to that saving grace that is alone able to produce a character well-pleasing to God. God cares about character; but 'without faith it is impossible to please God' " (see Heb. 11:6).

322 Belief Possible

God has put the matter of salvation in such a way that the whole world can lay hold of it. All men can *believe*. A lame man perhaps, might not be able to visit the sick; but he can believe. A blind man by reason of his infirmity, cannot do many things; but he can believe. A deaf man can believe. A dying man can believe. God has made salvation so simple that young and old, wise and foolish, rich and poor, can all believe if they will.

—D. L. Moody

323 "The Master Has Said It"

A schoolmaster gave to three of his pupils a difficult problem. "You will find it very hard to solve," he said, "but there is a way." After repeated attempts, one of them gave up in despair. "There is no way!" he declared. The second pupil had not succeeded, yet he was smiling and unconcerned. "I know it can be explained, because I have seen it done." The third worked on, long after the rest had given up. His head ached and his brain was in a whirl. Yet, as he went over it again and again, he said without faltering, "I know there is a way, because the master has said it." Here is faith—that confidence that rests not upon what it has seen, but upon the promises of God.

324 The Faith of a Child

A friend tells of overhearing two little girls, playmates, who were counting over their pennies together. One said, "I have five cents." The other said, "I have ten cents." "No," said the first little girl, "you have just five cents, the same that I have," but the second child quickly replied, "My daddy said that when he came home tonight he would give me five cents, and so I have ten cents." The child's faith gave her proof of that which she did not as yet see, and she counted it as being already hers because it had been promised by her father. So are we to trust the promises of our Heavenly Father, and we, too, can count among our possessions the thing which he has promised to give us.

325 A Faithful Wife Rewarded

Dr. Cuyler tells of an excellent woman, at one time a member of his congregation, who was for a

long time anxious for the conversion of her husband. She endeavored to make her own Christian life very attractive to him. On a certain Sabbath she shut herself up and spent much of the day in fervent prayer that God would touch her husband's heart. She said nothing to her husband, but took the case straight to the throne of grace. The next day when she opened her Bible to conduct family worship, according to her custom, he came and took the book out of her hands, saying, "Wifey, it is about time that I did this," and read the chapter himself. Before another week had passed away the man not only did the reading but the praying himself, and in less than a month was received into the church.

326 Faith—Napoleon and the Soldier

The Emperor Napoleon was reviewing some troops in Paris; and in giving an order thoughtlessly dropped the bridle upon his horse's neck, which instantly set off on a gallop. The emperor was forced to cling to the saddle. At this moment a common soldier sprang before the horse, seized the bridle and handed it to the emperor. "Much obliged to you, captain," said the chief, by this one word making the soldier a captain. The man believed the emperor, and saluting him, asked, "Of what regiment, sire?" Napoleon charmed with his faith, replied, "Of my guards," and galloped off.

As soon as the emperor left, the soldier laid down his gun, saying, "He may take it who will," and instead of returning to his comrades, he approached the group of staff officers. On seeing him, one of the generals scornfully said, "What does the fellow want here?" "This fellow," replied the soldier proudly, "is a captain of the guard." "You, my poor friend! You are mad to say so!" "He said it," replied the soldier, pointing to the emperor, who was still in sight. "I ask your pardon, sir," said the general respectfully, "I was not aware of it."

You see how a person may be sure that God gives peace: it is by believing His testimony, just as the soldier believed that of the emperor. That is to say, as he believed himself to be a captain *before* wearing his uniform; so on the word and promise of God, one believes himself to be a child of God *before* being sanctified by His Spirit.

327 Faith—What Is It?

"Without faith it is impossible to please God." But the question may be asked, "What is faith?" Faith includes two things—*belief in a person and trust in a promise*. For example: in the eleventh chapter of the Hebrews the writer says, "For he that cometh to God must believe that *He is*, and that *He is a rewarder* of them that diligently seek him." This trust is natural to a man; that is, man is so constituted that he intuitively believes in God, and is naturally trustful and confiding; is in fact so constituted that he must trust. You go out into the forest and ex-

amine various plants, and you say of certain kinds, though you may never have seen them before, "there are *climbers* or *clinging* plants." And if it be asked, "how do you know this?" you reply that the evidence is in the plants themselves. You say, "See this one throws out little spirals every few inches with which to cling to the branches of some forest tree; and that one every few inches throws out tiny rootlets with which to take hold of the bark of some sturdy oak." And these while clinging to their natural supports are beautiful to look upon; but remove the support and then in their helplessness they lie upon the damp earth and interwoven about each other, mildew and rot. So society becomes putrid and rotten when it turns aside from and refuses to cling to God.

It is this same principle of trust that binds society together as well as to the Creator; just as in the universe it is the same law which keeps the planets in their course around the sun that holds the constituent elements of the worlds together. It is by means of this great principle that it is possible for human beings to exist in communities.

328 Faith—How Much Required for Salvation?

It is not the quantity of thy faith that shall save thee. A drop of water is as true water as the whole ocean; so a little faith is as true faith as the greatest. A child eight days old is as really a man as one of sixty years; a spark of fire is as true fire as a great flame; a sickly man is as truly living as a well man. So it is not the measure of faith that saves thee—*it is the blood that it grips that saves thee;* as the weak hand of a child, that leads the spoon to the mouth, will feed as well as the strongest arm of a man; for it is not the hand that feeds you, but the meat. So, if you can grip Christ ever so weakly, He will not let you perish.

329 Childlike Faith

A little girl was dying. Struggling for her last breath, she was heard to whisper, "Father, take me!" Her father, who sat dissolved in tears, lifted her gently into his lap. She smiled, thanked him, and said, "*No, not that. I spoke to my heavenly Father,*" and died. O for a childlike faith, "for except we repent, and become as a little child, we cannot enter into the kingdom of heaven."

330 Anchor—One That Always Holds

"Believe on the Lord Jesus Christ, and thou shalt be saved" (Acts 16:31).

How simple the plan of salvation! Only believe! Faith in Christ begets hope, "which hope we have as an anchor to the soul, both sure and steadfast, and which entereth into that within the vail." This anchor never fails in the most tempestuous sea and the most stormy weather.

Says a gentleman: "As we lay off Queenstown harbor, one blustering afternoon, I saw the anchor lowered. I could scarcely believe my eyes that such a small piece of

iron could be expected to check the drift of the huge ship amid such a boiling sea, but the implicit confidence of the officers reassured me. They had tested it before. Small as it was, it held the ship amid the fury of the hurricane."

Faith in Jesus seems to be a little thing, but it has been tested and has never failed. Our boat is tossing on life's troubled sea, but the chain that binds us to the Eternal is a chain of love, and it is easier, far easier, for heaven and earth to pass away than for one link to fail—every link is a promise of the Everlasting God—and the flukes of the anchor take hold of the "Rifted Rock" within the vail.

331 Test of Faith

When a young mother has her first babe, if it whimpers and cries she thinks that pains and diseases are about to seize it. But the grandmother, that has had the care of her own children and her children's children, is not troubled when she hears a child cry. Now God is the everlasting Father of nations. For thousands of years he has been educating them towards manhood. There is no possible fantasy, or error, or deceit that is not perfectly familiar to him. There is not a road of prosperity or of adversity that he does not know. There is not a path that nations have ever trod, or that they will ever tread with which he is not acquainted. And, you that are distressed, where is your God? Are you men that have faith in God when the sun shines,

and that have no faith in him when it is cloudy?

332 The Evidence of Things Not Seen

The Christian man knows that he is but a stranger and pilgrim; and he comforts himself, as he goes through the wilderness, thinking of the home towards which he is traveling. And he weaves tapestries, and paints pictures, and carves various creations. Living, as he does, by faith, and not merely by sight, his imagining, his picture-painting, his idealizing, his holy reverie, are filling the great empty heavens with all conceivable beauty. And what if it be evanescent? So is the wondrous frost-picture on the window; but is it not beautiful and worth having? So is the dummer dew upon the flower; but is it not renewed night by night? And faith is given to man to life him above the carnal, the dull, the sodden, and to enable him to conceive of things beyond that to which any earthly realization has yet ever attained.

333 Wanted—A Worker

God never goes to the lazy or idle when He needs men for His service—

Moses was busy with his flocks at Horeb.

Gideon was busy threshing wheat.

Saul was busy searching for his father's lost sheep.

Elisha was busy plowing with twelve yoke of oxen.

Amos was busy following the flock.

Nehemiah was busy bearing the king's cup.

Peter and Andrew were busy casting a net into the sea.

James and John were busy mending their nets.

Matthew was busy collecting customs.

Saul was busy persecuting the friends of Jesus.

Let's all get busy at this great work and the Lord will use and bless us.

334 Unlimited Resources

Dr. J. Wilbur Chapman told of a time in his life when a great sorrow had come to him which occasioned his taking a trip into the far West. One of his elders, a banker, came to see him, and as he was taking his leave he slapped a bit of paper in to Dr. Chapman's hand. When he looked at it, he found it to be a check made out in his name and signed by the banker, but where there should have been figures it was blank. "Do you mean you are giving me a signed blank check to be filled out as I please?" Dr. Chapman asked. "Yes," the banker said. "I did not know how much you might need, and I want you to draw any amount that will meet your wants." "And while I did not use the check," Dr. Chapman said, "It gave me a comfortable, happy feeling to know that I had millions at my disposal." So God has given us a signed check in

Philippians 4:19. His resources are unlimited, and the more we draw on Him, the better He likes it. "I shall not want" (Ps. 23:1). We shall not want for anything, for God shall supply all our needs.

335 The Lean Year

The story is told that the aged pastor of a little Scotch church was asked to resign because there had been no conversions in the church for an entire year.

"Aye," said the old preacher, "its been a lean year, but there was one."

"One conversion?" asked an elder. "Who was that?"

"Wee Bobbie," replied the pastor.

They had forgotten a laddie who had not only been saved but had given himself in full consecration to God. It was "wee Bobbie" who, in a missionary meeting when the plate was passed for an offering asked the usher to put the plate on the floor, and then stepped into it with his bare feet, saying, "I'll give myself: I have nothing else to give." This "wee Bobbie," we are told, became the world renowned Robert Moffat, who, with David Livingstone, gave his life to the healing of the open sores of Africa—then known as the "Dark Continent."

336 "Is He Talking about You"

A woman and her little daughter were in a service in which the preacher spoke about how obedience toward God is revealed in the manner in which one attends to the small duties of everyday life.

He described how many parents neglected their spiritual duties in the home; how they retired night after night without praying for God's watchcare, and how in the morning they failed to thank Him for rest, protection, and the new blessings of the new day.

The little girl listened attentively. Turning to her mother, she whispered, "Mama, is the minister talking about you?"

The simple question pierced her heart. She said nothing, but that night she knelt and, before her bed, confessed her sin and asked God's help in carrying out her duties.

337 The Death of John Huss

When John Huss, the Bohemian martyr, was brought out to be burned, they put on his head a triple crown of paper, with painted devils on it. On seeing it, he said, "My Lord Jesus Christ, for my sake, wore a crown of thorns; why should not I, then, for His sake, wear this light crown, be it ever so ignominious? Truly I will do it, and that willingly." When it was set upon his head, the bishops said, "Now we commend thy soul to the devil. "But," said Huss, lifting his eyes to heaven, "I do commit my spirit into thy hands, O Lord Jesus Christ; to Thee I commend my spirit which Thou hast redeemed." When the torches were piled to Huss' neck, the Duke of Bavaria was officious enough to desire him to adjure. "No," said Huss, "I never preached any doctrine of evil tendency; and what I taught with my lips I now seal with my blood."

338 Intelligent Faith

Ignorance is the chief sin of our time. Some say unbelief is. I think not. Some say the great need is faith. But when we have intelligence we shall have faith. We need knowledge of God. I do think that what people need most in this world today is a belief in God. It is a very rare man that truly and deeply believes in God. If you believe in God, you see Him in everything—in the birds and flowers, and brightness and beauty, as well as when the storms gather and sorrow sweeps over you. If a man believes there is a God, his belief controls him all through his being. Jesus said, "Let your light so shine before men that they may glorify God" (Matt. 5:16). In order to make other men think of God we must believe in Him, and must have such a strong obedience coming out of our belief that men will take knowledge of us that we believe in God and know Him.

—Alexander McKenzie

339 Resignation

The faith of a Christian is sometimes tried in looking at the sorrows of those whom he regards as sincere believers. Still more is the sufferer himself tried and under providential calamities; and the question is forced on the heart, Am I a true child of God? If I were, would He thus deal with me? Have I been deceiving myself? Then it is that the ways of God have to be studied in the light of the Bible. The lively stones have to be cut so

as to fit into their places in the building. The jewels have to be polished. In wisdom and goodness God's hand chastens; then the believing heart is lifted into nearness to Him, and then He works deliverance. "Thy will be done."

—John Hall

340 Faith without Works

So long as there is a radical difference between truth and falsehood, and so long as truth sustains relations to life, it will make a difference whether men believe true or false doctrine. Doctrines are the roots of life. Great lives do not grow out of false beliefs. Doctrine is immensely important, but not all-important. The root does not exist for itself; it is a means to the tree and the fruit as an end. A Christian acts in the life as naturally as the root pushes its stalk up into the air and the sun. Cut the stalk, fell the tree, and the root dies at length. A faith without works is soon dead. If our doctrines do not flower and produce fruit in Christian living, they die. Many a man's creed is a field full of stumps. There was life there once, but because the natural expression of that life was prevented, it perished. We have not overestimated the importance of *believing* the truth, but we have underestimated the importance of *living* the truth.

341 Reason and Faith

God has made us with two eyes, both intended to be used so as to see one object. Binocular vision is the perfection of sight. There is a corresponding truth in the spiritual sphere. We have two faculties for the apprehension of spiritual truth—*reason* and *faith;* the former intellectual, the latter largely intuitive, emotional. Reason asks, How? Wherefore? Faith accepts testimony, and rests upon the person who bears witness.

Now reason and faith often seem in conflict, but are not. Reason prepares the way for faith, and then both act jointly. We are not called to exercise blind faith, but to be ready always to give answer to every man who asks a reason.

There are three questions which belong to reason to answer: First, Is the Bible the Book of God? Second, What does it teach? Third, What relation has its teaching to my duty? When these are settled, faith accepts the Word as authoritative, and no longer stumbles at its mysteries, but rather expects that God's thoughts will be above our thoughts. Thus, where reason's province ends faith's begins.

—A. T. Pierson

342 Dead or Alive

Theological beliefs—are yours active or dead?

A *USA Today*/CNN Gallup Poll was disclosed in December of 1994 with some interesting research on what Americans say they believe.

Of those polled, 90% believe in heaven. Only 73% think there is an opposite of heaven, even though the word for that fiery place is probably part of their daily vocabulary. Believers in angels number 72%. But less than 65% are convinced

that the devil cannot make you do anything. While there is an increase in the past decade, of those who believe in theological absolutes, more folks also believe in reincarnation and psychic contact with the dead.

Today there is more openness about what people believe. Yet those beliefs will not necessarily secure for them a place in heaven. The Bible says, *"You believe that there is one God. Good! Even the demons believe that—and shudder"* (James 2:19 NIV) There must be some evidence that your beliefs have transformed your life to the point that righteous actions are visible. God inspired this warning: *"Faith by itself, if it is not accompanied by action, is dead"* (James 2:17 NIV).

Remember: Upgrade your "B"eliefs into "A"ctions.

Reflections

Family

343 Mothers Help God

A little boy who was told by his mother that it was God who makes people good, replied, "Yes, I know it is God, but mothers help a lot."

344 Home Influence

Show me the home of a boy, and I will prophesy concerning his future without a tremor of uncertainty. Show me a man's home, and I can account for his peculiarities, his cheerfulness, or his despair.

A quiet home, on whose altar the flame of love and confidence never goes out, is as close to heaven as mortals can get this side the grave. A home which lacks love and confidence breeds germs of misery, which multiply until ruin has done its awful work.

345 Mother's Reward

It is a great compliment to a woman to have a great son. I remember an incident that took place at a certain village, which impressed this upon my mind as nothing else could. It was commencement. A young man was to graduate who stood at the head of his class, and received many honors. He was of humble parentage. It had cost quite a good deal of struggle and sacrifice on the part of his parents to keep him at school. When he de-livered his graduating speech, his old mother, with her sunbonnet on, sat just in front of him. No sooner had he finished speaking, and received his medal, than he stepped down off the platform, went and placed his arms around his mother's neck, and pinned his medal on her dress.

Someone said to her, as they went out of the hall: "I know you are proud of your boy."

"Ah, yes," said the young man, "but not half so proud as he is of his mother!"

346 Father Holding the Rope

On a dangerous cliff stood a little company of rescuers planning how they might let someone down over the precipice to search for one who was lost and carry to him the rope with which he might be rescued. They wanted to use a little shepherd lad, but he drew back unwilling to go until he saw his father coming, when he said: "Yes, I will go if father holds the rope." We need not hesitate to go down into the depths of this world to try and find and save the lost as long as we know that our Father holds the rope. He will supply the strength to keep us and bring us back safely.

347 A Little One's Needs

A little one's feet need big feet
To guide them every day.
Short little legs need longer legs
To help them not to stray.

Small little hands need stronger
 hands
That teach them work and play.

Young little knees need bended
 knees
To show them how to pray.

Cute little mouths need wiser
 mouths
In learning what to say.
Precious little hearts need pure
 hearts,
Teaching Christ's loving way.

—John C. Bains, Jr.
The Beacon

348 Father's Call

A famous military officer used to tell a story of an aged Quaker named Hartmann, whose son had enlisted in the army. There came the news of a dreadful battle, and this old father, in fear and trembling, started to the scene of conflict that he might learn something concerning his boy. The officer of the day told him that he had not answered to his name, and that there was every reason to believe that he was dead. This did not satisfy the father, so, leaving headquarters, he started across the battlefield, looking for the one who was dearer to him than life. He would stoop down and turn over the face of this one and then the face of another, but without success. The night came on, and then with a lantern he continued his search, all to no purpose. Suddenly the wind, which was blowing a gale, extinguished his lantern, and he stood there in the darkness hardly knowing what to do until his father's ingenuity, strength and affection prompted him to call out his son's name, and so he stood and shouted, "John Hartmann, your father calls you." All about him he would hear the groans of the dying and someone saying: "Oh, if that were only my father." He continued his cry with more pathos and power until at last in the distance he heard his boy's voice crying tremblingly, "Here, father." The old man made his way across the field shouting out, "Thank God! Thank God!" Taking him in his arms, he carried him to headquarters, nursed him back to health and strength, and he went on to live a long life. Over the battlefield of the slain this day walks Jesus Christ, the Son of God, crying out to all who are wrecked by this awful power, "Thy Father calleth thee," and if there should be but the faintest response to his cry he would take the lost in his arms and carry them home to heaven. Will you not come while He calls today?

—J. Wilbur Chapman

349 Father's Advice to Son

Charles Dickens once addressed a letter to his son Henry while he was at college, advising him to keep out of debt and confide all his perplexities to his father. The letter concluded as follows: "I most strongly

and affectionately impress upon you the priceless value of the New Testament, and the study of that book as the one unfailing guide in life. Deeply respecting it, and bowing down before the character of our Savior, you cannot go very wrong, and will always preserve at heart a true spirit of veneration and humility. Similarly, I impress upon you the habit of saying a Christian prayer every night and morning. These things have stood by me all through my life, and remember that I tried to render the New Testament intelligible to you and lovable by you when a mere baby. And so God bless you!"

350 Except Henry

In the home of a devout farmer there hung the well-known motto: "But as for me and my house, we will serve the Lord." The motto meant something in that house, for the farmer prayed daily that all might truly serve the Lord. The last clause fitted all the house except the oldest son, who persistently refused to accept Christ. One day the father and son were alone in the room where the motto hung. The father said, "My dear Henry, I cannot and will not be a liar any longer. You, who belong to my house, do not want to serve the Lord. Therefore I must add the words 'except Henry'; it hurts me to do it, but I must be true." The thought so impressed the boy that he gave himself to Christ.

351 "Are the Boys All In?

"Is it getting night?" said an old Scottish woman ninety-seven years of age. "Husband," she said, "is it getting night?" And her aged Scottish husband by her side, realizing that she was dying, bent down close to her and said, "Yes, Janet, it is getting night." Her mind was wandering a bit and she thought she was back in the olden days with her loved ones, but he knew that the end was near. She was still a moment, and then said, "Are the boys all in?" "Yes," he said, "the boys are all in, Janet." The last one had gone home three years before. She was again still a moment more when she said, "I will soon be in." "Yes, Janet, you will soon be in." "And you will soon come too?" she asked. "Yes," he said, "by the grace of God I will soon come too." She reached out her thin hands in order that she might clasp them round his neck and draw him down by her side as she said, "And He will then shut us all in." "All in." I wonder if you can say it—with the boys all in; the girls all in. It is a sad thing to have a boy that is a wanderer, and a girl that is lost.

—J. Wilbur Chapman

352 "Run Away, Boy"

A story is told of a young man who stood at the bar of a court of justice to be sentenced for forgery. The judge had known him from a child, for his father had been a famous legal scholar and his work on the Law of Trusts was the most ex-

haustive work on the subject in existence. "Do you remember your father," asked the judge sternly, "that father whom you have disgraced?" The prisoner answered: "I remember him perfectly. When I went to him for advice or companionship, he would look up from his book on the 'Law of Trusts' and say, 'Run away, boy, I am busy.' My father finished his book, and here I am." The great lawyer had neglected his own trust with awful results.

353 Home as a Refuge

Dr. Lyman Abbott once said:

"Blessed is the man whose home is a real refuge! who, being tossed to and fro on the waves of a tumultuous and combative sea throughout the day, leaves his office, his business perplexities behind him, and when he opens the door and enters the house, enters the landlocked harbor. But the home ought not to be a refuge for the husband and the father only, but we who are husbands and fathers ought to make it a refuge for the wives and mothers as well. They have their cares also, and when we come to our homes we ought to come bringing with us such a spirit as shall exorcise these cares and make home their refuge."

354 Home as a Test

There is the connection between harmony in a home and the honoring of God. Now, we may hope that when things are right with an earthly home the inhabitants may be ready for the heavenly home; because, there is no more searching test of solid Christianity than the home. It is all very well to be pleasant in society where you only meet the surface of people. It is all very well to be thought charming by strangers, or even to appear religious at a prayer meeting, or to deliver an eloquent sermon, but this will not stand God's test. "In the outside world," says J. R. Miller, "we do not get close to men. We often only see their best points," that is, we see the coating of sugar which hides the unwholesome cake. "We do not feel the friction of their meaner qualities. But at home all is laid bare. Lives touch there. The selfish motives which make us polite to outsiders have no place there, for we are sure of the hearts there." We can be as rude as we like at home; the place is still ours, they can't turn us out. There are only hearts to break there; no money will be lost by rudeness. And this is often all that men care about! Nothing but love for Christ which "endureth all things" (1 Cor. 13) is equal to the string of simple home life. "It is God that maketh men to be of one mind in a house."

355 Laughter Takes the Edge Off Parental Sternness

Once we asked the kids to compile a list of the things we most often said to them. This is what they wrote:

• I'm not talking just to hear my jaws flap.

• You just ate.

- It'll be good for you.
- Sit back and buckle up.
- Not another word.
- I had to walk five miles to school and five miles home and it was uphill both ways.
- Don't touch each other.
- There are starving people in Africa.
- Were you born in a barn?
- Don't you look at me like that.
- I'll give you something to cry about.
- Ask your mother.
- Ask your father.
- That drives me nuts.
- Do you want to live to see your next birthday?
- If you pick at it—it won't heal.

Then there are the mixed messages like:

- Shut your mouth and eat.
- Hurry up and don't run.
- Don't be smart.

Has formulating this list caused us to stop saying these things? Of course not. But at least laughing together about them makes it slightly less nausea-provoking to the kids when they're repeated for the eight-zillionth time.

There's no place in parenting for "jokes" that ridicule or put down children. But all kinds of room exists for humor that replaces sarcasm, or diffuses genuine fury. There are days with Heidi and Nathan, when, listening to songs about how sweet children are (even ours!), I wish the tape would self-destruct. On one really rough day I told the kids, "Here's a parenting song I'd like to write: 'I've got bald spots on my head, from tearin' my hair out over yew-w-w-w-w.' "

Humor is the spoonful of sugar that makes the medicine of all our serious parenting efforts more palatable to children.

—Steve and Annie Chapman
Gifts Your Kids Can't Break
Bethany House, 1991

356 The Foundation Is the Home

The Christian home is the most important institution in the world. That does not minimize the position of the church and state; they also have been ordained of God. But He places the home first—in time as well as in importance. It is the foundation upon which all other institutions are built; upon it the church and state will either stand or fall. What the homes are, the churches and schools are—and the government will be. Every place where there has been a neglect of home responsibility, there eventually has been a crumbling of the nation.

—Wesley L. Gustafson

357 Values and V-Chips

"Who are they?" I asked. "Who are the people who rate the shows? Do they share my values? Do they love my children as much as I do?"

My questions concerned the "V-chip," which President Clinton mandated a few months ago as a requirement for all new television sets. The chip is supposed to filter

TV programs, based on ratings assigned by a board similar to the movie rating board.

About that same time, a reporter from the local NBC affiliate station interviewed me (an associate pastor) for a story she was preparing on the V-chip—thinking that I would be solidly in favor of it. After all, it is pro-family values, right? Yes, but whose values? I am the only one who can integrate the principles and values I hope for my children to live by with the disciplines that those principles require.

The idea of taking a stand is at the heart of the V-chip problem. I really can't think of a single reason why I would defer to someone else the responsibility to mold and monitor my children's TV viewing habits. Some argue that time is a relevant factor: "With such busy households, parents don't always have the time to watch with the children." This may be a prevalent scenario, but have we reached a reasonable conclusion? Is letting someone else parent my child's TV watching the right solution to my time management problem? I am personally convicted about this. I am not willing to throw my children the remote control and implicitly say, "What you do with your time is not as important as what I do with my time."

Imagine what the world —your children's world—will be like if you stand for yours!

—Clark H. Smith

Fear

358 Fear, Its Influence in Conversion

Jens Haven, one of the first missionaries to the Eskimo Indians, of Labrador, while a careless youth, was awakened by a violent thunderstorm, the electricity of which struck him senseless to the ground. As soon as he recovered, he got upon his knees and cried to God for mercy and for conversion; and, from that day, was a new man, soon after devoting his life to mission work among the Moravians.

It will be remembered that Luther passed through an almost identical experience.

359 Fear of God

"One splendid evening," say the son and biographer of Cæsar Malan, "we climbed the road which rises from Bienne, skirting the deep gorges of the Suze. Arriving at the inn of Sonceboz, my father, while unhooking his knapsack, said to the mistress of the house that he would be conducting evening worship with us after supper, and that she would be welcome if she liked to be present with her household. 'We have no need of all that here,' replied the woman, seeming very busy, and adding some expressions of impatience. My father immediately resumed his bag, and grasping his stick, said to me: 'Do you feel that you still have legs for an hour's walk, my boy?' Then, without noticing the astonishment of the hostess, who wished to detain him, he added: 'Come, my children, I will not pass the night under a roof where prayer is despised, and where God is not feared.' "

360 Fear of the Future

What a vast portion of our lives is spent in anxious and useless forebodings concerning the future, either our own or that of our dear ones! Present joys, present blessings, slip by, and we miss half their sweet flavor, and all for lack of faith in Him who provides for the tiniest insect in the sunbeam. Oh, when shall we learn the sweet trust in God our little children teach us every day by their confiding faith in us? We who are so mutable, so faulty, so irritable, so unjust; and He who is so watchful, so pitiful, so loving, so forgiving! Why can't we, slipping our hand into His each day, walk trustingly over that day's appointed path, thorny or flowery crooked or straight, knowing that evening will bring us sleep, peace and home?

—Phillips Brooks

361 Fear Overcome

A soldier who had been through a long campaign once declared the order to "close up the ranks" drove away from him all sickening fear in entering on the battle, for the touch of other men at his elbows made him feel he was one of a vast host, and thus the sense of individual peril was forgotten. Christ's "Fear thou not, for *I am with thee*" (Is. 41:10), is just such an elbow-touch to our souls; and we reply, "I will fear no evil, for Thou art with me" (Ps. 23:4).

Fellowship

362 Old Friends

Old friends are best, I do agree,
 but to this fact I'll hold;

That everything must first be
 new before it can be old.

That old friend whom you love
 so much; who's staunch and
 true and bold,

Was brand new on the day you
 met, though now you call him
 old.

So make new friends each pass
 ing day—the years quickly
 unfold;

And new friends whom you
 make today, will soon be
 classed as old.

Then you will have a store of
 wealth that far surpasses gold;

For all the friends who now are
 new you'll soon be calling old.

Messenger

363 Fellowship Independent of Class

The Christian Czar, Alexander I,
said he could understand a Christ-
ian in five minutes; whether a
monarch or a peasant, his heart was
with them.

364 Unequally Yoked

*"Be ye not unequally yoked together
with unbelievers; for what fellowship
hath righteousness with unright-
eousness? and what communion
hath light with darkness?"*—(2 Cor.
6:14).

Eliza Embert of Paris was the
daughter of a wealthy citizen. She
was betrothed to a young man who
was both handsome and much
thought of. The evening preceding
the wedding they were at a party
where gaiety and laughter abounded.
The bridegroom was in fine spirits,
and he entertained the young folks
with sly remarks upon religion, or
"old women's faith," as he called it.

Finally the bride approached him
quietly and asked him to stop such
mockery as she could not endure it.
He however would not hear her re-
quest and said, "My clever little
bride is surely not involved in such
silly things," and then proceeded
to jest all the more.

A second time his bride ap-
proached him, and with tears in
her eyes and a tremor in her voice,
said firmly: "From this moment I
am no more yours. Whoever does
not hold God and His Word sacred,
will not hold the marriage tie sa-
cred; and whoever does not love
God will not truly love his wife."

This brought the young man to his senses. He insisted he was merely jesting and pretended he did have some respect for God and His Word. But it was all in vain. She abode by her resolution, *and never had need to repent of it.*

365 Christian Fellowship

"That which we have seen and hear declare we unto you, that ye also may have fellowship with us; and truly our fellowship is with the Father, and with His Son Jesus Christ" (1 John 1:3).

F. Kingdon Ward, the celebrated explorer and botanist, tells how trees in the Burmese jungle deteriorate and gradually perish when they are left standing alone. They can only flourish when they are growing among other trees. So the Christian grows only as he has fellowship with others, and sweet communion together with them in the things of the Lord.

On the other hand, we do well to recall the words of Allison Parr. "I cannot take a consensus of opinion about God—He must be *my* Lord, and *my* God." For no human fellowship can suffice to prepare the heart for Christian usefulness. As an ancient saint of the early church once said, "He who occupies himself with the things of Christ must ever dwell with Christ."

Let us be careful to maintain the balance John, the beloved apostle, so beautifully describes in the above verse. Let all our fellowship with each other be truly a fellowship with the Father and His Son Jesus Christ. Perhaps then more of our friends might say to us as Lord Peterborough said to Fenelon, after spending a few days with him: "If I spend another week here I shall become a Christian in spite of myself."

366 Christ's Need of Man's Fellowship

He offers us fellowship with Himself, but He looks for fellowship from us as well. He longed for the fellowship of His disciples on the eve of His crucifixion. "With desire I have desired to eat this passover with you before I suffer." He needed their fellowship to strengthen Him for His conflict and His cross. He asks for it today also. It is something constant and continuous that He needs. A sense of His presence at the Holy Communion is good, but it is not enough. A wave of emotion at some evening service and the opening of the heart to Christ is good, but it is not enough. An act of self-consecration at some service like the present is good, but it is not enough. Some characters are deeply touched at some mission service, but the impression soon passes away. Some welcome Christ as a visitor for the weekend; but when Monday comes, care or pleasure banishes Christ from heart and home. Something more is needed. Our heart must be one that He can make a home in. It must be a contrite heart. It must be a cleansed heart. It must be a sensitive heart.

"Thus saith the Lord, The heaven is My throne, and the earth is My footstool; where is the house that ye

build unto Me? and where is the place of My rest? . . . To this man will I look, even to him that is poor and of a contrite heart, and trembleth at My word" (Is. 66:1, 2). What shall our attitude be?

367 Your Whole Heart

God, the Father of men, is not satisfied if His children give Him simply gratitude for His mercies or the most loyal obedience to His will; He wants also, as the fulfillment of their love to Him, the enthusiastic use of their intellects, intent to know everything that it is possible for men to know about their Father and His ways. That is what is meant by loving God with the mind. And is there not something sublimely beautiful and touching in this demand of God that the noblest part of His children's nature should come to Him? "Understand Me! Understand Me!"

—Phillips Brooks

368 Strike That Iron and Let the Sparks Fly!

Show me a man's companions, and I'll show you his character. One of the most accurate spiritual barometers of someone's life is the people he chooses to keep company with. At the very least we know this is true when it comes to our children.

We as parents all have concern when it comes to the company that our children choose. We know the reality of the Scripture in 1 Corinthians 15:33: "evil company corrupts good morals." We have either seen

it in our own children, or in the children of our friends and neighbors. It is so easy to spot the negative influence of other people. Their behavior smacks of adolescent immaturity.

Unfortunately, the negative influence that is so easily detectable in children, sometimes is harder to discern in adulthood. I have found that many times as adults we make three major mistakes when it comes to relationships.

• We give little thought to the power of relationships.

• We have difficulty in recognizing negative relationships.

• We do not know how to develop Godly relationships.

God's Word commands us to abandon unhealthy relationships and activate Godly relationships. Whenever God wants to bless you, he will send someone into your life as that vehicle of blessing. In the same fashion whenever Satan wants to destroy your life he will send someone into your life to be that vehicle of destruction. The people around you either increase you or decrease you.

—Mike & Bonnie Fehlauer
Foundation Ministries

369 Christian Relationships

In Proverbs 27:17 we read: "As iron sharpeneth iron, so a man sharpens the countenance of his friend." John Wesley was such a friend to William Wilberforce, who tried again and again—with seemingly no success—to abolish Britain's slave trade.

In 1791 Wilberforce received a letter from Wesley which included this exhortation: "Go on, in the power of His might, till even American slavery...shall vanish away before it." Though Wesley died four days after writing that letter, it remained an inspiration to Wilberforce through years of disappointment after disappointment. Finally, after 20 years, he was able to get a bill passed which abolished the slave trade. Shortly after, slavery was completely outlawed throughout the British Empire. Wilberforce might not have prevailed if it had not been for the encouragement of his friend who strengthened him in the Lord.

Before you pray, "Lord, give me a friend like that," try praying: "Lord, make me a friend like that."

—Mike & Bonnie Fehlauer
Foundation Ministries

Forgiveness

370 Revenge

Governor Stewart, of Missouri, recognized, in a convict he was about to pardon a steamboat mate under whom he served as cabin-boy. He said: "I want you to promise that you will never again take a stick of wood and drive a sick boy out of his berth on a stormy night, because some day that boy may be governor, and you may want him to pardon you for another crime. I was that boy. Here is your pardon."

371 Forgiving Mercy

Many years ago in Russia a regiment of troops mutinied. They were at some distance from the capital, and were so furious that they murdered their officers, and resolved never to submit to discipline; but the emperor, who was an exceedingly wise and sagacious man, no sooner heard of it than, all alone and unattended, he went into the barracks where the men were drawn up, and, addressing them sternly, said to them: "Soldiers! you have committed such offenses against the law that every one of you deserves to be put to death. There is no hope of any mercy for one of you unless you lay down your arms immediately, and surrender at discretion to me, your emperor." They did so, there

and then. The emperor said at once: "Men, I pardon you; you will be the bravest troops I ever had." And so they were. Now, this is just what God does with the sinner. The sinner has dared to rebel against God, and God says: "Now, sinner, you have done that which deserves My wrath. Ground your weapons of rebellion. I will not talk with you until you submit at discretion to My sovereign authority." And then He says: "Believe in My Son; accept Him as your Savior. This done, you are forgiven, and henceforth you will be the most loving subjects that My hands have made."

372 Forgiveness Not for Sale

One day a poor girl ventured into the garden of the Queen's palace, and approached the gardener, telling him that her mother was lying very ill, and that she longed for a flower, such as she had seen in the Queen's gardens. It was winter time, and the flowers were rare at that season. The child had saved a few pennies and wished to buy a rose for her sick mother. The gardener had no authority to give away the Queen's flowers, and he said when she offered to pay, "The Queen has no flowers for sale," and would have sent the poor child away. But the Queen herself just happened to be

in the greenhouse, and, unobserved either by the gardener or his little customer, had overheard the conversation. As the child was turning away sorrowful and disappointed, the Queen stepped from behind her flowery screen and addressed the child, saying: "The gardener was quite right, my child, he has no authority to give you the flowers you want, nor does the Queen cultivate flowers for sale; but the Queen has flowers **to give away**"; and, suiting the action to the word, she lifted from the basket into which she had been snipping the flowers a handful of rare roses and gave them to the child, saying: "Take these to your mother with my love, and tell her that the Queen sent them. I am the Queen." So let me say to you, God has no forgiveness for sale; you cannot buy it with your poor penance of tears, prayers, or repentance; God has forgiveness to give, and you may take it by faith, but not barter for it with anything you can do.

373 Judge Pays a Prisoner's Fine

Two men who had been friends and companions in their youth met in the police court, the one on the magistrate's bench, the other in the prisoner's dock. The case was tried and the prisoner was found guilty. Would the judge, in consideration of their friendship years before, forbear to pass judgment? No, he must fulfill his duty, justice must be done, the law of the land obeyed. He gave out the sentence—fourteen days' hard labor or a fine of $500. The condemned man had nothing to pay, so the prison cell was before him. But as soon as he had pronounced the sentence the judge rose from the bench, threw aside his magistrate's robes, and stepping down to the dock, stood beside the prisoner, paid his fine for him, and then said, "Now, John, you are coming home with me to supper." It is just so with the sinner. God cannot overlook sin. Justice must be done, and the sentence pronounced, but Christ Himself pays the debt and the sinner is free.

374 Conviction through Excess of Sin

Richard Knill, in his early zeal which never cooled, seized an opportunity of distributing tracts to the North Devon Local Militia, when the regiment was on the point of being disbanded. The tracts were generally well received, but one man held up the tract and swore at it. Knill reproved him, saying he could not hurt the tract, but he would hurt himself. "Who are you?" cried the man, in anger. "Form a circle round him," he said to his comrades, "and I will swear at him." They did so, and the militiaman swore at Knill till he wept with grief. At this the men were ashamed, broke up the circle, and let him go. Many years after, when Knill returned from India, he was preaching in the open air a few miles from the same spot. During his sermon he noticed a tall, gray-headed man, and a young man with him, who seemed to be his son,

both of them weeping. At the close they came up to him, and the father asked: "Do you recollect giving tracts to the local militia at Barnstaple some years ago?" "Yes." "Do you recollect anything particular of that distribution?" "Yes; I recollect one of the grenadiers swore at me till he made me weep." "Stop," said the other; "oh, sir, I am that man; I never forgave myself for that wicked act. But I hope that it has led me to repentance, and that God has forgiven me. And now let me ask: Will you forgive me?" Mr. Knill wept again, and they parted this time with the prayer and hope that they might meet again in heaven.

375 The Sign of the Cross

"Forbearing one another, and forgiving one another, if any man have a quarrel against any; even as Christ forgave you, so also do ye"— (Col. 3:13)

Before Louis XII became King of France he suffered great indignities and cruelties at the hand of his cousin Charles VIII. He was slandered, thrown into prison, kept in chains and constant fear of death.

When he succeeded his cousin to the throne, however, his close friends and advisers urged him to seek revenge for all these shameful atrocities. But Louis XII would not hear to any of the suggestions of these whisperers in his court. Instead they were amazed to see him preparing a list of all the names of men who had been guilty of crimes against himself. Behind each name they noticed he was placing a red cross.

His enemies, hearing of this list and the red cross placed behind each name by the king himself, were filled with dread alarm. They thought that the sign of a cross meant they were thereby sentenced to death on the gallows. One after the other they fled the court and their beloved country. But King Louis XII learning of their flight called for a special session of the court to explain his list of names and the little red crosses. "Be content, and do not fear," he said in a most cordial tone. "The cross which I drew by your names is not a sign of punishment, but a pledge of forgiveness and a seal for the sake of the crucified Savior, who upon His Cross forgave all His enemies, prayed for them, and blotted out the handwriting that was against them."

376 Power of Forgiveness

There is a story of an incorrigible soldier who had been punished so often for so many offenses, without avail, that his commanding officer despaired of the man's amendment. Again he was under arrest, and the officer spoke hopelessly of him, asking what more could be done to save him from his own undoing. A fellow-officer suggested, "Try forgiving him." The man was brought in and asked what he had to say for himself. He replied: "Nothing, except that I'm very sorry." "Well," said the officer, "we have decided to forgive you." The man stood dazed for

a moment and then burst into tears, saluted, and went out to become the best and bravest soldier in the command.

—J. R. Miller

377 Definition of Forgiveness

A little boy being asked what forgiveness is, gave the beautiful answer: "It is the odor that flowers breathe when they are trampled upon." Philip the Good, when some of his courtiers would have persuaded him to punish a prelate who had used him ill, he declined, saying, "It is a fine thing to have revenge in one's power; but it is a finer thing not to use it."

378 Beautiful Forgiveness

How beautiful and yet how rare is forgiveness! Christ taught His disciples to forgive their enemies, and in this respect as in all others, He is our great example. He said amid the agonies of the crucifixion, "Father forgive them." A deaf mute being asked, "What is forgiveness?" took a pencil and wrote, "It is the odor which a flower yields when trampled upon," and Sir William Jones has given us the following extract from the Persian poet Sadi—

The sandal-tree perfumes when riven
The axe that laid it low;
Let man, who hopes to be forgiven,
Forgive and bless his foe.

379 The Forgiven

Do you consider yourself among "the forgiven"?

British Nurse Edith Cavell was executed in 1915. German authorities claimed she had assisted Allied soldiers in escaping from Belgium to the Netherlands, a neutral country.

This First World War witnessed the deaths of 9.7 million combatants during its duration. So what makes Nurse Cavell stand out? It was the spirit in which she died. True she had allowed the hospital under her control to be used by the underground. But the execution of a civilian nurse was not within the rules of war. Nevertheless, just before her death, she breathed these words, "Patriotism is not enough. I must have no hatred or bitterness toward anyone."

Could you have been that forgiving? Perhaps you are struggling just to forgive some neighbor, coworker, or family member who has barely slighted you. Although forgiveness is tough, we must not forget the words of Christ: *"And when you stand praying, if you hold anything against anyone, forgive him, so that your Father in heaven may forgive you your sins"* (Mark 11:25 NIV). You do want God to forgive you, don't you?

Remember: God's forgiveness is for "the forgiving."

Reflections

Giving

380 What Are You Giving Now?

A church member was expecting $300,000 in a will from a family member. The member said to the pastor, "If I get the $300,000 I will give one-third to the church." The pastor said, "How will you give one-third of this amount when you can't give one-tenth of what you now earn?" It's not what we would do if we had much money—it's what we are doing with what we have now!

381 The Best Gift

An evangelist had held a service, at the close of which a little girl presented a bouquet of flowers, the first spring had brought forth. He asked, "Why do you give me these flowers?" She answered, "Because I love you." "Do you bring the Lord Jesus such gifts of your love at times?" he inquired. "Oh," said the little one, with an angelic smile, "I give myself to him!"

That surely is the highest kind of giving, and without it, all other giving is in vain. To so give takes love, and without love every sacrifice is profitless according to 1 Cor. 13:3.

382 A Mother's Best Gift

A mother who has been very successful in rearing her children recently said: "When my children were young I thought the very best thing I could do for them was to give them myself; so I spared no pains to talk with them, to read to them, to teach them, to pray with them, to be a loving companion and friend to them. I had to neglect my house often. I had no time to indulge myself in many things which I should have liked to do. I was so busy adorning their minds and cultivating their hearts' best affections that I could not adorn their bodies in fine clothes, although I kept them neat and comfortable at all times. I have my reward now. My sons are ministers of the gospel; my grown-up daughter is a Christian woman. I have plenty of time now to sit down and rest, and plenty of time to keep my house in order, plenty of time to indulge myself, besides going about my Master's business wherever he has need of me. I have a thousand beautiful memories of their childhood to comfort me. Now that they have gone out into the world I have the sweet consciousness of having done all that I could to make them ready for whatever work God calls them to do." How terribly cheated is any mother who throws away that kind of success to indulge in fashionable frivolities!

383 Giving Inadequate

A pastor once spoke of the great embarrassment of churches under debt and said: "In a debt of five thousand dollars on one Church he knew of, the people prayed that some way might be instituted by which they could raise the money, while right in their midst, and of their own number, were men who represented fifteen million dollars of property, any one of whom could have paid it without feeling its loss."

384 True Missionary Giving

"And this they did, not as we hoped, but first gave their own selves to the Lord, and unto us by the will of God"—(2 Cor. 8:5).

David Livingstone, before he had thought of being a missionary himself, devoted to foreign missions all his wages except so much as was required for his frugal needs. Many businessmen today turn over the major portions of their profits to the Lord's work. And have you ever noticed—those that *give* the most are often those that *do* the most for Christ. It is not as though they permit their money to do the work while they sit idly by. No, no. These are those who first give of themselves to the Lord, and then of their substance.

385 The Two Misers

"There is that scattereth, and yet increaseth; and there is that withholdest more than is meet, but it tendeth to poverty"—(Prov. 11:24)

A teacher was once relating the parable of the rich man and Lazarus, and he asked: "Now which would you rather be, boys, the rich man or Lazarus?"

One boy answered, "I would rather be the rich man while I live, and Lazarus when I die."

This reminds me of the story I read of a wealthy farmer in the state of New York. He was a noted miser, but he was converted. Soon after his conversion, a poor man who had been burned out by a disastrous fire came to him for help. The farmer thought he would be liberal and give the man a ham from his smokehouse. But on his way to the little building, the tempter whispered, "Give him the smallest one you have."

Then and there he had a struggle whether he would give the poor man a small one or a large one. Finally he took down the largest ham he could find.

"Fool! Fool! You are a fool!" the devil screamed.

"If you don't keep still," the converted farmer replied, "I will give him every ham I have in that smokehouse!"

Needless to say the converted miser won his first battle with our adversary. Yet how often folk without any miserly reputation may be taken unaware by Satan in just these same situations. One does not need to be rich to become miserly. The miser is simply one who "withholds more than is meet"; one who for that reason is always tending toward poverty himself.

386 Giving in Loving Service

J. R. Miller once said:

"Mary's ointment was wasted when she broke the vase and poured it upon her Lord. Yes; but suppose she had left the ointment in the unbroken vase? What remembrances would it then have had? Would there have been any mention of it on the Gospel pages? Would her deed of careful keeping have been told over the world? She broke the vase and poured it out, lost it, sacrificed it, and now the perfume fills all the earth. We may keep our life if we will, carefully preserving it from waste; but we shall have no reward, no honor from it, at the last. But if we empty it out in loving service, we shall make it a lasting blessing to the world, and we shall be remembered forever.

387 Giving Blessed

A merchant of St. Petersburg at his own cost supported several native missionaries in India, and gave liberally to the cause of Christ at home. On being asked how he could afford to do it, he replied:

"Before my conversion, when I served the world and self, I did it on a grand scale and at the most lavish expense. And when God, by His grace, called me out of darkness, I resolved that Christ and His cause should have more than I had ever spent for the world. And as to giving *so much*, it is God who enables me to do it; for at my conversion I solemnly promised that I would give to His cause a fixed proportion of all that my business brought in to me, and every year since I made that promise it has brought me in about double what it did the year before, so that I easily can, as I do, double my gifts for His service." And John Bunyan tells us,

A man there was, some called
 him mad,
The more he gave, the more he
 had.

And there are truth and instruction in the inscription on the Italian tombstone, "What I gave away I saved, what I spent I used, what I kept I lost." "Giving to the Lord," says another, "is but transporting our goods to a higher floor." And, says Dr. Barrow, "In defiance of all the torture and malice and might of the world, the *liberal* man will ever be rich, for God's providence is his estate, God's wisdom and power his defense, God's love and favor his reward, and God's word his security."

388 Dangers Unseen

A doctor was hurrying along a lonely road at a late hour one night, thinking only of reaching home as soon as possible. As he neared a small house by the roadside, he heard what seemed to be a cry of distress. Alighting from his horse, he found that a little child had been calling to him from the doorway. Inside was a man who would have died but for his timely aid. He remained all night with the man, and thought nothing of it, except that he had saved the man's life. He never knew that down the road

that night two men had lain in wait to rob and murder him.

So those of us who have given ourselves to God will never know the full story of our deliverance. Saved means saved from the evil that awaited us, had we pursued our own way.

389 A Cheerful Giver

We are assured in the New Testament that the Lord loves a cheerful giver, and nothing is more discouraging than to see people give grudgingly for noble causes. A story told by the late Eugene Field illustrates the thought. When Lawrence Barrett's daughter was married, Stuart Robson sent to the bridegroom a check for five thousand dollars. Miss Felicia Robson, who attended the wedding, conveyed the gift.

"Felicia," said her father, upon her return, "did you give him the check?"

"Yes, father," answered the dutiful daughter.

"What did he say?" asked Robson.

"He didn't say anything," replied Miss Felicia, "but he shed tears."

"How long did he cry?"

"Why, father, I didn't time him; I should say, however, that he wept fully a minute."

"Fully a minute!" roared Robson. "Why, I cried an hour after I'd signed it!"

390 The Blessing of Giving

Why is it more blessed to give than to receive?

1) Because the act itself is more salutary. The act or habit of giving forever reminds us why we were sent into the world; disperses our regard from self on others; keeps up a tender spirit, a wakeful conscience, an onward look of hope for more opportunity of good, an earnest endeavor to better society, to promote happiness, to become a blessing to the world in the largest sense.

2) To give is more blessed than to receive, because it is more Christian—more the calling of the follower and imitator of Christ.

3) To give is more blessed, as being more in accordance with the teaching of the Holy Spirit. He is the Spirit of *Love*.

4) Again, it is more blessed as being more like the Father Himself, who giveth us all things freely to enjoy; who gave us His own Son and through Him His unspeakable gift of the Holy Spirit. It is likeness to Him, partaking of the Divine nature by being lifted into the likeness of all His glorious attributes, that is the utmost perfection of created being.

391 The Tither's Surprise

The Christian who begins to tithe will have at least six surprises. He will be surprised—

1. At the amount of money he has for the Lord's work.

2. At the ease in meeting his own obligations with the nine tenths

3. At the deepening of his spiritual life in paying the tithe.

4. At the ease in going from one tenth to a larger giving.

5. At the prudent disposal afforded to a faithful and wise steward over the nine tenths that remain.

6. At himself in not adopting the plan sooner.

392 Giving the Proper Amount

A pastor was getting his hair cut. The barber and those in the barbershop didn't know he was a pastor. Those in the shop were talking about giving to the church. The barber said, "I feel one should give what they feel is proper." When it was time to pay for the haircut, the pastor handed the barber one dollar instead of the usual ten dollars. The pastor said, "You said a person should give to the church what they feel is proper, so I feel the one dollar is proper for your work." Of course, the pastor paid the full amount, but the men in the barbershop got his message.

393 Simple Gifts

What is the best gift you could give this Christmas?

Church members in Essex, Maryland were despondent. They were virtually unable to dispense any holiday cheer, on Christmas Eve last year.

Samuel Booth, the pastor of the Tabernacle Church, had just been killed by someone who was in the process of receiving food and shelter from the generous shepherd. One of his flock believed that Booth "would want us to forgive this man, he really would. And we have to. But it's very hard."

The reason Jesus was born in a manger is lost in the tinsel of this holiday's celebration. From his very lips came these words: "*For if you forgive men when they sin against you, your heavenly Father will also forgive you*" (Matt. 6:14 NIV). The converse is also true. If you don't— He won't! The Christ-child would grow up to set the example. As he was being crucified, the cruelest of deaths, he cried, "Father, forgive them, for they do not know what they are doing." Christ came into this world to give forgiveness. When you fully realize the depth of his forgiveness toward you, it will be easy to forgive others.

Your optimum Christmas gift is— for "give" ness.

Reflections

394 Boxing Benefit

Can you be kind when you put your mind to it?

December 26 is a legal holiday in both Canada and Great Britain. Come on America, join the crowd. Today is "Boxing Day" in some parts of the world. No, it's not a day to honor George Foreman and his cronies. Rather, it's a day to show kindness to those who provide valuable services to you. In the days when the holiday first began, people would share "gift boxes" with their milkman, postman, lamplighter, iceman and other service givers. Many of those occupations are extinct, but without a doubt, you can think of others whom you truly appreciate throughout the year. What about the clerks who

handle your dry cleaning or service station needs? Well, you get the idea.

Your Creator will be impressed with your kindness as He inspired: *"Be kind and compassionate to one another"* (Eph. 4:32 NIV) However, if you are one of those people who need a little more incentive, here's a proverb that God also in- spired: *"A kind man benefits him- self"* (Prov. 11:17 NIV). Showing kindness is one of those arenas in which you simply can't lose. So get your heart in shape and begin "box- ing."

Anyone can be the "heavyweight champ" of "boxing."

Reflections

God

395 The Healing Tree

It has been stated by scientists that the eucalyptus tree is destined to save the world from a famine of wood. Its growing powers are marvelous. A certain large plantation on the Pacific coastline, set out some twenty-five years ago, has been cut down three times, and is again high in the air. It is most serviceable. It produces cordwood and piling; makes excellent fuel, protects orange and lemon groves along the coast from the ocean winds. Above all, its medicinal value for its oil extract is remarkable. In California it is a home cure for almost every ailment from simple cold to consumption. A wonderful tree, full of promise for mankind. There is another tree, however, that is destined to save the world in a higher and truer sense. The tree of shame—the Cross of Calvary—whose healing power has been proved on millions of souls, and under the Shadow of which they were shielded and sheltered from the fierce, piercing blasts of awful temptation. That is like the tree in the Paradise of God, whose leaves are for the healing of the nations.

396 God Forgotten

A Glasgow minister was sitting on a coach beside the driver on a lonely Highland road, and saw in the distance an old woman, who looked wistfully toward the coach. As it came near her face showed by turns anxiety, hope, and fear, and as the coach passed, the driver, with downcast eyes and sad expression, shook his head, and she returned disappointed to her cottage. Being much affected by what he saw, the minister asked an explanation of the driver. The driver said that for several years she had watched daily for the coach, expecting either to see her son or to receive a letter from him. The son had gone to a large city, and had forgotten the mother who loved him so dearly. But the mother went every day to meet the coach, trusting that one day her son would return to her. Such a tale makes our hearts bleed for the parent who was cruelly forsaken, but many forget how badly they are treating their heavenly Father when they forsake Him and refuse to return to Him.

397 Sounding the Call

During the Spanish-American War some transports with supplies for General Shafter's army found it im-

possible to secure anchorage off the coast of Cuba, and were compelled to steam slowly back and forth. This made it difficult to land the horses and mules, and it was finally decided upon to push them overboard and allow them to swim ashore. So they were pushed into the water, and soon the sea was black with animals. Some instinctively swam toward the shore; others completed circles in the water; still others, more frightened than the rest, started out to sea. It was a distressing situation, and the ship's officers showed much concern.

Finally the men who were aboard the transports espied a soldier on shore hastily making his way toward a rocky promontory. The stripes upon his uniform denoted the bugler. The jutting rocks reached, he placed the bugle to his lips and emitted one after another of the calls which the army horses and mules had learned to know so well. The sound traveled far out to sea, and was heard by every bewildered, struggling creature. Instinctively they turned and swam toward the call. The bugler stood there and sounded those calls until his lips were blue, and, when he finally did cease, every confused and trembling animal was safe.

That is about the way it is with God's call. He needs someone to sound it, and if Christians will but faithfully and earnestly sound the good tidings of the Master they will fall upon the ears of misguided and erring ones somewhere and some-time, and will be to them the means of salvation. It matters not that we may not understand how our feeble and hampered efforts are to win others to Christ. God will take care of that. It is for us to lift His call, to sound His good tidings—and to leave the rest with Him.

398 God's Paper Mill

A frightfully wicked woman working in one of the great paper mills of Glasgow was converted through the efforts of a city missionary, and became a person of great character. She described the process of her salvation in these terms: "I was like the rags that go into the paper mill. They are torn and filthy, but they come out clear, white paper. That is like what Jesus is doing for me." That is, indeed, the work which the great Redeemer is doing for millions of our race. That is the method by which the kingdom of God is being made triumphant in the earth.

399 God's Jewels

It is said that some years ago the king of Abyssinia took a British subject, by the name of Campbell, prisoner. They carried him to the fortress of Magdala, and in the heights of the mountains put him in a dungeon, without cause assigned. It took six months for Great Britain to find it out, and then they demanded his instantaneous release. King Theodore refused, and in less than ten days ten thousand British soldiers were on shipboard and sailing down the coast. They disembarked

and marched seven hundred miles beneath the burning sun up the mountains to the very dungeon where the prisoner was held; and there they gave battle. The gates were torn down, and presently the prisoner was lifted upon their shoulders and carried down the mountains and placed upon the white-winged ship, which sped him in safety to his home. And it cost the English government twenty-five million dollars to release that man.

—J. Wilbur Chapman

400 God the Source of Gifts

In 1808 a grand performance of the "Creation" took place at Vienna. Haydn himself was there, but so old and feeble that he had to be wheeled into the theater in a chair. His presence roused intense enthusiasm among the audience, which could no longer be suppressed as the chorus and the orchestra burst in full power upon the passages, "And there was light." Amid the tumult of the enraptured audience the old composer was seen striving to raise himself. Once on his feet, he mustered up all his strength, and, in reply to the applause of the audience, he cried out as loudly as he was able, "No, no! not from me, but," pointing to heaven, "from thence—from heaven above—comes all!" saying which he fell back in his chair, faint and exhausted, and had to be carried out of the room.

401 Wholly God's

When General Booth was asked what had been the secret of his success, he replied: "I will tell you the secret—God has had all there was of me. There have been men with greater brains than I, men with greater opportunities, but from the day I got the poor of London on my heart, and a vision of what Jesus Christ would do for them, I made up my mind that God should have all of William Booth there was; and if anything has been achieved, it is because God has all the adoration of my heart, all the power of my will, and all the influence of my life."

402 Irresponsive to God

The great Scottish preacher Alexander Maclaren once said: "A man cannot get these Divine blessings if he does not want them. You take a hermetically sealed bottle and put it into the sea, it may float about in mid-ocean for a century, surrounded by a shoreless ocean, and it will be as dry and empty inside at the end as it was at the beginning. So you and I float, live, move, and have our being in that great ocean of the Divine love in Christ, but you can cork up your hearts and wax them over with an impenetrable cover, through which that grace does not come. And you do do it, some of you."

403 The Minuteness of Providence

A gentleman tells of an interesting visit to the observatory of Harvard University, just after a new astronomical instrument had been purchased. According to astronomical

calculations contained in a little book ten years old, which calculations were based upon observations thousands of years old, a star was due at 5:20 p.m. When the hour drew near, the instrument was at once directed to the star, and prone on his back under the eyepiece lay the enthusiastic professor. It was agreed that when the star which came moving along in the heavens crossed the spider-web line stretched across the lens of the instrument, the professor who was watching should pronounce the word "Here." It was also agreed that the assistant who watched the second hand of the clock should let a hammer fall on a marble table the instant the clock said it was 5:20. The professor was watching the star and could not see the clock. Just as the clock indicated 5:20, the Professor said "Here," and the assistant tapped. So exact are the movements of God's universe.

404 A Veritable Telegram from Heaven

A young man was once employed as clerk in a telegraph office in a town in England. In some way or other God led him to see that he was a sinner, and this caused him great distress of mind. The young man went to the office one morning greatly troubled, and praying, "God be merciful to me a sinner" (Luke 18:13) when the click of his machine told him a message was coming. He looked and saw that it was from Windermere up among the beautiful lakes. There was first the name and residence of the one to whom the dispatch was sent, and then followed these words from the Bible: "Behold the Lamb of God which taketh away the sin of the world" (John 1:29), and "In whom we have redemption, through his blood, the forgiveness of sins according to the riches of his grace" (Eph. 1:7). Then followed the name of the person sending it. This was a strange message to send by telegraph! The explanation of it was this: a servant girl living in the town was distressed about her sins; having a Christian brother she wrote to him of her condition, asking the question, "What must I do to be saved?" The brother, being unable to write her at once, sent her the dispatch. The poor girl found her way to Jesus through the sweet words from her brother, and so did the young telegraph operator. This was a veritable telegram from Heaven to them both. God's word did the work.

405 God's Countenance

One day in the early spring a Scotchman was walking along the side of a mountain in Skye, when he came to a hut in which lived an old man he had known a great many years. He saw the old man with his head bowed, and his bonnet in his hand. He came up and said to him, after a bit: "I did not speak to you, Sandy, because I thought you might be at your prayers."

"Well, not exactly that," said the old man, "but I will tell you what I was doing. Every morning for forty years I have taken off my bonnet here to the beauty of the world."

Beauty wherever it is seen is a reflection of God's face, the shining of heavenly light down upon the earth. Wherever we come upon it, it should touch our hearts with a spirit of reverence. God is near; we are standing in the light of his countenance.

406 Trouble, the Pressure of His Hand

"O house of Israel, cannot I do with you as this potter? said the Lord. Behold, as the clay is in the potter's hand, so are ye in mine hand" (Jer. 18:6).

Our troubles are often the pressure of the hand of God upon us as His new creation in Christ. George MacDonald stresses this when he writes: "If men would but believe that they are in a process of creation, and consent to be made— let the Maker handle them as the potter his clay, yielding themselves in respondent motion and submissive hopeful action with the turning of His wheel, they would before long find themselves able to welcome every pressure of that Hand on them, even when it is felt in pain, and sometimes not only to believe, but to recognize the Divine end in view, the bringing of a son into glory."

407 God's Deliverance

"O Daniel, servant of the living God, is thy God, whom thou servest continually, able to deliver thee from the lions?" (Dan. 6:20).

It is the testimony of Christian biographies that our God delivers out of the most trying situations over which we are prone to worry. John Wesley, as a child, was delivered from a burning parsonage. Under his portrait there is a house in flames with the inscription: "Is this not a brand plucked from the burning?" Likewise Dr. Thomas Guthrie experienced a miraculous escape on the cliffs of Arbroath, and John Knox's extraordinary deliverance in rising from his study chair a second or two before it was shattered by a bullet. Then there is John Howard's wonderful escape from the hand of the assassin, and George Washington's similar adventure at White Plains. It is said that the famous missionary, David Livingstone, sometimes met with as many as three hairbreadth escapes in a single day. There is no testing from which the Lord cannot deliver us.

408 Giving God First Place

"I have set the Lord always before me; because he is at my right hand, I shall not be moved" (Ps. 16:8).

The story is told of Evangeline Booth visiting some wealthy friends. She herself lived in the slums of London with her grandfather of Salvation Army fame. They had barely enough to cover them, and sometimes only the food they had was what was thrown at them during their street meetings. So upon her arrival home from this particular visit, Evangeline Booth asked, "Grandpa, why don't we have things like other people?"

"Things, dear, what do you mean?" asked her grandfather.

She told him how nicely her friends were living, what fine clothes they wore, and what fine food they had eaten.

Quietly grandfather Booth told her to bring to him two pieces of paper. She did so, and he said, "Child, all my life I have given 'things' a little place in my life. I'll place a tiny circle here to represent 'things.' I've given 'others' a bigger place in my life, so we'll draw a circle around 'things' and call it 'others.' But above all, I've given God the big place in my life, so let's draw a circle around 'things' and 'others' and call it 'God.'

"Now, hand me the second piece of paper," he asked with a smile. "We'll make a tiny circle and call it 'God.' Now, then, a circle around it, and call this one 'self.' Next a large circle which we'll call 'things.'

"Look at these two papers together now, Evangeline," said the old gentleman. "You decide which is the best."

Evangeline Booth took the second sheet of paper, crumbled it and flung it through the open window as she cried, "No, grandpa, let's still let God have the big circle in our lives and keep 'things' in the smallest."

God help us all to put first things first and give Him the really big place in our life.

409 Our Sharing God

The proof of God's caring is His sharing. The everlasting arms of God are put beneath the load, not that we may escape our rightful obligations, but that we may be sustained in discharging them. The divine aid does not take the form of lavished charity. It is not "alms and the man," reducing him to the dependence of the beggar. For the most part the Father only shares the burden. That is the way in which personality is developed. He seeks to make the best of us, calling forth latent energy, awakening effort, kindling enthusiasm and enterprise. Surely that is worthy of His purpose and man's eternal destiny. That contemptible self-pity, that lethargy into which we are thrust by life's reverses, become impossible when we recall the aid of the sharing God.

410 God's Presence

The Church needs at this time to prevent the godless world saying, "Where is thy God?" There is a story that seems to represent the situation in the Church truthfully, it would seem. A very busy mother went into her room one day at twilight to write a letter. She sat at her desk absorbed in filling page after page of notepaper. After some time she heard a sigh close at hand and turning her head, she saw her little son cuddled up in an armchair. "Why, sonny, how long have you been there?" she asked. "All the time, mamma," he said, "but you have been too busy to notice me." Ask God how long He has been with us, and He will say, All the time; His presence undiscovered

because even the Christian people have been too busy to notice the fact—busy with their own affairs, and losing sight of the presence of God.

411 Hiding Sin from God

I can imagine a man in business calling himself a Christian about to engage in a doubtful transaction: how is he to discern the danger? Let him ask the Lord Jesus Christ to come while he is doing it. "Oh, dear no," cries one, "I had rather He should not come until that matter had been finished and forgotten." Then you can be sure that you are moving in the wrong direction. Suppose you think of going to a certain place of amusement about which you have a question, it is easy to decide it thus—When you take your seat your first thing should be to bow your head and ask for a blessing, and then say, "Lord, here I sit waiting for Thine appearing." "Oh," say you, "I should not want the Lord to come there." Of course you would not. Then do not go where you could not wish your Lord to find you.

—C. H. Spurgeon

412 The Peace of God

There is Martin Luther standing up in the minds of the Diet of Worms; there are the kings and the princes, and there are bloodhounds of Rome with their tongues thirsting for his blood—there is Martin rising in the morning as comfortable as possible, and he goes to the Diet, and delivers himself of the truth,

solemnly declares that the things which he has spoken are the things which he believes, and God helping him, he will stand by them till the last. There is his life in his hands; they have him entirely in their power. The smell of John Huss's corpse has not yet passed away, and he recollects that the princes before this have violated their words; but there he stands, calm and quiet; he fears no man, for he has nothing to fear; "the peace of God which passeth all understanding" keeps his heart and mind through Jesus Christ (see Phil. 4:7). There is another scene; there is John Bradford in Newgate. He is to be burned the next morning in Smithfield, and he swings himself on the bedpost in very glee, and delights, for tomorrow is his wedding day; and he says to another, "Fine shining we shall make tomorrow, when the flame is kindled." And he smiles and laughs, and enjoys the very thought that he is about to wear the blood-red crown of martyrdom. Is Bradford mad? Ah, no; but he has got the peace of God that passeth all understanding.

—C. H. Spurgeon

413 Accepting God's Will

A stage coach was passing through the interior of Massachusetts, on the way to Boston. It was a warm summer day, and the coach was filled with passengers, all impatient to arrive at the city at an early hour in the evening. The excessive heat rendered it necessary for the driver to spare his horses more than usual.

Most of the passengers were fretting and complaining that he did not urge his horses along faster. But one gentleman sat in the corner of the stage calm and quiet. The irritation, which was destroying the happiness of all the others, seemed not to disturb his feelings in the least. At last the coach broke down as they were ascending a long steep hill, and the passengers were compelled to get out and travel some distance on foot under the rays of the burning sun. This new interruption caused a general burst of vexatious feelings. All the party, with the exception of the gentleman alluded to, toiled up the hill, irritated and complaining. He walked along, good-humored and happy, and endeavoring by occasional pleasantry of remark to restore good humor to the party. It was known that this gentleman, who was extensively engaged in the mercantile trade, had business which rendered it necessary that he should be in the city at an early hour. The delay was consequently to him a serious inconvenience. Yet, while the rest of the party were ill-humored and vexed, he alone was untroubled. At last one asked how it was that he retained his composure under such vexatious circumstances? The gentleman replied that he had no control over the circumstances in which he was then placed; that he had commended himself and his business to the protection of the Lord, and that if it were the Lord's will that he should not enter Boston at as early

an hour as he desired, it was his duty patiently and pleasantly to submit. With these feelings he was patient and submissive, and cheerful. The day, which to the rest of the party was rendered disagreeable by vexation and complaint, was by him passed in gratitude and enjoyment. And when, late in the evening, he arrived in the city with a serene mind, he was prepared to engage in his duties.

414 God's Image

When a Roman penny was made, the image or likeness of Caesar the emperor was stamped upon it, and those who used it were reckoned as his subjects and expected to obey his laws. Ages ago God Himself made something and stamped His likeness upon it, as a sign that it belonged to Him and must be used in His service. It was not a coin God made. It was a man. And God's image has been stamped upon each of us to show that we were made, not to follow our own pleasure, but to serve him.

415 God's Great Gift

A king who wished to express his affection for a private soldier of his army gave him a richly jeweled cup, his own cup. The soldier, stepping forth to receive the gift, exclaimed shamefacedly, "This is too great a gift for me to receive." "It is not too great for me to give," the king replied. So Christ offers us this infinite gift of the Holy Spirit to cleanse and fill our hearts and to abide with us. Think then how

much He must have cared that we receive it.

416 He's Waiting for You

A little girl had been away all day with the family of a neighbor; they were belated in their return, and, instead of reaching home before dark, as they expected, it was almost midnight when they arrived at the house.

"I will get out first and rouse your father," one of the gentlemen said to the little girl.

"Rouse him!" said the child; "my father won't have to be roused. He's waiting for me."

Men out of Christ, do you imagine that it is only through continued beseeching that you can gain the ear of God? Let me tell you, your Father doesn't have to be roused. He's waiting for you.

417 God's Gift Undervalued

Some years since the managers of a Young Men's Christian Association missed a great opportunity by not knowing the value of a certain painting. A friend of the institution had given a picture for the walls of the building, not having suitable room for it in his own home. One day he offered to sell it to them, asking fifty dollars for it. When they declined the offer he said they might have it for twenty-five dollars; but they still declined to purchase it. Not long afterwards he died. In disposing of the estate his executors took the picture from the building and sent it to a picture-mart. There it was soon recognized as the work of a master and finally identified. Thirty-five thousand dollars was offered for it, and later fifteen thousand more. Fifty thousand for a picture once offered for twenty-five dollars!

How forcibly that illustrates the way men underestimate the value of religion. They think it is good for the low, the poor, the weak, the dying, not realizing that it is needful to live by, that it is the greatest need of man and the most valuable gift of God.

418 God Hears

A friend of mine said to a lifesaver at Newport, Rhode Island: "How can you tell when anyone is in need of help when there are thousands of bathers on the beach and in the water making a perfect hubbub of noises?" To which he answered: "No matter how great the noise and confusion, there has never been a single time when I could not distinguish the cry of distress above them all. I can always tell it." And that is exactly like God. In the midst of the babble and confusion He never fails to hear the soul that cries out to Him for help amid the breakers and storms of life.

419 Chastised Children

A wise father found it necessary recently to punish his little daughter. Later in the day the little girl, who had been greatly offended at first, came to where he was and, climbing into his lap, threw her arms around his neck, and

said: "Papa, I do love you." "Why do you love me, my child?" the father asked. "Because you try to make me good, papa." We ought to keep that childlike wisdom throughout all our mature years. If God chastises us it is because He loves us as children, and in all His dealings with us is ever trying to make us good.

420 God's Love the Source of Salvation

Some talk as if we were saved just because Christ paid our debt, representing God's share in the transaction as little else than that of a severe, stern, unrelenting creditor, who takes no interest in his imprisoned debtor beyond letting him out when the surety has taken up the bond. Is this true? Is it fair to God? True? It is utterly false. Salvation flows from a higher source than Calvary. It has its fountain, not in the cross of the incarnate Son, but in the bosom of the eternal Father. The central trust of the Bible, that on which I lay the greatest stress, is this, that God does not love us because Christ died for us, but that Christ died for us because God loved us. I do not disparage the work of Christ; far be such a thought from me. Yet Christ Himself is the gift of our Father's love.

421 God's Forgiveness Absolute

Paul, in describing the forgiveness of God produced through Jesus Christ, uses this remarkable figure: "Blotting out the handwriting of ordinances that was against us," It is like taking an indictment in court, and tearing it up and throwing it away. It is like taking a title-deed of a man's possession, a paper on which is written evidence that is fatal to his claim, and blotting it, or burning it. It is like taking away proof against a man which may lead to his injury.

422 A Personal Right to God

Do you wander abroad in foreign lands? Are you solitary among crowds? Are you weary of seeing endless faces that have no history for you and touch no string in your nature, and do you at last come upon a countryman speaking your language, your sweet mother tongue, whom you distinguish by ear before you can see him, and do you cry out, "Our countryman! our countryman"? How much is there in that *our*, which appropriates! How much pride and affection is blended with the appropriation when we say, "*Our* circle, *our* family, *our* companion, *our* friends, *our* child!" How many circuits of love does this word take! And how vast is the meaning when the soul, looking upon God, clasps him with this embrace, and is able to say, "My Father"; or when men standing as a congregation of Christians are able to say "Our Father!"

423 Hunger and Thirst for God

I love knowledge; I rejoice to know how God packed the trunk of this world, and what things he put

into it for its journey through time; I love to study the heavens that declare the glory of God, and the earth that shows his handiwork, everywhere and always; but an acquaintance with these things is not enough. I admire the majesty of the cathedral and the sanctity of the church, and the holiness of the altar, and the prayers and praises of the worshiping assembly; but these are not enough. My soul hungers and thirsts for God.

424 Man Needs God

Many in this day set God aside, and hold the view that each man, in some sense, is another little god in himself. I have no sympathy with such a view. None shall go further than I in estimating the sacredness of man; but to my thought, what man is, he is by virtue of his connection with God. Broken off, he is like a branch broken off from the vine. No matter how fine those leaves are, no matter how beautiful those clusters are, they at once begin to wither and shrink, and tomorrow will be severed from the branch, fit for nothing but to be gathered up and burned. The man in whose veins flows the sap of the vine; the man who carries in him the blood of Christ; the man whose reason is daily summoned by the inspiration of God; the man whose affections are daily purified by the inflowing affections of God; the man who has the dependence of weakness and love jointly, and lies in the bosom of the great All-father, and is strong because God is strong,

though weak in and of himself— that man is sacred.

425 Peace of God

Matthew Henry, in his own quaint and striking way, says: "When Christ was about to leave the world, He made His will: His soul He committed to His Father; His body He bequeathed to Joseph, to be decently interred; His cloths fell to the soldiers; His mother He left to the care of John; but what should He leave to His poor disciples that had left all for Him? Silver and gold He had none; but He left them that which was infinitely better—His peace. 'Peace I leave with you.'"

426 God's Providence

After the Mutiny, some wounded soldiers were brought home from India in a vessel that was found to have water rising in her hold before the voyage was half finished; and night and day the pumps had to be kept working. The noise of the machinery most sadly inconvenienced the sick men on board; and many times they begged the chief officer to stop the pumps, so that they could rest their shattered nerves. This, of course, he dared not do; but being a God-fearing man, he prayed most earnestly that God would send a stiff gale to hasten them on their way. But only calm weather accompanied them: the calmest weather ever experienced on that voyage by any of the crew. When at last the sad journey was over, and the ship safe in dock, she was examined for the cause of

the leak, when it was found that a bad hole had been made in her side below the water line, which was only covered by a sheet of copper held by two rails. Only the calm weather had saved her. The "stiff gale" prayed for must certainly have sent her to the bottom of the sea!

427 Only God Could Have Planned a Man

Said a woman physician, "I came into an anatomy room to study. The dead body meant nothing at all to me. I could not visualize the man or woman it might have been. Life left few records on those immobile faces. For weeks I worked, and each day the wonder grew; and then, one day, I was working on an arm and hand, studying the perfect mechanical arrangements of the muscles and tendons—how the sheaths of certain muscles are split to let tendons of certain muscles through, that the hand may be delicate and small and yet powerful. I was all alone in the laboratory when the overwhelming belief came: a thing like this is not just chance, but a part of a plan, a plan so big that only God could have conceived it. Religion had been a matter of form, a thing without convictions and now everything was an evidence of God; the tendons of the hand, the patterns of the little blue butterfly's wings—it was all part of a purpose."

Atlantic Monthly

428 God is Omnipresent

One Sunday morning an instructor in a theological school was sharing a seat with a small boy on a shuttle train, says the *Philadelphia Bulletin*. The boy was holding a Sunday-school lesson leaflet.

"Do you go to Sunday school, my boy?" asked the man in a friendly way.

"Yes, sir."

"Tell me, my boy," continued the man, thinking to have some fun with the lad, "tell me where God is, and I'll give you an apple."

The boy looked up sharply at the man and promptly replied, "I will give you a whole barrel of apples if you will tell me where He is not."

429 The Family with Short Memories

One Sunday afternoon a clergyman was returning home from Church, which was at some little distance from his house, when a man in working clothes stopped him and said, "Beg pardon, sir, but have you seen my boy on the road?" "Was he driving a cart?" asked the clergyman. "Yes, sir." "And were there some hurdles and a pitchfork in the cart?" "Yes, that's it," said the man. "A little boy with a short memory?" continued the clergyman. The man stared, and seemed surprised. "Well, I don't know that he is specially forgetful; but what made you think he had a short memory?" "I know he had, and, more than that, I think he belongs to a family that have very short memories." The man showed his extreme surprise

at this statement, and said, "Why, what in the world makes you think so, sir?" The clergyman looked him full in the face, and replied with calm solemnity, "Because God has said, *'Remember the Sabbath day to keep it holy'* (Ex. 20:8), and I think you have forgotten all about it."

430 The Master's Eye

Years ago a gentleman in Ireland had a farm, about a mile and a half from his house. It was situated on the side of a hill, and from his attic window he could get a view of every portion of the land. He would often go to this window, with a powerful telescope, and about five minutes every day he would spend in this way, examining what his workers were doing, and whether the work of the farm was being carried on properly or not. The men happened to know this, and it often quickened them in their various duties to know that the master's eye from the little attic window might possibly at that very moment be resting upon them. Our Master's eye is *always* resting upon us. He sees and knows all we think, or do, or say, and yet how many people act as though God were both blind and deaf!

431 The Abidingness of God

People change, and so we often lose those whom we counted friends. We ourselves change; and how full of changes is the world around us! But God reveals Himself as without shadow of turning: whom He loves He loves to the end. And so it is that Christ, His Son, is set before us as "the same yesterday, and today, and forever" (Heb. 13:8). Let us rejoice in this. At the same time let us remember that He is unchangeable in His holiness. Let us avoid the sins which He hates. Oh that we may be sanctified wholly!

—John Hall

432 My Life for God

So long as a man is living for himself and honoring himself, there is an association, however remote it may be, with all the lowest forms of selfishness in which men have lived; but the moment a man begins to live in genuine adoration of the absolute good, and worship God, he parts company from all these lower orders of human life. . . . When you say to God, "O God, take me, for the highest thing that I can do with myself is to give myself to Thee," you sweep into the current of the best, the holiest, and the most richly human of our humanity, which in every age has dedicated itself to God.

—Phillips Brooks

433 A Vision of God

Before any work for God there always comes the vision of God. To behold Him, to be lifted up above our troubled hearts, above our worries and discords, and to be absolutely sure that we have spoken with God, and He has spoken with us—this is the indispensable preliminary of doing anything in God's

service. If a servant of God is uncertain of his Master, he will be uncertain of everything that follows in his service. If you and I have no doubt about having seen God, then our divine service will grow sweeter and clearer and easier every year we live. I have had men say to me, "Didn't Paul's Christian life begin with the question, 'What wilt thou have me to do?'" No, it did not; no life begins with that question. It began with the question, "Who art thou, Lord?" (Acts 9:5ff). When Paul had settled that it was the risen Christ who appeared to him, then came the much easier question, "What wilt thou have me to do?" We cannot feed the multitude out of an empty basket; we cannot present the Lord until we have seen the Lord.

434 Conquering Difficulties

Here is another poignant quotation by John Hall:

"Moses was a true servant of God, called to and fitted for His great work. But Moses had times of great anxiety. Then he made his appeal to God, recalled God's gracious words, and as we read the record we see how faithfully God fulfilled His promises to him. So God's children, passing through a fallen world, and with remaining evil within—against which there must be watchfulness and war—have times of fear, of deep anxiety; and there is one way, and but one, of getting out of them: 'Call upon me in the day of trouble: I will deliver thee, and thou shalt glorify me'" (Ps. 50:15).

—John Hall

435 Access to God

Every act is made up of a purpose, a method, and a power. And so the purpose and the method and the power are here. What is the purpose or the end? "To the Father we all have access." What is the method? "Through Christ Jesus." What is the power? "By the Spirit." In this one total act the end, the method, and the power are distinguishable; and, what is more, each is distinctly personal. This salvation, which is all the work of God, first, last, and mid-most, has its divine personalities distinct for its end and its method and its power. It is salvation to the Father, through the Son, and by the Spirit. The salvation is all one; yet in it method, end, and power are recognizable. It is a three in one.

—Phillips Brooks

436 From Nature to God

The summer is smiling around, and trees and flowers return the smile. Many have the charms of country life around them all the year. Now the dwellers in the cities begin to seek the clear air and the beautiful surroundings of the country home. Well, here is a fresh call to remember the Creator. It is not only that astronomy displays His power and wisdom. You consider the lilies how they grow. As the charms and beauties of these "products of nature," as we sometimes say, forgetting that nature is only a name for what God has made—as these attract and delight us, let us

look up and think of our Father, the maker of all.

—John Hall

437 *None Beside Thee*

Now under all outward rebellion and wickedness there is in every man who ought to be a friend of God—and that means every man whom God has made—a need of reconciliation. To get back to God, that is the struggle. The soul is God-like, and seeks its own. It wants its Father. There is an orphanage, a home-sickness of the heart which has gone up into the ear of God, and called the Savior, the Reconciler, to meet it by His wondrous life and death. I, for my part, love to see in every restlessness of man's moral life everywhere, whatever forms it takes, the struggles of this imprisoned desire. The reason may be rebellious, and vehemently cast aside the whole story of the New Testament, but the soul is never wholly at its rest away from God.

—Phillips Brooks

438 *If You Love God*

As the sun shines upon a bank of snow, no two of all the myriad particles catch His light alike or give the same interpretation of His glory. Have you ever imagined such a purpose for your commonplace existence? If you have, you must have asked yourself what the quality is in a man's life which can make it *reflective* of God—capable of bearing witness of Him. There is some quality in the polished brass or in the calm lake that makes it able to send forth again the sunlight that descends upon it. What is it in a soul that makes it able to do the same to the God who sheds Himself upon its life? The Bible is not so much an action of the soul as it is a quality in the soul permitting God to do His divine actions through it. The love of God is a new nature, a new fiber, a new fineness and responsiveness in the soul itself, by which God is able to express Himself upon and through it as He cannot when He finds only the medium of the coarse material of an unloving heart.

439 *"They Have Their Reward."*

Matthew 6

We have each "the heart of the sons of men" (Eccl 8:11; 9:3), and even though, by grace, it has been made a new heart, there is, as Paul tells us, a force still within moving toward evil. So we have to guard against subtle temptations. God does not explain, day after day, His providence's. Delayed punishment is no evidence that there will be no punishment. "It is the glory of God to conceal a thing" until the time comes for the display of His judgment and justice. He protects, however, them that wait on Him, and makes all things, even the mysteries of life, to work together for their good. Reader, you may safely say, "Though he slay me, yet will I trust in him."

440 Glorifying God

The Holy Ghost is a divine Person. He can, therefore, be present everywhere. He can take our human nature, consecrate it to God, body and spirit. So even the body is honored as a temple of the Holy Ghost. Is such a temple to be desecrated by impurity, by drunkenness, and the like? Even the decorations given to the body, and the uses made of it—as in the games of heathen Greece and Rome—should be looked at and judged of in this light by all who count themselves Christians. Pray for grace to glorify God in your body and spirit.

441 "A Building of God"

*For we know that if our earthly house of this tabernacle were dissolved, we have **a building of God, an house not made with hands, eternal in the heavens** (2 Cor. 5:1).*

Death is mysterious and awful to man naturally. Hence it is feared, under the influence of natural religion, all the world, over, except where even natural religion is put aside by some attractive error. The religion of our Bibles recognizes its solemnity, but removes the terror, and shows how mortality is swallowed up of life. The disciple of Christ passes from death unto life. It is not merely that there is a Father's house above, but the spirit enters into it in a state of perfection never reached on earth. The soul, absent from the body, is at home with the Lord.

442 The Watchful Eye

Go where we may, we cannot get away from the calm, clear gaze of the divine Eye. Neither in the blue depths of the heavens nor in the dark abysses of the grave can one hide away from God. If we could take the morning sunbeams for wings and fly away on them with all the swiftness of light to the remotest bounds of space, we could not get beyond the reach of the divine Eye. If we creep into the darkness—darkness so deep and dense that no human eye can behold us—still God sees us as clearly as if we stood in the bright noonday sunshine. Darkness hides not from Him; night shines to His eye as brightly as day.

When we know that God loves us, there is infinite comfort in this thought of His unsleeping watchfulness. It is our Father who watches. There ought also to be wondrous incitement and inspiration in the consciousness: while the Eye of divine love is looking upon as we should always do our best.

—J. R. Miller

443 Your Only Hope

God is the only final dream of man. Door after door opens; there is no final chamber till we come where He sits. All that ought to be done in the world has a right to know itself as finally done for Him.

It is God, and the discovery of Him in life, and the certainty that He has plans for our lives, and is doing something with them, that

gives us a true, deep sense of movement, and lets us always feel the power and delight of unknown coming things.

—Phillips Brooks

444 Why a Christian Can Move against the Wind

Travelers in the North Atlantic Ocean traffic have frequently observed icebergs traveling in one direction in spite of the fact that strong winds are blowing the opposite way. The icebergs were moving against the wind. The explanation is that the great bergs, with eight-ninths of their bulk under the water, were caught in the grip of mighty currents that carried them forward, no matter which way the winds raged.

So the ideal Christian leader has the greater part of his being thrust down into the deep places of God. The currents move him toward righteousness no matter how the winds of passing opinion blow.

445 He Holds My Hand

As a boy in Oklahoma my family would spend a lot of time on the creeks and rivers. As a small boy my Dad would take me by the hand and would wade out to the sandbar in the streams. The swift water was dark and often over my head, but how I loved and enjoyed the water, because of my father's hand. My father is dead, and if asked, "What do you miss about your Dad?" it would be his hand.

All of us today do have a hand we can hold on to. It is the hand of God. We can remember the words of the Psalms: *"If I take the wings of the morning, and dwell in the uttermost parts of the sea; even there shall thy hand lead me, and thy right hand shall hold me"* (139:9, 10).

Today we must take hold of the right thing in our life, for holding on to the wrong thing will end in death. The story is told of a sailor on one of the sailing ships of the last century. He tumbled out of the rigging. In his fall he caught with both hands a rope; and observers said, he is saved! But the rope itself had no fastening, and he fell further and faster as the rope played out, till he struck the deck a mangled mass. A man may attempt to save himself by will-power; but what if the will itself has no hold on God!

Proverbs 16:25 says, *"There is a way that seemeth right unto a man; but the end thereof are the ways of death."*

—J. F. Carter

446 Unshakable

Has loneliness ever hung around you, virtually unshakable?

English poet John Milton died in 1674. Although the number of his works is large, his greatest writing is *Paradise Lost*, completed nine years before his death.

For all his postmortem fame, Milton endured many difficulties in his life. Perhaps those trials refined his material. There was a painful period of separation from his wife. And at the end of his life, he was almost blind and was only able to

navigate through each day's tasks with assistance. His oppressive loneliness once prompted him to pen this truth: "Loneliness is the first thing that God's eye named not good."

It was loneliness that prompted God to look at His Creation and make an adjustment by providing Adam and Eve. It was this same Creator that would later say, *"Though the mountains be shaken and the hills be removed, yet my unfailing love for you will not be shaken"* (Is. 54:10 NIV). No matter how distant you are from God now, know that by beginning a relationship with his Son, Jesus Christ, you will never be all alone again—never again.

Remember: loneliness can't exist in the unshakable presence of God's love.

Reflections

447 Overemphasis of "Self-Esteem"

"…Master, which is the great commandment in the law? Jesus said unto him, Thou shalt love the Lord, thy God, with all thy heart, and with all thy soul, and with all thy mind. This is the first and great commandment. And the second is like it, Thou shalt love thy neighbor as thyself. On these two commandments hang all the law and the prophets" (Matt. 22:36-40).

We are hearing it backwards these days. This self-esteem stuff is getting way too much of the spotlight. God-esteem isn't even a recognizable catch phrase: and what God thinks of me is infinitely more important than anything I could ever think about myself.

Ponder this: Healthy self-esteem either comes as a by-product of doing right or else it is not healthy at all. So it would seem that we ought to quit focusing on how we feel about ourselves and simply set about the life of serving our Lord.

Add this to the mix: Jesus said that even when we have done all the commandments, we are still unprofitable servants who have only done what was their duty to do (see Luke 17:7-10). So, what could I ever do that I could hold up as reason for thinking highly about myself?

When has God ever taught His people to focus on their self-esteem? What He has always taught us is that we must trust in Him and keep His commandments. What we will find is that in living a life of trusting Him and keeping His commandments, cheerfully serving God and our fellow man, self-esteem will take care of itself. It becomes a by-product that no one really pays much attention to or worries about. It just comes. And even as it comes, no one really gives it much thought. As a matter of fact it will probably never be an issue with us at all while we do our best to keep those two commandments.

So we can put an end to the pity parties. We can quit moping and whining, and just do what's right. And if we don't want to do

that . . . then we don't have any right or reason to feel good about ourselves. After all, shame has its place, too. But that's another lesson.

—Marty Kessler

God's Guidance

448 Shipping Forecasts

A few years ago we were fishing north of the oil rigs about ninety miles east-northeast from Peterhead for prawns and fish. It was October and fishing was good, with a large fleet of boats at work.

Up to Wednesday night it had been a lovely week of weather, but that night the forecast was for storm-force winds on Thursday night. With the sea so calm and the fishing good, we, along with a lot of other boats decided to carry on fishing. Some of the fishing boats that never normally came out that distance went away in. We fished until six o'clock on Thursday evening when we heard the shipping forecast—severe gale 9 to violent storm 11: a very, very bad forecast.

We arrived into Fraserburgh on Friday morning after a good pounding. The wind was so strong that the boxes on the pier were going everywhere. There were some record wind speeds recorded in different parts. We heard in the harbor that one of the boats we were fishing along with, and were only a couple of miles from us, when we began steaming in, was missing with all aboard feared drowned. After an air and sea search failed to find anything, it was called off. Another tragedy with parents losing sons, wives losing husbands and children losing fathers—**yet warned.**

God is giving many warnings to sinners. "*Blow the trumpet and warn the people*" (Ezek. 33:3). How can we escape from the judgment to come? "*Jesus, our deliverer from the coming wrath*" (1 Thess. 1:10).

The captain of the *Lussitania* (a passenger liner sunk by a German submarine, just prior to America's declaration of war against Germany and its allies in World War I) is a fitting story of one who rejected a warning. He received a message while in New York that his great ship would be torpedoed before he reached Britain. He laughed at the idea, but it was true. Do not reject the warnings from God!

—G.M.
The Fisherman's Gospel Manual
Chapter Two, London

God's Protection

449 The Eternal Principle: Loss=Gain

A rabbi was forced by persecution to leave his homeland, according to an ancient Hebrew story, and to wander about in distant countries. His only earthly possessions, other than the clothing he wore and a copy of the Scriptures, were a lamp by which he studied and a donkey upon which he rode.

Late one evening, after a long day's journey, he came upon a small village where he sought shelter for the night. The villagers, however, turned him away. The only shelter this weary rabbi was able to find was next to a wall which surrounded a well on the outskirts of the village.

Trying to make the best of the situation, he lit his lamp and began to read from the Scriptures. Soon a violent wind arose and repeatedly blew out the lamp. Unable to read in the darkness, he reclined against the wall and tried to go to sleep. His rest was soon disturbed, however, by the nearby roar of a lion. He looked over the wall just in time to see the lion dragging his slaughtered donkey into the underbrush.

The rabbi was overwhelmed with distress, grief, and a sense of self-pity. He tried praying to God, but his prayers were hindered by the many complaints and embittered sentiments which kept going through his mind. Finally, in exhaustion, he fell into a deep sleep.

The next morning, upon awaking and coming from behind the shelter of the wall, he beheld a shocking sight. On the streets of the village lay the mutilated bodies of the villagers; slain by a vicious band of marauders who had descended from the hills during the night.

It was only then that the rabbi began to understand, and to put his losses in perspective. If the villagers had received him, he also would have been killed. If the lion had not killed and dragged away his donkey, its presence may have given him away. He had learned a valuable lesson: Sometimes great gain comes from great loss!

—Al Maxey
(Abridged)

God's Providence

450 God's Choice

"God hath chosen the foolish things . . . the weak things . . . the base things of the world"—(1 Cor. 1:27, 28).

The Bible saints, who now shine as stars in the firmament of heaven, were men of like passions with ourselves. They were not always saints; they sinned, and murmured, and rebelled, as we do. Heaven's rarest blades were not produced of finer metal than that which is in our own constitution. God's choicest vessels were not turned from superior earth to that of which we are made. The jewels which now lie at the foundation of the new Jerusalem were once obscure, unnamed men of no finer texture than ourselves.

Look to the quarry from whence they were hewn, and the hole of the pit whence they were digged, and say if there was much to choose between their origin and your own. Then take heart, for if God were able to take up such men and make them princes and kings surely He can do as much with you. The discipline may be keen as fire; but the result shall be glorious, and all eternity shall ring with the

praises of Him who raises up the poor out of the dust, and lifts up the beggar from the dunghill, and makes them kings and priests unto God.

This assurance gives peace and satisfaction and repose to the believer, for it places all responsibility upon a faithful Lord. Ask the man carving the stone where it will fit in the building, and how he will get it there; and he simply points you to the builder's plan. So when wondering where and how you will fit into God's plan just remember that is God's responsibility. Yours is the task to submit to His carving of your life for the place He has designated for you in His Holy Temple.

451 Providence of God

Mr. Spurgeon once had a singular experience. He had been out in the country to preach, and, when traveling back to London, suddenly found that he had lost his railway ticket. A gentleman, the only other occupant of the compartment, noticing that he was fumbling about in his pocket, said, "I hope you have not lost anything, sir?" Mr. Spurgeon thanked him, and told him that he had lost his ticket, and that by a remarkable coincidence he had neither watch nor money with him. "But," added Mr. Spurgeon, "I am not at all troubled, for I have been on my Master's business, and I am quite sure all will be well. I have had so many interpositions of Divine Providence, in small matters as well as great ones, that I feel as if,

whatever happens to me, I am bound to fall on my feet. . . ." The gentleman seemed interested, and said that no doubt all would be right. When the ticket collector came to the compartment, the collector touched his hat to Mr. Spurgeon's companion, who simply said, "All right, William," whereupon the man again saluted and retired. After he had gone Mr. Spurgeon said to the gentleman, "It is very strange that the collector did not ask for my ticket." "No, Mr. Spurgeon," he replied, using his name for the first time, "it is only another illustration of what you told me about the Providence of God watching over you, even in small matters; I am the general manager of the line, and it was no doubt divinely arranged that I should be your companion just when I could be of service to you."

452 He Calms the Storm

There are times at sea when I've seen a beautiful morning after a stormy night. It is great to see the daybreak of a beautiful morning; it is just like the experience of the sinner after he accepts Jesus into his life. No longer tossed about under the storm of sin but all is calm in their lives now, the dawning of a new life in Jesus; like the dawning of a beautiful morning after a storm at sea.

—G.M.
The Fisherman's Gospel Manual
Chapter Two, London

God's Sovereignty

453 God Rules among the Nations

One hundred Puritans sail across the ocean on the "Mayflower" and in New England find a home where they can serve God according to the dictates of their conscience. Persecution in England being continued, men cross the Atlantic to join the Pilgrim Fathers, in a land where religion and liberty have found a sure home. In ten years twenty thousand persecuted Englishmen find a refuge in that Western land. A Protestant colony is founded by sturdy, resolute men; not only were they religious men, but they were the noblest class of emigrants who ever left the shore of any land, and in that new land God's Church prospered, and today Protestant America is the result of men flying from one land to another for liberty to serve God. He guided the Mayflower across the sea and watched over the infant colony and founded His church on free American soil.

454 I Saw It First

Who was the first one to see the continental United States?

It is at this time of the year that we teach children about the *Mayflower*, Pilgrims and the Thanksgiving holiday.

For two centuries, Americans have been coming away from that account with the idea that the Pilgrims were the first to land on our shores. But we all know that Indians migrated from the Asian continent across Alaska and into America, possibly as early as the biblical account of Babel. Although Vikings from Greenland and Iceland visited the Atlantic coast around the year 1000, they did not settle. Other Europeans would come and go in the 1500's. When the Pilgrims arrived in 1607, they found a group of Polish artisans already hard at work.

So who was the first to say, "Land ho!"? There are these inspired words: *"Before the mountains were born or you brought forth the earth and the world, from everlasting to everlasting you are God"* (Ps. 90:2 NIV). Before the earth was even formed, God could see the history and topography of the United States in his mind's eye. Aren't you thankful we have such a great and eternal God?

Remember: before every discovery, God was there.

Reflections

455 Bragging Rights

Are you extremely proud of your lifetime accomplishments?

It was on November 21 of 1877 that Thomas Edison announced to the world that he had invented the phonograph.

Edison's accomplishments are often forgotten. In his Menlo Park, New Jersey fix-it shop he designed the following items: the household light bulb, a motion picture device, the telephone transmitter, stock ticker improvements, the mimeograph machine, the dictating ma-

chine and much more. If anyone had a right to brag, Edison did. However, he humbly acknowledged he couldn't create the simplest form of life.

The Creator of everything and everyone has this perspective on bragging rights. He inspired: *"Let not the wise man boast of his wisdom or the strong man boast of his strength or the rich man boast of his riches, but let him who boasts boast about this: that he understands and knows me, that I am the LORD"* (Jer. 9:23, 24 NIV). When you understand how incomparable your Creator is and then realize how your knowledge, talents and wealth are but gifts from his limitless storehouse, then and only then will you discover how few bragging rights you really have.

Reflections

God's Will

456 God's Unchangeable Will

Do you feel that you have lost your way in life? Then God Himself will show you your way. Are you utterly helpless, worn out, body and soul? Then God's eternal love is ready and willing to help you up, and revive you. Are you wearied with doubts and terrors? Then God's eternal light is ready to show you your way; God's eternal peace ready to give you peace. Do you feel yourself full of sins and faults? Then take heart; for God's unchangeable will is to take away those sins and purge you from those faults.

—Charles Kingsley

457 God's Promises

God's promises are ever on the ascending scale. One leads up to another, fuller and more blessed than itself. In Mesopotamia, God said, "I will show thee the land." At Bethel, "This is the land." In Canaan, "I will give thee all the land, and children innumerable as the grains of sand." It is thus that God allures us to saintliness. Not giving us anything till we have dared to act—that He may test us. Not giving everything at first—that He may not overwhelm us. And always keeping in hand an infinite reserve of blessing. Oh, the unexplored remainders of God! Who ever saw His last star?

—F. B. Meyer

458 When the Waves Rise

A little boy made himself a boat and went off in high glee to sail it on the water. But presently it got beyond his reach, and in his distress he appealed to a big boy for help, and asked if he could get it back for him. Saying nothing, the big boy picked up stones and seemed to be throwing them at the boat. The little chap thought that he would never get his boat again, and that instead of helping the big boy was annoying him. But presently he noticed that instead of hitting the boat, each stone went beyond it and made a little wave, which moved the boat nearer to the shore. Every throw of the stones was planned, and at last the toy was brought within reach, and the little boy was happy again in the pos-

session of his treasure.

Sometimes things in our lives seem disagreeable and without sense or plan. But if we wait a while, we shall see that each trial, each striking of a stone upon the quiet waters of our lives, has brought us nearer to God.

Grace

459 Receiving Grace

Do you reign in life? If not, the reason may be that you do not distinguish between *praying* and *taking*. There is a profound difference between entreating for a thing and appropriating it. You may admit that God's abundant grace is near you through Jesus Christ, and yet you may not quite see the necessity of learning how to take it. Some people are always telegraphing to heaven for God to send a cargo of blessing to them; but they are not at the wharfside to unload the vessel when it comes. How many of God's richest blessings for which you have been praying for years have come right close to you, but you do not know how to lay hold of and use them! Note—"They which *receive* the abundance of grace shall reign" (see Rom. 5:17) The emphasis is not on grace, not on abundance, but on *receiving* it; and the whole grace of God may be around your life today, but if you have not learned to take it in, it will do you no good.

—F. B. Meyer

460 God's Grace

One cannot think that any holy earthly love will cease, when we shall be like the angels of God in heaven. Love here must shadow our love there, deeper because spiritual, without any alloy from our sinful nature and in fullness of the love of God. But as we grow here by God's grace will be our capacity for endless love. So, then, if by our very suffering we are purified, and our hearts enlarged, we shall, in that endless bliss, love more those whom we loved here, than if we had never had that sorrow, never been parted.

461 Nature Furnishes
Illustrations of Grace

Take, for instance, the eucalyptus tree. It seems especially adapted to antidote the gaseous effects of a polluted atmosphere. It is the loftiest timber tree of Australia; it grows especially in malarious districts, sometimes to a height of five hundred feet. It absorbs moisture to a very remarkable extent, and grows with extraordinary rapidity, covering vast barren districts with a huge forest in a few years. And you may enclose seed enough in an envelope to plant an acre. How like the blessed Gospel, making the tree of life to grow in the worst moral marshes, rapidly, beautifully, gloriously covering the deserts with the foliage and fragrance of heaven! And you may distribute the seed so easily and cheaply.

462 Door of God's Grace

One warm summer afternoon, a bird flew through the open door into a chapel, where service was being conducted. Full of fear it flew backward and forward near the ceiling and against the windows, vainly seeking a way out into the sunshine. In one of the pews sat a lady, who observed the bird, while thinking how foolish it was, not to fly out through the open door into liberty. At last the bird's strength being gone, it rested a moment on one of the rafters. Then seeing the open door, it flew out into the sunshine, venting its joy in a song.

Then the lady who had been watching the little bird thought to herself: "Am I not acting as foolish as I thought the bird was? How long have I been struggling under the burden of my sin in the vain endeavor to get free and all the while the door of God's grace has been wide open?" Then and there the decision was formed to enter in.

"I am the Way," says Jesus, "no man cometh unto the Father, but by me" (John 14:6).

463 A Wonder of Grace

It is wonderful that an infinite creator and Ruler of the world and a fallen, sinful human being can be in fellowship—the Creator showing Himself to the creature, and the creature leaning, as it were, upon the arm of the Creator. It is a wonder of grace. It comes about through One who is fittingly called Wonderful. Why should we not say hourly, "Lord, what will you have me to do?" yes, or to bear, for it is possible for us to "endure as seeing him who is invisible" (see Heb. 11:27).

—John Hall

464 "My Grace is Sufficient"

2 Corinthians 12:9

Remember it is not just compensation, but transformation, that you are to seek. Not heaven yet that looms before us always, tempting us on; but now the earth, with all its duties, sorrows, difficulties, doubts, and dangers. We want a faith, a truth, a grace to help us *now*, right here, where we are stumbling about, dizzied and fainting with our thirst. And we can have it. One who was man, yet mightier than man, has walked the vale before us. When He walked it He turned it all into a well of living water. To them who are willing to walk in His footsteps, to keep in His light, the well He opened shall be forever flowing. Nay, it shall pass into them and fulfill there Christ's own words: "Whosoever drinketh of the water that I shall give him shall be in him a well of water springing up into everlasting life" (John 4:14).

—Phillips Brooks

Growth

465 Not Accepting the Medication

The medical staff at the hospital were puzzled why a patient was not improving. The nurses were giving the proper medication. Yet, there was no improvement. The following day the nurse gave the medication and hid. Thinking the nurse had left, the patient spit it out. Too many Christians act similar when hearing the word of God. They retain it for a short time, then spit it out. As the result, there is no improvement in their Christian life.

466 Work of Grace

A friend once showed an artist a costly handkerchief on which a blot of ink had been made. "Nothing can be done with it now, it is absolutely worthless." The artist made no reply, but carried it away with him. After a time he sent it back, to the great surprise of his friend, who could scarcely recognize it. In a most skillful and artistic way he had made a fine design in India ink, using the blot as a basis, making the handkerchief more valuable than ever. A blotted life is not necessarily a useless life. Jesus can make a life beautiful though it has been marred by sin.

467 Imperceptible Operations of Grace

The grandest operations both in nature and in grace are the most silent and imperceptible. The shallow brook babbles in its passage and is heard by everyone, but the coming on of the seasons is silent and unseen. The storm rages and alarms, but its fury is soon exhausted and its effects are partial and soon remedied; but the dew, though gentle and unheard, is immense in quantity and the very life of large portions of the earth. And these are pictures of the operations of grace in the Church and in the soul.

468 Growth in Spiritual Knowledge

Alexander I of Russia told Mr. Venning that when he began to read the Bible, he understood but little; what little he understood he marked; next time he had to mark more—beauties having escaped his observation at first reading; and by laying aside his own prejudices and reasonings, he had come to love the Bible.

469 Fruit an Index to Character

Travelers, who have ascended very high mountains, tell us that they were able to determine their altitude by the productions of na-

ture around them. Fruits and flowers at the base; higher up, those of the temperate variety; and still higher, those of the frigid zones. The fruit you bear will reveal your relation to Christ.

470 "Sin Revived, and I Died"

For I was alive without the law once: but when the commandment came, sin revived, and I died (Rom. 7:9).

Let us illustrate how it is that sin revises. You have seen a carpenter take a straight-edge, as it is called, to see whether boards are straight. He takes a board, and looks at it, and says, "I guess that is straight"; but when he applies the straight-edge to it, he finds that it is full of bends. He could not see the inequalities till he laid the straight-edge along the board; but then he saw them plainly.

Now, God's word is a straight-edge; and if a man lays it on his course of conduct, it shows him that what he thought was right is wrong.

471 Defrauding God

There was once a horse that ran away in the morning and did not return till the evening. When the master upbraided him the horse replied, "But here am I returned safe and sound. You have your horse." "True," answered the master, "but my field is unplowed." If a man turns to God in old age, God has the man, but He has been defrauded of the man's work. And the man himself has been defrauded worst of all.

472 Sowing and Reaping

Error is not as good as truth, I do not care how sincerely you hold it. Sincerity does not change the great lien of cause and effect.

We know this to be true always in regard to the lower elements. Fire is fire, whether a man thinks it is or not. It is true in regard to all the parts of the human body—the bone, the nerve, the tissue, the circulation, etc. The Bible says that it is just the same higher up—that in all spiritual elements cause and effect govern. Whatsoever a man does, he shall receive according to the nature of it. They that sow to the flesh, the apostle says, shall of the flesh reap corruption; and he that sows to the spirit shall, by that same universal and inevitable law of cause and effect, reap life eternal (Gal. 6:7, 8).

473 Thirty Seven Stood by the Boy

After a pastor had counseled with an eleven-year-old boy one Sunday during the invitation, he happily told the congregation that the lad had accepted Christ and wanted to follow Him.

The Pastor then made and unusual request. In addition to the parents and teachers of this boy, every person who had been his superintendent, leader or teacher was asked to come to the front of the auditorium.

Among those who responded to this call were the following: A nursery worker who recalled singing, "I like to go to church" when the boy

was just a toddler. A Beginners superintendent remembered the smiling face of a five-year-old as the child saw seeds sprouting in their Nature Center. A Primary superintendent of the Junior Department rejoiced that he had made those extra visits last year to the home of the lad confined with the measles. For several minutes people moved to the front of the building: thirty-seven adults gathered around the young lad! Each obviously had had a share in the child's decision for Christ that day.

Every time a child, or anyone for that matter, comes down our aisle to receive Christ, think back and see if you have had anything to do in his/her conversion. Contrariwise, if someone whose life you, as a Christian have touched does not respond to an invitation to accept Christ, perhaps you should examine your life to see why not.

The Sword of the Lord

Heaven

474 "Too Late"

There are no more melancholy words in the language than these. Too late! I have heard them uttered by a brother, as he hurried home to see a dying father, he arrived only to be told that he had breathed his last; and not soon shall I forget the agony they then expressed. Too late! I have known them uttered by a skillful surgeon, when he was summoned to the bedside of a dying man, and I have marked the sadness to which they have given birth. Too late! I have heard them uttered by an anxious crowd, as they stood gazing on a burning building and sadly saw the failure of those who sought to save the inmates from destruction. Too late! I have known them uttered by the noble crew of the lifeboat, when, as they put out to the sinking ship, they beheld her go down before their eyes, and "the frightened souls within her." But, oh! none of these circumstances are half so heart-rending as those in which the sinner who has despised his day must find himself when the terrible discovery is made that he is too late to enter heaven.

475 No Strife in Heaven

An old Scottish elder had been disputing with his minister at an elders' meeting. He said some hard things, and almost broke the minister's heart. Afterwards he went home, and the minister went home too. Next morning the elder came down, and his wife said to him, "Eh, Jan! ye look very sad this morning. What's the matter wi' ye?" "Ah!" said he, "you would be sad, too, if you had had such a dream as I've had." "Weel, and what did ye dream about?" "Ooh! I dreamed I had been at an elders' meeting, and I said some hard things and grieved the minister; and as he went home I thought he died and went to heaven. A fortnight after, I thought I died, and that I went to heaven, too. And when I got to the gates of heaven, out came the minister and put out his hand to take me, saying, 'Come along, Jan, there's no strife up here, and I'm happy to see ye.'" The elder went to the minister to beg his pardon directly, but he found he was dead; and he laid it so to heart that within a fortnight the elder himself departed. And I should not wonder if he did meet the minister at heaven's gates, and hear him say, "Come along, Jan! there's no strife up here." It would be good for us to recollect that there is no strife up there. Glorified saints have not strife among themselves; and we should love one another more in

brotherly kindness if we thought
more of heaven and more of our
blessed Jesus.

—C. H. Spurgeon

476 Heaven a Prepared Place

A scoffing infidel, of considerable
talents, being once in the company
of a person of slender intellect, but
a real Christian, and supposing, no
doubt, that he should obtain an
easy triumph in the display of this
ungodly wit, put the following
question to him: "I understand, sir,
that you expect to go to heaven
when you die; can you tell me what
sort of place heaven is?" "Yes, sir,"
replied the Christian, "heaven is a
prepared place for a prepared peo-
ple; and if your soul is not prepared
for it, with all your boasted wis-
dom you will never enter there."

477 Round-Trip Ticket

A Christian woman was once talk-
ing to a servant of Christ about the
assurance of her safety in the Savior
and said, "I have taken a single ticket
to glory, and do not intend to come
back." Whereupon the man of God
replied, "You are going to miss a
lot. I have taken a return ticket, for
I am not only going to meet Christ
in glory, but I am coming back with
him in power and great glory to the
earth.

478 Watching for the Lord

When Shackleton was driven back
from his quest of the South pole,
he left his men on Elephant Island,
and promised to come back to
them. Working his way as best he

might to South Georgia, he tried to
get back to fulfill his promise, and
failed; tried again and failed. The
ice was between him and the is-
land; he was not able to come, but
he could not rest; though the season
was adverse, and they told him it
was impossible, yet in his little boat
"Yalcho" he tried it again. It was
the wrong time of year, but strange
to say he got nearer the island; there
was an open avenue between the
sea and the place where he had left
his men; he ran his boat in at the
risk of being nipped, got his men, all
of them, on board, and came out
again before the ice crashed to. It
was all done in half an hour. When
the excitement was partly over he
turned to one of the men and said,
"Well, you were all packed and
ready!" and the man said, "You see,
boss, Wild (the second in com-
mand) never gave up hope, and
whenever the sea was at all clear
of ice he rolled up his sleeping bag
and said to all hands, 'Roll up your
sleeping bags, boys; the boss may
come today.' " "And so it came to
pass," said Shackleton, "that we sud-
denly came out of the fog, and from
a black outlook; in an hour all were
in safety, homeward bound."

479 What Heaven Will Be

A banquet was to be given to a
number of notable people. One of
the projectors of it went to a friend,
who was in greater authority than
himself, and asked with some anxi-
ety what the menu was to be. "I re-
ally don't know," was the reply. "And
you are not concerned about it?"

"No; B—," mentioning the name of a famous caterer, "is to prepare the feast, and that is assurance enough that it will be all right." He did not have to explain the details. He would not have fully understood them if he had. It was enough to know that the matter was in the hands of one who never made a mistake. When Jesus said, "I go to prepare a place for you," He told all that we need to know. He knows our needs and our longings as we do not know them ourselves. It is enough. If His hand is to make ready the feast, we have no need to question as to whether or not it will fully satisfy.

480 Awaking in Heaven

A story is told of a little girl, who one evening wanted to sit up with the family while they were visiting with their pastor. As the little one became very sleepy, her mother begged her to retire to her room. But she pleaded to remain, because she was so delighted to be with the preacher. Finally, she fell asleep in her mother's arms and was gently carried upstairs to her bed without awaking. She did not know she was in the upper room till she opened her eyes in the morning. So Enoch visited with God one day and was not, for God took him, carried him away in everlasting arms. What a delightful way to refer to death!

So we might say of our loved ones, carried by angels, or in the arms of Jesus, into the heavenly mansion. They fell asleep in Jesus and did not know they were in the upper room till they awoke in the morning.

This is our resurrection hope. This is what Easter morning means.

481 Heavenly View of Earthly Dangers

I remember, once, when I was treading a Western forest at twilight, I came towards a little opening, I saw a man lurking on the edge of the forest, with a rifle drawn at me. Although I was a really brave man, my blood ran cold. There I was, sitting up on the horse, a fair mark for a man that was standing and taking deadly aim at me; and I was at a great disadvantage. I did not laugh, for I had not gotten over my shock, when I came up to the spot and found, instead of a man with a rifle, only a tree with a branch pointing towards me; but afterwards I laughed, to think what I had been so frightened at, and what a shock it sent through me.

When men get to heaven, and find what many of those things were which stood aiming at them in this life; when they find what sort of make-believe dangers those were which threatened them, I think they will laugh. And we shall look back on the vision of life, and all its fantastic imaginings, with wonder and gladness—with sorrow for ourselves, but with joy and gratitude to God, who brought us through the dangers of the way, and finally saved us.

482 A Mother's Arms

A sorrowing mother, bending over her dying child, was trying to soothe it by talking about heaven.

She spoke of the glory there, of the brightness shed around, of the shining countenances of the Holy Angels; but presently a little voice stopped her, saying, "I should not like to be there, mother, for the light hurts my eyes." Then she changed her word picture, and spoke of the songs above, of the harpers harping with their harps, of the voice as the voices of many waters, of the new song which they sang before the Throne; but the child said, "Mother, I cannot bear any noise." Grieved and disappointed at her failure to speak words of comfort, she took the little one from its bed of pain, and enfolded it in her arms with all the tenderness of a mother's love. Then, as the little sufferer lay there, near to all it loved best in the world, conscious only as its life ebbed away of the nearness of love and care, the whisper came, "Mother, if Heaven is like this, may Jesus take me there!"

483 To Know the Love of Christ

Heaven is not only real because His humanity is there, not merely glorious because His greatness is there. It is dear because His love is there—the love which filled His earthly life, the love of the miracle and of the wayside teaching and of the cross. The nearness and the glory might be there, and yet heaven does not lay hold of our hearts. We might be well content to stand far off and gaze. We might not want to go there. We might not listen for messages, nor send our feeble voices forth in prayer. But now our Christ is there, our Savior, no wonder if the earth a thousand times seems dull and wearisome, and always gets its best brightness from that other world in which He is, of which this is the vestibule!

—Phillips Brooks

484 Our Citizenship in Heaven

"My kingdom is not of this world," said Christ (John 18:36). And why is it not? The apostle tells us it is righteousness, and peace, and joy in the Holy Ghost. These three principles are not of this world; they came down from the Father of lights and of mercies. But are the kingdoms of this world under no obligation to receive them? Is it come to this, that because a principle is not of this world, the world has no concern with it? Truth, love, holiness are all from above, and on that very account their claim on men is stronger, and they are to be accepted gladly by the children of men.

485 Heavenly Gain

Are you in the "Golden October" of your life?

If so, you may be susceptible to the frightful disease of "age-phobia." The symptoms are easy to spot. You reach the age of fifty-nine, a year passes and you can't say "sixty." When folks ask your age, your hand mysteriously reflexes to cover your mouth as you answer. Not a day goes by that you aren't gripped with fear that someone will discover your birth date and begin

the subtraction process. Speed limit signs are cruel reminders of your age. Full price is preferable to admitting that you're eligible for a senior citizen discount. And when birthdays roll around, only inner-circle friends are invited.

A man, who lived a full life and avoided "age-phobia" once wrote, "I enjoy celebrating birthdays. And I am not worried about the alternative because I'm ready any time to leave this world and head for a perfect place." The Apostle Paul agreed: *"For to me, to live is Christ and to die is gain"* (Phil. 1:21).

Do you have the kind of confidence in your destiny that being chronologically gifted doesn't upset you? Or, are you bound by the dreaded "age-phobia?"

Reflections

486 *The Riches of Heaven*

(Rom. 8:18; Heb. 12:2, 3)

To encourage us in our battles and give us joy the Bible sets before us the wonderful riches of heaven. Listen to Paul, *"I consider that our present sufferings are not worth comparing with the glory that will be revealed. . . ."* (Rom. 8:18 NIV). Listen to Hebrews 12:2, 3 (NIV): *"Let us fix our eyes on Jesus . . . who for the joy set before him endured the cross, scorning its shame, and sat down at the right hand of God the father."* Critics of heaven, some of whom call themselves Christians, mock us who long for heaven and call us weak. They say we should serve God and man because it is right, not because we get paid back in eternity. Like all lies this has an element of truth, but I'm so glad the couple from our church who just learned their precious three-year-old has only a few weeks to live (unless God intervenes), can be told they will see her again in heaven. What a motivation to keep on believing and serving.

487 *Leave Your Broom Behind*

Some years ago there was a crossing-sweeper in Dublin with his broom, at the corner, and in all probability his highest thoughts were to keep the crossing clean and look for the pence. One day a lawyer put his hand upon his shoulder and said to him, "My good fellow, do you know that you are heir to a fortune of ten thousand pounds a year?" "Do you mean it?" said he. "I do," he said; "I have just received the information. I am sure you are the man." He walked away, and forgot his broom. Are you astonished? Why, who would not have forgotten a broom when suddenly made possessor of ten thousand a year? So, poor sinners, who have been thinking of the pleasures of the world, when they hear that there is heaven to be had, may well forget the deceitful pleasures of sin and follow after higher and better things. (Phil. 3:13, 14).

488 *Once a Child*

"Who took him on the other side?" A pair of soft blue eyes, full

of tenderness and tears, looked up into mine. "On the other side! What do you mean, my darling"; and I looked wondering at the child.

"My baby brother, I mean. He was so small and weak, and had to go all alone. Who took him on the other side?"

"Angels," I answered, as steadily as I could speak; for the child's question moved me deeply—"loving angels, who took him up tenderly and laid his head softly on their bosoms, and sang to him sweeter songs than he had ever heard in this world."

"But every one will be strange to him. I'm afraid he'll be grieved for mother and nurse and me."

"No dear. The Savior, who was once a baby in this world, is there; and the angels who are nearest to him take all the little children who leave our side, and love and care for them just as if they were their own. When Bobby passed through to the other side, one of these an-gels held him by the hand all the way, and he was not in the least afraid; and when the light of heaven broke upon his eyes, and he saw the new beauty of the new world into which he had entered, his little heart was full of gladness."

"You are sure of that?" The grief had almost faded out of the child's countenance.

"Yes, dear, very sure. The Lord, who so tenderly loves little children who took them in his arms and blessed them when he was on earth, who said that 'their angels do always behold the face of my Father,' is more careful of the babes who go to him than the tenderest mother could possibly be."

"I am so glad!" said the child; "and it makes me feel so much better! Dear Bobby! I didn't know who would take him on the other side."

Adapted from an illustration
from *Children's Hour*

Holy Spirit

489 The "Switch-Key" of the Holy Spirit

The president of the Pennsylvania Railway, was making a quiet tour over one of the branches of the system, and wandered into an out-of-the-way switch-yard, where something one of the yard men was doing did not meet with his approbation. He made some suggestions to the man, who asked: "Who are you that's trying to teach me my business?" "I am an officer of the road," replied the president. "Let's see your switch-key, then," said the man, suspiciously. Mr. Cassatt pulled from his hip-pocket his key-ring, to which was attached the switch-key, which no railroad man in service is ever without. It was sufficient proof for the switchman, who then did as he was told. This story suggests a great spiritual lesson. If you are going to have any real leadership in dealing with the souls of men, they must see in your conversation, in the tone of your character, in the spirit of your life, that you possess the "switch-key" of the Holy Spirit.

490 Blotting Out Sins

Thank God! He not only separates our sins from us, but He blots them out of His book of remembrance, and remembers them against us no more forever." I never knew the real significance of those words, "I will blot them out of the book of remembrance forever," until I was preaching for Brother James Morris, at the Fifth and Walnut Streets Methodist Church, Louisville, Kentucky. After my sermon, Brother Morris got up and told of the sins of his early years, how he had been a gambler, a drunkard and a sinner in the sight of God. While he was talking, I looked over at his old mother. She was twisting and turning, and it seemed to me that she could not control herself. She seemed to go to pieces like a jointed snake. When he sat down and the service was dismissed, she ran up, threw her arms around his neck and said, "Jimmie, what made you say that? What made you say you were a gambler and a drunkard? You know you have always been good." That precious old mother had forgotten that her boy had ever been a sinner; and I said, "Glory to God! Though sunk in the depths of sin, God not only forgives us, but blots our sins out of the book of remembrances forevermore," And now I shall live in glory forever, as if I had never sinned.

491 Coming of the Holy Spirit

When Nansen started on his Arctic Expedition he took with him a carrier pigeon, strong and fleet of

193

wing; and after two years—two years in the desolation of the Arctic regions—he one day wrote a tiny little message and tied it under the pigeon's wing, and let it loose to travel two thousand miles to Norway; and oh! what miles! What desolation—not a living creature! Ice, ice, ice, snow, and death. But he took the trembling little bird and flung her up from the ship, up into the icy cold. Three circles she made, and then, straight as an arrow she shot south; one thousand miles over ice, one thousand miles over the frozen wastes of ocean, and at last dropped into the lap of the explorer's wife. She knew, by the arrival of the bird, that it was all right in the dark night of the North. So with the coming of the Holy Spirit, the Heavenly Dove, the disciples knew that Christ was alive, for his coming and his manifest working were proofs of it.

492 Grieving the Spirit

Once a man who owned a beautiful house invited one of his friends to come and live with him. He provided for his guest a room, a bed to sleep in, and a place at his table. By and by, though, he met another man, who charmed him, so he invited this one also to come and stay with him. He went to the one that he had invited first and asked that he share his room with the stranger; a little while afterward he was asked to give up his bed for the same purpose; then to surrender his place at the table. We are not surprised to know that, deeply grieved, he left the house altogether.

Thus had many a man crowded the blessed Guest from his heart. When the world begins to war with the Spirit for the possession of your heart, beware lest the Holy One be grieved and take His departure.

493 Holy Spirit

The pearl-diver lives at the bottom of the ocean by means of the pure air conveyed to him from above. His life is entirely dependent on the life-giving Spirit. We are down here, like the diver, to gather pearls for our Master's crown. The source of our life comes from above.

—Henry Drummond

494 More to Follow

A benevolent person gave Mr. Rowland Hill a hundred pounds to dispense to a poor minister, and thinking it was too much to send him at once, Mr. Hill forwarded five pounds in a letter, with simply these words within the envelope: "More to follow." In a few days' time, the good man received another letter by the post—and letters by the post were rarities in those days; this second messenger contained another five pounds, with the same motto: "And more to follow." A day or two after came a third and a fourth, and still the same promise: "And more to follow." Till the whole sum had been received the astonished minister was made familiar with the cheering words: "And more to follow."

Every blessing that comes from God is sent with the self-same message: "And more to follow." "I forgive you your sins, but there's more to follow." "I justify you in the righteousness of Christ, but there's more to follow." "I adopt you into my family, but there's more to follow." "I educate you for Heaven, but there's more to follow." "I give you grace upon grace, but there's more to follow." "I have helped you even to old age, but there's still more to follow." "I will uphold you in the hour of death, and as you are passing into the world of spirits, my mercy shall still continue with you, and when you land in the world to come there shall still be 'More to follow.'"

—C. H. Spurgeon

495 Baptism of Fire

On the Saturday night when Chicago was destroyed, I was preaching in Farwell Hall. We had an after meeting, and while the bells were ringing the alarm of fire, we were singing that verse—

Today the Savior calls;
　For refuge fly;
The storm of vengeance falls,
　And death is nigh.

Many of the young men present, who sung that hymn, were burned to death before morning—a thousand people lost their lives that night. It seemed to me that fire burnt out all my prejudices and dislikes, and I love the whole world.

—D. L. Moody

496 The Unifying Power

"Endeavoring to keep the unity of the Spirit in the bond of peace" (Eph. 4:3)

A famous and beloved university professor, in referring to an experiment in electromagnetism which he performed every year for his class, said that he never repeated the experiment without the increasing sense of the mysterious powers about and above him.

The experiment was this: On an oak table was placed a pile of horseshoe nails. In one corner of the room was a powerful dynamo. When the electric current was turned on and the poles of the battery were brought up under the table, although they did not touch the nails themselves, immediately there was constituted around them a field of magnetic force. So long as this field of force was maintained the loose horseshoe nails could be built up in various forms, such as a cube, a sphere, or an arch. So long as the current was on, the nails would stay in exactly the form placed, as if they had been soldered together. But the second the current was cut off, the nails would fall into a shapeless mass.

What that field of magnetic force was to those nails, the Holy Spirit is to all believers. By His power we are held together in a bond of love, a bond that is broken when we grieve and quench the Holy Spirit by our self-willed actions. Let us endeavor to keep the unity of the Spirit in the bond of peace.

497 Beautiful Motion but No Progress

"Many will say to me in that day, Lord, Lord, have we not prophesied in thy name? and in thy name have cast out devils? and in thy name done many wonderful works? And then will I profess unto them, I never knew you; depart from me, ye that work iniquity" (Matt. 7:22, 23).

Many people are working and working, as Rowland Hill said, like children on a rocking horse—it is a beautiful motion, but there is no progress. Those who are working for salvation are like men on a treadmill, going around and around, toiling and toiling, but nothing comes of it. There is no progress. There never can be until you have the motive power within, till the breath of life comes from God, which alone can give you power to work for others.

A great many think that we need new measures, new churches, new organs, new choirs, and a host of other things new. That is not what the church of God needs. It is the old power that the apostles had that men need today.

At a prayer meeting in Chicago years ago, D. L. Moody tells how one old pastor prayed earnestly that the Lord would put new ministers in the pulpits. "Oh, Lord," he cried, "put new ministers in every pulpit."

The next Monday Mr. Moody relates how he heard three or four folk stand up in a testimony meeting to say, "We had a new minister last Sunday—the same old pastor, but he had a new power."

Who can measure what benefit would come upon us if the prayer would more often be heard, "Lord, give us new ministers in every pulpit."

498 The Indwelling Spirit

"For if ye live after the flesh, ye shall die; but if ye through the Spirit do mortify the deeds of the body, ye shall live" (Rom. 8:13).

The absolute necessity of the indwelling Spirit of God is demonstrated by the forester. Whitewashing and spraying never reaches some parasites attacking the tree, so the forester bores into the very heart of the tree, and introduces chemical solutions which mingle with the sap and circulate through every branch and leaf. Thus is the old tree rendered absolutely safe from its foes.

Is this not exactly the work of the Holy Spirit in the lives of believers—to so indwell them as to render them safe from their foes? His ministry is very much like that of the antiseptic. To be effective the antiseptic must come in direct contact with the putrefaction in the flesh. Just so the Holy Spirit must be permitted direct access to the innermost secret sins of the believer if there is to be real spiritual blessing.

499 Burning Out Our Sins

Not long ago an enormous fire became kindled in Virginia's famous Dismal Swamp. It was started by hunters and spread rapidly through the undergrowth and frost-bitten shrubbery, giving forth great clouds

of thick smoke. So extensive was it that hundreds of wild animals, such as bear and fox and deer, as well as many smaller animals, were driven out into the farming settlements, where they were speedily killed by hunters. When the refining fire of the Holy Spirit goes through a heart that has been the abode of sinful passions and lusts, it drives them out from their hidden lairs to be destroyed.

500 Holy Spirit in the Believer

To quote the great leader of the Protestant Reformation, Martin Luther, "The believing man hath the Holy Ghost; and where the Holy Ghost dwelleth, He will not suffer a man to be idle, but stirreth him up to all exercises of piety and godliness, and of true religion, to the love of God, to the patient suffering of afflictions, to prayer, to thanksgiving, and the exercise of charity towards all men."

501 The Beauty of Holiness

Ugly Christianity is not Christ's Christianity. Some of us older people remember that it used to be a favorite phrase to describe unattractive saints, that they had "grace grafted on a crab stick." There are a great many Christian people whom one would compare to any other plant rather than a lily. Thorns and thistles and briars are a good deal more like what some of them appear to the world. But we are bound, if we are Christian people, by our obligations to God, and by our oblig-

ations to men, to try and make Christianity look as beautiful in people's eyes as we can. . . . Do you remember the words, "Whatsoever things are lovely; whatsoever things are of good report, . . . if there be any praise [from men] think on these things" (Phil. 4:8). It may be a modest kind of beauty, very humble, and not at all like the flaring reds and yellows of the gorgeous flowers that the world admires. . . . But unless you, as a Christian, are in your character arrayed in the "beauty of holiness," and in the holiness of beauty, you are not quite the Christian that Jesus Christ wants you to be; setting forth all the gracious and sweet and refining influences of the Gospel in your daily life and conduct.

—Alexander Maclaren

502 Quenching the Spirit

A man has lost his way in a dark and dreary mine. By the light of one candle, which he carries in his hand, he is groping for the road to sunshine and to home. That light is essential to his safety. The mine has many winding passages, in which he may be hopelessly bewildered. Here and there marks have been made on the rocks to point out the true path, but he cannot see them without that light. There are many deep pits into which, if unwary, he may suddenly fall, but he cannot avoid the danger without that. Should it go out that mine will be his tomb! How carefully he carries it! How anxiously he shields it from sudden gusts of air, from water dropping on it, from everything

that might quench it! The case described is our own. We are like that lonely wanderer in the mine. Does he diligently keep alight the candle on which his life depends? Much more earnestly should we give heed to the warning, "Quench not the Spirit." Sin makes our road both dark and dangerous. If God gave us no light, we should never find the way to the soul's sunny home of holiness and heaven. We must despair of ever reaching our Father's house. We must perish in the darkness into which we have wandered. But He gives us His Spirit to enlighten, guide, and cheer us.

503 Life-Giving Breath

In South America the wind from the marshes comes charged with the germs of intermittent fever, and often the most deadly cholera accompanies stillness in the atmosphere. A storm is the best purifier of the air, and the inhabitants long eagerly for it. From the marshy places of our lower nature the fever of lust and the unsanctified passion comes. The stillness of inactivity and do-nothingness is always favorable to the cholera of doubt and unbelief. The great preventive is the soul-stirring breath of the Holy Ghost. When He comes as a mighty, rushing wind, the whole atmosphere of the life is purified.

504 Constant Cleansing

Learn a lesson from the eye of the miner, who all day long is working amid the flying coal dust. When he emerges in the light of day his face may be grimy enough; but his eyes are clear and lustrous, because the fountain of tears in the lachrymal gland is ever pouring its gentle tides over the eye, cleansing away each speck of dust as soon as it alights. Is not this the miracle of cleansing which our spirits need in such a world as this? And this is what our blessed Lord is prepared to do for us if only we will trust Him.

—F. B. Meyer

505 Holy Spirit in the Bible

In the diamond fields of South Africa a diamond was found, celebrated lately under the title of "fly-stone"; placed under magnifying glass, you see enclosed in all its brilliancy a little fly, with body, wings, and eyes, in the most perfect state of preservation. How it came there no one knows, but no human skill can take it out. So in Holy Scripture the spirit of God is found in a place from which no power of man can remove it.

506 Reopening the Fountain of Life

Rev. F. B. Meyer once related how, in olden days, amid the Roman Forum, there was a little brooklet, called the "Girl's Fountain," which sang merrily as it broke into the light and passed on its way toward the yellow Tiber. For centuries, however, it was lost sight of; not that it had ceased to exist, but that it had become covered and almost choked by tons of rubbish, accu-

mulated thickly on the spot, as the proud city was subjected to repeated and ruthless violence at the hands of many spoilers. But when the debris was removed, that fountain, so long choked and hindered, freed from all restraints, again took up its song and recommenced its useful ministry. Is not that a type of the work of the Mighty One within us? He has not left us; but his gracious power, which would have been put forth in us and for us, has been rendered almost inoperative and dead. What shall now hinder us from ridding ourselves of all which has hindered Him from doing His mighty works, so that He may do that which He so loves and which we so much need?

507 Divers Faults

A gentleman's watch was once out of order, and it was examined. It was found that in one of them the main-spring was injured; the glass which protected the dial-plate of the other was broken; while the machinery of the third had become damp and rusty, although the parts were all there. So the lack of holiness, in some cases, arises from the lack of a desire to love God; another man has not the glass of watchfulness in his conduct; another has become rusty with backsliding from God, and the sense of guilt so clogs the wheels of his machinery, that they must be well-brushed with rebuke and correction, and oiled afresh with the divine influence before they will ever go well again.

508 Saint Patrick and the Shamrock

About the year 441 A.D., St. Patrick, who has since been called the Apostle of Ireland, went over there bent upon carrying out his long-cherished plan of converting the Irish to Christianity. On one occasion, when preaching before one of their petty kings, he spoke of the Holy, Blessed, and Glorious Trinity, the Father, and the Son, and the Holy Ghost, as being not three Gods, but Three Persons in One God. The king listened in amazement, and at length interrupted him, to ask in the words of one of old, 'How can these things be?' St. Patrick stooped and picked a leaf of the *shamrock,* with which the ground was there carpeted. Then, holding it up, he said, "Do you see this leaf, O king?" "Certainly I do," replied the king. And now, touching each lobe of the trefoil in succession, Saint Patrick asked the King, "What is this?"

"A leaf."

"And this?"

"A leaf."

"And this?"

"A leaf."

"As, then, O King, you see and confess that this leaf consists of three leaves, and yet nevertheless is but one leaf; so God the Blessed Trinity consists of Three Divine Persons, the Father, the Son, and the Holy Ghost, and yet is but One Lord—God Almighty." The king saw the force of the illustration, believed in and confessed the mystery of the

Holy Trinity, and was baptized into the faith. From the use thus made by St. Patrick of the shamrock in illustrating the doctrine of the Holy Trinity, this leaf has ever since been employed as the national emblem of Ireland.

509 *"My Peace I Give"*

I know that there is such a thing as *peace* to seek and find. But here is my work to do, to worry over whether I am doing it right, to keep myself restless over how it will turn out. *"My work,"* I say; but if I can know that it is not my work but God's, should I not cast away my restlessness, even while I worked on more faithfully and untiringly than ever? If I could pour through all the good plan over which I am laboring the certainty that all that is good in it is God's and must succeed, how that certainty would drive the darkness out of it! And while I worked harder than ever, my work would have something of the calmness with which he labors always. To every poor sufferer, to every discouraged worker, to every man who cannot think much of himself, and yet is too brave to despair, this is the courage that the gospel gives.

—Phillips Brooks

510 *Unconscious Goodness*

If you are abiding in Christ, you are reproducing yourself in thousands of instances when you are wholly unaware of it. Out of the personal relationship between the soul and Christ come the fruits of holy living. The vine does not bear fruit of itself; it bears its fruit through the branches. Our unconscious influence thus becomes far more fruitful than our conscious influence. In the last great day many will bewail that they have accomplished so little, and, looking at the scanty results, will say, "When saw we thee an hungered, and fed thee? Or thirsty, and gave thee drink?" (Matt. 25:37). To find that unconsciously their lives had abounded in fruits well-pleasing in the Master's sight. It is from such holy lives as this that is derived our Master's highest joy. It is when the whole body of Christ becomes instinct with His Spirit that the world is made conscious of His divine headship over the church.

511 *That We Be Holy*

Praise may well be given to God, even in times of trouble. He gives all spiritual blessings, and they often come through trials. "Tribulation worketh patience" (Rom. 5:3). But though our conditions change He does not. His choice was made before the foundation of the world, and He is unchangeable. He meant us to be holy, and He uses the needful means to this high end. Christ believed: that is the basis of our pardon. Christ loved and served: that is sanctification. The Father chose; the Son redeemed; the Spirit makes holy. We may well sing a doxology.

—John Hall

512 *Joseph's "Father's Day"*

It had been a night the like of which Joseph had never dreamed

could occur. Away from their home, their friends, and all familiar surroundings, his wife had given birth to a son in a hillside cave ordinarily used to shelter animals in the little town of Bethlehem.

As Joseph looked at Mary, asleep now, he cried. He should have been able to provide something better for her tonight. This precious woman who was "highly favored" and "blessed among womankind" had been entrusted to his care. But the best he had been able to do tonight was a cave, a tiny cleared area, and a bed of straw. "I should have been able to do more for her," he whispered.

Then he looked at the baby. So tiny. So helpless. So dependent on Mary and him. But how could it be! This was God's own son, not his. This baby was the God of creation, of Abraham, of Moses. He was the God of Joseph and Mary. How could he be lying beside Mary now?

Many fathers feel guilty that they are unable to do more for their families. Not enough money for a nice house. Furniture that needs to be replaced. Things always breaking down. Then there is the guilt over bad decisions. Over the inability to guide a troubled child. Over having to watch a child agonize to find his or her own way in life.

A caring, loving, father served God's son at Bethlehem in the only way he could. The Father of us all asks of us only what he asked of Joseph on that holy day.

—Adapted from an illustration by Rubel Shelly

Hope

513 Traces of God's Image

In English folklore a story is told of a child of one of Britain's noble families who was stolen from his house by a chimney sweep. The parents spared no expense or trouble in their search for him, but in vain. A few years later the lad happened to be sent by the master into whose hands he had then passed to sweep the chimneys in the very house from which he had been stolen while too young to remember it. The little fellow had been sweeping the chimney of one of the bedrooms, and fatigued with the exhausting labor to which so many lads, by the cruel custom of those times were bound, he quite forgot where he was, and flinging himself upon the clean bed dropped off to sleep. The lady of the house happened to enter the room. At first she looked in disgust and anger at the filthy black object that was soiling her counterpane. But all at once something in the expression of the little dirty face, or some familiar pose of the languid limbs, drew her nearer with a sudden inspiration, and in a moment she had clasped once more in her motherly arms her long-lost boy.

514 Hope for the Hopeless

One night when I was crossing the Atlantic, an officer of our boat told me that we had just passed over the spot where the *Titanic* went down. And I thought of all that life and wreckage beyond the power of man to recover and redeem. And I thought of the great bed of the deep sea, with all its held treasure, too far down for man to reach and restore. "Too far down!" And then I thought of all the human wreckage engulfed and sunk in oceanic depths of nameless sin. Too far gone! For what? Too far down! For what? Not too far down for the love of God! Listen to this: He descended into hell, and He will descend again if you are there. "If I make my bed in hell, thou art there" (Ps. 139:8). "Where sin abounded, grace did much more abound" (Rom. 5:20). "He bore our sin" (see 1 Pet. 2:24); then He got beneath it; down to it and beneath it; and there is no human wreckage lying in the ooze of the deepest sea of iniquity that His deep love cannot reach and redeem. What a Gospel! However far down, God's love can get beneath it!

—J. H. Jowett

Humility

515 Elisha's Humility and Ambition

The friendship between Elijah and Elisha is a beautiful story of a strong love growing up between an old man and a young one. Elijah was no doubt often the guest in the home of Elisha's father, who was a rich farmer. One day Elijah came through the field, past where Elisha was plowing, and, throwing his mantle over the boy's shoulders, walked away as fast as he could. Elisha knew very well what that meant. It was the call of God to be a prophet. He settled up his affairs at once and went forth with Elijah. As Elijah's translation drew near, Elisha begged that the mantle of the man of God might fall upon him. He had such reverence and love for Elijah that he longed to be like him, and to be able to go on doing his work when he should lay it down. The humility as well as the elevation of a noble soul is revealed in this longing to carry on the work of the Lord in the spirit of his friend.

516 Reaching the Summit by Way of the Valley

The Christian is to find exaltation by humility. Christ advised his hearers, when they went to a great dinner, not to go early and get the best places, but to go in modestly and take a humble seat; and then if it was proper for them to have the higher place, the host would honor them by public invitation to the better seat. It is by being, and not by seeming to be, that one really comes to be exalted. Christ emptied himself of all reputation, laid aside his glory and his riches, and came to the earth to be born among the lowly in the manger of an inn stable; but it was the way toward exaltation, for Paul says: "God also hath highly exalted him, and given him a name which is above every name: that at the name of Jesus every knee should bow, of things in heaven, and things in earth, and things under the earth; and that every tongue should confess that Jesus Christ is Lord, to the glory of God the Father" (Phil. 2:9-11). We, too, shall come to our highest through sacrificing ourselves in humility for the blessing of others.

517 Hasty Pudding

Do you know what was eaten on the first Thanksgiving Dinner?

Despite what you may have been taught, the Mayflower pilgrims probably didn't have ambrosia, ham, potato salad, and pumpkin pie. Almost assuredly, with their lack of resources, they had roots,

berries, wild fowl and perhaps some hasty pudding. Hasty pudding is simply a cornmeal mush, so named for the short time it takes to prepare it.

A chef was preparing a Thanksgiving meal in a restaurant when a young man came running in the back door and shouted at him, "Carl, your house is on fire!" The chef immediately dropped his cookware and bolted out the door with his apron flapping in the breeze. After about fifty yards, he stopped in his tracks and said, "Wait a minute, my name isn't Carl and I don't even have a house!"

Most of us eat "hasty pudding" more often than we will admit. We go off half-cocked with incomplete information to an uncertain location. Happily, our Creator left this advice: *"It is not good to have zeal without knowledge, nor to be hasty and miss the way"* (Prov. 19:2 NIV). We are to patiently wait on the Lord, for his timely and perfect course of action.

Reflections

Hypocrisy

518 Evil under the Guise of Good

Sir Charles Follett, the chief of Her Majesty's Customs, speaking on the clever tricks of smugglers, says: "We have had many extraordinary dodges come under our notice. For instance, innocent-looking loaves of bread, when accidentally examined, were discovered to have every particle of crumb removed from them, and the inside crammed with compressed tobacco. This is only one example of manifold specimens of cunning to bring in prohibited goods." How cunning is our great enemy to bring into our souls his contraband! Evil thoughts, desires, and deeds, covered with the most innocent and harmless-looking excuses; so that we need the wisdom from above if we are not to be unmindful of his devices.

519 Pretending

Judge Rooney, of Chicago, fined a man $100 plus court fees and sentenced him to jail for ninety days for impersonating a doctor and practicing medicine without a license. I wonder how many professing Christians, ministers, and laymen would be "hit" by a law fining those who pretended to be Christians and were not. Are we leading or misleading people by our pretensions?

Judgment

520 Vacant Niche

The following anecdote is by J. Wilbur Chapman:

"I was once a pastor at Schuylerville, New York, where on the Burgoyne surrender grounds stands a celebrated monument. It is beautiful to look upon. On one side of it in a niche is General Schuyler, and on the other side, if I remember correctly, General Gates; on the third, in the same sort of a niche, another distinguished general is to be seen, but on the fourth the niche is vacant. When I asked the reason I was told that 'It is the niche which might have been filled by Benedict Arnold had he not been a traitor.' "

—J. Wilbur Chapman

521 God's Anger

I have read that a frown of Queen Elizabeth killed Sir Christopher Hatton, the Lord Chancellor of England. What, then, shall the frowns of the King of nations do? If the rocks rend, the mountains melt and the foundations of the earth tremble under His wrath, how will the ungodly sinner appear when He comes in all His royal glory to take vengeance on all that knew Him not, and that obeyed not His glorious Gospel?

522 No Hiding from God

It was said of the Roman Empire under the Caesars that the whole world was only one great prison for Caesar, for if any man offended the emperor it was impossible for him to escape. If he crossed the Alps, could not Caesar find him out in Gaul? If he sought to hide himself in the Indies, even the swarthy monarchs there knew the power of the Roman arms, so that they could give no shelter to a man who had incurred imperial vengeance. And yet, perhaps, a fugitive from Rome might have prolonged his miserable life by hiding in the dens and caves of the earth. But, oh, sinner, there is no hiding from God.

—C. H. Spurgeon

523 Judging Prematurely

When Dr. Wayland was president of Brown University and professor of science, his eldest son, who was a senior, in reciting to him one day, drew from his father, by a question, the expression of a certain opinion. "The esteemed author of this book," said the young man, holding up his father's textbook on science which the class was using, "holds a different opinion." "The author of that book, my son," said Dr. Wayland quietly, "knows more

now than he did ten years ago." The teacher of any science who does not know more now than he did ten years ago, who never finds occasion to modify and qualify and reshape his utterances, is probably a cheap and poor sort of teacher.

524 Chickens Come Home to Roost

Do you remember that poem of Southey's about Sir Ralph, the Rover? In Eastern Scotland, in the old days, a good man had placed a float with a bell attached on the dangerous Inchcape Rock, so that the mariners, hearing it, might keep away. This Sir Ralph, the Rover, in a moment of devilry, cut away both float and bell. It was a cruel thing to do. Years passed. Sir Ralph roamed over many parts of the world. In the end he returned to Scotland. As he neared the coast a storm arose. Where was he? Where was the ship drifting? Oh, if he only knew where he was! Oh, if he could only hear the bell on the Inchcape Rock! But years ago, in his sinful folly, he, with his own hands, had cut it away. Hark! to that grating sound heard amid the storm, felt amid the breakers; the ship is struck; the rock penetrates her, she goes to pieces, and, with curses of rage and despair, the sinner's sin has found him out; he sinks to rise no more until the great day of judgment.

525 Unrighteous Judgment

General Grant, speaking of charges of cowardice, says: "The distant rear of an army engaged in battle is not the best place to judge what is going on. The stragglers in the rear are not to make us forget the intrepid soldiers in front." But how many judge the Christian Church and religion by its worst representatives!

526 Traitor Within

A garrison is not free from danger while it has an enemy lodged within. You may bolt all your doors and fasten all your windows; but if the thieves have placed even a little child within doors, who can draw the bolts for them, the house is still unprotected. All the sea outside a ship cannot do it damage till the water enters within and fills the hold. Hence, it is clear, our greatest danger is from within. All the demons in hell and tempters on earth could do us no injury if there were no corruption in our natures. The sparks will fall harmlessly if there is no tinder. Alas, our hearts are our greatest enemies; they are the little homeborn thieves. Lord, save me from that evil man, myself.

—C. H. Spurgeon

527 Regret of Lost Souls

In the palace at Versailles, as if by the irony of fate, is a famous statue of Napoleon in exile. His noble brow is lowered in thought, his mouth is compressed, his chin is resting upon his breast, and his grand eye gazes into space as if fixed on some distant scene. There is something inexpressibly sad in that strong, pale face. It is said that the sculptor represented Napoleon at St. Helena, just before his death.

He is looking back upon the field of Waterloo, and thinking how its fatal issue was the result of three hours' delay. Those three short hours seem ever to write on the walls of his memory—"The summer is ended, the harvest is passed!"

528 A Poisoned Honor

If we are to credit the annals of the Russian empire, there once existed a noble order of merit, which was greatly coveted by the princes and noblesse. It was, however, conferred only on the peculiar favorites of the Czar, or on the distinguished heroes of the kingdom. But another class shared in its honor in a very questionable form. Those nobles or favorites who either became a burden to the Czar or stood in his way received this decoration only to die. The pinpoint was tipped with poison—and when the order was being fastened on the breast by the imperial messenger the flesh of the person was "accidentally" pricked. Death ensued, as next morning the individual so highly honored with imperial favor was found dead in bed from apoplexy. Satan offered to confer a brilliant decoration upon Adam and Eve— "Ye shall be as gods" (Gen. 3:5). It was poisoned; the wages of sin is death.

529 Trapped!

A Boston shoplifter was caught in a comical way. He had stolen a hat in a department store, and ran with it to the escalators; but instead of boarding the one going down, in his haste he took the ascending stairway. He tried hard to run down, but was confronted by the ascending passengers, while all the time the merciless steps were rising. Finally, in spite of his frantic efforts, he was borne back to the head of the stairs again, where he found a policeman awaiting him.

This is just a picture of the difficult ways of sinners. They try to escape with their loot, but they find all the ways of providence running against them. Everything conspires to their discovery.

"Be sure your sin will find you out" (Num. 32:23). The sinner is his own detective. If there is no policeman at hand, he will arrest himself. If the police-wagon is out of commission, he will run to the courtroom. Remorse is more stern than any judge, and a guilty conscience is more terrible than any prison.

Be certain of this: If you sin, the entire universe will become an escalator, going the wrong way!

530 No Escape

There is an old tale in Scottish history, that a bridegroom was murdered by a friend on the festal day. The cup that his friend presented to him was mingled with poison; and when death was in the castle, the culprit took the fleetest horse from the stable and plunged into the forest. All night long the hooves of that horse struck fire as he went at galloping speed through the forest. The man wanted to get away from the scene of his crime,

and would not let the fleet animal rest, but plunged the spurs deep into the horse's flanks. All night on and on, and as the dawn was breaking he emerged, horse bespattered with foam, breathless from the forest—right before the castle. He had ridden hard, but he had ridden in a circle: he thought he was going away from his crime, and in the morning he came to it.

Ah, you cannot get away from your sin unless God takes you away. You cannot by speed of foot get away from your sin, your sin will go to the grave with you, your sin will go to the great white throne with you. You cannot race your sin, you had better give it up, and see whether God in His mercy hath not some plan of redemption from sin.

531 The Betrayer Denied

I went to West Point, and we had an evening meeting in the old chapel. As we passed under the rear gallery to go out, one of the students stopped and said: "I wish you would look at that shield on the wall there; that is the most striking thing at the academy to me." I looked at the wall; all around there were marble shields set in the wall, and on each shield was the name of one of our Revolutionary generals. Then I looked up at the particular shield to which attention had been called, and that shield was blank. It was there in form just as the others, but with no name on it; simply the words Major General, and the date of the unnamed general's birth. "What does it mean?" I asked.

"Well," said the cadet, "that is the shield for Benedict Arnold. There is a shield for every Revolutionary general, and one for him too, but the nation would not cut his name on it nor the date of his death. He denied his country; his country has denied him."

532 Judging by Appearance

While standing at the wharf of a quiet harbor, looking at the shipping which lay at anchor, we heard a young lady remark to a friend: "That nicely painted ship I would choose for a trip across the sea." He replied: "I would not, but I prefer the dark old vessel near it. For that handsome ship is unsafe; she has been newly painted—but her timbers are rotten." Very suggestive, we thought, of practical truth. There are painted ships on all seas. Upon the waters of life they are gaily sailing to eternity with an inward decay which will yield to the storm which awaits every mortal mariner.

533 False Fears

A minister, while crossing the Bay of Biscay, became greatly alarmed as he beheld what he thought was an approaching hurricane. Tremblingly he addressed himself to one of the sailors: "Do you think she will be able to go through it?" "Through what?" inquired the sailor. "That awful hurricane that is coming down upon us." The old sailor smiled and said: "That storm will never touch us. It has passed us already." So, in regard to the believer,

judgment as to the penalty of our sins is past. We were tried, condemned, and executed, in the person of our surety, Jesus Christ.

534 Saving or Showing Off

Determination is a necessary qualification for the soul-winner, but it isn't the only one. A man, who had more determination than devotion, heard a preacher remark that the case of a certain man was hopeless. He made up his mind to show the faithless shepherd what he could do; so he worked day and night till he had induced the man to confess Christ. The convert was, however, soon disgusted with the inconsistent life of the man who had urged him to become a Christian and fell back into his old ways. The worker had silenced the preacher, but he had not saved a sinner. The four men who brought the paralytic to Christ were not simply determined to show the crowd that when they started out to do a thing, they were not to be hindered. The fact that Christ commended their faith shows that they thought more about carrying the man than about carrying their point.

535 Life's Little Pieces

In most things we are reasonable enough to withhold judgment until we have examined them in their entirety. For instance, no man attempts to judge as to the vastness and grandeur of the ocean because he has seen a cup of its water; no man judges the beauty and strength of a building from a bit of the brick of which it is built, or of the purpose of the author from a word cut here and there from one of his books. When we look at our own lives, however, logic seems to weaken, and we draw the most unreasonable conclusions. We plunge into some dark cavern and lament, "Oh that all my labor and pains should have come to this! Oh that God should have turned a deaf ear to my pleadings!" If we would wait long enough, we would see that we have been gently forced into the only avenue through which the light we asked for can be reached. Israel stubbornly refusing to look beyond for the land to which the Lord their God would lead them, is not without a counterpart in our modern life.

536 Judgment Day

It was my sad lot to be in the Chicago fire. As the flames rolled down our streets, destroying everything in their onward march, I saw the great and the honorable, the learned and the wise, fleeing before the fire with the beggar and the thief and the harlot. All were alike. As the flames swept through the city, it was like the judgment day. The Mayor, nor the mighty men, nor the wise men could stop these flames. They were all on a level then, and many who were worth hundreds of thousands were left paupers that night. When the day of judgment comes there will be no difference. When the Deluge came there was no difference; Noah's ark was worth more than all the world. The day before it was

the world's laughing-stock, and if it had been put up to auction you could not have gotten anybody to buy it except for firewood. But the Deluge came, and then it was worth more than all the world together. And when the day of judgment comes Christ will be worth more than all this world—more than ten thousand worlds.

—D. L. Moody

537 Heart-Breaking Justice

Two sons of an officer of the Atlanta police force were convicted of burglary on their father's evidence and sentenced to two years in the penitentiary. The two boys were arrested by their father in the act of burglarizing a store, and he appeared in court as prosecutor.

The father, in giving evidence, said: "I tried to raise my boys right, and it nearly killed me when I found them trying to rob the store, but I feel it my duty under my oath as an officer to arrest them and prosecute. I told them they were guilty and they must take their punishment."

"There is indeed a real man," said the Judge when the father had finished speaking, "and an officer who has the highest possible regard for his oath. He deserves to rank with the old Roman judge who condemned his own son."

Our heavenly Father is not only compassionate, but just. Love must yield where disobedience calls for justice.

Kindness

538 Helping or Hindering

A small boy was visiting his grandparents on their farm. In the orchard he noticed a locust coming out of his shell. So he thought he would assist the locust. When telling how he helped the locust, his grandparents said he hurt the locust and did more harm than good, since it is God's plan the locust works out of the shell himself. Sometimes we can do more help by leaving people alone, and letting them work out their own problems.

539 Easy to Hurt Others

We are so related to each other that we are continually leaving impressions on those we touch. It is easier to do harm than good to other lives. There is a quality in the human soul which makes it take more readily and retain more permanently touches of sin than touches of holiness. Among the ruins of some old temple there was found a slab which bore very faintly and dimly the image of the king, and in deep and clear indentations the print of a dog's foot. The king's beauty was less clear than the marks of the animal's tread. So human lives are apt to take less readily and deeply, to retain less indelibly, the touches of spiritual beauty, and more clearly and permanently the marks and impressions of evil. It needs, therefore, in us infinite carefulness and watchfulness, as we walk ever amid other lives, lest by some word, or look, or act, or influence of ours we hurt them irreparably.

—J. R. Miller

540 "Mister, Are You There?"

A New York Sunday-school superintendent urged his teachers to bring new children with them the next Sunday, and as he walked down Sixth Avenue attempted himself to win a street boy. "Will you go to Sunday School?" he said, and in the vernacular of the street the boy said, "Nope." The superintendent said: "We have picture papers for every boy," and he would not come. "We have music, we have everything to make you have a good time," and the boy steadily refused. Disappointed, the superintendent turned away and, when he had gone a short distance, he heard the patter of little feet behind him and, turning back he saw the boy. He said with an earnest, eager look: "Mister, are you there?" and the superintendent said, "Yes, I am there." "Well," he said, "next Sunday I'll be there." And he was. Sunday School papers, music, and other attractions of school were simply the first mile,

212

the spirit of the superintendent was the second mile, and was an influence the boy could not shake off.

—J. Wilbur Chapman

541 Power of Kindness

A good lady, living in a large city, was passing a saloon just as the keeper was thrusting a young man into the street. He was very pale, and his haggard face and wild eyes told that he was very far gone on the road to ruin, as with profane speech he brandished his clenched fists, threatening to be revenged upon the man that had ill-used him. He was so excited and blinded with passion that he did not see the lady who stood very near to him, until she laid her hand upon his arm, and asked, in a gentle, loving voice, what was the matter. At the first kind word the young man started as though a heavy blow had struck him, and turned quickly around, more pale than before, and trembling from head to foot. He surveyed the lady from head to foot, and then, with a sigh of relief, he said: "I thought it was my mother's voice; it sounded strangely like it. But her voice has been hushed in death for many years."

"You had a mother, then," said the lady, "and she loved you?"

The young man burst into tears, and sobbed out: "Oh, yes; I had a mother, and she loved me. But since she died all the world has been against me, and I am lost—lost forever."

"No; not lost forever; for God is merciful, and His pitying love can reach the chief of sinners," said the lady. The young man was spellbound; and when, after more kind words, she went on her way, he followed her, until he saw her enter her home, and then he wrote down the name on the doorplate, in his pocketbook, and turned away with a deep purpose in his heart.

Years glided by, and the lady forgot the incident, until it was brought to her recollection by the visit of a noble-looking, well-dressed man, who told her he was the young man whom she had thus addressed, long before, in words of Christian love and hope.

"The earnest expression of 'No, not lost forever,' followed me wherever I went," said he; "and it always seemed that it was the voice of my mother speaking to me from the tomb. I repented of my many transgressions, and resolved to live as Jesus and my mother would be pleased to have me; and by the mercy and grace of God I have been enabled, in some good measure, to do so."

542 The Great Teacher

A young pianist was giving concerts in the provinces of Germany, and, to add to her renown, she announced herself as a pupil of the celebrated Liszt. Arriving at a small provincial town, she advertised a concert in the usual way; but what was her astonishment and terror to see in the list of new arrivals at the hotel the name of "M. l'Abbe Liszt!" What was she to do? Her deception would be discovered, and she could

never dare to give another concert. In her despair she adopted the wisest course, and went directly to the Abbe himself. Pale, trembling, and deeply agitated, she entered the presence of the great maestro to confess her fraud, and to implore forgiveness. She threw herself at his feet, her face bathed in tears, and related to him the history of her life. Left an orphan when very young, and possessing nothing but her musical gifts, she had ventured to shelter herself under the protection of his great name, and thus to overcome the many obstacles which opposed her. Without that she would have been nothing—nobody. But could he ever forgive her? "Come, come," said the great artist, helping her to rise, "we shall see what we can do. Here is a piano. Let me hear a piece intended for the concert tomorrow." She obeyed, and played, at first timidly then with all the enthusiasm of reviving hope. The maestro stood near her, gave her some advice, suggested some improvements, and when she had finished her piece, said most kindly—"Now, my child, I have given you a music lesson. You are a pupil of Liszt." Before she could recover herself sufficiently to utter a word of acknowledgment, he added, "Are the programs printed?" "Not yet, sir." "Then let them add to your program that you will be assisted by your master, and that the last piece will be played by the Abbe Liszt." Could any reproof be keener than such forgiving kindness—such noble generosity as this? The illustrious musician would no doubt have been questioned, and it would have been impossible for him to speak anything but the truth. But charity is ingenious in covering "a multitude of sins."

543 Believe in Them

More lost men and women have been rescued by the thought that somebody believed in them, than by any other human agency. There is nothing that will go so far toward making your class the most giddy or the most unruly class in the school, as to once let them know that they bear such a reputation.

I recall just now a striking instance of this sort. In a certain village the grade of conduct in the public school had fallen so low that the teachers universally agreed that it was beyond them. One after another came with stern visage and artfully laid plans, determined to conquer the belligerents. But all in vain. Finally, there came a teacher, a lover of young people, and a man of such guileless mind that he seemed to have no other thought than that his gentleness would be returned in kind. To their own astonishment, the scholars found that there was something about him that put them on their good behavior when they were in his presence. Still, there were threats as to the daring pieces of mischief they would execute in his absence.

One day, after he had been with them not quite a week, he had occasion to go into one of the other departments.

"You may go on with your studies just as though I were here," he said naturally. They looked at each other in astonishment. No other teacher had ever thought of trusting them out of his sight. They were suspicious. It must be some kind of trap he was setting for them. But they were mistaken. When they found that they had been really left alone, they were silent for a moment from sheer astonishment. Then a boy decided to throw his geography book across the room at the head of one of his schoolmates. But the fun, like the book, fell flat, and looks of disapproval were cast upon him. They seemed to say, "We are not afraid of whippings and scoldings, but a man that believes in us when nobody has told him anything good about us is too much."

That man remained for almost ten years with the school and saw it rise to be an acknowledged model school. He saw those boys and girls develop into a manhood and womanhood that was in every way different from anything of which they gave promise before they came in contact with him.

544 Such as You Have

Two mechanics, going home one cold night, passed a lame man who had been on the street all day trying, with little success, to sell his poor wares. "Dear me!" said one of them, "how miserable that poor fellow looks. If I had plenty of money, I should like nothing better than to relieve such cases. The first thing I would do would be to get him a good pair of shoes and a comfortable crutch that would make walking less painful for him." In the meantime, his friend had stopped and was talking to the lame man.

"Pretty bad walking, neighbor," he said cheerily. "Take my arm and maybe you can get along better. I am going your way; that is, if you will tell me where you live." He did not stop until he had seen the man safe in the little room and had succeeded in kindling a fire. He filled the cracks around the window with paper, and left the poor man by his steaming kettle, cheered and comforted. He did not say anything about his benevolent desires. He had no money, but he had given freely of what he had. He was like Peter, who said to the man who asked for alms, "Silver and gold have I none, but such as I have, give I unto thee" (Acts 3:6). Too many of us are disposed to be generous with such as we have not.

545 The Law of Kindness

It always pays to live up to the law of kindness. One cannot always tell what great results will come in the train of seemingly small deeds that are performed with a desire to be helpful. An engineer of a passenger-train on a Mississippi railroad was driving through a snowstorm, eagerly scanning the track as far as he could see, when, halfway through a deep cut, something appeared lying on the rails. It was a sheep with her two little lambs. His first thought was that he could rush on without any damage to his train; but the sight

of the innocent family cowering in the storm touched him, and he pulled the air-brake and sent his fireman ahead. In a few minutes the fireman came back with a terrified face. There had been a landslide, and just beyond the cut the track was covered with rocks. It seemed certain that if the train had gone on at full speed, in the blinding snow, it would have been impossible to stop in time to escape disaster.

In the absolute sense the incident was providential; but circumstantially the passengers on that railway owed their safety, if not their lives, to an engineer who was too tender-hearted to kill a sheep and her lambs. So many men and women who have given their earnest, faithful service to make a safer path for the neighbor's boy, or bring greater happiness to the neighbor's girl, have been thus saving their own dear ones. Unselfish devotion to the good of others is the surest way to take care of ourselves, for this is God's world and not the devil's.

546 *Who is Your Neighbor?*

Mr. Jacob A. Riis, whom President Roosevelt once declared to be the most useful citizen in New York City, tells an interesting story concerning his work among the poor in New York. A while ago he went to visit a friend in a suburban town. On the evening of his arrival, as they sat at his table, the host looked around at his flock of five healthy children and said: "I wish you could find for me in the city some poor family—if possible, a widow with children about the age of these—who would be ours to work and advise with and to help over the rough places when they came along. Then each of mine could have his own friend, and he could get more out of it than he would give, I know. Here they are shut off, as you see, from that. All the neighbors are well-to-do." Mr. Riis promised to try, for he knew the man was right. They were sadly handicapped. The best in them was being starved by the ultra-respectability of their surroundings. So one day he found in a tenement-house on the East Side a brave little woman who was making a noble fight to keep her flock together. The oldest boy was about old enough to go into an office, and his face fairly shone with delight at the prospect that he was soon to "help mamma." She was a custodian, she told Mr. Riis, and worked in a public building a couple of miles away, on the west side of town. Mr. Riis started for his office to telephone to his friend that he had found what he wanted. On the way it struck him that he had forgotten to ask where the widow scrubbed and he went back to find out. "Once or twice," says Mr. Riis, "in my life it has been given to me to see, as it were, the veil rent asunder and the hand of the Almighty working in my sight. This was one of those times. I shall not soon get over the thrill that went through me when I learned that she worked in the Mission Building, at my friend's very door. Just the thickness of it, two inches of

wood, separated the two, each in need of the other, and asking vainly, as the years went by, 'Where is the neighbor who will give me a hand?'"

547 Our Friend at Court

Dr. J. Wilbur Chapman told this story of one of his friends who was a boyhood companion of Robert Lincoln. He entered the Civil War and went to the front. When Robert Lincoln found that he was a private soldier, he said to a friend, "Write, and tell him to write to me, and I will intercede with father, and get him something better." The young soldier said: "I never took advantage of the offer, but you do not know what a comfort it was to me. Often after a weary march I would throw myself on the ground and say, 'If it becomes beyond human endurance, I can write to Bob Lincoln and get relief; and I would rather have his intercession than that of the President's cabinet members, because he is President Lincoln's son.'" Every true Christian knows that he has the best friend possible at the court of heaven in the Son of God, who "ever liveth to make intercession for us" (see Heb. 7:25).

548 Generosity and Benevolence

Many generous men are not benevolent men. There are a great many who live in fragmentary, unconnected kindnesses. They are ready to relieve trouble when it comes to them. When a want is presented to them, they give it a mo-ment's notice, and only a moment's. Everything that touches them receives an instant response, but that is all.

If a little child goes past a piano and strikes it, and returns and strikes it again, and passes it again, and strikes it yet again, it certainly produces musical sounds; but what is the sound of a piano touched by the random finger of a vagrant child, compared with the magnificent sounds of him that has a theme which his broad and multiplex hand is evoking through all the harmonies and progressions of this lordly instrument? There should be intelligence, and connection, and plan, and sequence, and application in our benevolence.

549 The Fragrance of Good Deeds

The Mosque of St. Sophia in Constantinople, is always fragrant with the odor of musk, and has been for centuries, though nothing is done to keep it perfumed. The explanation is that when it was built, over one thousand years ago, the stones and bricks were laid in mortar mixed with a solution of musk. If the deeds we do are full of kindness and love, long after we have passed away their fragrance will linger in the world.

550 Value of a Kind Word

A man came one day to Lord Shaftesbury, bringing a note from the governor of Manchester jail, saying that the bearer was absolutely incorrigible, and had spent

twenty years of his life in prison. Lord Shaftesbury talked kindly to the man, and found certain marks of humanity left in him, and he said; "John Spiers, shall I make a man of you?" "You can try, but you can't do it," was the discouraging reply; "though I'll try too." Lord Shaftesbury placed him in a reformatory for men, where the discipline was severe, but good, and in three days' time went again to see his *protégé,* asking, "Shall we go through with it and save you?" "If you can," was the answer this time; and Lord Shaftesbury placed his hand lovingly on the poor fellow's shoulder, saying, "By God's help we will," and by the conversation that followed John Spiers was completely broken down. Two years after he was met by a friend of Lord Shaftesbury's, clad in good clothing, and filling a trusted, honored situation. "Ah!" he said, "it was all the earl's kinds words that did it. That was new. Why, I'd never had a kind word or a loving look given to me in my life before, or I might have acted very differently."

551 The Three Young Travelers

Some months ago, three small children—a boy and two girls aged ten, seven, and four years old respectively, arrived in St. Louis, having traveled all the way from Germany, without any escort or protection beyond a New Testament, and their own innocence and helplessness. Their parents, who had emigrated the previous year from the Fatherland and settled in Missouri, had left them in custody of an aunt, to whom in due time they forwarded a sum of money sufficient to pay the passage and other expenses of the little ones to their new home across the Atlantic. As the children could not speak a word of any other language than German, it is doubtful whether they would ever have reached their destination at all, had not their aunt, with a woman's ready wit, provided them with a passport, addressed not so much to any earthly authority, as to Christian mankind generally. Before taking her leave of the children, the aunt gave the elder girl a New Testament, instructing her to show it to every person who might accost her during her long voyage, and especially to call their attention to the first page of the book. Upon that page the wise and good woman had written the names of the three children, their birthplaces and several ages, and this simple statement: *"Their father and mother in America are anxiously awaiting their arrival at Sedalia, Missouri."* This was followed by the irresistible appeal— their guide, their safeguard, and their interpreter throughout a journey, over sea and land, of more than four thousand miles. Many were the little acts of kindness shown to the dear little travelers, many the hands held out to help and smooth their journey, by those who read the first page of their New Testament, until they reached their parents in perfect health and safety.

552 Kindness in a Rusty Chevy

Shortly after I arrived in the United States, I was invited to speak at a banquet in one of the big Chicago hotels. My wife and I decided to drive down to the "Windy City" together and left ourselves plenty of time to find our way around. As we approached Chicago I noticed we were getting low on gas, but I knew there would be plenty of filling stations. When we suddenly came to a halt in the fast lane of the freeway, in the rush hour, with the rain pouring down, I realized my assumptions about filling stations were wrong, as my tank was empty. I climbed out of my car, to be greeted by a chorus of horns expressing displeasure and expletives filling in the details. There was nothing I could do and less that anyone else was ready to do, so I stood in the rain, and like the sailors on Paul's sinking ship, I "wished for the day."

One particularly dilapidated car drew alongside; the driver rolled down his window. I braced myself for more verbal abuse but was relieved that his English was so bad I couldn't understand it. About fifteen minutes later the same car returned in a mass of traffic and pulled up in front of mine. The driver jumped out and without a word proceeded to replenish my tank from a can. He had seen my plight, gone to a filling station off the freeway, borrowed a can, gotten back on the freeway, fought the traffic, and come to my rescue. When I tried to thank him, he shrugged and said, "You look kinda new around here. Me, I just come from Puerto Rico, Friday. Ain't nobody do nothing for nobody in this city," and with that he was gone. That was generosity, kindness in a rusty Chevy.

—Stuart Briscoe
David C. Cook Church Ministries

553 Helping Others

It was said of Sir Bartle Frere that he was always helping someone. Lady Frere was going to a railway station to meet her husband with a servant who had never seen him before. "Madam, how shall I know him?" asked the man. "Look for a tall gentleman helping someone," replied Lady Frere, and sure enough the description was sufficient, for Sir Bartle was discovered helping an old lady out of a railway carriage.

Knowledge

554 Knowledge Vain without Grace

A man may know all about the rocks, and his heart remain as hard as they are; a man may know all about the winds, and be the sport of passions as fierce as they; a man may know all about the stars, and his fate be the meteor's that after a brief and brilliant career is quenched in eternal night; a man may know all about the sea, and his soul resemble its troubled waters which cannot rest; a man may know how to rule the spirits of the elements, yet know not how to rule his own; a man may know how to turn aside the flashing thunderbolt, but not the wrath of God from his own guilty heart: he may know all that Shakespeare knew—all that Einstein knew—all that all the greatest geniuses have known; he may know all mysteries and all knowledge; but if he does not know his Bible, what good will it bring him?

555 Learn These Two Things

Learn these two things: never be discouraged because good things develop so slowly here, and never fail daily to do that good which lies next to your hand. Do not be in a hurry, but be diligent. Enter into the sublime patience of the Lord.

Be charitable in view of it. God can afford to wait; why can't we, since we have Him to fall back upon? Let patience have her perfect work, and bring forth her celestial fruits. Trust to God to weave your little thread into a web, though the patterns do not show it yet.

556 Useless Knowledge

The prompt action of a young woman had saved the life of a man whose arm had been almost severed from his body. When the others were praising her for what she had done, she replied modestly that she deserved no special praise, as her teacher at school had taught her what to do under such circumstances.

"Oh, I knew that, too," exclaimed another young lady, "and if anyone had asked how to stop the flow of blood from a wound, I could have given the answer just as it is in the book; but I never thought of applying it to this case."

The young woman is a typical character. In cases of spiritual peril, a good many of us, who could give the answer "just as it is in the Book," never think of applying our knowledge for the benefit of those who are in danger. Too many, who know the great Physician for themselves, never seem to think of sending their friends to him.

Love

557 A Little Jam on the Bread

The teacher asked the pupils to tell the meaning of loving-kindness. A little boy jumped up and said, "Well, if I was hungry and someone gave me a piece of bread that would be kindness. But if they put a little jam on it, that would be loving-kindness."

Sparks

558 "Home, Sweet Home"

On the tenth of April, in 1852, beneath the African sun, died an American. He was laid to rest in a lonely cemetery in Tunis, Africa. Thirty-one years later, as an act of a grateful public, the United States dispatched a man-of-war to the African coast, American hands opened that grave, placed the dust of his body on board the battleship, and turned again for his native land. Their arrival in the American harbor was welcomed by the firing of guns in the fort and by a display of flags at half-mast. His remains were carried to the nation's Capital City on a special train. There was a suspension of all business, an adjournment of all departments of government, and, as the funeral procession passed down Pennsylvania Avenue, the president, vice-president, members of the cabinet, congressmen, judges of the supreme court, officers of the army and navy, and a mass of private citizens, rich and poor, stood with uncovered heads. To whom did they thus pay homage? To a man who expressed the longing of his heart rather than the happy experience of his life; a man whose soul longed for the domestic tranquillity of a pious home, and he expressed that longing in the words of that sweet song, "Home, Sweet Home."

559 Love's Responses

He stood there in his soggy,
smelly diaper–
a helpless creature
reaching up to his father.

I marveled that anyone could
love this runny-nosed,
candy-smeared,
tear-streaked being
Enough to lift him up,
kiss him, and care for his needs.

I heard your whisper, Lord.
And, I remembered
how I came to You–
heartbroken and dirty
from playing in the world.

Thank You, Father,
For picking me up
and loving me
through my unloveliness.

—Kitty Chappell

560 Why He Loved Her

A young woman who runs a power sewing machine for fifty hours a week in a factory tells the following story of her married life: "My husband, left an orphan, never had a chance to go to school or learn a trade. He is a hard worker and makes very little money, but he loves me enough to trust me with all he earns. My husband does not go to saloons or places of that sort, and he never goes out for pleasure without me. Do you think it hurts me that he can't give me fine clothes when every day he tells me I am the best thing God ever gave him? Every night he kisses my hands that have worked so hard all day. We have been married over a year and never a cross word has been spoken. I did not know anyone could be so happy. Do you think I mind working to help a man like that? His love makes everything worthwhile. Here is a man, ignorant of books, with no business training, yet possessing the rare faculty that guides his home-life in ways of happiness and peace.

561 The Mystery of God's Love

A gentleman who thought Christianity was merely a heap of puzzling problems, said to an old minister, "That is a very strange statement, 'Jacob have I loved, but Esau have I hated.'" "Very strange," replied the minister; "but what is it that you see most strange about it?"

"Oh, that part, of course, about hating Esau."

"Well, sir," said the minister, "how wonderfully are we made and how differently constituted! The strangest part of all to me is that He could ever have loved Jacob. There is no mystery so glorious as the mystery of God's love."

562 Captured by Friends

An escaped prisoner in the Civil War wandered for many days and nights, seeking the Union lines. At last, in the dusk of the early twilight, he came to a camp which he supposed belonged to the Confederates. Before he knew it he was surrounded by the pickets and captured, to be hurried back to prison, as he thought. But what was his surprise and joy, on looking a little closer, to find that it was the Union blue, and not the Confederate gray, that the soldiers wore! He had been captured by his friends. When he thought that his friends were far away they were all around him. Oh, wanderer, and fugitive from God, lift up your eyes; the hosts of your friends surround you! God is near you. Jesus Christ is by your side. The Holy Spirit is hovering over you. The opening of your spiritual eyes will reveal it all.

563 Lack of Love

A friend of mine employed for five years an ex-convict who had seemed to be converted, and during that time this man handled $24,000 a year of his employer's money without the misappropriation of a cent. At the close of that time my friend, not having need for him, told his whole story to a gentleman in an-

other city who needed such a helper, and who received this former convict into his employ. Inside of three weeks he was arrested for stealing from his new employer. And when my friend heard of it he went to see him in the jail and said to him: "Ike, how is it that when you worked for me you could be trusted with anything, and that as soon as you came into this new employment you went back to your old dishonest life?" The man burst into tears and said: "I couldn't help it. He suspected me, and I had to steal."

564 Condition of Adoption

There was a ripple of excitement all through the orphanage, for a great lady had come to take little Jane home with her. The girl herself was bewildered with the thought. "Do you want to go with me and be my child?" the lady asked in gentle tones. "I don't know," said Jane timidly. "But I'm going to give you beautiful clothes, and a lot of things—a room of your own, with a beautiful bed and table and chairs." After a moment's silence the little one said, anxiously: "But what am I to do for—for all this?" The lady burst into tears. "Only to love me and be my child," she said, as she folded the little girl in her arms.

God adopts us, protects, and gives us an inheritance in glory. All He asks in return is that we should love Him and be His children.

565 Love Never Fails

When Romney, the great English artist, was young he fell passionately in love with a young lady of the North of England and they were married. But his real passion was his work. One day he heard that Sir Joshua Reynolds had said that it was a pity that Romney had married, as he had the talents for greatness as a painter, and he would not get very far if he was burdened with a wife. Consequently, Romney left his young wife and came down to London. His work was his one passion now. He made good! Portraits of the first people of the land came from his brush, landscapes, that in this day are worth many, many thousands. He was a lion in London for a time. Then he grew old and ill and, gathering his effects together, went back to his wife in the North, and she took him in and nursed him tenderly till he was laid away. And some one has rightfully said that the spirit manifested by that wife was worth more than all the pictures that Romney ever produced. We treat Jesus that way. We forsake Him and then plan to get back and die in His arms. He never forsakes us, but loves us and abides with us through all our years.

Note in Cambridge edition of Alfred Lord Tennyson's *Poems*

566 Love Begets Love

Walking through my field on a winter's morning, I met with a lamb, that I thought was dead, but taking it up I found it barely alive; the cruel mother had almost starved it to death. I put it inside my jacket and brought it into my house; there I rubbed its starved

limbs, and warmed it by the fire and fed it with warm milk. Soon the lamb revived. First it feared me, but afterwards it thoroughly loved me, as I mostly fed it with my own hands. So it followed me wherever I went, bleating after me whenever it saw me, and was always happy when it could frisk round me, but never so pleased as when I would carry it in my arms. Jesus is our Shepherd—the Shepherd of our souls—and of Him it is said, "He carries the lambs in His arms, and gently leads those that are with young." If you desire to know the love of Jesus, read it in the Bible. There you will find such things as I hope will melt your eyes to tears, your hearts to love.

—Rowland Hill

567 Loving Our Enemies

"But I say unto you, Love your enemies, bless them that curse you, do good to them that hate you, and pray for them that despitefully use you, and persecute you" (Matt. 5:44).

A slave in the West Indies, called Caesar by his master, had gained his freedom and also became a Christian. One day his lord took him to the slave market in search for some new slaves. After securing all he wanted the owner was surprised to hear Caesar beg for the purchase of yet one more, an old tired Negro. "Why, Caesar, should I buy him? Of what use can he possibly be?"

"Please, sir," replied Caesar, "you must buy him for me."

So the purchase was made and the old man returned to the plantation. Soon after he took sick, very sick, and Caesar cared for him as though he were his father. He washed him, waited on him, nursed him in every spare moment he found. Of course the people all noticed this, and tried to guess why Caesar was so devoted to the old man. Finally his master asked, "What connection do you have with that old man? Is he perhaps your father?"

Caesar simply smiled and answered, "No, master, he is not my father."

"Well, is he some old heathen friend or relative?"

"No, master, he is no relative of mine."

"He must be your friend then."

"No, master, he is not my friend."

"But who in the world is he?" asked the master impatiently.

Caesar's eyes moistened as he said, "He is my enemy. While yet a child he tore me from my parents and sold me as a slave. But I must love my enemy, master, I must!"

568 A Testimony of Love

"We know that we have passed from death unto life, because we love the brethren. He that loveth not his brother abideth in death" (1 John 3:14).

During the war in China a village pastor answered a knock at his door and found a Japanese soldier with a Chinese woman outside. He had seen much of Japanese methods

and was, therefore, amazed when this enemy soldier said to him, "This woman is in great danger so I bring her to you for safety. *I, too, am a Christian.*

Baron Von Hugel tells the story of what happened during a violent earthquake in the Roman Campagna. It was a scene of terror and death, where the devastations of nature were made more terrible by the panic of the people. Amid the wreckage, however, moved a secular priest, with two infants, one on each arm, and wheresoever he went he brought order and faith and hope into that confusion and despair. That, also, was a demonstration of love's quiet manner. Its ministry is felt rather than heard.

569 Saved Others But Could Not Save Herself

A little girl eleven years old, who was doing the housework in her home in Elizabeth, New Jersey, during the sickness of her mother, was suddenly horrified to see that her little baby brother had upset the lamp, and his clothing had taken fire. She determined to save the child, and ran with him to a lounge, screaming for help. She rolled him over and over until the flames were put out, although her own clothing had taken fire and she was being burned to death while she was making sure of the baby's safety. She saved the baby, and he was not badly burned, but the heroic girl died after a few hours. The brave little girl was living in the spirit of Him who, when he was hanging upon the cross, was mocked by his persecutors, with the insulting challenge that was truer than they knew, "He saved others; himself he cannot save" (Matt. 27:42; Mark 15:31).

570 A Heroic Young Man

Nicholas Doyle, working in a printing office in New Brunswick, New Jersey, was known in the office as the printer's "devil," but proved himself a noble young hero when the building in which he worked was on fire. The fire originated in the pressroom, and Doyle discovered it. Despite the danger, he rushed upstairs, through the thick smoke, and went to every department giving the alarm, and did not think of trying to save himself until all the rest were safe. By that time escape was cut off by the stairway, and he was compelled to jump from the second-story window, but fortunately was not badly hurt. He saved twenty lives by his unselfish heroism. Christian heroism is like that, in that its chief glory is in its unselfishness. To think first of others and put ourselves last is to follow in the footsteps of Jesus.

571 Homespun Chivalry

A New York reporter was coming across City Hall Square, in a pouring rain, when he noticed an old woman dressed very shabbily and in clothing long out of date; walking by her side was an old man as torn and seedy as herself. But poor and unfortunate as they evidently were, no knight at an emperor's

court was ever more gallant and chivalrous than the old man in care of his feeble wife. He guided her around puddles and between wagons, with his hand ever at her ragged elbow. Never for a moment did they trail miserably along, one behind the other. His hand was upon hers, his glance was directing both. There was evident grace and deference in his every movement. As they reached the bridge entrance he admonished her tenderly: "Watch the steps, Ellen, they do be terribly slippery today." It is the mission of Jesus Christ to make this whole world tender and gentle and chivalrous. So the weak shall lean upon the strong with grateful love, and the strong shall bear the burdens of the weak with sympathetic courtesy.

572 Love Melts Icebergs

A prisoner who found Christ and salvation through the kind and loving ministrations of Mrs. Ballington Booth says: "Love melts icebergs. I do not suppose any prisoner in the United States ever heard a public speaker say, 'I love you all,' till the sweet words came like a fragrant dew upon a dry and parched earth from her overflowing heart. Of course it worked like magic. The frozen ground began to thaw, icy streams melted into liquid rivulets; new purposes arose in my heart as the sap mounts up a grapevine in the spring when baptized in warm sunshine." Love is the secret of Christ's growing grip upon this world; it is the lifting power of

which he spoke in his daring prophecy: "And I, if I be lifted up . . . will draw all men unto me" (John 12:32).

573 A Father's Love

In the Common Pleas Court in Cleveland, Ohio, in the trial of a case, the question was raised as to the affection of a father for his son. A physician testified that when the boy was ill it became necessary, in order to save his life, to secure some living flesh. The father was informed of this, and he unhesitatingly offered to allow the doctor to take as much from his body as he needed for the boy. Thirty pieces of living flesh were literally cut from the father's body, causing excruciating pain and suffering. In the hospital this was engrafted on the poor suffering boy, and he soon began to show signs of renewed strength. During all this time the father did not seem to notice his own suffering, so great was his sympathy for the child. What a commentary such an incident is on such Scriptures as "Like as a father pitieth his children, so the Lord pitieth them that fear him" (Ps. 103:13) or the other declaration of David, "When my father and my mother forsake me, then the Lord will take me up" (Ps. 27:10).

574 Love Develops Kindness

Love blossoms out in inevitable countless kindnesses. And Paul is certain that in proportion as he really loves, he cannot envy. . . . The envious spirit cannot be kind, and

the really kind spirit cannot be envious.

575 Paul's Passion for Souls

He was, at Rome, a prisoner under military custody, chained by the arm both night and day to one of the Praetorian Guard. What passion for souls burned like a pent-up fire in his bones when he not only turned his lodgings into a sanctuary, "receiving all who came to him," but actually used his close contact with these soldiers as a means of extending his acquaintance and influence. With these sentries he spoke of the great salvation, until, as they relieved each other, he was brought into contact with the whole bodyguard unit in turn; and this is doubtless what he means when in Philippians 1:13 (NIV), he says that his bonds became manifest in Christ *throughout the whole of the Palace Guard.* Grand man! the clank of whose chain, like the pomegranates and bells on the high priest's robe, were vocal with the music of the Gospel's message! who could not be kept from witnessing to Christ and winning souls even by present fetters and prospective martyrdom!

576 Love for Mother

A pleasant-faced woman boarded a bus with her two small sons during the busy noon hour of the holiday season. The smaller boy sat with his mother upon one side of the bus, while the other, who was about four years old, took a seat opposite. It interested him to look out of the window, but frequently he glanced across at his mother. At length he called softly, "Mother!" "Mother!" This time it was said a bit louder, and the mother looked over and smiled. The boy's eyes lighted, and he whispered: "Mother! I love you." The mother turned a glorified face upon her small son, and men and women in the bus looked tenderly from one to the other. The city bus had suddenly become a place of blessing because a little boy had voiced this ever beautiful sentiment: "Mother, I love you."

577 Love of Father

I remember to have heard a story of a bad boy who had run away from home. He had given his father no end of trouble. He had refused all the invitations his father had sent him to come home and be forgiven, and help to comfort his old heart. He had even gone so far as to scoff at his father and mother. But one day a letter came, telling him his father was dead, and they wanted him to come home and attend the funeral. At first he determined he would not go, but then he thought it would be a shame not to pay some little respect to the memory of so good a man; and so, just as a matter of form, he took the train and went to the old home, sat through all the funeral services, saw his father buried, and came back with the rest of the friends to the house, with his heart as cold and stony as ever. But when the old man's will was brought out to be read the

ungrateful son found that his father had remembered him along with all the rest of the family, and had left him an inheritance with the others, who had not gone astray. This broke his heart in penitence. It was too much for him, that his old father, during all those years in which he had been so wicked and rebellious had never ceased to love him.

—D. L. Moody

578 Value of Love

A king asked his three daughters how much they loved him. Two of them replied that they loved him better than all the gold and silver in the world. The youngest one said she loved him better than salt. The king was not pleased with her answer, as he thought salt was not very palatable. But the cook, overhearing the remark, put no salt in anything for breakfast next morning, and the meal was so insipid that the king could not enjoy it. He then saw the force of his daughter's remark. She loved him so well that nothing was good without him.

579 True Love Never Gives Up

In Brooklyn one day I met a young man passing down the streets. At the time the war broke out the young man was engaged to be married to a young lady in New England, but the marriage was postponed. He was very fortunate in battle after battle, until the Battle of the Wilderness took place, just before the war was over. The young lady was counting the days at the end of which he would return. She waited for letters, but no letters came. At last she received one addressed in a strange handwriting, and it read something like this—"There has been another terrible battle. I have been unfortunate this time; I have lost both my arms. I cannot write myself, but a comrade is writing this letter for me. I write to tell you you are as dear to me as ever; but I shall now be dependent upon other people for the rest of my days, and I have this letter written to release you from your engagement." This letter was never answered. By the next train she went clear down to the scene of the late conflict, and sent word to the captain what her errand was, and got the number of the soldier's cot. She went along the line, and the moment her eyes fell upon that number she went to that cot and threw her arms round that young man's neck and kissed him. "I will never give you up," she said. "These hands will never give you up; I am able to support you; I will take care of you." My friends, you are not able to take care of yourselves. The law says you are ruined, but Christ says, "I will take care of you."

—D. L. Moody

580 Loving Our Enemy

The story is told of a wounded Scottish Highlander, stroking a German spiked helmet, as he lay upon a cot in a London hospital. A nurse said to him, "I suppose you killed your man?" "No, indeed," was the reply. "It was like this: he lay on the field badly wounded and bleed-

ing, and I was in the same condition. I crawled to him and bound up his wounds; he did the same for me. I knew no German, and he knew no English; so I thanked him by just smiling. He thanked me by smiling back. By way of a token I handed him my cap, while he handed me his helmet. Then, lying side by side, we suffered together in silence till we were picked up by the ambulance squad. No, I didn't kill my man."

581 Service of Love

The following news article comes from *The New York Times:*

Several influential citizens of Long Island declared yesterday that they would commend Patrolman Barney Kearney of the Hunters Point Police Station to Commissioner Enright, after they had seen the patrolman save the life of a shaggy little dog on the Diagonal Street viaduct over the tracks of the Long Island Railroad in Long Island City yesterday afternoon.

The little dog became bewildered from the heavy traffic coming from the Queensboro bridge and was first struck by a truck and hurled to one side and then run over by a passenger automobile. This latter automobile passed over his front legs making them useless.

The dog lay on the floor of the viaduct pawing helplessly with his hind feet when Patrolman Kearney passed on a motorcycle, stopped and bandaged the dog's injuries with his handkerchief, while the dog licked his hands in gratitude. He carried the little dog to a watchman's shanty, laid him on a blanket and telephoned for the Society for the Prevention of Cruelty to Animals.

"Why don't you shoot him?" said one gruff onlooker.

"Would I shoot you if you were run over?" asked Kearney.

The approval of the crowd for this reply caused the man immediately to disappear.

582 Sacrificial Love

A little boy had a canary bird which he loved very much. His mother became ill, and the singing of the bird gave her great annoyance. The boy was told by the mother that the bird gave her great pain by its singing. He went at once and gave the bird away to his cousin, and then came home and told his mother that the bird would not disturb her anymore, for he had given it away. "But did you not love it very much?" she asked him. "How could you part with it?" "Yes," he replied, "but I love you a great deal more. I could not really love anything that gave you pain." We must love God as this boy loved his mother, more than we love anything else, and also everything that grieves Him we must give up, however much we may like it.

583 Gift of the Heart

A touching incident has been told of a sixteen-year-old girl who was a chronic invalid, and whose mother was a pleasure-loving woman who could not endure the idea of being much with her shut-in daughter. While the mother was traveling abroad in Italy, she remembered the coming birthday of her daughter, and sent her a rare and wonderful Italian vase. The trained nurse brought it to the girl, saying that her mother had sent it so carefully that it came right on her birthday. After looking at its beauty for a moment the girl turned to the nurse and said: "Take it away, take it away. O mother, mother, do not send me anything more; no books, no flowers, no vases, no pictures. Send me no more. I want you, you!"

Don't give Christ things—only things. He wants you. "Son, daughter, give me your heart." That daughter wanted her mother. She wanted her presence, her companionship, her love. Christ wants you. He wants you first of all. He wants your yielded heart, your confidence, your trust, your union with Him. He wants your love, prompting you to give the best possibilities you have. He says, "I want you, you." Your heart fully given, He knows all else will follow.

584 The Love of Beauty

An experiment is being tried in the poorest and most degraded quarters of London, of seeking to arouse an interest in art. The result is very gratifying. The Whitechapel Art Gallery is justifying itself in a way that is surprising some of its keenest supporters. During the first month an average of about ten thousand people a day visited the gallery, and they showed the most intense interest in the pictures. The fact is, human nature is a good deal alike everywhere, and the love of beauty and the longing for knowledge, as well as the possibility of goodness, are in every man and woman. Man does not belong to the devil. Satan is only an invader.

585 Chastening Proof of Love

A gentleman saw a dozen boys teasing an aged beggar. The gentleman stepped up to them, and taking one of the boys by the collar, he shook him, and took him home (presumably for further discipline). But the other boys he did not meddle with. Now, why did he punish that boy and leave alone the others? Because it was his own son! The very word "chasten," to make chaste, to make pure, has a depth of significance.

586 The Touch of Love

An opal lay in the case, cold and lusterless. It was held a few moments in a warm hand, when it gleamed and glowed with all the beauty of the rainbow. All about us are human lives of children or of older persons, which seem cold and unbeautiful, without spiritual radiance or the gleams of indwelling light which tell of immortality. Yet they need only the touch of a warm human hand, the

pressure of love, to bring out in them the brightness of the spiritual beauty that is hidden in them.

—J. R. Miller

587 On the Latch

"For the Son of man is come to seek and to save that which was lost" (Luke 19:10).

I have heard of a girl who in an evil hour left her mother—won by the promises of some villain, and traveled to a large city. And there went down to the lowest depths. At last all sad at heart and perishing with hunger she thought she would creep back and see the old home again, and die. Of course her mother would never receive her anymore, but nobody in the village would know her, and it would be good to see the cottage and the flowers of the garden and to hear the birds sing again. And so with heavy heart and wearied steps she wandered on until she reached the little village. It was night when she got there. Footsore and faint she could just stand by the gate, and, dark as it was, the stars would give light enough to see the place—and there she would stand and try to feel again as she had done long ago. But, as she came near, a light glimmered along the path and she saw that it was her mother's cottage. Long ago her mother must have gone to bed. What did this mean? And wondering she came on—and she found the gate was set wide open—the gate that was always so carefully shut, and noiselessly she crept to the door. It was on the latch, the door that always used to be bolted and barred at night. She stepped within, and whispered wondering, "Mother." Ah, it was enough, the arms were about her neck. Their tears mingled together, and love, as deep and true and full as ever, welcomed her home and loved her into goodness. And she found that ever since she had left her home that door had been on the latch, that gate was left wide open, and in the window was the candle set to guide her steps. That was a mother's love, but very far beyond that is the Savior's love.

588 Motherly Love

That grand old man of English statesmanship, William Gladstone, one day arose in Parliament and solemnly announced that he had a sad statement to make. "Princess Alice is dead," said he; "and love did it." Her boy was ill with diphtheria and near to death. The physician had cautioned her not to come close enough to the child to breathe his breath. But the little fellow looked up from his bed, reached out his tiny arms, and said feebly, "Mamma, please come and kiss me." And she did it, in spite of warning, and at the cost of her own life.

589 A Mother's Sacrifice

One night of bitter cold and pitiless storm a mother was out in the wilds with her child in her arms. Unable to carry her precious bur-

den and find a shelter, she took off her own outer clothing, and wrapping it about her little one she laid him in a cleft of the rock, and hastened on, hoping to find help. Next morning some shepherds heard the cry of a child, and found the babe safe and warm in the rock's cleft. Then, not far away in the snow, they discovered the mother—dead. She had died in the cold to save her child. Did not Jesus do the same?

—J. R. Miller

590 "I Am The Boy"

Fanny Crosby, the blind songwriter, was at the McAuley Mission. She asked if there was a boy there who had no mother, and if he would come up and let her lay her hand on his head. A motherless little fellow came up, and she put her arms about him and kissed him.

They parted; she went from the meeting and wrote that inspiring song *Rescue the Perishing;* and when Mr. Sankey was about to sing the song in St. Louis he related the incident. A man sprang to his feet in the audience and said, "I am the boy she kissed that night. I never was able to get away from the impression made by that touching act, until I became a Christian. I am now living in this city with my family, am a Christian, and am doing a good business."

591 A Hard Heart Broken

A Christian woman, laboring among the degenerate of London, found a poor street girl desperately ill in a bare cold room. With her own hands she ministered to her, changing her bed linen, procuring medicines, nourishing food, building a fire, and making the poor place as bright and cheery as possible, and then she said, "May I pray with you?"

"No" said the girl, "You don't care for me; you are doing this to get to heaven."

Many days passed, the Christian woman unwearily kind, the sinful girl hard and bitter. At last the Christian said, "My dear, you are nearly well now, and I shall not come again, but as it is my last visit, I want you to let me kiss you," and the pure lips that had known only prayers and holy words met the lips defiled by oaths and unholy caresses—and then the hard heart broke. That was Christ's way.

592 Love One Another

Human nature is selfish. The new nature is to be affectionate. Much of the Ten Commandments are introduced with "Thou shalt not." A "new commandment" is positive, and it may well secure our obedience, coming, as it does, from the lips of Jesus, who is Love incarnate. "Love one another," notwithstanding faults and weaknesses. How unlovely we were; yet Christ loved us! Let us show that we have learned and are learning of Him, by the love we display to one another.

—John Hall

593 Let Love Abound

Every element in our nature is to be under the influence of grace, and we are bound to make the best use of every faculty. We have affections. They are to be set on things above. They are also to go out towards the rest of the redeemed family. They are to become stronger as life advances. Our love is to "abound." We have understanding. It is to be exercised in reliance on divine guidance. How often we make mistakes in our own wisdom, and then wonder why Providence sends us the troubles these mistakes occasioned! Let us approve things that are excellent, and then we shall have no stumbling-block ("offense") in our own minds or before others.

—John Hall

594 Maturity

When Donna was three years old she gave me a birthday card which ended with, "I love you, Daddy! Donna!" When she wrote "D" for daddy she came to the end of the page and at the beginning of the next line wrote "addy." Do you think I gave it back and told her to do it right? Of course not. It was full of love and hard work and 3-year-old ability. Her love on the inside came to the outside and showed itself in words and works just like ours should for our heavenly Father.

595 All His Strength

A little boy declared that he loved his mother "with all his strength."

He was asked to explain what he meant by "with all his strength."

He said, "Well, I'll tell you. You see, we live on the fourth floor of this tenement; and there's no elevator, and the coal is kept down in the basement. Mother is busy all the time, and she isn't very strong; so I see to it that the coal hold is never empty. I lug the coal up four flights of stairs all by myself. And it's a pretty big hold. It takes all my strength to get it up here. Now, isn't that loving my mother with all my strength?"

Gospel Herald

596 What Is Christmas?

"Mommy, what is Christmas?," asked the three-year-old girl. Her mother carefully explained that Christmas is Jesus' birthday. "Then why do we not give gifts to Jesus if it's His birthday?" The mother explained the tradition of exchanging Christmas gifts as expressions of our love for each other, and that seemed to end the matter.

It did not come up again until Christmas Eve when a sleepy little girl placed a package under the Christmas tree on her way to bed and explained that it was a birthday gift for Jesus which she was sure He would open during the night while she slept. After she was asleep, the mother not wanting her daughter to be disappointed, opened the clumsily wrapped package and found the box empty.

On Christmas morning the little girl was thrilled to find the package had been opened and her gift

was gone. "What was in it?" asked the confused mother. "It was a box full of love," came the answer.

How childlike! How Christlike!

—Beverly I. White
The Christian Reader

Marriage

597 *Helpfulness*

One wintry day Nathanael Hawthorne, the American author, went home with a heavy heart, having lost his government appointment. He cast himself down, as men generally do under such circumstances, and assumed the very attitude of despondency. His wife soon discovered the cause of his distress. But instead of indulging in irrational hysterics, she kindled a bright fire, brought pen, ink, and paper, and then, lovingly laying her hand on his shoulder, exclaimed, as she gazed cheerfully in his face, "Now you can write your book." The words worked like a magic spell. He set to work, forgot his loss, wrote his book, made his reputation, and amassed a fortune.

598 *Healthy Marriages*

Healthy marriages begin with biblical, practical relationship instruction we give to our teens. It includes giving sound and convincing reasons for sexual abstinence before marriage, raising our teenagers' standards of expectations regarding the kind of marital relationship they are willing to wait for, instead of settling for second best. It involves developing their biblical self-respect and self-confidence so that it will motivate them to catch the vision to skillfully advance beyond the level of intimacy and harmony between husband and wife which they have seen modeled in their own home.

Healthy marriages require strenuous preparation during engagement. At no time in life is a person more motivated to work hard on relational skills than in those few precious months just prior to marriage. That overwhelming sense of optimism and confidence that comes from "feeling in love" provides a unique window of opportunity for a couple-to-be to honestly face issues that normally would be neatly locked deeply beneath their self-protective psychological defense mechanisms. The ancient adage, "an ounce of prevention is worth a pound of cure," is true; facing potential problems in marriage before they say "I do" is vastly preferable to trying to pick up the scattered pieces afterwards.

Healthy marriages need extra encouragement during the parenting years. That is when the initial glowing willingness to sacrifice anything for each other tends to fade (backslide?) into self-centeredness and conflict as life's priorities get powerfully tested by pressures growing concurrently with babies and toddlers.

Healthy marriages still need continual attention in the empty nest years. Cars need regular maintenance. Bodies need physical checkups. Teachers and doctors need continuing education. Workers need training for new skills. It should not seem strange to us, then, that marriages of all stages of life need similar maintenance for healthy relational growth.

—Dale Johnsen

599 A Covenant, Not a Contract

Marriage is a covenant, not a contract. There is a big difference. God made a blood covenant with Abraham in Genesis 15 by cutting five animals in two and laying their carcasses on both sides of a path, with God "walking through" these body parts. This represents the absolutely binding nature of a covenant, for it says that "If I ever violate this covenant, may I be torn in two just like these animals."

Have you thought of your marriage covenant in that way?

Don't ever give up on your marriage, no matter what comes your way. When friction festers into fights, new "oil" is needed to relubricate the relationship. When romance disappears into a dull fog of mundane sameness, fresh oxygen is needed to fan the cooling embers into sparks that will rekindle the glowing flames of love. When chronic financial distress threatens the emotional equilibrium of the home; or when dysfunctions and compulsions surface like white caps in the bay to rock the family boat; or when in-law interference, tangled expectations, health crises or other predictable issues persist as huge problems that won't go away, biblical words of help and encouragement are needed to revive the marriage out of the emergency room and carry it gently into rehabilitative therapy. Whether it's the hot flare-ups of polarization or the long dry dredges of boredom and disillusionment, decide now that you will fight what infects the intimacy of your marriage relationship.

Keep your vows. Never give up. God will reward your faithfulness.

—Dale Johnsen

600 Becoming "One Flesh"

Marriage is a unique human relationship. Good friend-to-friend relationships are rewarding and good parent-child relationships are important. However, according to Scripture, no other human relationship should receive the degree of attention required for a successful marriage, and no other relationship can provide the satisfaction that a good marriage does.

In Genesis 2:24 (NASB), God states the unique purpose of marriage, *"For this cause a man shall leave his father and mother, and shall cleave to his wife, and they shall become one flesh."* Such unity will not happen all at once. And even after unity is achieved, it will have its "ebbs and flows."

Achieving unity is impossible without the power of Jesus to make

each partner a child of God—a Christian. Romans 6 teaches us that unity with Christ creates a new person. This new person can then achieve unity with another human being.

As we depend on Christ's power and obey Him, the Holy Spirit provides the strength to do what our own strength could not do. Galatians 5:16 (NIV) says, "*So I say, live by the Spirit, and you will not gratify the desires of the sinful nature.*" A vibrant relationship with Christ will help a couple to truly become "one flesh."

The joys of a good marriage which is based on a biblical relationship with Christ has rewards in this world and beyond!

—Jim Wilson, Jr.
Glen Rock Light

Obedience

601 Holding the Father's Hand

Mr. Sankey tells the story of his boy who was with him, when a little fellow, in Scotland, and for the first time he possessed what in that country is known as a top-coat. They were walking out one cold day, and the way was slippery. The little fellow's hands were deep down in his pockets. His father said to him: "My son, you had better let me take your hand," but he said you never could persuade a boy with a new top-coat to take his hands from his pockets. They reached a slippery place and the boy had a hard fall. Then his pride began to depart and he said: "I will take your hand." and he reached up and clasped his father's hand the best he could. When a second slippery place was reached, the clasp was broken and the second fall was harder than the first. Then all his pride was gone, and raising his little hand he said: "You may take it now"; and his father said: "I clasped it round about with my great hand and we continued our walk; and when we reached the slippery places," said he, "the little feet would start to go and I would hold him up." This is a picture for the Christian. I am saved not so much because I have hold of God as because God has hold of me, and He not only gives me shoes with which I may walk and which never wear out, but Christ holds my hand in His and I shall never perish, neither shall any man pluck me out of His hand.

—J. Wilbur Chapman

602 Clear Conscience

A little boy was seen one day lounging around a circus tent. If there is anything in the world tempting to a boy it is a circus, and, knowing this, a gentleman said:

"Come, Johnny, let's go into the circus."

"No," said the boy, "father would not like it."

"But your father need not know it," said the man.

"But I will know it," said the boy, "and when father comes home tonight, I could not look up into his face."

Ah, how important! Able to look into our Father's face! He has been very good to us. No good thing has He withheld from us, and yet so many times we find ourselves unable to look into His face. God help us to live so close to Himself, so pure and so holy, that all the time we can be able to look into His face.

603 Obedience Better than Sacrifice

A wealthy man called on his dentist in great distress over a broken front tooth. The dentist told him it must come out. "No, no, you must build it up," exclaimed the man of riches. "I can't spare that tooth. Its removal would make my mouth look like an open port-hole." "Oh, well, I can replace it," complacently answered the dentist. "The old one must certainly come out, but I will put in a new one that will make you look better than ever before. It will be firm and regular and much more attractive than the old one." "Ah!" muttered the wealthy man. "That's what I want, make it as attractive as possible. Say, doctor, couldn't you set a large diamond in the middle of it?" "Oh, no, I wouldn't do that," replied the dentist, hastily. "Of course I know you can well afford it, but it would look—well, just a trifle too conspicuous, don't you know." Perhaps the rich man was only joking, but there are a good many people who wear their profession of religion like that. It is all show and display, and no loving obedience or humble service in it. One ounce of obedience is worth a ton of showy sacrifice.

604 Loving Obedience

Obedience must be the struggle and desire of our life. Obedience, not hard and forced, but ready, loving and spontaneous; the doing of duty, not merely that the duty may be done, but that the soul in doing it may become capable of receiving and uttering God.

—Phillips Brooks

605 Great Heroism

General Elliott, governor of Gibraltar during the siege of that fortress, was making a tour of inspection to see that all under his control was in order, when he suddenly came upon a German soldier standing at his post silent and still, but he neither held his musket nor presented his arms when the general approached.

Struck with the neglect and unable to account for it, he exclaimed, "Do you know me, sentinel, or why do you neglect your duty?"

The soldier answered respectfully: "I know you well, general, and my duty also; but within the last few minutes two of the fingers of my right hand have been shot off, and I am unable to hold my musket."

"Why do you not go and have them bound up, then?" asked the general.

"Because," answered the soldier, "in Germany a man is forbidden to quit his post until he is relieved by another."

The general instantly dismounted his horse. "Now, friend," he said, "give me your musket, and I will relieve you. Go and get your wounds attended to."

The soldier obeyed, but went to the nearest guardhouse, where he told how the general stood at his post; and not till then did he go to the hospital and get his bleeding

hand dressed. This injury completely unfitted him for active service; but the news of it having reached England, whither the wounded man had been sent, King George III expressed a desire to see him, and for his bravery made him an officer.

606 Value of Obedience

Years ago a famous children's specialist said to me: "When it comes to a serious illness, the child who has been taught to obey stands four times the chance of recovery that the spoiled and undisciplined child does." Those words made a lasting impression upon me. Up to that time I had been taught that one of the Ten Commandments was for children to obey their parents. Never had it entered my mind that a question of obedience might mean the saving or losing of a child's life.

607 Patience in Obedience

We know very well that when we prune a tree in the right manner, we prune it for fruit, and that we must wait a certain length of time for the fruit to appear; but suppose a man should take his knife and cut the branch, and look, and say, "There is no fruit here, after all?" The gardener would say to him, "Why, my friend, you must have patience, and give the fruit time to develop itself. Wait till next year, or the year after, and then you may begin to look for fruit."

And so the Apostle says, "Ye have need of patience, that, after ye have done the will of God, ye might receive the promise."

608 A Peculiar People

The following quotation is from the pen of D. L. Moody:

"I suppose that if you had asked the men in Elijah's time what kind of man he was, they would have said, 'He is very peculiar.' The king would say, 'I hate him.' Jezebel did not like him; the whole royal court didn't like him, and a great many of the nominal good people didn't like him; he was too radical. Be willing to be one of Christ's peculiar people, no matter what men may say of you."

609 If Ye Obey

The setting of the less finite into the complete infinite nature Christ calls by various names. Sometimes it is *faith:* you must *believe* in God. Sometimes it is *affection:* you must *love* God. Always what it means is the same thing—you must *belong* to God. Then His life shall be your life. "I am come that they might have life, and that they might have it more abundantly" (John 10:10). Sometimes He seems to gather up His fullest declaration of this vital connection of man with God and call it in one mighty word, *Obedience.* You must *obey* God, and so live by Him.

—Phillips Brooks

610 A Life Long Learner

In *Teaching to Change Lives,* Howard Hendricks tells about an 83-year-old Michigan woman he

met at a Sunday school convention in Chicago.

"In a church with a Sunday school of only 65 people, she taught a class of 13 junior high boys. She had traveled by bus all the way to Chicago the night before the convention. Why? In her words, 'to learn something that would make me a better teacher.'

"I thought at the time, most people who had a class of 13 junior high boys in a Sunday school of only 65 would be breaking their arms to pat themselves on the back: 'Who, me? Go to a Sunday school convention? I could teach it myself!' But not this woman.

"Eighty-four boys who sat under her teaching are now in full-time vocational ministry. Twenty-two are graduates of the seminary where I teach."

Discipleship Journal

611 Seven Day Waiting Period

Noah and his family had no doubt spent years building the ark. Now Noah and his family were inside the ark and the Lord Himself had closed the door. The waiting now began. For seven days Noah and his family waited. And waited.

I wonder what went through the mind of Noah during these seven days of waiting? Did Noah wonder whether God would be faithful to His promise? Did Noah ever fear his labor had been in vain? These seven days of waiting must have seemed like an eternity! But finally, any questions Noah might have

had were answered as the sky began to grow dark and the rain began to fall. The waiting was over!

As Christians today we too are in a period of waiting. According to 1 John 3:2 (NKJV), "... *it has not yet been revealed what we shall be, but we know that when He is revealed, we shall be like Him, for we shall see Him as He is.*" Yes, someday we are going to see the One who walked up Calvary's hill for us. We are going to be changed as the *"mortal puts on immortality"* (see 1 Cor. 15:53). We do not yet know what we shall be, but we know *"we shall be like Him."* We then shall be taken to that *"city of gold"* whose *"builder and maker is God"* (Rev. 21:18; Heb. 11:10). But this is something for which we must wait! We must also sometimes wait for God to answer prayers in our lives. Sometimes He responds to our prayers by saying "yes," at other times "no," and then sometimes "later." But whatever the answer, we must be willing to wait for the Lord to bring about His will in our lives.

"But those who wait on the Lord
Shall renew their strength;
They shall mount up with
* wings like eagles,*
they shall run and not be weary.
They shall walk and not faint"

(Is. 40:31).

Noah was a man who waited on the Lord and so must we! Think about it.

—Gaylon Williams
Broad Street Banner

612 Dogs and Sheep

We have two dogs. These two mixed-breed mutts are lovable but they can cause a lot of problems. For one thing they like to escape and play with the neighbor's dogs and kids, so we have to keep them penned up when we're not out in the backyard.

But those dogs don't like that pen. They'd rather run free. When we first started training them it was a hassle to drive them into the pen. Often we'd get one in the pen and then try to get the other in. When we opened the gate, the first one would run out as we put number two in.

Then Lynn discovered a secret which she shared with me. The secret: it's easier to lead those dogs than to drive them.

With two doggie treats we walk outside. The dogs can smell the food and get excited. We walk ahead of them and say "night-night." They usually beat us to the pen.

People are like sheep! The Bible tells us this (Ps. 100:3). You cannot drive sheep. You have to lead them.

Likewise, you cannot drive non-Christians into becoming Christians—you must lead them. You cannot drive Christians into obedience—you must lead them! (1 Pet. 5:1-5). In our dealings with family and friends (both inside and outside the church), let's learn this valuable lesson. Leading means doing our best and providing an example to follow. Leading is teaching with both our words and our actions.

—Larry Fitzgerald

Pastors

613 Ministers Must Deal Faithfully

Ministers should not be merely like dials on watches, or milestones on the road, but like clocks and alarms, to sound the alarm to sinners. Aaron wore bells as well as pomegranates, and the prophets were commanded to lift up their voices like a trumpet. A sleeping sentinel may be the loss of the city.

614 Instant in Season

At the beginning of the present world war it is said that a clergyman appeared before Bishop William Taylor-Smith, Chaplain General of the British army, and applied for a chaplaincy. Because he was a part of the great Church of which the Bishop was a leader, he felt reasonably sure of an appointment.

It is said that Bishop Taylor-Smith looked intently at him for a moment, then taking his watch from his pocket, said: "I am a dying soldier on the battlefield—I have three minutes to live—what have you to say to me?"

The clergyman was confused and said nothing.

Then the Bishop said: "I have two minutes to live—what can you tell me to help my soul?" and still the waiting clergyman made no response. Then said the Bishop solemnly: "I have only one minute to live."

With that the clergyman reached for his Prayer-Book, but the Bishop is reported to have said: "No, not that at such a time as this," and because the clergyman had nothing to say to the dying soldier upon the battlefield, he did not received his appointment.

—J. Wilbur Chapman

615 Universal Gospel

The late Duke of Wellington once met a young clergyman, who, being aware of his Grace's former residence in the East, and of his familiarity with the ignorance and obstinacy of the Hindus in support of their false religion, gravely proposed the following question: "Does not your Grace think it almost useless and absurd to preach the Gospel to the Hindus?" The Duke immediately rejoined: "Look, sir, to your marching orders, 'Preach the Gospel to every creature.'"

—F. F. Trench

616 "We Would See Jesus"

(John 12:21)

On a lovely Sunday morning in August we arrived at Osborne. We were desirous of seeing Her Majesty, but did not succeed. We only saw her house, her gardens, and her retain-

ers. Then we went to Whippingham Church, having been told that the Queen would attend service. But again we were disappointed. We only saw the seat the august lady was known to occupy. The ladies and gentlemen of the court came to church, and those we saw; we even heard the court-chaplain preach, but of the sovereign we saw nothing. Well, this was a disappointment we could easily get over. But with me it led to a serious frame of thought. I said to myself: "What if the flock committed to your care should come to church to see the King of kings, and yet through some fault of yours not get to see Him! What if you, the great King's dependent, detain men with yourself, by your words and affairs and all sorts of important matters which yet are trifles in comparison with Jesus! May it not be that we ministers often thus disappoint our congregations?

—Pastor Funcke

617 Anxieties of Pastoral Care

St. Francis, reflecting on a story he heard of a mountaineer in the Alps, who had risked his life to save a sheep, says: "Oh, God, if such was the earnestness of this shepherd in seeking for a lowly animal, which had probably been frozen on the glazier, how is it that I am so indifferent in seeking my sheep?"

618 Importance of Prayer for Ministers

"Brethren, pray for us" (1 Thess. 5:25; 2 Thess. 3:1). Paul makes this request seven times in his epistles. He knew that the success of the minister depended largely on the prayers of God's people. Some congregations seem to be pervaded largely by a heavenly atmosphere. You feel its hallowed influence the moment you enter the house. It matters not how rich may be the tones of a bell; if it be struck *in vacuo* or under water, you get no sound, or only a heavy thud; strike it in the air and how mellow its notes ring out. So with preaching in or out of the atmosphere of devotion. A praying people make a strong pulpit. A Paul may plant and an Apollos may water, but it is God who gives the increase, and He gives it only in answer to prayer.

619 Pastor, Praise Your Wife

Much of a pastor's success results from his wife's prayers, steadiness, encouragement, and correction. Her contentment rests largely on his recognition of her as his help-meet.

Perhaps no one in the entire church has as difficult a job as the pastor's wife. But if her husband praises her (Prov. 31:28), he will find her his greatest support. She will be blessed by knowing they both serve Christ.

We have to understand that the model of our family life outweighs our finest messages.

The church looks beyond the sermon and into the home.

—David S. Gotaas
From "Who's Keeping Your Vineyard?"
Moody Monthly

620 The Preacher's Wife

There is one person in your
 church
Who knows your preacher's life
Who wept and smiled and
 prayed with him,
And that's your preacher's wife.

The crowd has seen him in his
 strength,
When wielding God's sharp
 sword,
As underneath God's banner
 folds
He faced the devil's horde.

But deep within her heart she
 knows
That scarce an hour before,
She helped him pray the glory
 down
Behind the closet door.

She's heard him groaning in his
 soul
When bitter raged the strife,
As, hand in his, she knelt with
 him
For she's the preacher's wife!

You tell your tales of prophets
 brave
Who marched across the world,
And changed the course of history,
By burning words they hurled.

And I tell how back of each
Some woman lived her life,
Who wept with him and smiled
 with him—
She was the preacher's wife.

—Author unknown
Baptist Challenge

Prayer

621 Effectual Prayer

It is not the arithmetic of our prayers, how many they are; nor the rhetoric of our prayers, how eloquent they may be; nor the geometry of our prayers, how long they be; nor the logic of our prayers, how argumentative they may be; nor the method of our prayers, how orderly they may be: it is fervency of spirit which availeth much!

622 Prayer Work

"I am sorry I am late today," said a clergyman visiting an aged parishioner, "but I have been all round the parish." "Why," said the old woman, "that's just where I've been!" "But you cannot walk," exclaimed the astonished minister. "Ah," said the old saint, "you see, my *soul* isn't bedridden! So I just go round the parish every day in prayer, while I lie here."

623 Expectant Prayers

A beautiful little book, *Expectation Corners*, tells us of a King who prepared a city for some of his poor subjects. Not far from them were large storehouses, where everything they could need was supplied if they but sent in their requests. But on one condition—they should be on the outlook for the answer, so that when the kings' messengers came with the answers to their petitions, they should always be found waiting and ready to receive them. The sad story is told of one despondent, one who never expected to get what he asked, because he was too unworthy. One day he was taken to the king's storehouses, and there, to his amazement, he saw, with his address on them, all the packages that had been made up for him and sent. There was the garment of praise, and the oil of joy, and the eye-salve, and so much more; they had been to his door, but found it closed; he was not on the outlook. From that time on he learned the lesson Micah would teach us: "I will look to the Lord; I will wait for the God of my salvation; my God will hear me" (Mic. 7:7).

—Andrew Murray

624 Praying Members

Mr. Moody tells us a remarkable incident in connection with an early visit to London. He had gone there for a visit. He was unknown in London, hence he did not expect to preach; but a little while after arriving there he was invited to preach for a certain church, which he did. He described the ceremony as a very cold and uninter-

esting service to him, but he announced that he would preach again that night.

Upon reaching the church, he noticed that the atmosphere had changed, he did not know just why. At the close of the meeting he was led to give an invitation for those who wanted to be saved to stand. A great crowd of people stood. He left the next day for Dublin, Ireland. Shortly after arriving there he received a telegram from the church to return, stating that the whole community was in an upstir and clamor for a series of meetings. He went back and found that a great revival was beginning, and hundreds of people were being converted.

Not long after he learned the secret. An invalid lady, who could not attend the church, was praying for a mighty outpouring of the Spirit upon the church. She prayed for months. Once she saw in the papers' accounts of some of the Moody meetings in America, and, although she had never heard of Mr. Moody before, she began to pray that God would send him to her church in London for a revival. One Sunday morning her sister, upon her return from the service, informed her of Moody's presence and his preaching, whereupon she spent the whole afternoon in prayer that God would make that night a night of power. That explains the difference between morning and evening services!

Oh, I tell you what we need in the churches is praying members!

Oh, if we could find even one who would thus resolve to pray to God for salvation and power to come upon the church. This is the need of today—importunate prayer, like the Syro-Phoenician woman's "Lord, help! Lord, help!" (Matt. 15:22–28).

625 Prayer for Ministers

John Livingston, of Scotland, once spent a whole night with a company of his brethren in prayer for God's blessing, all of them together besieging the throne; and the next day, under his sermon, five hundred souls were converted. All the world has heard how the audience of Jonathan Edwards was moved by his powerful sermon on "Sinners in the Hands of an Angry God"; some of them even grasping hold of the pillars of the sanctuary, from feeling that their feet were actually sliding into the pit. But the secret of that sermon's power is known to but very few. Some Christians in the vicinity of Enfield, Massachusetts had become alarmed lest, while God was blessing other places, He should in anger pass them by; and so they met on the evening preceding the preaching of that sermon, and spent the whole night in agonizing prayer.

626 Thanksgiving with Prayer

A child knelt at the accustomed time to thank God for the mercies of the day, and pray for His care through the coming night. Then as usual came the "God bless mother

and—." But the prayer was stilled, the little hands unclasped, and a look of sadness and wonder met the mother's eye, as the words of helpless sorrow came from the lips of the kneeling child, "I cannot pray for father anymore."

Since her little lips had been able to form the dear name, she had prayed for a blessing upon her father. It had followed close after her mother's name. But now he was dead. I waited for some moments, and then urged her to go on. Her pleading eyes met mine, and with a voice that faltered, she said: "Oh, mother, I cannot leave him all out; let me say, 'Thank God that I had a dear father once'; so I can still go on and keep him in my prayers." And so she still continues to do, and my heart learned a lesson from the loving ingenuity of my child. Remember to thank God for mercies past as well as to ask blessings for the future.

627 An Answer to Prayer

George was a working man much given to drink, who, through the prayers and example of a wise and godly wife, had been led to total abstinence and to repentance. Christmas, however, was coming on. It was the custom for the chief manager to give the men a keg of beer to make merry with at that time. George was afraid of the coming temptation. He was standing on a ladder at a considerable height from the ground; it was three in the morning; he was in prayer, asking that this time of fierce temptation, as he felt it would be, might pass over him without his being drawn into sin. Suddenly his feet slipped; he fell down on an iron bar below, and, being a heavy man, was doubled over it, and then dropped to the ground. He was carried home in intense agony, and put to bed. There he lay for nearly a week. During this time his repentance was deepened, his view of sin increased, his trust in Christ strengthened, and when he came forth, it was found that no internal injury had been sustained. But the object was accomplished; the danger was over; Christmas passed, and God's penitent servant was safe and well. "Did not God," said George himself, "answer my poor prayer as completely and immediately as if I had seen *His* hand making my feet to slip, and causing me to fall, that I might stand and not fall?"

628 Undergirding Prayer

When Dr. J. Wilbur Chapman had finished his first sermon as the newly elected pastor of the Bethany Presbyterian Church in Philadelphia an aged man leaning upon his cane approached the famous preacher, and said, "I am afraid you will make a failure here."

That wasn't much of an encouragement for a young man entering a new pastorate, but Dr. Chapman waited patiently for the old man to finish his remarks. "You see," he continued as he drew closer to Dr. Chapman, "we have always had a man of large experience, and this is a large church. But I have made up

my mind to help you!"

Dr. Chapman wondered just how this crippled old man could help him, keep him from failing as pastor of the church.

"I have resolved to pray for you every day that you are pastor in this church, and I have covenanted with two other men to pray for you."

The three men grew to ten, the ten to fifty, the fifty to a hundred, and the hundred increased until there were as many as three hundred and fifty to five hundred men who would meet with Dr. Chapman at 9:45 Sunday morning to pray with him and for him as he preached. With such undergirding it is not surprising that in less than three years Dr. Chapman should have received eleven hundred persons into the church on confession of faith.

629 Maternal Prayers

"And she vowed a vow, and said, "O Lord, if thou . . . wilt give unto thine handmaid a man child, then I will give him unto the Lord all the days of his life. . . ." (1 Sam. 1:11).

"Only a short time ago," writes an eminent preacher, "I was shown an old bundle of letters faded with age in which a mother—long dead now—set down all her longings for her wonderful baby boy; and as I read, my soul blushed red. The writer of those letters was my mother, and the baby boy was I."

His mother's longings and prayers became the inspiration of a more consecrated ministry. Her prayers

had followed him through the years.

Another example of this very thing came out of World War I. "When you go home will you do me a favor, Padre?" asked a lad dying on one of Flander's Fields. "Certainly, my boy, what is it?" replied the chaplain. Then slowly drawing a ring from his finger, he said in a faltering voice: "My mother gave me this ring to remind me that every time I looked at it she would be praying to God for strength to help me keep straight. Will you give it to her, Padre, and tell her that I have been greatly helped to keep straight?"

A bundle of letters and a precious ring—lovely tokens of a mother's unending intercession for her children. God grant us the vision of the power of fervent, effectual praying (James 5:16)!

630 A Prayerless Day

"Ye have not, because ye ask not. . . ." (James 4:2).

A German merchant, named Hahnel, in his last hours called for his children at his bedside. He related this story.

"Once in my younger years I made a business trip. My team was obliged to delay for a short time. I, however, stepped into a church that was nearby, in which services were being held just at that hour. The minister spoke of the blessedness and value of prayer, and frequently repeated the words, 'A day without prayer is a day without blessing.'

"In the midst of all the cares and labors of my later life I have found

that alone in prayer is discovered the deeper rest and cheerfulness, the courage and strength for both life and death. For God, to whom my spirit is about to go, became long ago through prayer an old familiar friend of mine, whose face I daily sought, and now I rejoice in the midst of the pains of death that I shall look upon His loving countenance.

"So now that I am about to leave you, I know of nothing more valuable to leave you than the exhortation to prayer, for in and with prayer you have everything you can wish for both time and eternity."

Then in simple faith the aged father raised his voice for the last time in prayer. "My Lord and my God, Thou didst love me first, and I in my weakness and sin have learned to love Thee. . . . Let it be my last prayer that the sweet name of Jesus and His divine power may never depart from the heart and life of my children and children's children. Make Thou in this home a family of prayer, for Thy Name's sake. Amen."

631 Prayer and Work

"Therefore said he unto them, The harvest truly is great, but the laborers are few; pray ye therefore the Lord of the harvest, that he would send forth laborers into his harvest" (Luke 10:2).

Prayer and work go together. Yet many believers are like the clownish fellow whose cart was stuck in the mud. He began to cry and pray that Hercules would come and help him. But Hercules, looking down from his cloud, bid him not to lie there crying, but to get up, put his shoulder to the wheel, and work!

A living example of working by prayer is found in the diary of David Brainerd. At the beginning of his ministry, and while yet very young, he spent hours and days "in the power of intercession for precious, immortal souls, for the advancement of the kingdom of my dear Lord and Savior in this world." He continued to say, "I grasped for multitudes of souls." Small wonder the Lord so marvelously used this man in His service.

632 One of Daniel's Habits

Daniel had a habit of praying to God. No doubt his pious mother taught him to pray when he was a little boy, and when as a promising young prince he was carried away captive to Babylon to be educated for the public service in a foreign land, Daniel was so in the habit of praying that he continued his prayers as faithfully in Babylon as he had at home. After a while, when his enemies had secured the king's signature making it a capital offense, to be executed by throwing the criminal into a den of lions, to worship anybody except the king for a period of thirty days, the habit of praying was so strong on Daniel that he could not put it off thirty days, but went straight ahead and in the same chamber three times every day he kneeled down at the window with his face toward

Jerusalem and prayed. It takes more than a den of lions to keep from prayer a good man who has known the joy and peace of communion with God from his childhood on to old age.

633 Sudden Prayer

I have a thousand times tested the effectiveness of sudden prayer in moments of difficulty, when confronted with a little temptation, when overwhelmed with irritation, before an anxious interview, before writing a difficult passage. How often has the temptation floated away, the irritation mastered itself, the right word been said, the right sentence written! To do all we are capable of, and then to commit the matter to the hand of the Father, that is the best that we can do.

634 Prayer is the Key

Prayer is a golden key, which should open the morning and lock up the evening.

—Bishop Hopkins

635 Faith and Prayer

"More things are wrought by prayer than this world dreams of." And you know the conclusion of the poet. "For so the whole round world is bound by golden chains about the feet of God." We are passing through days of unrest and of great depression. The manager of a large corporation said in my hearing, "I have just come from our annual meeting and I was never so depressed in my life." Pessimism abounds and the hearts of many grow faint. But have we not an antidote to all that? Our Lord spoke "a parable to this end, that men ought always to pray and not to faint" (Luke 18:1). Confidence over discouragement, divine strength over tribulation, patience having her perfect work in the trusting soul of man.

636 Prayer

Prayer will make a man cease from sin, or sin will entice a man to cease from prayer.

—John Bunyan

637 Experience Prayer

Prayer is the experience in which ideals are born. Sincere prayer brings a person to his highest peak of worth. When pouring his heart forth to God his spirit is most sensitive to the Divine Spirit. So it is that God's will for character and career is often most clearly felt and seen in the very moments of prayer. There flash upon us at such times glimpses of our possible selves.

Oh, when shall we learn the sweet trust in God that our little children teach us every day by their confiding faith in us? We, who are so mutable, so faulty, so irritable, so unjust; and He, who is so watchful, so pitiful, so loving, so forgiving! Why can't we, slipping our hand in His each day, walk trustingly over that day's appointed path, thorny or flowery, crooked or straight, knowing that evening will bring us sleep, peace and home?

—Phillips Brooks

638 Private Prayer

The means to this end are, first of all, the one which Christ commands when He says, "Enter into thy closet and shut thy door, and pray to thy Father who seeth in secret" (Matt. 6:6). Private prayer, the quiet isolation in the chamber, where we may look into our own souls and weigh the value of things passing in the balance of eternity, where we may speak to God and feel how blessed to get away from the world, and how awing the fact is "Thou has searched me and known me; Thou knowest my downsitting and mine uprising," and then to pour forth our desires for holiness and for conformity to His unutterable glorious way. Oh! surely without such habits as these the whole religious life must become shallow, mechanical; a thing of opinions, doctrines, disputes, rather than the abiding blessedness of those who are in communion with God.

639 Spurgeon's Witness

Some years ago a poor woman, accompanied by two of her neighbors, came to my vestry in deep distress. Her husband had fled the country; in her sorrow she went to the house of God, and something I said in the sermon made her think I was personally familiar with her case. Of course, I had known nothing about her. It was a general illustration that fitted a particular case. She told me her story, and a very sad one it was. I said: "There is nothing that we can do

but to kneel down and cry to the Lord for the immediate conversion of your husband." We knelt down, and I prayed that the Lord would touch the heart of the deserter, convert his soul and bring him back to his home. When we rose from our knees I said to the poor woman, "Do not fret about the matter. I feel sure your husband will come home; and that he will yet become connected with our church." She went away, and I forgot all about it. Some months after she reappeared with her neighbors and a man, whom she introduced to me as her husband. He had indeed come back, and he had returned a converted man.

On making inquiry and comparing notes, we found that the very day on which we had prayed for his conversion, he, being at the time on board a ship far away on the sea, stumbled most unexpectedly upon a stray copy of one of my sermons. He read it. The truth went to his heart. He repented and sought the Lord, and as soon as possible he returned to his wife and to his daily calling. He was admitted a member, and last Monday his wife, who up to that time had not been a member, was also received among us. That woman does not doubt the power of prayer. All the infidels in the world could not shake her conviction that there is a God that answers prayer. I should be the most irrational creature in the world if, with a life every day of which is full of experiences so remarkable, I enter-

tained the slightest doubt on the subject. I do not regard it as miraculous; it is part and parcel of the established order of the universe that the shadow of the coming event should fall in advance upon some believing soul in the shape of prayer for its realization. The prayer of faith is a divine decree commencing its fulfillment.

640 Answer to True Prayer

Dr. Adoniram Judson, while laboring as a missionary, felt a strong desire to do something for the salvation of the Jewish race. But his desire seemed not gratified; even to his last sickness, he lamented that all his efforts in behalf of the Jews had been a failure. He was departing from the world sad with that thought. Then, at last, a gleam of light thrilled his heart with grateful joy. Mrs. Judson, sitting by his side while he was in a state of great languor, read to her husband one of Dr. Hague's letters from Constantinople. That letter contained some items of information that filled him with wonder. At a meeting of missionaries at Constantinople, Mr. Schauffler stated that a little book had been published in Germany giving an account of Dr. Judson's life and labors; that it had fallen into the hands of some Jews, and had been the means of their conversion; that a Jew had translated it for a community of Jews on the boarders of the Euxine, and that a message had arrived in Constantinople, asking that *a teacher might be sent to show them the way of life*. When Dr. Judson heard this, his eyes were filled with tears, a look of almost unearthly solemnity came over him, and, clinging fast to his wife's hand, as if to assure himself of being really in the world, he said, "Love, this frightens me; I do not know what to make of what you have just been reading. I never was deeply interested in any object, I never prayed sincerely and earnestly for anything, but it came; at some time—no matter how distant the day—somehow, in some shape, probably the last I should have devised, it came!" What a testimony! It lingered on the lips of the dying Judson; it was embalmed with grateful tears, and is transmitted as a legacy to the coming generation. The desire of the righteous shall be granted. Pray and wait. The answer to all true prayer will come. In Judson's case the news of the answer came before he died, but it was answered long before.

641 Habits of Prayer

When a pump is frequently used, but little pains are necessary to have water; the water pours out at the first stroke, because it is high. But if the pump has not been used for a long time, the water gets low, and when you want it you must pump a long while, and the water comes only after great effort. It is so with prayer; if we are instant in prayer, every little circumstance awakens the disposition to pray, and desires and words are always ready. But if we neglect prayer, it is difficult for

us to pray, for the water in the well gets low.

642 Whitefield's Prayer

"I prayed God this day to make me an extraordinary Christian." So reads an entry in the diary of the legendary George Whitefield, and his life is the evidence that the prayer was heard and answered. In spirit, in prayerfulness, in ceaseless labor, in love to Christ, and in earnest and tireless efforts to win men from their sins to Him, he was, as he prayed to be, "*an extraordinary Christian.*" As I read the prayer, I cannot but approve and admire its spirit. But can I and do I adopt it as *my own*? Is it my daily, earnest, heartfelt prayer, "O Lord, make *me* an extraordinary Christian."

643 A Mother's Faithfulness

I tried when I was a boy to be rebellious, but there was one thing I could never get over. I never could answer my mother's love and character. My father was an intemperate man, and my mother, when made miserable by his brutal treatment, would lead my little brother and myself to a spot under a hillside, and kneeling there, would commend us to God. Hardship and her husband's harshness brought her to her grave. At the age of twenty-one I was vicious, hardened, utterly impenitent. Once I found myself, near the home of my boyhood, and felt irresistibly moved to take another look at the little hollow under hill. There it was as I left it; the very grass looked as if no foot had ever trod it since the guide of my infant years was laid in her early grave. I sat down. I heard again the voice pleading for me. All my bad habits and my refusals of Christ came over me and crushed me down. I did not leave the spot till I had confidence in my Savior. My mother's prayers came back in answers of converting grace, and I stand today the living witness of a mother's faithfulness, of a prayer-hearing God.

644 Safety in Prayer

You remember the story of the godly family whose home lay across the track a returning army was expected to follow, when flushed with victory and athirst for destruction and blood. "Be a wall of fire unto us, O God," was the prayer which the father put up as he knelt at the household altar before retiring for the night, and having thus committed himself and his circle to the hands of a preserving God, he and they together laid them down in peace, and took their quiet rest, knowing who it was that made them dwell in safety. The night-watches hastened on, morning came, and the family awoke. All was unusually dark and still when they rose. There was no light from chink or from window nor sound of stirring life around. Noiselessly, and all unseen, the hand whose protection they craved stole forth from the wintry heavens, not, indeed, in the shape of a wall of fire, but in something as sufficient and safe—in wreath upon wreath of

driven snow. Meanwhile the foe had passed by, and had gone on his way, and those whom he threatened breathed freely, for they knew that their tabernacle was at peace.

645 Relying on Prayer

I shall never forget what the late Dr. A. C. Dixon, of Spurgeon's Tabernacle, once said when speaking upon this theme of prayer. I cannot quote him verbatim, but the substance was this: "When we rely upon organization, we get what organization can do; when we rely upon education, we get what education can do; when we rely upon eloquence, we get what eloquence can do, and so on. Nor am I disposed to undervalue any of these things in their proper place. But," he added impressively, "when we rely upon prayer, *we get what God can do.*"

646 Foolish Prayer

If I am to talk to my friend on the telephone, after I have dialed his number, I must wait for an answer. It is not a bit of use to ring up and then put the phone down. I must wait until I hear the "Hello!" or "Are you there?" from the other end. Now, it is exactly like that with prayer—we must give God time to reply. It is not a bit of use to offer up a prayer and then "hang up." That is a mistake people often make in prayer.

647 Delayed Answers

At sixty years of age Dr. A. T. Pierson was not too old to learn, and,

with humility and an eager thirst after knowledge, he listened as George Müller of Bristol gave detailed testimony to show God as a hearer and answerer of prayer. In one of these interviews he asked Mr. Müller if he had ever petitioned God for anything that had not been granted.

"Sixty-two years, three months, five days and two hours have passed," replied Mr. Müller with his characteristic exactness, "since I began to pray that two men might be converted. I have prayed daily for them ever since and as yet neither of them shows any signs of turning to God."

"Do you expect God to convert them?"

"Certainly," was the confident reply. "Do you think God would lay on His child such a burden for sixty years if He had no purpose for their conversion?"

Not long after Mr. Müller's death, Dr. Pierson was again in Bristol, preaching in Bethesda Chapel. In the course of his sermon, he told of this conversation, and as he was going out at the close of the service a lady stopped him and said: "One of those two men, to whom Mr. Müller referred, was my uncle. He was converted and died a few weeks ago. The other man was brought to Christ in Dublin."

From *The Life of A. T. Pierson*

648 Delayed Answer to Prayer

A poor woman stood at a vineyard gate and looked over into the

vineyard. "Would you like some grapes?" asked the proprietor. "I should be very thankful," replied the woman. "Then bring your basket." Quickly the basket was brought to the gate. The owner took it and was gone a long time among the vines, till the woman became discouraged, thinking that he was not coming again. At last he returned with the basket heaped full. "I have made you wait a good while," he said, "but you know the longer you have to wait the better grapes and the more." So it is sometimes in prayer. We bring our empty vessel to God and pass it over the gate of prayer to Him. He seems to be delaying a long time, and sometimes faith faints with waiting. But at last He comes, and our basket is heaped full with luscious blessings. He waited long that He might bring us a better and a fuller answer.

—J. R. Miller

From *Making the Most of Life*

649 The Price of Prayer

"I wish you would come down and lead our prayer meeting tonight," a young man said to a friend he met downtown. "We are particularly anxious to spark interest, and you know you have a gift for stirring people." The young man thus petitioned demurred for a moment. What his friend had said was true. He was a Christian, so far as a blameless life was concerned, and yet it had been impossible to enlist him in really unselfish effort. His gift for "stirring" people had been exercised chiefly in furthering what was to his personal advantage. His friend's words appealed to his pride somewhat, so he agreed to go.

When he arrived at the place of meeting, he learned that the prayer meeting was to be held for the purpose of enlisting workers in a certain mission that was just now in great need. He tried to speak of the needs of the case and to urge his hearers to help, but somehow his eloquent tongue seemed to have deserted him. When he knelt down to pray, he found himself in a still more difficult situation. He was mocking God when he asked him to put it into the hearts of others to do the things he himself was unwilling to do. A conception of the needs of the case rushed over him, and, instead of asking that laborers be raised up, he finished in broken tones, "Lord, I am ready to go. Take me and use me."

It was not the first time that prayer for a sacrifice to lay upon the altar had led the man to offer himself. When men begin really to pray to God to send helpers, they may expect to hear their own names called. Jesus said unto his disciples, "Pray ye therefore the Lord of the harvest, that he will send forth laborers into his harvest" (Matt. 9:38; Luke 10:2). Then he called the twelve unto him and sent them forth, saying, "As ye go, preach" (Matt. 10:7).

650 Praying Aloud

One day a little five-year-old girl, about five years old, heard a ranting

preacher praying most lustily, till the roof rang with the strength of his supplication. Turning to her mother, and beckoning the maternal ear down to a speaking-place, she whispered: "Mother, don't you think that if he lived nearer to God he wouldn't have to talk so loud?"

651 Prayer for Service

Years ago a devout woman of Scotland prayed earnestly that her son might be called to the ministry. He grew up to be an earnest Christian man, and in the very morning of that manhood began to prepare for the high calling to which he seemed destined. But before his preparation was complete, he decided that he was not called of God to this work. He left school and entered a bank. He continued to the end of his days a financier. He died, successful and rich. The mother's prayer was not granted.

But when her son's will was read, it was found that his large fortune had been left to the endowment of what is now the Kentucky Theological Seminary. By this not one, but many ministers are given in answer to the Scottish mother's prayer.

For that prayer, though not granted, was answered.

652 God Rewards Those Who Pray

It often happens that prayers of parents for their children are answered long after the loving pleaders have gone home to heaven. Dr. Theodore L. Cuyler tells how a certain Captain K—, when he sailed on his last sea voyage, left a prayer for his little boy written out and deposited in an oaken chest. After his death at sea his widow locked up the chest, and when she was on her dying bed she gave the key to their son. He grew up a licentious and dissolute man. When he reached middle age he determined to open the chest out of mere curiosity. He found in it a paper, on the outside of which was written, "The prayer of M— K— for his wife and child." He read the prayer and put it back into the chest, but could not lock it out of his troubled heart. It burned there like a live coal. He became so distressed that the woman with whom he was living as his mistress thought he was becoming deranged. He broke down in penitence, cried to God for mercy, and, making the woman his legal wife, began a new life of prayer and obedience to God's commandments. And so God proved to be the rewarder of a faith that had been hidden away in a secret place a half century before.

653 Genuine Prayer

One of the great secrets of effective prayer is that the attitude of the heart shall be right toward God. The heart that recognizes the divine wisdom and love and trusts to them will pray as simply as a child asking help from its mother. One of the most beautiful prayers I have ever read is that of Fénelon: "O Lord! I know not what I should ask of thee. Thou only knowest what I want; and Thou lovest me, if I am Thy friend, better than I can love

myself. O Lord! give to me, Thy child, what is proper, whatsoever it may be. I dare not ask either crosses or comforts. I only present myself before Thee. I open my heart to Thee. Behold my wants, which I myself am ignorant of; but do Thou behold, and do, according to Thy mercy, smite or heal, depress me or raise me up. I adore all Thy purposes without knowing them. I am silent; I offer myself in sacrifice. I abandon myself to Thee. I have no more desire but to accomplish Thy will. Lord, teach me how to pray. Dwell Thou Thyself in me by Thy Holy Spirit. Amen."

654 *"Without Ceasing"*

In regard to the moral sentiments and the affections, men know that by education certain parts of the mind learn to diffuse their influence gently, and almost continuously, through the experience of life. We live habitually under the influence, direct or indirect, of certain of our feelings. And to "pray without ceasing" means, not that we are literally to iterate and reiterate without cessation the words of prayer, but that we are to give to this praying tendency of the mind the education that we give to taste, to kindness, to conscientiousness and to understanding. We are to make it not an occasional but a uniform tendency, so that even when we are not praying by direct volition there will be a latent impulse towards conversation with God, felt through all the soul.

655 *Prayer Spiritual, not Material*

A father hears that his child has prayed that God would give him a sled; and in order to confirm the child's trust in God he buys a sled, and slyly puts it in the child's room the next day, and so cheats the child into a lie, teaching him to believe that he can pray for sleds, and have his prayers answered.

But men have found out that in all spheres except the spiritual God acts only generically, leaving germ-forms, primitive organizations, to work out their own functions under human volitions. And even spiritual effects are produced through natural—that is, God-ordained—principles.

656 *Praying for the Weak*

In one of the old cities of Italy the king caused a bell to be hung in a tower in one of the public squares, and called it "The Bell of Justice," and commanded that any-one who had been wronged should go and ring the bell, and so call the Magistrate of the city and ask and re-ceive justice. When, in the course of time the lower end of the bell-rope rotted away, a wild vine was tied to it to lengthen it; and one day an old and starving horse that had been abandoned by its owner and turned out to die wandered into the tower, and in trying to eat the vine rang the bell. The Magistrate of the city, com-ing to see who rang the bell, found this old and starving horse. He caused the owner of the horse, in whose service he had toiled and

been worn out, to be summoned before him, and decreed that as his horse had rung the bell of justice he should have justice, and that during the remainder of the horse's life his owner should provide for him proper food and drink and stable. The weakest spirit can ring the prayer bell, and if rung with confident faith in the love and power of God, shall not be in vain. "For *everyone* that asketh receiveth" (Matt. 7:8; Luke 8:10).

657 Real Prayer

There is all the difference in the world between saying prayers and praying. Scores of men pray who are not religious in the sense that the word is ordinarily employed. All aspiration is prayer and all real prayer is the spontaneous expression of the soul's hunger.

Prayer is a kind of door to the treasure house of God, and it is of infinite importance that we should know how to open that door and enter into possession of the wealth of God.

Do not let us degrade prayer. I have heard people talk about prayer as if it were a kind of errand-boy sent to fetch something. Prayer is something more than simply talking to God. It is not only getting but giving, not only speaking but listening.

658 To Whom Shall We Pray

A little lad in Central Africa had learned to read the New Testament in the mission school. Some time later the Roman Catholic fathers

persuaded him be baptized into the Roman Church. They gave him a medal to wear, on which was a representation of the Virgin. "It will be easier for you to pray when you look at that," they said, "and the mother of Jesus will pray to her Son for you."

Several months passed, and the boy returned to the evangelical mission. Asked the reason, he said, "I read in the Gospels that Mary lost Jesus when she was on a journey; so I thought, *If she forgot her own little boy, she will surely forget me*, so I am going to pray straight to Jesus."

659 Is Prayer Only for Self?

The story is told of a minister who called at Johnnie's house, and in the course of the conversation he asked him, "Do you pray every night, my boy?" "Naw," Johnnie replied, "some nights I don't want anything."

Some people share this selfish view of prayer. Prayer is not only for personal petition—it is for confession, praise, thanksgiving, worship, and intercession for others. Prayer is a ministry of supplication for others and adoration of God, as well as requests for self.

660 The Irony of Answered Prayer

Much that perplexes us in our Christian experience is but the "answer" to our prayers.

We pray for patience and God sends tribulation, for tribulation produces patience (Rom. 5:3).

We pray for submission, and God sends suffering, for we learn

obedience by suffering (Heb. 5:8).

We pray for unselfishness, and God gives us opportunities to sacrifice ourselves by thinking on the things of others (Phil. 2:4).

We pray for victory, and the things of the world sweep down upon us in a storm of temptation, for "this is the victory that overcometh the world, even our faith" (1 John 5:4).

We pray for strength and humility, and some messenger of Satan torments us till we lie in the dust, crying to God for its removal (2 Cor. 12:7-11).

We pray for union with Christ, and God severs natural ties, and lets our best friends misunderstand us and seem indifferent to us (Matt. 10:34-39; John 15:18-20).

We pray for love, and God sends peculiar suffering, and puts us with apparently unlovely people. He lets them say things which rasp the nerves and lacerate the heart, for "love suffereth long, and is kind" (1 Cor. 13).

661 The Boy Who Said His Prayers

A little boy, not more than eleven or twelve years of age, somewhat delicate in health, and rather backward, once went to a large public school. The first night that he slept there, when they came to go to bed, he glanced timidly round the room to see what other boys were doing, and then he saw how first one and then another got into bed without saying their prayers. And then it came into his head that he should look singular if he knelt down and said them, and that after all he might just as well say them in bed; and Satan whispered that if we pray with all our heart it does not matter how or where we say our prayers, or whether we kneel or not. But just as he was hesitating there flashed into his mind those words of our dear Lord, "Whosoever therefore shall deny Me before men, him will I also deny before My Father which is in heaven" (Matt. 10:33). And so, after a short, sharp struggle, he took courage and knelt down. Then there arose such a shouting and howling, such a volley of oaths, such a tempest of sounds as might well have daunted a brave man, much more a weak and timid boy. But he held his ground. Shoes, slippers, anything and everything that they could lay hands on, were thrown at him; he was reviled, and mocked, and threatened. And so it went on night after night; as soon as he knelt down the room was in an uproar, the same insults and injuries were heaped upon him. But he bravely and quietly held on. Wherever he went among his school-fellows he was jeered at as "the boy who said his prayers." At last, however, by degrees first one and then another of his school-fellows began to take his part; then they began to follow his example, and to kneel down and say theirs. And so by slow degrees, in that school, where, when he first went, none of the boys knelt down and said their prayers, they all did so. The good ex-

ample of one brave boy changed the practice of the whole school.

662 Begin Well

There is an old-world proverb, "What is well begun is half ended." It refers, of course, to success in some specific work. To bring success into a day, the wise course is to begin it at the throne of grace. A morning sacrifice of this sort is due to God. But still more is it needful for us to have guidance, strength, and usefulness through the day's duties and temptations. Reader, do not fail thus to begin the day, not in mere form, but in sincerity of soul.

—John Hall

663 The Guiding Hand

According to John Hall: "The prayer of the Seventy-third Psalm may well be uttered by a believer. How truly may one say: 'Lord, make me meek and lowly; show me my own heart in the light of Thy holy law, that it may be contrite. I have need of guidance at every step of my way. Guide me by Thy counsel, that I may be saved from errors of judgment and from practical mistakes. Impart unto me the wisdom that cometh from above, that I may discriminate between the good and the bad, between the service of Christ and the service of the world, and conduct me at length to the kingdom of Thy glory, for Christ's sake. Amen.' "

664 Slim Pickens

Guests came together at a dinner table and the host said, "Let me offer a bone of a prayer." Is that what you are offering to God?

George MacDonald was born in 1824, in the Scottish Highlands. He was a teacher, pastor, father, lecturer, and writer. MacDonald's writing was so powerful that a better known C. S. Lewis would say, "I have never concealed the fact that [MacDonald] was my master."

MacDonald loved prayer. He once said, "Never wait for fitter time or place to talk to Him. To wait till you go to church or to your room is to make Him wait. He will listen as you walk."

Often when prayer is unanswered, it's due to infrequency and lack of intensity. We offer mere bones of prayers and expect God to be impressed by our meagerness. The employee who asks for a raise often receives based on his intensity. The child is granted requests because of his tireless pestering. In a discourse on prayer to his disciples, Jesus suggested that: *"They should always pray and not give up"* (Luke 18:1 NIV). Are you making God wait to answer your request because of your lack of enthusiasm?

Reflections

665 The Prayer That Has Power

What is prayer? Has every prayer power with God? Let us endeavor to get some clear ideas on that point. Some people seem to regard prayer as the rehearsal of a set form of solemn words, learned largely from the Bible or a liturgy, and

when uttered they are only from the throat outward. Genuine prayer is a believing soul's *direct conversation with God.* Phillips Brooks has condensed it into four words—a "true wish sent God-ward." By it adoration, thanksgiving, confession of sin, and petition for mercies and gifts ascend to the throne, and by means of it infinite blessings are brought down from heaven. The pull of our prayer may not move the everlasting throne, but—like the pull on a line from the bow of a boat—it may draw us into closer fellowship with God and fuller harmony with His wise and holy will.

—Cuyler

Spurgeon on Prayer

The remaining illustrations on prayer are by C. H. Spurgeon

666 Frequent Prayer

I had a dear friend whose company I esteemed, but suddenly he did not come to see me. He stayed away; and as I knew he had not ceased to love me, I wondered why. At last I found that the good brother had taken it into his head that he might outrun his welcome; he had read those words of Solomon, "Withdraw thy foot from thy neighbor's house; lest he be weary of thee, and so hate thee" (Prov. 25:17). I admired my friend's prudence, but I labored hard to make him see that Solomon knew nothing of *me*, and that I was more wearied when he

stopped visiting than when he came. I hope he made *me* an exception to a very sensible rule. But never get that thought into your head concerning your God. Will you weary my God also? You may weary him by restraining prayer, but never by abounding in supplication. Abide with your God, and cry to him day and night, and let this be the music of your whole life, "Whereunto I may continually resort" (Ps. 71:3).

667 The Pledge of Security

I have heard an anecdote of two gentlemen traveling together, somewhere in Switzerland. Presently they came into the midst of the forests; and you know the gloomy tales the people tell about the inns there, how dangerous it is to lodge in them. One of them, a lost man, said to the other, who was a Christian, "I don't like stopping here at all; it is very dangerous indeed." "Well," said the other, "let us try." So they went into a house; but it looked so suspicious that neither of them liked it; and they thought they would prefer being at home in England. Presently the landlord said, "Gentlemen, I always read and pray with my family before going to bed; will you allow me to do so tonight?" "Yes," they said, "with the greatest pleasure." When they went upstairs, the worldly person said, "I am not at all afraid now." "Why?" said the Christian. "Because our host has prayed." "Oh!" said the other, "then it seems, after all, you think something of religion; because a man prays, you can go to sleep in his

house." And it was marvelous how both of them did sleep. Sweet dreams they had, for they felt that where the house had been roofed by prayer, and walled with devotion, there could not be found a man living that would commit an injury to them.

668 Revival through Prayer

All the mighty works of God have been attended with great prayer, as well as with great faith. Have you ever heard of the commencement of the Great American revival? A man, unknown and obscure, laid it up in his heart to pray that God would bless his country. After praying and wrestling and making the soul-stirring inquiry, "Lord, what wilt thou have *me* to do? Lord, what wilt thou have me *to do*?" he hired a room, and put up an announcement that there would be a prayer-meeting held there at such-and-such an hour of the day. He went at the proper hour, and there was not a single person there; he began to pray, and prayed for an half an hour alone. One came in at the end of the half–hour, and then two more, and I think he closed with six; the next week came around, and there might have been fifty dropped in at different times. At last the prayer-meeting grew to a hundred; then others began to start prayer-meetings; at last there was scarcely a street in New York that was without a prayer-meeting. Merchants found time to run in, in the middle of the day, to pray. The prayer-meetings became daily ones, lasting for about an hour; petitions and requests were sent up; these were simply asked and offered before God, and the answers came; and many were the happy hearts that stood up and testified that the prayer offered last week had been already fulfilled. Then it was when they were all earnest in prayer, suddenly the Spirit of God fell upon the people, and it was rumored that in a certain village a preacher had been preaching in earnest, and there had been hundreds converted in a week. The matter spread into and through the northern states. These revivals of religion became universal, and it has been sometimes said, that a quarter of a million people were converted to God through the short space of two or three months.

669 Mother's Prayers

I cannot tell you how much I owe to the solemn words of my good mother. It was the custom on Sunday evenings, while we were yet little children, for her to stay at home with us; and then we sat round the table and read verse after verse, and she explained the Scriptures to us. After that was done, then came the time of pleading; there was a little piece of Alleyn's Alarm, or of Baxter's Call to the Unconverted, and this was read with pointed observations made to each of us as we sat round the table; and the question was asked how long it would be before we would think about our state, how long before we would seek the Lord. Then

came a mother's prayer, and some of the words of a mother's prayer we shall never forget, even when our hair is gray.

Preaching

670 Great Examples

The greatest preacher the world has ever known was remarkable for his use of illustrations. Our Master never preached a sermon when He did not liken His truth to some everyday, ordinary object so that the little children in His company could take in the power and sweetness of the truth He taught. There is a great difference between the illustrations of Jesus and Paul. Paul lived in the city, and his truth was colored because of his contact with the people in the great centers of population; but Jesus lived in the country, and the sparrows flying through the air, the grass growing beneath His feet, and the lilies blooming on every side furnished His illustrations. We are following in right footsteps when we pattern our ministries after Jesus and Paul in illustrating truth.

—J. Wilbur Chapman

671 Satan's Commentary

Said a quaint New England preacher: "Beware of Bible commentators who are unwilling to take God's words just as they stand. The first commentator of that sort was the devil in the Garden of Eden. He proposed only a slight change—just the word "not" to be inserted—"Ye shall not surely die." The amendment was accepted, and the world was lost. Satan is repeating that sort of commentary with every generation of hearers. He insists that God couldn't have meant just what He said. To begin with, Satan induced one foolish woman to accept his exegesis; now he has theological professors who are of his opinion on these points; and there are multitudes of men and women who go on in the ways of sin because they believe Satan's word, and do not believe the Word of God.

—Joseph Parker

672 Value of Preachers

Longfellow I had learned to love from my youth up; Sherlock Holmes ever since the mystery of the three Johns and the three Toms caught my schoolboy fancy, years ago, has been to me a monolith of wisdom. And naturally the attraction of these names was a powerful inducement to me to spend my last days (of the first visit to America) in quiet worship at shrines so revered and beloved. But some eight hundred miles off, away by Lake Erie, were two men who were more to me than philosopher or poet, and it only required a moment's thought to convince me that for me at least

a visit to America would be much more than incomplete without a visit to Mr. Moody and Mr. Sankey. It was hard, I must say, to give up Longfellow, but I am one of those who thinks that the world is not dying for poets so much as for preachers.

—Henry Drummond

673 A Good Conscience More Than Liberty

John Bunyan, being apprehended on the charge of "devilishly and perniciously abstaining from coming to church to hear Divine service, and of being a common upholder of several unlawful meetings and conventicles, to the great disturbance and distraction of the good subjects of this kingdom, contrary to the laws of our sovereign lord, the king," would have been discharged if he had simply promised not to speak any more in the name of Jesus. "But," said Bunyan, "I told him (the judge) as to this matter I was at a point with him; for *if I was out of prison today, I would preach the Gospel tomorrow, by the help of God.*" The result was on one hand twelve years in Bedford jail, and on the other, *The Pilgrim's Progress*, with its immeasurable honor to the writer, and blessing to the world.

674 Foolishness, the Gospel to the World

When Dr. Chalmers was converted, the change in his ministry was quickly apparent to all. The rationalists, to whose class he had belonged, commonly said: "Tom Chalmers is made." Some years after, when he was settled in Glasgow, a lady and gentleman on their way to hear him met a friend, who asked where they were going. On being told, he said: "What! To hear that madman?" They persuaded him to go for once and do the same, promising never to dispute with him about that title again, if he were inclined to apply it to the preacher after his sermon. To the surprise of all three, when Dr. Chalmers gave out his text, it was: "I am not mad, most noble Felix, but speak forth the words of truth and soberness" (Acts 26:25). The skeptical hearer was not only convinced of the preacher's sanity, but was likewise converted to faith in evangelical truth.

675 A Gospel to Die By

"Who delivered us from so great a death, and doth deliver: in whom we trust that He will yet deliver us" (2 Cor. 1:10).

The King Street United Brethren church of Chambersburg, Pennsylvania, is next door to the Franklin County Jail. All the services of the congregation are broadcast to the jail over a loudspeaker system. The pastor, Dr. Clyde Meadows, tells how a young man sentenced to the electric chair for murder was listening to one of their evening services. The text was, "Though your sins be as scarlet, they shall be white as snow" (Is. 1:18).

For several weeks the pastor tried

to convince this convicted murderer that God would graciously forgive him for the sake of Christ. But there was always the complaint that his sin was so great, so black that God could not save him. That night, however, sitting by the warden of the jail, and hearing those words, "Though your sins be as scarlet they shall be as white as snow," the young man jumped to his feet, shouting, "I see it now, warden, I see, God will forgive me, He will!"

The pastor spent hours with this doomed man, and even when the news arrived that the Supreme Court of Pennsylvania rejected the appeal for his pardon, he seemed perfectly content to meet his death.

On March 27, 1938, he went to the death chamber of the Rockview Penitentiary, Dr. Meadows staying close by his side. It was just a few minutes before the execution when he turned to the pastor, and with marked enthusiasm said, "Rev. Meadows, one thing I want you to know," and for emphasis he struck his hand against his knee and repeated, "I want you to know that I know that the gospel of Christ that you preach is real *and I'm ready to die by it.*"

676 *Finding What You Seek*

"And when he sowed, some seed fell by the wayside . . . but other fell on good ground" (Matt. 13:4, 8).

One Sunday morning the great Dr. Henry Ward Beecher was preaching. After the service a stranger who had come to hear him got him in a corner and said, "I counted your mistakes in English today, Doctor, and you made exactly twenty." To this Dr. Beecher responded, "I'm afraid you are mistaken; I think I must have made at least a hundred."

Now it happened that at that same service a young immigrant boy was sitting in the rear pew of the church. He was a lad just growing up into manhood. He was alone in the great city, having come here from Serbia. His testimony given later when he became known as the world-renowned scientist, Michael Pupin, was this, "Nothing so inspired me and stimulated me as those sermons of Dr. Beecher."

A faultfinder found twenty mistakes in English, but a lonesome immigrant boy found help, hope and inspiration. The one who really wants to find Christ will find Him in the preaching of the Gospel. We usually find the very thing for which we are seeking.

677 *Sermons on Obedience*

"If thou put the brethren in remembrance of these things, thou shalt be a good minister of Jesus Christ, nourished up in the words of faith and of good doctrine, whereunto thou hast attained" (1 Tim. 4:6).

A New York preacher said not so long ago, "One of our most venerated and farseeing citizens recently remarked that in his eighty years of active life, associated with some of the most stirring events in the

commonwealth, he had never seen such an orgy of lawlessness as that through which we are now living."

Startled into thoughtfulness by that remark, the preacher made some interesting discoveries. He could not recall ever having preached a sermon on obedience; that after searching volume after volume of sermons, he found none on respect for authority. There were plenty of discourses on freedom, on happiness, but rarely any on submission to the commands of God.

Gradually this New York preacher came to the frightful conclusion that our orgy of lawlessness is not a post-war psychological reaction, but rather the result of a deep-rooted habit of thought in the spiritual realm.

We dimly acknowledge that Christ's teaching is our great hope for the recovery of our sense of Divine Law, but all we dislike in His teaching we ignore. Thus, though one-third of His teaching declares God's judgment of disobedience is certain, unexpected, and very awful, we have been keeping silent on the subject for the last fifty years.

678 Powerless Sermons

"But I will come shortly, if the Lord will, and will know, not the speech of them which are puffed up, but the power. For the kingdom of God is not in word, but in power" (1 Cor. 4:19, 20).

Some preaching reminds one of the soldiers firing blank cartridges. Their guns are good, they take aim,

you see the fire and hear the noise, but it is only a harmless cartridge.

Just so, it is possible for preachers to use a powerless cartridge. They may have a good sermon, mean well, and have a grand delivery—both loud and fiery—yet entirely without power to slay the enmity of the human heart against God. Without the power of the Holy Spirit the sermon will always be like the blank cartridge.

There are perhaps these two reasons for such powerlessness on the part of preachers. Their sermons are like well-blended tea. The great object is to make it palatable to all. The flavor is the chief thing. And it has become quite an art in some quarters to mix up the thoughts of men with the Word of God, and so blend (corrupt) them that itching ears are highly pleased with the sermon. Law and Gospel, works and faith, are so artfully blended that unrenewed hearts receive it gladly. But we are not told to blend, but to rightly divide the Word of Truth.

And the second reason for powerless sermons is that some preachers are too like the amphibious animal—they live a double life. The amphibious religious professor, who feels equally at home in the world or in the Church, who finds pleasure in sin and sermons, is useless to God. "I would thou were cold or hot" (Rev. 3:15).

679 Speech That Preaches

Speech is one of the most ordinary and powerful means for influ-

encing one another. I think that we can all look back and see how a chance word here and a chance word there has remained in our memory, and greatly influenced us, and been a power for shaping our lives altogether out of proportion to its seeming importance at the time. In fact, it was just because it seemed so unpremeditated, so much a revelation of the true inward self of the speaker, that it has remained in memory and molded character. It may have been a word of faith, of cheer, of comfort, of counsel, or of rebuke, but whatever it was, there was in it a certain inward excellence and moral worth which we recognized as altogether appropriate for the occasion, and beyond that to life in general.

680 Preaching a Divine Science

The preacher may say, as Kepler did of his astronomical researches and discoveries: "O, Almighty God, I think Thy thoughts after Thee!" So is it a divine *art*; as Paul Veronese said of painting: "It is a gift from God." The preacher, like Michaelangelo, sees the angel imprisoned in the dingy, yellow block, and by God's help sets the angel free. A *sermon* is the Word of God as found in the Bible, used to save and sanctify souls, through the utterance of an anointed tongue. It implies the Bible with a man behind it, to enforce and emphasize it by personal experience. Hence converted men are chosen, rather than angels, to preach; for

Never did angels taste above
Redeeming grace and dying Love.

And so the humblest believer can preach better than Gabriel, for he can say, "I am a sinner saved by grace."

681 The Plain Message Effective

A prominent clergyman in Boston, some years ago, received a visit from a plain-spoken country pastor, and he invited him to address his people at the mid-week meeting in their chapel. The visiting preacher was so plain and straightforward in his mode of speech, and in the homely illustrations used, that the Boston pastor was quite disturbed, fearing his cultivated congregation would take offense at the sharp thrusts of the unconventional brother. But a few days later a prominent member of the congregation came to this pastor in great trouble of soul, earnestly desiring to be shown the way to Christ; when asked as to the cause of his interest, he referred to the homely words of the country preacher, who had evidently spoken straight to the heart of this man. When the pastor told the story to a friend, he added: "I'll never again distrust God's Spirit in the guiding of God's servants as his preachers. I had written more than one sermon for the express purpose of reaching that one man in my congregation; but here he was reached by one plain sentence from a plain man whom God's Spirit guided."

682 How John Wesley Spoiled the Sermon

A farmer once went to hear John Wesley preach. The preacher said he would take up three topics of thought; he was talking chiefly about money. His first heading was, "Get all you can." The farmer nudged his neighbor and said: "That man has got something in him; it is admirable preaching." Wesley reached his second division, "Save all you can." The farmer became quite excited. "Was there ever anything like this?" he said. The preacher denounced thriftlessness and waste, and the farmer rubbed his hands as he thought, "And all this have I been taught from my youth up." What with getting and with hoarding, it seemed to him that "salvation" had come to his house. But Wesley went on to his third heading, which was, "Give all you can." "Oh, dear! he has gone and spoiled it all," exclaimed the listener. But getting, without giving, makes only stagnant pools of us.

683 Illustrations Should Illustrate

There must be something to be illustrated. In former days, preachers were exceedingly sparing in their use of comparisons; but a great reaction has set in, and the danger now is that discourses shall consist of illustrations and nothing else. But the beauty of a simile lies in its pertinence to the point which you design to brighten by its light. Without that, it has no business in your discourse. When illustrations will help to make your argument more simple, they are to be used with discretion; but when they are employed purely for the sake of the stories of which they consist, and to hide the poverty of the thought, they are a snare to the preacher and an offense to the hearer.

684 Proper Use of Illustrations

For the mass of the people it is well that there should be a goodly number of illustrations in our discourses. We have the example of our Lord for that, and most of the great preachers have abounded in similes, metaphors, allegories and anecdotes. But beware of overdoing this business. Illustrate richly and aptly, but not so much with parables imported from foreign sources as with apt similes growing out of the subject itself. Do not, however, think the illustration everything; it is the window, but of what use is the light which it admits, if you have nothing for the light to reveal? Garnish your dishes, but remember that the joint is the main point to consider.

—C. H. Spurgeon

685 God's Desire to Save All

Whatever else you do, don't slam the door of possibility in any man's face. Don't hold up any of the truths of the gospel in such a way that the man who looks at them shall say it is not possible to be saved. The teaching of Christ and the Apostles was that God wanted all men to be saved, and made overtures to them; that there is a possi-

bility of every man's being regenerated by the power of the Holy Ghost. Build up such a spiritual superstructure that every little child shall feel it to be easier to live a Christian life than an ungodly life.

686 The Whole Gospel

John Nelson preaching about the influence of John Wesley's preaching and its effects upon him, said: "This man can tell the secrets of my heart, but he hath not left me there, he hath showed me the remedy, even the blood of Christ. Then was my soul filled with consolation, through hope that God for Christ's sake would save me." That is the experience wherever Christ and Him crucified is proclaimed. We must tell of sin, but also of the sacrifice that atones for it; of guilt, but also of grace that pardons; show man's depravity but God's redeeming mercy. Not half a gospel, but a whole one.

687 After Many Days

George Whitefield on his fourth visit to America preached from the steps of the courthouse at Philadelphia to a great crowd. As in the twilight he read a portion of Scripture, a little boy standing by held a lantern up to enable the preacher to see to read. While holding the lantern he listened intently to the sermon, and forgetful of his light he let it fall, breaking it to pieces. Twenty years later, Whitefield was staying at a minister's house and recalled the incident, and said he wondered what had become of the lad. His host replied: "I am that little boy. I held the lantern and let it drop. Your preaching made me what I am."

688 No Competition

A group of clergymen were discussing whether or not they ought to invite Dwight L. Moody to their city. The success of the famed evangelist was brought to the attention of the men.

One unimpressed minister commented, "Does Mr. Moody have a monopoly on the Holy Ghost? The Holy Ghost seems to have a monopoly on Mr. Moody."

689 Spurgeon's Greatest Compliment

Charles H. Spurgeon reckoned as the highest compliment ever paid him the words of an open enemy who said, "Here is a man who was not moved an inch forward in all his ministry, and at the close of the nineteenth century is teaching the theology of the first century, and is proclaiming the doctrine of Nazareth and Jerusalem current eighteen hundred years ago."

690 The Important Point

A layman visited a great city church during a business trip. After the service he congratulated the minister on his service and sermon. "But," said the manufacturer, "if you were my salesman, I'd discharge you. You got my attention by your appearance, voice, and manner; your prayer, reading, and logical discourse aroused my interest; you

warmed my heart with a desire for what you preached; and then—and then you stopped without asking me to do something about it. In business the important thing is to get them to sign on the dotted line."

Ah, preachers too often fail just here. They must press for decisions for Christ. In the words of Joshua they must say to their hearts, "Choose you this day whom ye will serve" (Josh. 24:15).

Pride

691 Pride in Our Inheritance

Many years ago a public debate arose concerning a proposal to purchase as a public reservation Thomas Jefferson's famous home in Monticello. The scheme was thwarted at the very start by the refusal of its owner, Mr. Jefferson M. Levy, a descendant of the great commoner, to part with it. He said, when asked about the matter, that it was a matter of personal and family pride with him that Monticello be kept up, and that no sum of money could possibly compensate him for the loss of the estate. Some years ago William M. Evarts, then Secretary of State, urged Mr. Levy to allow him to ask Congress to purchase Monticello. His answer was: "Mr. Secretary, if you offered me all the money this room would hold, you could not tempt me." Mr. Evarts replied: "Well, Mr. Levy, I admire you, and do not blame you."

There is no more striking figure under which the New Testament seeks to arouse our love and gratitude and righteous pride than Paul's declaration that the Christian is an heir of God and a joint-heir with Jesus Christ (Rom. 8:17). We ought to be proud of our inheritance. If a descendant of Thomas Jefferson is to be admired for sacrificing many personal luxuries in order that he may keep up the family inheritance, how much more admirable is he who endures hardship with gladness that he may keep the Christian name in honor before all the world!

692 Insidious Flattery

Praise is a thing we all love. I met with a man the other day who said he was impervious to flattery; I was walking with him at the time, and turning round rather sharply, I said, "At any rate, sir, you seem to have a high gift in flattering yourself, for you are really doing so, in saying you are impervious to flattery." "You cannot flatter me," he said. I replied, "I can, if I like to try; and perhaps may do so before the day is out." I found I could not flatter him directly, so I began by saying what a fine child that was of his; and he drank it in as a precious draught; and when I praised this thing and that thing belonging to him, I could see that he was very easily flattered; not directly, but indirectly. We are all pervious to flattery; we like the soothing cordial, only it must not be labeled flattery; for we have a religious abhorrence of flattery if it be so called; call it by any other name, and we drink it in, even as the ox drinketh in water.

—C. H. Spurgeon

273

693 Nebuchadnezzar's Boast

"Is not this great Babylon, that I have built?" (Dan. 4:30).

This boast seems strange, considering that Babylon had existed in one form or another for fifteen centuries or more. But, like many other things in Scripture about which historic doubts have been entertained, it is illustrated and confirmed by the discoveries which have been made in our own times. Nine-tenths of the bricks which have been dug up on the plains whereon once stood Babylon are stamped with the name of Nebuchadnezzar, proving that he so completely renovated the entire city that it might well be called his own. And what was true of Babylon was true of other cities in his empire. "I have examined," says Sir H. Rawlinson, "the bricks *in situ*, belonging to a hundred different towns and cities in the neighborhood of Bagdad, and I never found any other legend than that of Nebuchadnezzar, son of Nabopolassar, king of Babylon."

—John Kennedy

Priorities

694 *Freezing to Death*

A man was making his way over the mountains through a terrible snowstorm. He gradually got weaker and weaker, until at last he stumbled and fell. He said to himself: "This is the end. I shall never be found." He was too weak to rise, but as he fell his hand struck the body of another man who had fallen in the same place. This first man was unconscious, and the man who had just fallen rose to his knees and, bending over the prostrate form, began to chafe his hands and to rub his face, until by and by the man's eyes opened. He had saved another's life, but he had also saved himself, for the exercise had kept the life in his own body. And when you have a passion for souls, when you go seeking the lost, when you lift the burdens of others, your own vision of Jesus is clearer, your own hope of eternity is stronger, your own assurance of salvation is greater.

—J. Wilbur Chapman

695 *Which?*

"Choosing rather to suffer affliction with the people of God, than to enjoy the pleasures of sin for a season" (Heb. 11:25)

A well-known merchant had a placard nailed to the desk in his office. It said, "WHICH? Wife or whiskey? The babies or the bottles? HEAVEN OR HELL?" To the question of a visitor, he replied, "I wrote that myself. Sometime ago I found myself falling into the habit of drinking an occasional glass with a friend. Soon my stomach got bad, my faculties dulled, and I had a constant craving for stimulants. I saw tears in the eyes of my wife and wonder on the faces of my children. One day I sat down and wrote that card. As I looked at it an awful revelation burst upon me like a flash. I nailed it there and read it many times that day. I went home sober that night and have not touched a drop since."

That man came to realize that he must treat his wife as his own personality or his own body. He must be as kind toward her as he would toward himself. Such love between parents will lead the entire home-life along in a serene, happy and wholesome way. It will not only double the joy, but will give strength in the hour of sorrow, dividing the griefs and burdens of life.

696 *Saving or Losing*

Dr. Nansen, the legendary Norwegian explorer, was greatly honored in London. Seven thousand distinguished people gathered to

cheer him, while the Prince of Wales presented to him the medal of the Royal Geographical Society. To Nansen what a contrast it must have seemed to the loneliness and cold and danger of the arctic solitude where this honor was earned. There is no easy way to greatness. That which is worth having costs heavily. This is true also in the spiritual world. How clearly Christ sets forth this truth: "For whosoever will save his life shall lose it: but whosoever shall lose his life for my sake, the same shall save it" (Mark 8:35; Luke 9:24).

697 Whom Riches Make Happy

I knew a man to whom riches brought happiness. I do not believe he would have been happy without them. When he was a mere boy he had a fine head for business. He was wise, industrious, and had a wonderfully clear financial insight. But he wanted to be a preacher. He tried two years, and then said, "I can't do that, but I will give the Lord the one talent I have." So he became a stockbroker. He was fair, businesslike and painstaking. The result was that he prospered marvelously. He became noted for the high grade of his stock and for his remarkable sense of honor.

There were temptations, but he stood so firmly by his Christian faith that men never felt that there was anything incongruous about it when he stopped in the midst of a business transaction and talked freely to them of the greater riches.

Never a needy soul that came in contact with him went away without realizing that here was a man to love and to honor.

Toilers in hard fields at home and abroad were able to work with better heart because he gave of his substance, though many of them never knew his name. He thought sometimes of his boyish dream of preaching the gospel. Still it seemed to him the greatest thing in the world, but he was happy because he knew that he was doing it. Riches had brought him happiness.

698 Doing Things We Do Not Like to Do

Sir Edward Malet said of Abraham Lincoln that of all the great men he had ever known, Lincoln was the one who had left upon him the strongest impression as being a sterling child of God. Straightforward, unflinching, not loving the work he had to do, but facing it with a bold and true heart; mild whenever he had the chance, stern as iron when the public weal required it, following a bee-line to the goal which duty set before him. The test of life is not when we are doing the things we like to do. It does not require much courage to keep good-humored and patient when all our surroundings are congenial. But the true test of Christian manhood and womanhood is when we are compelled to face labor that is uncongenial to us and duties from which everything in us shrinks. To take up these uncomfortable burdens and go forward with a bold

and patient face is the highest grace of the Christian character.

699 *The Well-Dressed Woman*

What am I going to wear today? For most ladies this is a daily dilemma because we want to look our best. Some women consult the latest fashion magazines for hints on hairstyles, clothes and makeup. But, believe it or not, the Bible offers tips on fashions that never go out of style. Here are some of the requirements for the well-dressed Christian woman:

1. A gentle and quiet spirit (1 Pet. 3:3, 4). This does not mean we must be silent or never speak our mind. It does mean that we should not be loud or boisterous, or call attention to ourselves by being bawdy or brazen.

2. Contentment (Heb. 13:5). We may not have a big, fancy house or the latest car, but we need to remember to count the blessings we do have and to be content with them. Nothing is less attractive than a jealous spirit.

3. A smile. This is a reflection of a joyous heart. Christians have every reason to be happy because we have hope above all hope (John 16:22). Why would others desire to serve Christ if they see us wearing pained expressions on our faces? Don't forget that smile!

4. Inner peace (Rom. 5:1). God gives us strength and peace in facing whatever we encounter everyday.

5. Confidence...not necessarily in ourselves so much as in Christ (Phil. 4:13). He is our strength and our refuge (Ps. 46:1, 2).

6. Kindness. Before we act, react or speak we should always consider the feelings of the other person. How would you feel if you were in their shoes (Matt. 7:2)? Treat them kindly, gently, with compassion.

If you remember to wear these things daily you still may not make Blackwell's Best Dressed List, but you will make Christ's list. Which is more important to you?

—Billie Hawks
Life Lines

Promises

700 Standing on the Promises

In the last two centuries, railroads have sought and conquered many remarkable places. From California, however, comes one of the strangest of railroad stories. It tells of a train that actually runs over treetops. In the building of the road a huge ravine was encountered, the sides and bottom of which were heavily wooded, two giant redwood monarchs of the forest towering far above the less pretentious growth, and imparting an air of almost regal impressiveness. The big redwoods were sawed off seventy-five feet from the ground, this being the exact height from the level of the ravine to the tops of the lowest of the other trees. Next, trees on either side were sawed off of sufficient height to make their tops in a direct line with the tops of the redwoods as well as of the edges of the banks. And thus the trains roll above the treetops and stand upon the living trees. So God's promises upon which the Christian rests are not dead stumps, but living trees that are vital with the life of God.

701 Claiming Promises

Carvosso had seen all his children converted, except one, and burdened with the lost one he sought counsel of a Christian leader, who said: "Why don't you claim a promise of the Lord?" "I don't understand you," he replied. "Well, the Book is full of promises, some bearing right on your case. Seize one of these and throw all your weight upon it until God feels your confidence in heaven." "I'll do it," said the father. They parted, and he looked up, and there came sweeping into his heart the words: "Thou shalt not leave one hoof behind thee" (see Ex. 10:26). It was enough.

For ten days he saw no change. On the tenth day, he was plowing near his house when a message came from his wife: "Do come at once, it seems our daughter will die." He understood it, and when he reached the room he asked: "Daughter, what's the matter?" She cried in agony: "Oh, father, pray for me; I do believe I am lost." In a very little time she rested by faith upon the finished work of Christ for salvation, and he said: "Now, daughter, tell me all about it." "I don't know anything about it," said she, "except that Sunday night ten days ago, just before you came home from the meeting, something got hold of my heart that I

could not shake off. I have been miserable ever since." "I know all about it," said the father; "that very night I claimed the promise made to Israel—that is what has moved you."

Quotes

702 Faith is . . .

"Faith is taking God at His word."

703 Affliction the Real Battle of Life

"A Christian without affliction is only like a soldier on parade."

—Felix Neff

704 Spurgeon on Faith

"We have no more faith at any time than we have in the hour of trial. All that will not bear to be tested is mere carnal confidence."

—C. H. Spurgeon

705 Doing the Will of God

"I find the doing of the will of God leaves me no time for disputing about his plans."

—M. D. Babcock

706 Watching Your Weakest Points

"By watching against your weakest points, you may make them your strongest points. That the universe was formed by a fortuitous concourse of atoms, I will no more believe than that the accidental jumbling of the alphabet would fall into a most ingenious treatise of philosophy."

—Dean Swift

707 Let Your Walk Talk

"It is a great deal better to live a holy life than to talk about it. We are told to let our light shine, and if it does we won't need to tell anybody it does. The light will be its own witness. Lighthouses don't ring bells and fire cannon to call attention to their shining—they just shine."

—D. L. Moody

708 A Man May Go To Heaven . . .

"A man may go to heaven without health, without riches, without honors, without learning, without friends; but he can never go there without Christ."

—John Dyer

709 The Bible

"The Bible, as a revelation from God, was not designed to give us all the information we might desire, nor to solve all the questions about which the human soul is perplexed, but to impart enough to be a safeguard to the haven of eternal rest."

—Albert Barnes

710 Experience

"Experience is a fine word for suffering."

—Hannah More

711 Burdens of the Day

"It has been well said that no man ever sank under the burden of the day. It is when tomorrow's burden is added to the burden of today that the weight is more than one can bear."

—George MacDonald

712 God's Delight in Beauty

"The world is God's journal wherein He writes His thoughts and traces His tastes. The world overflows with beauty. Beauty should no more be called trivial since it is the thought of God. Through beauty things become useful. It is a religious duty for a man, so far as he honestly can, to surround his children with creations of taste and beauty, that their finer instincts may be cultivated and gratified. The love of beauty is the gift of God, and it is born in the heart of every child."

—H. W. Beecher

713 Personal Responsibility

"This truth of personal responsibility is one of tremendous moment. We do not escape it by being in a crowd, one of a family, or of a congregation. No one but ourselves can live our lives, do our work, meet our obligations, bear our burdens. No one but ourselves can stand for us at last, before God, to render an account of our deeds. In the deepest, realest sense, each one of us lives alone."

—J. R. Miller

714 Friendship

"A friend—a true friend—the first person who comes in when the whole world has gone out."

715 Helpful Ministry

Cicero from Rome said in a letter to Plautius: "Whatever friendliness you can show my friend Furnius I shall take it as done to myself." The King of Heaven says to all of us: "Whatever you can do to make life better for those near you I will count as done unto me."

—J. M. Blake

716 Five Terse Truths

1) If you let trouble sit upon your soul like a hen upon her nest, you may expect the hatching of a large brood.

2) In order to have faith, you must work; faith is the wages of work.

3) Scripture is one Book; Nature is another; the latter reveals the Power of God, the former, His Will.

4) When alone, guard your thoughts; in the family, guard your temper; in company, guard your words.

5) The bread of life is love, the salt of life is work, the water of life faith.

Repentance

717 Painting the Pump

Reformation is no more the whole of Christianity than cultivation constitutes the whole of successful farming. A farmer may plow and harrow his ground every day of the summer and not permit a single weed to grow; that would be a high state of cultivation; but if he plants no seed in his field he will gather no crop in the autumn. Simply ridding your life of the weeds of undesirable habits, without planting the seeds of Christianity in your heart-garden, is as great a folly as for a farmer to cultivate his ground all summer and sow no seed. Repentance pulls up the weeds now growing and plants the seeds of righteousness. The man who attempts to improve by reforming is whitewashing his life, while the one who repents washes white his life, and there is a vast difference between the two processes. Morality can never save anybody. Painting the pump does not kill the typhoid germs and purify the water in the well. You may have literary circles and culture clubs, Carnegie libraries and schools of art, but your city will never be won to Christ until there is brought about an old-time revival of genuine repentance.

718 Friend in Need

I read of a boy that left home to make a way for himself in the world. As many before him, so had he wasted his substance, and the inevitable time of reckoning came. He sought assistance from friends and companions, but in a little while they all grew tired of helping him. In his last distress he determined to write home. "Dear Father," the pathetic appeal ran, "I am ill and undone. I have been foolish and sinful and have forgotten the spirit of your home. I want to get well, live right and be a man. But I cannot unless you help me. I deeply need your help, and I think you love me enough to forgive all, and to help me now. Will you come?" The next train found that father speeding on his way to his needy son, to put his strength, his character, his resources at the service of the son who was to be placed once more on the road to manhood. That father was a paraclete, a called one, a friend that soothes and strengthens and inspires. It was in this sense that the Greeks used the word "paraclete," a word forever consecrated by the Lord in applying to Himself and to the Holy Spirit. For He does apply the word to Himself when He calls the Holy Spirit "another Paraclete."

719 Penitent's First Effort

In every building the first stone must be laid and the first blow must be struck. The ark was 120 years in building; yet there was a day when Noah laid his axe at the first tree he cut down to form it. The temple of Solomon was a glorious building; but there was a day when the first huge stone was laid at the foot of Mount Moriah. When does the building of the Spirit really begin to appear in a man's heart? It begins, so far as we can judge, when he first pours out his heart to God in prayer.

—Bishop J. C. Ryle

720 Backslider Reclaimed

George Whitefield had a brother, who had lived far from the ways of godliness; and one afternoon he was sitting in a room in a chapel-house. He had heard his brother preach the day before, and his poor conscience had been cut to the very quick. Said Whitefield's brother, when he was at tea: "I am a lost man," and he groaned and cried, and could neither eat nor drink. Said Lady Huntingdon, who sat opposite: "What did you say, Mr. Whitefield?" "Madam," said he, "I said I am a lost man." "I'm glad of it," said she; "I'm glad of it." "Your ladyship, how can you say so? It is cruel to say you are glad that I am a lost man." "I repeat it, sir," said she; "I am heartily glad of it." He looked at her, more and more astonished at her barbarity. "I am glad of it," said she, "because it is written, 'The Son of Man came to seek and to save that which was lost.'" With the tears rolling down his cheeks, he said: "What a precious Scripture; and how is it that it comes with such force to me? O! Madam," said he, "Madam, I bless God for that; then he will save me; I trust my soul in his hands; he has forgiven me." He went outside the house, felt ill, fell upon the ground, and died.

—C. H. Spurgeon

721 Repentance Late

An American physician stated that he had known a hundred or more instances, in his practice, of people who, in prospect of death, had been hopefully converted, but had afterwards recovered. Of all these he only knew of three who devoted themselves to the service of Christ when they got well. An English doctor once told that he had known three hundred sick people profess repentance and faith when they thought they were dying, but who afterwards recovered. Only ten of these gave evidence of reality by a change of life.

722 Immediate Decision

One evening, in 1859, a young schoolmaster, intent only on fun and frolic, went to a prayer-meeting. He heard asked in the most solemn manner, the startling question: "How shall *you* escape if you neglect so great a salvation?" "Well, truly," he said in his own mind, "*that is a puzzle.* I am neglecting the great salvation. I cannot escape." He walked slowly home. He would like to be a

Christian, he thought; but how could he? He must give up his wicked companions. How they would laugh at him if he did not go to the same places, and lead the same life as before! And then, if he took his stand among Christians, he would fall back again into sin; and what disgrace he would bring upon religion! A still small voice whispered to him: "My grace is sufficient for thee." Then and there, on the road, on that calm summer night, he resolved, to use his own words, "to leave himself in the hands of Jesus, and set to his duty cheerfully."

723 Confession of Christ Indispensable

During a series of evangelistic services in Ireland, I spoke to a young man who was deeply convicted of sin. I showed him from the Bible God's word *for* him, and he accepted it with the same faith he had exercised in believing the word *against* him. The effect was similar in both cases: feeling followed, and was the result of believing the news. On his knees he thanked God; then he pressed my hand and thanked me for "helping" him, and went on his way rejoicing. Three nights after, to my surprise and disappointment, I found him sitting in the inquiry meeting looking the picture of misery. "What's wrong?" I said.

"I was too precipitate the other night; there is no change in me."

"No, sir; that is not the reason. You have not confessed Christ." He almost jumped up with amazement.

"How do you know? Who told you?" "Nobody told me, nor needed to tell me. When a man goes away trusting one night, and comes back doubting the next, it is an infallible sign that he has not confessed Christ." He then said, "You are quite right; I live alone with my mother, who is a Christian. I thought as I walked home that I would tell her, but my heart failed. I then said to myself, 'I'll tell her tomorrow morning'; but next day it seemed more difficult, instead of less, and it occurred to me that she would say, 'Why did you not tell me last night?' Then the thought arose, 'If you had found a hundred dollar bill, you would have told her fast enough; yet here you have found Christ and eternal life, and you utter not a sound; why, it is all a delusion!' and I said to myself, 'I'm not saved at all: if I had been, I could not have helped confessing.'"

I said, "Yes, my friend; instead of the devil tempting you, you tempted the devil. You opened your heart to him, and of course he came in and began his old game of making you distrust God's word."

We then went on our knees again. He confessed his sin, gave his heart anew to his Savior, rested on God's written word as to the result, and went away to tell his mother. Next night I found him in the inquiry room, trying to point a soul to Christ. I touched him in passing, and said: "How is it with you now?" He looked up with a bright smile, and said: "I told my mother!"

724 Divine Compensation

A man and his wife, nominal Roman Catholics, living in one of the darkest spots of London, were induced to attend one of Dr. Pentecost's meetings. No words could describe the brutal character of the man: his poor wife was quite blind from his ill-treatment. He listened with intense astonishment, and his conscience became more and more aroused. On being asked if he and his wife would like to have the question of sin settled, he was shown into the inquiry room, holding by the hand his sightless wife. On leaving the inquiry room, she remarked: "True, my sight is gone, but the Lord has given me back my husband; for it was the drink made him do it."

725 To Repent Is to Begin Again

To repent is to begin over again in devotion to the better thing we should have done. That is the very alpha of the gospel. And we begin over again not with tears but with joy. The very sins and blunders of the past may be caught up into some divine atonement that may make grace and joy to abound. That is the omega of our gospel. When sin abounded, grace did much more abound (Rom. 5:20).

726 The Modern Prodigal Worse Than the First

The hell to which the dissipation of strong drink leads could hardly be more graphically illustrated than by a story which the Bishop of Lon-don told of the way the children of the drunken poor reason from the horrible experiences of their own sad lives. A little London girl from the slums was being examined on the parable of the Prodigal Son. The teacher had gotten as far as the repentance of the prodigal, and his eating of the swine-husks, when she inquired, "What else could he have done?" The child replied, evidently speaking out of her experience, "He could have pawned his little girl's boots!"

727 What Is Repentance?

"From that time Jesus began to preach, and to say, Repent: for the kingdom of heaven is at hand." (Matt. 4:17).

J. R. Miller writes the following on this passage of Scripture:

"Christ's first call of His ministry, like John the Baptist's was a call to repentance. All men need to repent. We never can reach the gates of heaven unless we repent. The prodigal son had to rise and leave the far country, and walk back all the painful way to his father's house, before he could be restored to favor and be at home again. That is what every impenitent man and woman must do. The first step in coming to Christ is repentance.

"We must be sure that we know just what this word means. Some people imagine that if they are sorry for doing wrong they have repented. But sorrow for a wrong way does not take us out of that

way. Tears of penitence will not blot out sin; we must turn about and walk in holy paths. Repentance is ceasing to make blots on the record, and beginning to live a fair, clean, white life."

Salvation

728 *Power in the Blood*

Mr. Innis, a great Scottish minister, once visited a lost man who was dying. When he came for the first time he said, "Mr. Innis, I am relying on the mercy of God; God is merciful, and He will never damn a man forever." When he got worse and was nearer death Mr. Innis went to him again, and he said, "O, Mr. Innis, my hope is gone; for I have been thinking, if God be merciful, God is just, too; and what if, instead of being merciful to me, He should be just to me? What would then become of me? I must give up my hope in the mere mercy of God; tell me how to be saved!" Mr. Innis told him that Christ had died in the stead of all believers—that God could be just, and yet save the justified through the death of Christ. "Ah!" said he, "Mr. Innis, there is something solid in that; I can rest on that; I cannot rest on anything else"; and it is a remarkable fact that none of us ever met with a man who thought he had his sins forgiven unless it was through the blood of Christ. Meet a lost man; he never knows that his sins are forgiven. Meet a legalist; he says, "I hope they will be forgiven"; but he does not pretend they are. No one ever gets even a fancied hope apart from this, that Christ, and Christ alone, must save by the shedding of His blood.

—C. H. Spurgeon

729 *All Saved but One*

A terrible storm swept the Atlantic and hurled the billows upon the coast of England and a ship was thrown on the rocks. The night fell dark and lowering. The storm rose higher as the night deepened. Fires were kindled all along the shore, if by any means to help those who were needing help. The lifeboat was manned. Out through the breakers and into the storm they went to the rescue. By and by they came back with all on board except one man; and John Holden, who stood upon the shore, cried: "Do you have all the ship's company?"

They answered, "All but one man."

"Why did you not get him?"

"Well, our strength was nearly gone, and if we had tarried long enough to rescue him we all should have been engulfed in the pitiless sea." Then John Holden said: "These men who have been to the rescue are nearly exhausted. Who is there who will go with me to rescue the one man?" and six sturdy fellows came promptly forward. Then John

Holden's mother threw her arms about his neck and said, "John, don't you go! Your father was swallowed up by the angry ocean, and your brother William two years ago went out upon the sea, and I fear that he is lost, too, for we have not heard of him since. You are the pillar of my life and my only dependence. Who will care for me if the sea swallows you also?" Then John Holden, with his firm, strong grasp, took those arms in which he had reposed in innocent infancy and removed them from his neck; and then he said, as he gently pushed his mother aside: "There is a man there drowning, and I must go, mother. If the sea should swallow me, God will take care of you; I'm sure He will." Kissing her furrowed cheek, he turned and stepped into the lifeboat which was already manned. They pushed out into the breakers and to the wreck. They found the man still clinging to the rigging, and, getting him into the boat, they pulled back to the shore. As the boat neared the shore, someone shouted, "Have you found the man?" "Yes," answered John Holden, "and rescued him; and say to my mother that he is my brother William!"

730 New Birth

Human nature is too bad to be improved, too dilapidated to be repaired. Here is a cracked bell. How can it be restored? By one of two methods. The first is to repair the bell, to encompass it with hoops, to surround it with bands. Neverthe-less, you can easily discern the crack of the bell in the crack of the sound. The only effective way is to remelt the bell, recast it, and make it all new; then it will ring clear. And human nature is a bell, suspended high up in the steeple of creation, to ring forth the praises of the Creator. But in the fall in Eden the bell cracked. How can it be restored? By one of two ways. One is to surround it with outward laws and regulations, as with steel hoops. This is the method adopted by philosophy, as embodied in practical statesmanship, and without doubt there is a marked improvement in the sound. Nevertheless, the crack in the metal shows itself in the crack of the tone. The best way is to remelt it, recast it, remold it; and this is God's method in the Gospel. He remelts our being, refashions us, makes us new creatures in Christ Jesus, zealous unto good works; and by and by we shall sound forth His praises in a nobler, sweeter strain than ever we did before. Heaven's high arches will be made to echo our anthems of praise.

731 Danger of Delay

A lady had a very important lawsuit on hand for which she needed the services of an advocate. She was strongly urged to secure the help of a very prominent and well-known lawyer, but she could not make up her mind to entrust her case to anyone. Time passed on, and at last she was compelled to take steps to secure an advocate,

and called upon the great lawyer who had been mentioned to her. He listened while she expressed her wish to engage his help, but in a few minutes he said with a grave face: "Madam, you are too late; had you come to me before, I would gladly have been your advocate, but now I have been called to the bench, and am a judge, and all I can do is to pass judgment upon your case." Now is the day of grace, and the Lord Jesus Christ is our Advocate, ever pleading the merits of His precious blood, but the day will come when He will be the Judge of sinners, and must pass sentence upon them.

732 Started Too Late

How many more days do you want to spend in rebellion against God? I am reminded of that little boy who ran to the train. Just as he reached the platform the train moved off and left him. He stood there panting and watching the train, now in the distance. A man said to him: "You didn't run fast enough!" "No," said the boy, "I ran with all my might, but I didn't make it because I didn't start soon enough." Many a man will rush up and find the gates of heaven closed, and say, like the boy, "I didn't start soon enough."

733 Procrastination

The steamship *Central America,* on a voyage from New York to San Francisco, sprung a leak in mid-ocean. A vessel, seeing her signal of distress, bore down toward her.

Perceiving the danger to be imminent, the captain of the rescue ship spoke to the *Central America*, asking, "What is amiss?"

"We are in bad repair and going down; lie by till morning," was the answer.

"Let me take your passengers on board now."

But, as it was night, the commander of the *Central America* did not like to send his passengers away lest some might be lost, and, thinking that they could keep afloat awhile longer, replied: "Lie by till morning."

Once again the captain of the rescue ship called: "You had better let me take them now."

"Lie by till morning," was sounded back through the trumpet.

About an hour and a half later her lights were missed, and, though no sound was heard, the *Central America* had gone down, and all on board perished, because it was thought they could be saved better at another time.

734 Successful Endeavor

The Rev. Edward Judson, of the Berean Baptist Church, New York, prints the following note at the end of a list of the services of his church: "A Christian man, deeply devoted, and wise to win souls, made it a rule to speak to some unconverted person every day on the subject of his soul's salvation. One night, as he was about to retire, he realized that he had not fulfilled his vow that day. He immediately put on his clothes and prepared to go in

quest of a soul. But where should he go was the question. He concluded to make a visit to a grocer with whom he was in the habit of trading. He found him engaged in closing up his store. When the errand of his customer was made known he was surprised. He said all sorts of Christians traded with him—Methodists, Episcopalians, Baptists, etc.—but no one had ever spoken to him about his soul. The night visit of his customer and his earnest pleadings made such an impression upon his mind that it led to his speedy conversion.

735 Catching Fish

Seeking diversion by fishing in the streams of Scotland, a literary man went from the city with expensive fishing rod and tackle and a complete outfit of the most luxurious kind. After hours of effort without even a bite, he came across a country boy with only a switch for a pole and a bent pin for a hook— but he had a long string of fish.

"Why is it I can't catch any?" the man inquired.

"Because you don't keep yourself out of sight," the boy quietly replied.

This is the secret of fishing for men as well as trout. Hold up the cross of Christ. Send the people away talking about Him instead of praising you.

736 Soul-Winning Invalid

Dr. J. G. K. McClure tells about an invalid woman residing at Springfield, Illinois, who had been bedridden for seventeen years and was almost helpless. For many years she had been praying to God in a general way to save souls. One day she asked for pen and paper. "She wrote down the names of fifty-seven acquaintances. She prayed for each of these by name three times a day. She wrote them letters telling them of her interest in them. She also wrote to Christian friends, in whom she knew these persons had confidence, and urged them to speak to these persons about their souls' welfare and to do their best to persuade them to repent and believe. She had unquestioning faith in God. In her humble, earnest dependence upon Him she thus interceded for the unsaved. In time every one of those fifty-seven persons avowed faith in Jesus Christ as his Savior."

737 Keeping Your Vow

Are you keeping your vow? Take your devotion for your church. Don't you remember, when you were converted, how you loved the services of the church? I remember when I first experienced a change of heart—it was in an old schoolhouse in the country. My mother was by my side talking to me. I felt a load roll away from my heart, and I felt good. They were singing that good old hymn: "Come, ye sinners, poor and needy, Weak and wounded, sick and sore; Jesus ready stands to save you, Full of pity, love and power."

I shall never forget my feelings. I wanted to stay there all night and

sing. Many years have passed; mother has gone to heaven; the old log house has been torn down; but I love that spot.

You felt that way, too. I fancy, when Sunday morning came, you were the first in Sunday School. You were always on hand at prayer-meeting. But how about it today? It was so in your giving. At first you gave your money liberally and freely; but now it takes a dozen church collectors to get it out of you, and you growl and whine over pocket change when you then rejoiced in dollars. How about your vows, brother?

738 Saved to Serve

I once knew an old man who was possessed with a mania for buying up wheels of all sorts. A wheel, whether from a wagon, a cart or a wheelbarrow, possessed peculiar attractions for him; and yet in all his life he never owned even a wheelbarrow. He did not put his wheels to any use. He is a pretty good counterpart of the man the ultimatum of whose idea of successful church work is that of getting people to join the church. A good many churches where this idea has been followed are, therefore, practically nothing more than a heap of wheels and bolts and bars that are of no use because they have been put to none.

"Saved to serve" is a good motto, but it implies more than we are sometimes disposed to take into consideration. It means that we must train people as well as save

them. It is not enough that we induce men and women to be good; we are to see to it that they are put in the way of becoming good for something.

739 Personal Touch Wins

A noted evangelist was once holding a series of services in a church whose minister was a man of long experience and of great influence. One night as they sat on the platform together the minister pointed out to the evangelist a man in the audience.

"For twelve years," he said, "I have tried to win that man to Christ; I have preached to him so long that I sometimes find myself doing it almost unconsciously."

"From the pulpit?" asked the evangelist.

"From the pulpit, yes."

"How many times have you gone to him with the love of God in your heart and said: 'I want to see you become a child of God?'"

"I must confess," said the minister, "that I have never spoken to him personally and directly concerning his salvation."

"Then," said the evangelist, "perhaps he is not impregnable after all."

That night the evangelist, after the service, caught the man before he got to the door. He spoke only a few words, but they were earnest and loving. And the next evening in the "after service," in which many souls have found lasting peace and eternal life, the man was on his knees with the tears streaming

down his cheeks. It was the personal touch that did it.

The sermon is effective with many. Music has brought salvation to many a life. But on thousands and thousands of cases it is only the personal touch that wins.

740 Come Home!

S. H. Hadley, of the Water Street Mission, once met a boy in the street utterly ragged and miserable. He had stolen money from his father, and had run away from home. He was reaping the bitter wages of sin, and was penniless in the great city. Mr. Hadley advised him to go back to his father, but the boy said: "You don't know my father. He is a hard man; he will never forgive me."

"Well, come to the mission and stay tonight."

That very evening a letter went to the father, telling him that his missing boy was at the Water Street Mission, in destitute circumstances, and that he was sincerely sorry for his wrongdoing. The next morning a message flashed over the wire, saying: "My boy is forgiven; tell him to come home."

That is Christ's message to the wandering ones today. How the blessed word "Come," echoes through Holy Scripture! But human hearts too seldom hear its music.

741 Working at the Keyhole

A blessed work of grace had been going on in various parts of Scotland. Many had accepted God's "great salvation" and rejoiced in their newly-found Savior. Among these was a Mr. Murray, an office-bearer in one of the churches and for fifty years a professor of religion, without, however, the "one thing needful." One day as Mr. Murray was reading a gospel paper he came across the following statement: "The gospel brings us not a work to do, but a word to believe about a work done." "I see it all," said he to his wife. "I have been working away at the keyhole, and the door has been open all the time. My fifty years' profession goes for nothing, and I get salvation through simply accepting Christ."

742 Refusals

A famous scientist tells how that, in the course of his experiments in the mountains, he used to be lowered over a precipice. He would step into the basket, and the men would lower him for his work; but whenever they lowered him, they would always test his weight to see if they could lift him again. One day they let him down farther and farther than ever before, until all the rope at their command was exhausted. When his day's work was done, he would give the signal, and they would draw him up. But on this night, when they took hold of the rope to lift him, they could not do so. They tugged and pulled and strained, but they could not manage it, and he had to wait until they got additional men to pull him up, and the scientist says that the reason they could not lift him was because they failed to take into consideration the length and weight of the

rope. I know why a fifty-year-old man has a hard time to surrender. It is because he must always lift against his past refusals. You say, "No," and your heart is hardened; you say, "No," and your will becomes stubborn, and if you are finally lost, the responsibility is not with God.

—J. Wilbur Chapman

743 Willful Rejection of Salvation

To me it is especially appalling that a man should perish through willfully rejecting the Divine salvation. A drowning man throwing away the life-belt, a poisoned man pouring the antidote upon the floor, a wounded man tearing open his wounds—any of these is a sad sight. But what shall we say of a soul refusing its Savior and choosing its own destruction?

—C. H. Spurgeon

744 Right About Face

A young soldier, who had led a careless life, but afterwards had become a Christian, described very well the change that had been produced in him when he said—"Jesus Christ said to me, Right about face! And I heard and obeyed Him in my heart." That is exactly what we call "repentance." It is a turning-about of the face—from the world to God. But with the face it is a turning also of the heart.

745 Neander's Conversion

A young Jewish lad named David Mendel, who used to astonish a bookseller in Hamburg by losing himself for hours in volumes so learned that no one else would touch them, was attracted to certain works on Christianity, and read them with glowing interest. He was impressed with the claims which Jesus makes upon humanity, and finally became convinced that He who taught such ethics, and required of His adherents such a life, must be more than a man. For a long time he wavered between fidelity to the teachings of his parents and loyalty to the new conceptions which had entered his soul. At length he could hold his false position no longer, and publicly renounced Judaism and was baptized. To commemorate the change which had occurred in his life he adopted the name Neander, signifying a new man. Such, by a slow but steady process from the first awakening of his mind to the final surrender of his will, was the conversion of the man who has been called the father of modern Church History.

746 Charles Wesley's Peace Offering

Although Charles Wesley had been engaged in preaching the gospel with much diligence and earnestness, he did not know what it was to enjoy peace with God until he was in his thirtieth year. Being laid low by an alarming illness, and seeming as if he were going to die, a young Moravian named Peter Bohler, who was undergoing a course of preparation

by him to go out as a missionary, asked him, "Do you hope to be saved?" Charles answered, "Yes."

"For what reason do you hope it?"

"Because I have used my best endeavors to serve God." The Moravian shook his head and said no more. That sad, silent, significant shake of the head shattered all Charles Wesley's false foundation of salvation by endeavors. He was afterwards taught by Peter Bohler the way of the Lord more perfectly, and brought to see that by faith in the Lord Jesus Christ men are justified. And now in his sick-room he was able to write for the first time in his life, "I now find myself at peace with God"; and it was on this occasion he composed that beautiful hymn, "*O for a thousand tongues to sing my great Redeemer's praise!*"

747 Conversion of Wilberforce

When William Wilberforce was brought to Christ he went with fear and trembling to his friend, the great statesman of the day, William Pitt, to tell him of the change. For two hours his friend endeavored to convince him that he was becoming visionary, fanatical, if not insane. But the young convert was steadfast and immovable. He had spent his twenty-fifth birthday at the top wave and highest flow of those amusements—the racecourse and the ballroom—which had swallowed up a large portion of his youth. He had laughed and sung, and been envied for his gaiety and happiness. But true happiness he had never found till he found Christ. And now he laid his wealth and wit and eloquence and influence at the feet of his Lord, his motto being—"Whatsoever others do, as for me, I will serve the Lord."

748 Mr. Torrey's Conversion

Sometimes God's messenger is home influence. Did you ever hear Mr. Torrey, the far-famed evangelist, tell what an awful unbeliever he was when he was a young man, how he went to the deepest depths of infidelity and scouted everything—the Bible, Christ, God, heaven, hell, immortality—everything like that? But his dear mother yearned after him, and loved him, and pleaded with him, and prayed for him, and after awhile he said to his mother: "I am tired of it all, and I am going to leave and not bother you anymore." She followed him to the door, and followed him to the gate, pleading and praying and loving and weeping, and then at last she said, as her final word: "Son, when you come to the darkest hour of all, and everything seems lost and gone, if you will honestly call on your mother's God, you will get help." Years later, as he contemplated committing suicide in a hotel far from home, the last words that his mother had said came back to him. And Torrey said he fell beside his bed and said: "Oh, God of my mother, if there is such a Being, I want light, and if Thou wilt give it, no matter how, I will follow it." He

was converted right then and there, and hurried back home. Oh, the power of a mother's prayer!

—George W. Truett

749 Pam Chick and Partner

Some years ago a writer of religious fiction told the story of a man named Pam Chick, who was long a drunkard. He was in business, but his business suffered. Then there was a change in his personal appearance and in the appearance of his store. New stock was added; the building was painted. Finally a new sign was put up which read: "Pam Chick and Partner."

Of course there was much curiosity as to the identity of the partner. To all inquiries the reformed man only smiled. At first people thought that anyone would be foolish to enter into a partnership like this, but as time passed and the business prospered, they were not so sure. Then they were all the more eager to know who the partner could be. He must be a far-sighted man, they thought, to enter into business relations with Pam Chick. How did he know there would be such a marvelous change in the man? What was the secret of the change?

The curiosity was not satisfied till after the death of Pam Chick. Then it came out that the Partner was the Lord Jesus Christ. To make real the thought that he had entered into partnership with the Lord, when he became a Christian, Pam Chick had painted the sign and had made the effort to tell everything about the business, and indeed about all his life, to the Partner, precisely as he would have done with an ordinary partner, if he had had him.

When the story was told, neighbors and friends were able to see the secret of the transformed life of the former drunkard. His Partner was responsible!

750 Saved and Not Ashamed

The Rev. George F. Pentecost tells of a timid little girl, who wanted to be prayed for at a religious meeting in the south of London. She wanted to come to Jesus, and said to the Christian man who was conducting the meetings; "Will you pray for me in the meeting, please? But do not mention my name." In the meeting which followed, when every head was bowed and there was perfect silence, the gentleman prayed for the little girl, and he said: "O Lord, there is a little girl who does not want her name known, but Thou dost know her; save her precious soul." There was stillness for a moment, and then away back in that congregation a little girl arose, and a pleading little voice said: "Please, it's me; Jesus, it's me." She did not want to have a doubt. The more she had thought about it the hungrier her heart was for forgiveness. She wanted to be saved, and she was not ashamed to say: "Jesus, it's me."

751 Not Ashamed

The moment a man is converted, if he would let himself alone, his in-

stincts would lead him to tell his fellows. I know that the moment I came out of that little chapel wherein I found the Savior, I wanted to pour out my tale of joy. "Now will I tell to sinners round, What a dear Savior I have found; I'll point to Thy redeeming blood, and say, 'Behold the way to God!' "

—C. H. Spurgeon

752 Cost of Redemption

A little boy about ten years old was once ordered by his father to go and do some work in the field. He went as he was told, but took little pains about it, and made very slow progress in his task. By and by his father called to him very kindly, and said: "Willie, can you tell me how much you have cost me since you have been born?" The father waited a while, and then said that he reckoned he had "cost him a hundred pounds." The boy opened his eyes and wondered at the expense he had been. He seemed to see the hundred sovereigns all glittering before him, and in his heart determined to repay his father by doing all he could to please him. The reproof sank deeper into his heart than a hundred stripes. When I read the story it occurred to me: "What have I cost my Savior?" Then I remembered the words, "Ye are not redeemed with corruptible things, as silver and gold, but with the precious blood of Christ, as of a lamb without blemish and without spot" (1 Pet. 1:18, 19).

753 Resting Place for the Soul

Years ago there came to the late Canon Hoare, a rich man, then in his old age, to arrange with him about his burial place, and after they had gone carefully over the churchyard, and had chosen the spot where he was to lie, Canon Hoare turned to him and said, "You have chosen a resting place for your body, but have you yet found a resting place for your soul?" Turning around and looking him full in the face, the old man answered: "You are the first clergyman who ever asked me that question." He went with Canon Hoare into his study, and, to make a long story short, he gave his heart to Christ, and found his resting place, and in Canon Hoare's study to the day of his death hung a wellknown picture representing the saving of a life from a wreck. It was the gift of the grateful man, who had found a resting place not only for his body but for his soul. Ask yourself the question now, before you turn to another page: "Have I found a resting place for my soul?"

754 Saved by a Tract

At a tea meeting in an English seaside town, a poor woman asked permission to speak. When the minister reluctantly consented, she told a terrible story of sin and wretchedness, culminating in a resolve on her part to murder her husband, if as usual he came home drunk, and then to kill herself. She went to look at the place where she meant to

drown herself, and on her return found that someone had laid a tract on her table. She always refused to read tracts, but the title of this one caught and held her attention. It was, "The greater the sinner, the greater the Savior." This went to her heart, and she cried to the Savior for mercy. To her surprise her husband came home sober and continued so to the end of the week, bringing home his wages. She told him of the tract, and at his proposal they went to church together. Not finding at first what helped them, they went to different churches, till they heard the gospel plainly preached. "And now," she said, "I hope and believe we are both saved from God's wrath, which we so certainly deserved, by that great Savior, whose great mercy the tract sets forth, and whose Son you so constantly proclaim."

755 The Shadow of His Wing

"He that dwelleth in the secret place of the most high shall abide under the shadow of the Almighty" (Ps. 91:1).

Two Americans were crossing the Atlantic and were singing the hymn, "Jesus, Lover of My Soul." They were joined by a third man having an exceedingly rich tenor voice. When the music ceased one of the Americans turned to this third party to ask if he had been in the Civil War. The man replied that he had been a Confederate soldier.

"Were you at such a place on such a night?" asked the first man.

"Yes," he said, "and a curious thing happened that night; this hymn recalled it to my mind. I was on sentry duty on the edge of a wood. It was a dark night and very cold, and I was not a little frightened because the enemy was supposed to be near at hand. I felt homesick and miserable, and about midnight, when everything was still, I was beginning to feel weary and though I would comfort myself by praying and singing a hymn. I remember singing this hymn—

All my trust on Thee is stayed
All my help from Thee I bring
Cover my defenseless head
With the shadow of Thy wing.

After I had sung those words a strange peace came down upon me, and through the long night I remember having felt no fear.

"Now," said the first man, "listen to my story. I was a Union soldier, and was in the woods that very night with a party of scouts. I saw you standing there in the woods, my men focused their rifles upon you, but then you sang out that song. We listened. We never fired. I said, 'Boys, put down your rifles; we will go home. I couldn't kill after that.'"

756 He Knows His Sheep

"My sheep hear my voice, and I know them, and they follow me" (John 10:27).

In far off Syria some shepherds still maintain the old practice of calling their sheep by name. An

American, doubting that each sheep would respond to its name when called by the shepherd, insisted the shepherd demonstrate.

"I wish you would call just one or two," he said.

The shepherd called, "Carl."

The sheep stopped eating and looked up.

"Come here," commanded the shepherd.

The sheep came and looked up into the shepherd's face.

He called another and another, and there they all stood looking up into the shepherd's face.

"How can you tell them apart?" asked the American.

"Oh, there are no two alike. See, that sheep's toes are in a little; this one is squint-eyed; and that one has a black mark on its nose." In fact, every one of those sheep had its own marking.

I suppose that is the way the Lord distinguishes His sheep. There is a man that is covetous, he wants to grasp the whole world. He needs a shepherd to keep down that spirit. There is a woman who stirs up the whole neighborhood by her gossiping. She too needs the Shepherd to keep her tongue from deceit and her lips from speaking guile. There is a father whose cursing is damning his reputation. Does he not need the Shepherd's attention?

There isn't a man or woman without some failing, some marking by reason of sin, which makes it easy for the Lord to identify him by his own besetting sin.

757 *Trodden under Foot*

"Of how much sorer punishment, suppose ye, shall he be though worthy, who hath trodden under foot the Son of God. . . ." (Heb. 10:29).

The story is told of a great scientist, a naturalist, who one lovely summer day, went out in the Highlands of Scotland to study under his microscope the heather bell in all its native glory. In order to see its perfection, he got down on his knees, without plucking the flower, adjusted his instrument, and was reveling in its color, its delicacy, its beauty, lost in "wonder, love, and praise."

How long he stayed there he does not know, but suddenly there was a shadow on him and his instrument. He waited for a time, thinking it might be a passing cloud. But it stayed there, and presently looking up over his shoulder saw a Highland shepherd watching him. Without saying a word the scientist plucked a heather bell and handed it, with the microscope, to the shepherd that he, too, might see what he was beholding.

The old shepherd put the instrument up to his eyes, got the heather bell in place and looked at it until the tears ran down his rugged face like bubbles on a mountain stream. Then handing the microscope back to the scientist, he said, "I wish you had never shown me that. I wish I had never seen it."

"Why? asked the surprised scientist.

"Because," was the reply, "mon,

this rude foot has trodden on so many of them."

Even so, when once you look through God's telescope—the Word of God—and see the marvels of His love displayed at Calvary's Cross, you, too, will accuse yourself for having ever treated Him badly for a single moment. The Lord open our eyes to see the exceeding sinfulness of any light-hearted regarding of the sacrifice He made there for our salvation.

758 The Time is Short

"Arise, shine, for thy light is come!" (Is. 60:1).

In the Polar regions the summer season causes much joy and brightness. Every hour is utilized, as they well know that in a few weeks the opportunity will be gone, and the severity of a long winter will again set in. They act as those who believe that the time is short. Such is the "accepted time, the day of salvation" (2 Cor. 6:2). A brief but precious season. Yet many do not heed this—their only chance of a harvest of eternal bliss before the long winter of death and eternal gloom sets in. "Arise, shine, for thy light is come!"

759 Earnestness Needed in Soul-Saving

As the ferry boat *St. Louis* was nearing mid-stream in the North River, the passengers were startled by a cry of "Stop the boat! My God, stop the boat! My sister has jumped overboard!" It of course attracted immediate attention to the drown-

ing woman, but no one among all the passengers criticized the sister for her passionate outcry or bade her keep still. It seemed the most natural thing in the world that she should evince this deadly earnestness. We need the same passionate earnestness in seeking to save our friends and neighbors who have jumped overboard from righteousness and innocence into the whirling current of sin and worldliness, and will be drowned eternally if not speedily rescued.

760 The Seeking Savior

Some shipwrecked sailors have been rescued from an island in the Pacific, who had been for ten months anxiously watching for some opportunity of escape. For ten months and ten days they had kept their flag of distress flying from the treetops during the day, and their signal-fires burning by night. They knew no ship would be seeking for them, and their only hope of succor was in making their wants known to some passing ship. At last their signal was seen, and with joy unutterable they beheld a friendly ship bearing down toward the place of their exile. The sinner has more hope than that, "for the Son of man is come to seek and to save that which was lost" (Luke 19:10). No man who is finally lost can complain that he did not have a fair chance for salvation.

761 The Greatest Jewel of All

At the beginning of the eighteenth century, a soldier belonging to one of

the French garrisons in India became enamored of the eyes of Brahma, in the Temple of Seringham. These eyes were diamonds, and were the most brilliant in all the East. Their luster captivated the soldier's soul. He haunted the temple and pretended to yield to the might of the god, and become a convert to his worship. The priests so far believed in him that he was admitted to some care of the temple. They doubtless thought Brahma would be able to protect his own eyes. But on a stormy night the soldier disappeared, and with him one of the idol's eyes, the other having resisted all his efforts to dislodge it. So Brahma was left squinting, and the treacherous Frenchman sold his prize to a captain in the English navy for ten thousand dollars. A shrewd Armenian merchant paid fifty thousand dollars for it, and sold it to County Gregory for Catherine of Russia for four hundred thousand dollars. That was the origin of the famous Orloff diamond. The most splendid jewel in the world, however, is not a diamond, but a pearl. Jesus calls it the Pearl of Great Price (Matt. 13:45–49). He declares that a man is wise who sells all he has in order to purchase that pearl. It is the Pearl of Salvation, and the poorest man in the world may purchase it as easily as a king on his throne, but the conditions are always the same, the surrender of the whole heart and life to Jesus.

762 Miracles

The age of miracles has not passed. To take a young man who has been indifferent, who has been living along as though this world were all, and suddenly confront him with the call of Christ, and have him yield to that call so that he turns away from the things he has loved, and enters upon a new life, rejoicing in the fellowship of Jesus Christ, is surely a greater miracle than to cure a man of leprosy. One Sunday evening a young man heard the story of Christ's love and yielded his heart to it. It was the first time he had ever been in the church where this wonderful change was brought. A few days afterward I received a letter from him that opened with these words: "I have found much peace with my Savior, whom I accepted as my personal Savior last Sunday evening. I only regret that I did not take that step a long time ago; but now, as a young man, twenty-four years of age, I shall do all that is in my power to advance his kingdom. Oh, how grand it is to be a Christian! I have enjoyed unspeakable comfort, peace, and joy during the past week."

763 Saved by Grace

God, then, is more earnest for me to be saved than I am to be saved! "He so loved the world that He gave His Son" (see John 3:16). He loved not saints, not penitents, not the religious, not those who love Him; but "the world," secular men, profane men, hardened rebels, hopeless wanderers and sinners! He gave not a mere promise, not an angel to teach us, not a world to ransom us, but His Son—His only begotten! So

much did God love the world, sinners, me! I believe this. I must believe it; I believe on Him who says it. How can I, then, do otherwise than rejoice?

—Martin Luther

764 Too Late

Have you never heard of the Indian in his boat upon one of the great rivers of America? Somehow his moorings had broken and his canoe was in the power of the current. He was asleep, while his canoe was being swept rapidly along by the stream. He was sound asleep, and yet had good need to have been awake, for there was a tremendous waterfall not far ahead. Persons on shore saw the canoe—saw that there was a man in it asleep; but their vigilance was of no use to the sleeper: it needed that he himself should be aware of his peril. The canoe quickened its pace, for the waters of the river grew more rapid as they approached the falls; persons on shore began to cry out, and raise alarm on all sides, and at last the Indian was aroused. He started up, and began to use his paddle, but his strength was altogether insufficient for the struggle with the gigantic force of the waters around him. He was seen to spring upright in the boat and disappear—himself and the boat—in the fall. He had perished, for he woke too late! Some persons on their dying beds just wake up in time to see their danger, but not escape from it; they are carried right over the precipice of judgment and wrath.

—C. H. Spurgeon

765 Running into God's Arms

The following anecdote is yet another from the pen of C. H. Spurgeon:

"Some years ago I was walking in the garden one evening, and I saw a stray dog about whom I had received information that he was in the habit of visiting my grounds, and that he did not in the least assist the gardener, and therefore his attentions were not desired. As I walked along one Saturday evening meditating upon my sermon, I saw this dog busily doing mischief. I threw my stick at him, and told him to go home. But what do you think he did? Instead of grinding his teeth at me, or hurrying off with a howl, he looked at me very pleasantly, took up my stick in his mouth, and brought it to me and then, wagging his tail, he laid the stick at my feet. The tears were in my eyes; the dog had beaten me. I said, 'Good dog! Good dog; you may come here when you like after that.' Why had the dog conquered me? Because he had confidence in me, and would not believe that I could mean him any hurt. To turn to grander things; the Lord himself cannot resist humble confidence. Do you not see how a sinner brings, as it were, the rod of justice to the Lord, and cries, 'If thou smite me, I deserve it, but I submit to thee.' The great God cannot spurn a trustful heart. It is impossible. He were no God if he could cast the soul away that implicitly relies on him. This is the power of faith, then, and I marvel not that the Lord

should have chosen it, for believing is a thing most pleasing to God. O that you would all trust him! God lifts his sword against you—run into his arms. He threatens you—grasp his promise. He pursues you—fly to his dear Son. Trust at the foot of the cross in his full atonement, and you must be saved."

766 Salvation—Most Wonderful

When Gypsy Smith was holding a testimony meeting at one time, a man got up and said: "I have spent twenty years in prison for murder, but God has saved me." Another said: "I have been a drunkard for twenty years, and God has saved me." Another said: "I have been a coiner of counterfeit money, and the Lord has saved me." Then Gypsy Smith got up and said: "Men, listen. God has done wonders for you, but don't forget he did more for this gypsy boy than for all of you put together. He saved me before I got there."

767 Assurance of Salvation

A theological student once called on Archibald Alexander in great distress of mind, doubting whether he had been converted. The old doctor encouraged him to open his mind. After he was through, the aged disciple, laying his hand on his head, said, "My young brother, you know what repentance is—what faith in Christ is. You think you once repented and once believed. Now don't fight your doubts; do it all over again. Repent now; believe in

Christ—that's the way to have a consciousness of acceptance with God. I have to do both very often. Go to your room and give yourself to Christ this very moment, and let doubts go. If you have not been His disciple, be one now. Don't fight the devil on his own ground. Choose the ground of Christ's righteousness and atonement, and then fight him."

768 Faulty, Effective Speech

In Moody's early days, an overzealous critic, who was not an overactive worker, took him to task for his defects in speech. "You oughtn't to attempt to speak in public, Moody. You make many mistakes in grammar." "I lack a great many things" said Moody, "but I'm doing the best I can with what I've got." But, look here, my friend, you've got grammar enough; what are you doing with it for Jesus?"

769 Salvation by Sacrifice

In the early days of the French in Canada, those living at Quebec heard that the Iroquois were coming down the St. Lawrence, twelve hundred strong. If they reached the settlements they would burn the houses, and destroy the crops even if those who gained the Fort were secure. They must not reach Quebec. So Daulac with sixteen followers volunteered to go up the river and meet them, and turn them back. On the way they were joined by forty-four Hurons and coming to the foot of a rapid which the Iroquois must descend, they built a

little fort of stakes and stones and awaited the foe. And they came twelve hundred strong and hurled attack after attack against the little citadel. But those behind were fighting off the enemy for country and for life. They beat off the enemy for days and days. But the water was exhausted and their parched throats refused to swallow the dry corn. But there was no thought of surrender and so the fight went on. But the task was too unequal even for men such as they, and they were at last slain. But the Iroquois had learned to fear Frenchmen so that they never went on to Quebec. The seventeen brave Frenchmen had saved their countrymen's lives by laying down their own.

770 Dangerous Delay

I remember when Mr. Sankey and myself were in Chicago preaching, we had been five Sunday nights on the life of Christ. We had taken Him from the cradle, and on the fifth night we had just got Him up to where we have Him today. He was in the hands of Pilate, and Pilate didn't know what to do with Him. I remember it distinctly, for I made one of the greatest mistakes that night that I ever made. After I had nearly finished my sermon, I said, "I want you to take this home with you, and next Sunday night we will see what you will do with Him." Well, after a while the meeting closed, and we had a second meeting. The people gathered in the room, and Mr. Sankey during the service sang a hymn, and as he got down to the verse, "The Savior calls, for refuge fly," I saw I had made a mistake in telling the people that next week they could answer. I saw that it was wrong to put off answering the question. After the meeting, I started to go home. They were ringing the fire alarm at the time, and it proved to be the death knell of the city. I didn't know what it meant, and so went home. That night the fire raged through the city, destroying everything in its path, and before the next morning the very hall where we had gathered was ashes. People rushed through the streets crazed with fear, and some of those who were at the meeting were burned to death. O what a mistake to put off the answer! May God forgive me! "Today the Savior calls; for refuge fly."

—D. L. Moody

771 "Born Again"

Because it is so frequently repeated, this phrase does not make much impression upon those who hear it. Nobody seems to think there are earthquakes and revolutions in it; but there are. Nobody seems to think it is a part of the "power of God and the wisdom of God"; but it is. Not the thunder that cracks and rolls through the mountains, not the summer storms that sweep across the earth, not the volcano and the earthquake, are for prodigiousness of power to be compared with this simple annunciation, "Ye must be born again." *Must?* Take out that word, and say, with tears of

gratitude, "We *can* be born again!" There is no other truth so full of hope as this.

772 *Witness!*

A God-pleasing witness is honored with wondrous fruit. God strengthened, honored, justified, and used Simeon's testimony to Jesus through the life of Jesus that followed. God works before, with, and after God-honoring witnesses. An illiterate evangelist preached a simple sermon in an Irish barn. A youth name Toplady accepted Christ, became a minister of Christ and wrote *Rock of Ages*. A humble shoe cobbler witnessed to a six-teen-year-old lad named Charles H. Spurgeon. Spurgeon has witnessed and still witnesses to the world for Christ through his many published sermons and books.

773 *Soul-Winning*

Perhaps the strongest love of a Christian friend is that which impels him to speak to another of his Savior.

Gypsy Smith said that when he was converted he immediately became anxious for the conversion of his uncle. Among gypsies it was not considered proper for children to address their elders on the subject of duty, and so the boy just prayed, and waited for God to open the way.

One day his uncle noticed a hole in his trousers, and said, "Rodney, how is it that you have worn the knees of your pants so much faster that the rest of them?" "Uncle, I have worn them out praying for you, that God would make you a Christian," and then the tears came, of course. Nothing more was said, but the uncle put his arm around the boy, and drew him close to his breast, and in a little while he was bending his knees to the same Savior.

When we wear clothes thin in prayer for others we shall not find it hard to speak to them if the opportunity occurs.

774 *Someone Else Is Watching*

"Ye shall be witnesses unto me" (Acts 1:8).

A friend of mine, who had been a hold-up man and a kidnapper for twelve years, met Jesus Christ in prison. Christ said, "I will come and live in you and we will serve this sentence together," and they did. Several years later he was discharged, and just before he went out he was handed a two-page letter written by another prisoner. After the salutation, it said in effect, "You know perfectly well that when I came into this jail I despised preachers, the Bible, and everything. I went to the Bible class and the preaching service because there wasn't anything else interesting to do. Then they told me you were saved, and I said, 'There's another fellow taking the gospel road to get a parole'; but, Roy, I've been watching you for two and a half years. You did not know it, but I watched you when you were in the yard ex-

ercising, when you were working in the shop, when you played, while we were all together at meals, on the way to our cells, and all over, and now I'm a Christian, too, because I watched you. The Savior who saved you has saved me. You never made a slip." Roy said to me, "When I got that letter and read it through I came out in a cold sweat. Think what it would have meant if I had slipped even once."

775 Those Christ Saves

A businessman brought a thirty-year-old man to a summer Bible conference who was paralyzed from his hips down. As he sat beside the soul-winner on a bench under the trees, he expressed his desire to be saved. He said, "I believe everything in the Bible," but it gave him no peace. The Christian then inquired of him whether he knew he was lost, to which he replied he did. The inquiry was then made as to whether he knew that Christ is the One who saves and the only One who can save. He replied also to this that he believed it. Just at this point a public bus drew up in front of the conference grounds and the Christian said to his lame friend, "that bus is intended to carry everybody into the city, is it not?" "Yes," he replied. "Does it carry everyone?" he asked. "No," he said, "only those who get into the bus." He had hardly made this statement when the light of God broke into his soul. "I see!" he said. "Christ came to save everybody, but He saves only those who take Him: The light of

heaven flooded his soul. The peace of God filled his heart. His face became radiant with joy. He had entered into the Lord Jesus by faith.

776 He Saw the Point

A minister was boarding at a certain farmhouse. The farmer was not a Christian, but his wife had been praying for him for some time, and the minister was awaiting his opportunity to make the meaning of Calvary plain to him. Early one morning the farmer beckoned to the minister to follow him out to the chicken house. There on one of the nests sat a hen with a brood of chickens peeping out from under her wings.

"Touch her, Mr.—," the farmer said.

As the minister put his hand on the hen he found that she was cold.

"Look at that wound in her head," the farmer continued. "A weasel has sucked all the blood from her body, and she never once moved for fear the little beast would get her chicks."

"Oh," said he, "that was just like Christ. He endured all that suffering on the Cross. He could have moved and saved His own life, but He wouldn't, because you and I were under His wings. If He had moved, we would have been lost."

The farmer saw the point, and accepted the Lord Jesus Christ as Savior.

777 The Old Sailor's Gospel

A ship had been wrecked, and when the boats had been let down it was seen that there was not room

in them for all. Lots were cast, and among those who had to remain was a young and very wicked sailor. He was very pale, and those near him heard him mutter, "Lost—lost eternally." But he was picked up bodily and thrown into one of the boats. The man who had done that called to him, "You are not ready to die yet, but I am, and willing to die for you. But mind that I see you in heaven." An old sailor who had often told him of Jesus and asked him to receive the Savior thus died in his stead. Ever after, the young man, who really accepted Christ, was known to testify in these words: "For me two have died."

778 All May Be Saved

One great difference between the Christian and the non-Christian worker is this: non-Christian workers say that there is a certain proportion of men who cannot be reached any way. As a modern English author has said, "There is no substitute for a good heart, and no remedy for a bad one." O frightful gospel that some of the philanthropists of our day are preaching! Is that all the message they have to the world—no remedy for a bad heart? What does the parable of the lost coin mean if, though lost, there was no gleam of its original luster? What does the parable of the lost sheep mean, if there was not some dumb, inarticulate longing for the shelter of the fold? And what does the parable of the lost son mean, if there was not in those distant fields a cry of longing for the father's home and heart?

779 Death-Chair Testimony

Billy had been a bad man on the outside—so bad that he was sentenced to die for his crimes. However, while on death row in a Southern prison, Billy finally met Christ Jesus, and was able to lead several other death-row inmates to the Lord.

But in January, Billy's execution date arrived. The following account was told by a volunteer chaplain, who had been instrumental in leading Billy to his Savior.

Several people were on hand to witness the execution, including a woman who had been a key witness against Billy at his trial. This woman hated Billy, doubtless with good reason.

A closed curtain covered the window between the viewing room and the electric chair while preparations were completed. Before the curtain was opened, the audience in the viewing room heard someone singing, "Amazing Grace." Then, when the curtain opened, they realized the singer was Billy. His last request had been to sing that song as a witness of his changed life. When he finished, he nodded to the executioner, and went to meet his Lord.

The chaplain, who was also present, saw that the woman was so touched that she began to cry, and he was able to lead her also to receive Christ as her Savior. Even in his death, Billy gave a powerful witness to his beloved Lord.

—Nathan Chandler

780 Let's Go Fishing

"And He said to them, 'Follow Me and I will make you fishers of men' " (Luke 4:19).

The Bible has a lot of stories involving fish and fishermen. Even Jesus fished. He told others how to do it and where to do it! Not only that, He took a group of fishermen and molded them into **fishers of men**! Maybe that's why I like the gospel so much.

If you stop and think for a moment, that's what the church is about. The folks I worship with have learned some things about fishing. We know we are not going to catch all the fish, nor are we going to land all the fish that we hook. We've learned you can't force the fish or the line will snap. We also have learned to try new and different lures and baits in the different waters in which we are fishing and in doing so, we have started to catch fish!

That's why the church exists—to fish and catch fish. That's our goal. We can never allow any other activities to be substituted for or move us from our one goal—fishing.

Sometimes it's easy to get sidetracked in the everyday events of the work of fishing. Nets need mending and sharks need to be shot. Granted, both of these need attention, but they can't become our focus. We need to keep fishing to get some action and reward! Let us cast the lure of the gospel in the waters of the lost world and trust in Jesus that we will have a large catch!

—Bill Kern

781 White Christmas

Did your wish for a White Christmas come true?

A majority of the world will not see a white Christmas at any time in their life, much less this Christmas. But whatever the color of your holiday, may it be a joyous one.

Irving Berlin's "White Christmas" is one of the all-time, most popular songs. Yet for all its expression of yearning for the ambiance of a purely ivory landscape, the words were not the desires of its composer. Even though Berlin was born in Russia and lived in New York, he headed south to Florida during his winters, as often as he could.

Snow is often coupled with adjectives such as pristine, virginal and pure. Today's celebration is about a pristine God who sent his virginal Son to earth that we might be pure. After he grew up, a spotless Jesus said to a group who were looking for a better way of living: *"Blessed are the pure in heart, for they will see God"* (Matt. 5:8 NIV). If today, this is the upward motivation you need, you'll want to pray this Psalmist's prayer: *"Wash me, and I shall be whiter than snow"* (Ps. 51:7). Your request for purity will make this the Whitest Christmas ever!

Make sure your life is as pure "as wind-driven snow."

Reflections

782 The Miracle of Salvation

"I tell you Jesus Christ is a myth," shouted an atheistic lecturer as he concluded his talk in which he ridiculed the Bible and denied the existence of God. A miner, who had come to the meeting in his grimy clothes, stood up and said, "I am only a working man. I don't know what you mean by the word 'myth.' But, can you explain to me? Three years ago I had a miserable home. I neglected my wife and children. I cursed and swore. I drank up all my wages. Then someone came along and told me of the love of God and of deliverance from the shackles of sin by turning to Christ. Now all is different! We have a happy home. I feel better every way. A new power has taken possession of me since Christ came into my life! Sir, can you explain to me?"

You will never be able to explain or to understand the miracle of the incarnation of God until God is made a reality in your heart through Christ who came into the world to bring God to human hearts.

783 The Healing of a Homosexual

The following illustration comes from a testimony of a young man who has since died of AIDS:

"There are many major barriers to inner healing for the homosexual. These barriers are failure to forgive others, failure to receive forgiveness for ourselves, and failure to accept ourselves. The greatest of these barriers is the failure to accept ourselves. This barrier is worsened by the fear of rejection. From a personal viewpoint after accepting Christ and moving out to change through Him, I was unable to stand up and be bold for my Lord and Savior when I was exposed to the people from my past. I was in a sort of limbo, trying to walk the fence. Fearing rejection from those friends of my past as being a lunatic, but a greater fear about my new-found love for the Lord—a fear that if I didn't stand up for Him that I would fall out of His grace.

"We must be willing to not hide our light under a bush. I know it sounds strange, but I would have much rather died for the Lord among non-believing strangers than stand up for my Lord among my non-believing friends. It was not until I started writing this that I realized just how stupid this is.

"It's as though I was trying to keep from offending or upsetting these friends in order to keep the door open to this lifestyle in case I found that salvation wasn't going to work for me. But we all know that is ridiculous. You cannot straddle the fence or walk the middle of the road. You must make a complete 110 percent commitment to the Lord!

This is what I have chosen to do and I have no desire to keep that foot in the door of the past. I have asked the Lord for boldness, especially around my old friends, and I know that I will receive this boldness. The Lord is my Savior and I thank God that He has shown me

the love and grace to allow me to come to know Him in a personal way. Praise God that I live and that I truly have a new life in the Lord Jesus Christ and that the old sinful defiled "me" no longer exists. *'Bless the Lord, oh my soul, and all that is within me bless the Lord!'"*

Satan

784 Satan Will Advance if the Christian Does Not

Confederate General Longstreet, during the battle of Gettysburg, had one of his generals come up to him and report that he was unable to bring up his men again so as to charge the enemy. "Very well," said the general, "just let them remain where they are; the enemy's going to advance, and will spare you the trouble."

785 Answer to the Devil

A minister asked a little converted boy, "Doesn't the devil tell you that you are not a Christian?"

"Yes, sometimes."

"Well, what do you say?"

"I tell him," replied the boy, "whether I am a Christian or not is none of his business."

786 Satan and Our Weak Spot

We all have our tender spots. When Thetis dipped Achilles in the River Styx, you remember she held him by the heel; he was made invulnerable wherever the water touches him, but his heel not being covered with the water, was vulnerable, and there Paris shot his arrow, and he died. It is even so with us. We may think that we are covered with virtue till we are totally invulnerable, but we have a heel somewhere; there is a place where the arrow of the devil can make way; hence the absolute necessity of taking to ourselves "the *whole* armor of God," so that there may not be a solitary joint in the harness that shall be unprotected against the arrows of the devil. Satan is very crafty; he knows the "ins" and "outs" of manhood. There is many an old castle that has stood against every attack, but at last some traitor from within has gone outside, and said, "I know an old deserted passage, a subterranean back way, that has not been used for many a day. In such and such a field you will see an opening; clear away a heap of stones there, and I will lead you down the passage; you will then come to an old door of which I have the key, and I can let you in; and so by a back way I can lead you into the very heart of the citadel, which you may then easily capture." It is so with Satan. Man does not know himself so well as Satan knows him. There are back ways and subterranean passages into man's heart which the devil well understands; and he who thinks that he is safe, let him take heed lest he fall.

—C. H. Spurgeon

310

787 *Resisting the Devil*

D. W. Whittle tells of a man who came to Mr. Finney and said: "I don't believe in the existence of a devil." "Don't you?" said the old man. "Well, you resist him for a while, and you will believe in it."

788 *The Three Lusts*

The lust of the flesh, and the lust of the eye, and the pride of life—these, according to the last survivor of Christ's "disciples," make up the essence of worldly life, and they are the elements of attraction which the old serpent has been presenting to all who will listen to him ever since the temptation of our first parents. How many are fascinated by the kind of wisdom which he commends among his refuges of lies! Blessed be Thy name, O Lord Jesus, for the victory which Thou, the second Adam, didst secure. Oh, make us sharers in it, and help us to resist Satan, for Thy name's sake. Amen.

—John Hall

Self

Self-Deception

789 Late, but Not Lost

I remember hearing of a young man who went to a minister of Christ in great distress about his spiritual state. He said to the minister, "Sir, can you tell me what I must do to find peace?" The minister replied, "Young man, you are too late." "Oh!" said the young man, "you don't mean to say I am too late to be saved?" "Oh, no," was the reply, "but you are too late to do anything. Jesus did everything that needed to be done twenty centuries ago."

790 Cease from Our Own Works

A drowning boy was struggling in the water. On shore stood his mother in an agony of fright and grief. By her side stood a strong man, seemingly indifferent to the boy's fate. Again and again did the suffering mother appeal to him to save her boy. But he made no move. By and by the desperate struggles began to abate. He was losing strength. Finally he arose to the surface, weak and helpless. At once the strong man leaped into the stream and brought the boy in safety to the shore. "Why did you not save my boy sooner?" cried the now grateful mother. "Madam, I could not save your boy as long as he struggled. He would have dragged us both to certain death. But when he grew weak, and ceased to struggle, then it was easy to save him."

To struggle to save ourselves is simply to hinder Christ from saving us. To come to the place of faith, we must pass from the place of effort to the place of accepted helplessness. Our very efforts to save ourselves turn us aside from that attitude of helpless dependence upon Christ which is the one attitude we need to take in order that he may save us. It is only when we "cease from our own works" and depend helplessly upon Him that we realize how perfectly able He is to save without any aid from us.

791 Surrender Now

Dr. Andrew Bonar told me how, in the Highlands of Scotland, sheep would often wander off into the rocks and get into places that they couldn't get out of. The grass on these mountains is very sweet and the sheep like it, and they will jump down ten or twelve feet, and then they can't jump back again, and the shepherd hears them bleating in distress. They may be there for

days, until they have eaten all the grass. The shepherd will wait until the sheep is so faint it cannot stand, and then he will put a rope around him, and he will go over and pull that sheep up out of the jaws of death.

"Why don't they go down there when the sheep first gets there?" I asked.

"Ah," he said, "they are so very foolish they would dash right over the precipice and be killed if they did!"

And that is the way with men; they won't go to God till they have no friends and have lost everything. If you are a wanderer, I tell you that the Good Shepherd will bring you back the moment you have given up trying to save yourself and are willing to let Him save you His own way.

—D. L. Moody

Self-Control

792 Out of Self

Put your hand in Christ's, that as He leads you, other men, who have turned away from Him, may look and see you walking with Him, learn to love Him through your love. I do not believe any man ever yet genuinely, humbly, thoroughly gave himself to Christ without some other finding Christ through him. I wish it might tempt some of your souls to the higher life. I hope it may. At least I am sure that it may add a new sweetness and nobleness to the consecration which some

young heart is making of itself today, if it can hear, down the new path on which it is entering, not merely the great triumphant chant of personal salvation, "Unto Him that loved us and washed us from our sins. . . . be glory and dominion" (Rev. 1:5, 6) but also the calmer, deeper thanksgiving for usefulness, "Blessed be the God . . . of all comfort; Who comforteth us . . . that we may be able to comfort them which are in any trouble" (2 Cor. 1:3, 4).

—Phillips Brooks

793 Spiritual Self-Control

"If any man will come after me, let him deny himself" (Matt. 16:24; Luke 9:23).

The Christian life is not an easy life. We cannot, as Carlyle said, slackly wander into the kingdom of Heaven.

We carry with us a body prone to much that is evil, to sloth and pleasure, to spiritual idleness, to lust and envy. If a great Apostle, like St. Paul, felt himself bound to keep his body under subjection (see 1 Cor. 9:27), how can we dispense so airily with the common forms of self-control in which Christians have always believed? It is plain that at the present day self-control is out of fashion. Children are brought up to know scarcely anything about it as a virtue. Of the many Christian virtues discounted by popular novelists and playwrights, self-control is the one least thought of as even desirable, much less as a necessary foundation of Christianity. Unlike

Felix we do not tremble at the thought of it (see Acts 24:25).

794 Self-Effacing

As Michaelangelo wore a lamp on his cap to prevent his own shadow from being thrown upon the picture which he was painting, so the Christian minister and servant needs to have the candle of the Spirit always burning in his heart, lest the reflection of self and self-glorying may fall upon his work to darken and defile it.

795 Our Worst Enemy

When Abraham Lincoln was candidate for the presidency, someone asked him what he thought of the prospect of being president. With characteristic humor he answered, "I do not fear Breckinridge, for he is of the South, and the North will not support him; I do not much fear Douglas, for the South is against him. But there is a man named Lincoln I see in the papers of whom I am very much afraid. If I am defeated, it will be by that man."

796 A Sterling Character

When Governor Charles E. Hughes was beginning his heroic campaign to secure the passage of his anti-racetrack gambling legislation many of his so-called friends warned him of the violent attacks he would certainly be subjected to were he to adopt such a course. "The opposition will stop at nothing; they will defame your character, they will ruin you politically." "Gentlemen," said the governor,

"there is only one man in this world who can harm Charles E. Hughes, and that man is Charles E. Hughes."

Self-Indulgence

797 The Give and Take of Life

Dr. George H. Hepworth aptly said in a sermon that there is too much of self in the world. Our hands are stretched out to take, not to give. We plan for personal gain, are forgetful of the wants of others, build a moat about ourselves, and keep the drawbridge up lest someone may cross to ask for help. All that is like poison to the soul. It causes us to wilt, as a flower that is not fed with water. We become like a field of grain after a long drought, for the very life is parched. And yet nothing could be so unwise as to imagine that the great happiness of life could come from sucking up like a sponge things which we never give out. It is not what we get from the world but what we give to the world that marks our grade of humanity and dictates the real blessing and happiness of living. The Scripture was never truer than in these words: "It is more blessed to give than to receive."

798 Needless Self-Indulgence

Our lives are often enervated by needless self-indulgence. Rev. Hugh Price Hughes tells a very interesting story, and makes a very sane comment on it in illustration. During a visit to Palestine, at one point, when he happened to be riding in the carriage, he had a striking expe-

rience. "It was very hot, the sky was cloudless, the road was hard and white. Suddenly a Syrian, staff in hand, passed the carriage. Instantly I thought: 'There, that poor man, with flowing robe and turbaned head and sandaled feet, is dressed just as my Lord was dressed two thousand years ago. When he came up, as he did come up, again and again, from Jericho to Jerusalem, he had to trudge through the heat on foot, as that poor fellow is trudging. And here I am—professedly a disciple of his—riding up this hill with a carriage and pair of horses. How dare I ride where my Lord walked?' " He felt it so much that he stopped the driver, got out, and walked the rest of the way to Bethany. Commenting upon his action, Mr. Hughes says: "That sudden impression was neither Scriptural nor rational. There is nothing in Christianity that should lead any of us to decline the conveniences of life, provided always that we use for the good of men any energy we conserve. But there was this point of truth in the emotion which filled my heart. We do exceedingly need greater simplicity of life among all who name the name of Christ. We are too self-indulgent and luxurious in these days."

799 Emptied of Self

While it is the Divine Spirit that makes the ground of the human heart good, the truth that is set forth in the parable of the sower bears on human responsibility. We must try to have our hearts like good ground for "the seed," to hear and understand the word. Let us hear it regularly, not "now and then"; let us pray beforehand for the grace of the Holy Spirit; let us guard against preoccupying the heart with the things of the world—as in a Sunday newspaper; and let us be ready to do as the word directs, like the jailer when he asked, "What must I do to be saved" (Acts 16:30), or like Saul when he said, "Lord, what wilt thou have me to do?" (Acts 9:6).

—John Hall

800 Surrender of Self

There are many, very many Christians who are afraid of making an unreserved surrender to God. They are afraid that God will ask some hard thing of them, or some absurd thing. They fear sometimes that it will upset all their life-plans. In a word, they are afraid to surrender unreservedly to the will of God, for Him to do all He wished to for them and whatsoever He wills with them. Friends, the will of God concerning us is not only the wisest and best thing in the world; it is also the tenderest and sweetest. God's will for us is not only more loving than a father's; it is more tender than a mother's. It is true that God does oftentimes revolutionize utterly our life plans when we surrender ourselves to His will. It is true that He does require of us things that to others seem hard. But when the will is once surrendered, the revolutionized life plans become just the plans that are most pleasant, and the things that to others seem hard are just the things

that are easiest and most delightful. Do not let Satan deceive you into being afraid of God's plans for your life.

—R. A. Torrey

801 She Bought a Fancy Coffin

Mrs. Frances Hiller, of Wilmington, Massachusetts, passed away in the spring of 1900. Mrs. Hiller was not known for the substance of her life, but for the dreams of her death.

She bought a $30,000 carved coffin, placed it in her parlor, and frequently climbed into it to show visitors just how glorious she would appear. After tiring of that in-and-out process, she placed a wax dummy in the ornate box and dressed it in her $20,000 funeral robe. Thirty five years after her death, the gaudy Hiller mausoleum, which included an identical coffin containing her husband, was seen as an eyesore and destroyed.

The reason folks are so preoccupied with their burial status is usually due to their lack of belief in God's Word. For Christians, there are these comforting words: "*Now we know that if the earthly tent we live in is destroyed, we have a building from God, an eternal house in heaven, not built by human hands*" (2 Cor. 5:1 NIV). Sorry, but your earthsuit is as impermanent and disposable as a funeral cloth tent. Your heavensuit, however, will be eternally glorious!

—Jim Bassett
Reflections

Sin

802 God's Love for Sinners

I remember the case of a young man who was afflicted with a frightfully loathsome disease. He had to be kept out of sight. But was he neglected? No. I need not tell you who looked after him. There was not a morning that his loving mother did not bathe his wounds and massage his limbs, and not a single evening did she weary in her toil. Do you think she had no natural sensitivity? I knew her to be as sensitive as any lady, but by so much more as she felt the loathsomeness of her work, do you see the love that constantly upheld her in doing it? But oh! what is the loathsomeness of cankered wounds compared with the loathsomeness of sin to God? There is but one thing that God hates, and that is sin. Yet with all His hatred of sin how He hangs over the sinner!

803 Holding onto a Sin

A little child was one day playing with a very valuable vase, when he put his hand into it and could not withdraw it. His father, also, tried his best to get it out, but all in vain. They were talking of breaking the vase when the father said, "Now, my son, make one more try; open your hand and hold your fingers out straight, as you see me doing, and then pull." To their astonishment the little fellow said, "Oh, no, pa; I couldn't put out my fingers like that, for if I did I would drop my penny."

He had been holding on to a penny all the time! No wonder he could not withdraw his hand. How many of us are like him? Drop the copper; surrender, let go, and God will give you gold.

804 Sin in the Heart

There once sailed from the city of New Orleans a large and noble steamer, laden with cotton and having a great number of passengers on board. While they were taking in the cargo, a portion of it became slightly moistened by a shower of rain that was falling. This circumstance, however was not noticed; the cotton was stowed away in the hold and the hatches fastened down. All went well at first, but one day an alarm of fire was made, and in a few moments the whole ship was enveloped in flames. The damp and closely packed bale of cotton had become heated, and it smoldered and got into a more dangerous state every day, until it burst forth into a large sheet of flame, and nothing could be done to "quench" it. Now, that heated cotton, smoldering in the hull of the

317

vessel, is like sin in the heart. Do not let us think lightly of sin, speaking of little sins and big sins, white lies and black lies. Sin is sin in God's sight, and God hates sin.

805 Soiled Garments

"I think a Christian can go anywhere," said a young woman who was defending her continual attendance at some doubtful places of amusement. "Certainly she can," rejoined her friend, "but I am reminded of a little incident which happened last summer when I went with a party of friends to explore a coal mine. One of the young women appeared dressed in a dainty white gown. When her friends remonstrated with her, she appealed to the old miner who was to act as guide to the party. 'Can't I wear a white dress down into the mine?' she asked petulantly. 'Yes, mum,' returned the old man, 'there is nothing to keep you from wearing a white frock down there, but there will be considerable to keep you from wearing one back.'"

806 Clinging to the Prison

There is a man in the Ohio State Penitentiary at Columbus who has been there over thirty years. The crime for which he was imprisoned was committed when he was but a young man, only twenty-two years of age. He is now past middle age and looks like an old man. Nearly 25,000 prisoners have come and gone since he first went to his cell. For a long time he longed for freedom and dreamed of pardon, but the other day, when he was offered a release on parole, he declined it and said he preferred to end his days in the penitentiary. There are many men like that in regard to their sins. They have carried their chains so long that they cease to rebel against them and give themselves over to be "led captive by the devil at his will." It is a terrible thing to surrender one's self to the prison-house of sin, and thus run the risk of seeing the day when the freedom of a noble life will seem to be a thing to be shunned.

807 Changing the Label

A distinguished Methodist minister of the city of Adelaide, Australia, preached on sin, and one of his church officers afterwards came into his study to see him. He said to my friend, the minister, "Mr. Howard, we don't want you to talk as plainly as you do about sin, because if our boys and girls hear you talking so much about sin they will more easily become sinners. Call it a mistake if you will, but do not speak so plainly about sin." Then my friend took down a small bottle and showed it to the visitor. It was a bottle of strychnine and was marked, "Poison." Said he, "I see what you want me to do. You want me to change the label. Suppose I take off this label of 'Poison' and put on some mild label, such as 'Essence of Peppermint,' don't you see what happens? The milder you make your label, the more dangerous you make your poison."

—J. Wilbur Chapman

808 Original Sin

A minister, having preached on the doctrine of original sin, was afterwards waited on by some persons who stated their objections to what he had advanced. After hearing them, he said, "I hope you do not deny actual sin, too?" "No," they replied. The good man expressed his satisfaction at their acknowledgment; but, to show the absurdity of their opinions in denying a doctrine so plainly taught in Scripture, he asked them, "Did you ever see a tree growing without a root?"

809 Sins Swallowed Up

You see the Thames River as it goes sluggishly down through the arches, carrying with it endless impurity and corruption. You watch the inky stream as it pours along day and night, and you think it will pollute the world. But you have just been down to the seashore, and you have looked on the great deep, and it has not left a stain on the Atlantic. No, it has been running down a good many years and carried a world of impurity with it, but when you go to the Atlantic there is not a speck on it. As to the ocean, it knows nothing about it. It is full of majestic music. So the smoke of London goes up, and has been going up for a thousand years. One would have thought that it would have spoiled the scenery by now; but you get a look at it sometimes. There is the great blue sky which has swallowed up the smoke and gloom of a thousand years, and its azure splendor is unspoiled. It is wonderful how the ocean has kept its purity, and how the sky has taken the breath of the millions and the smoke of the furnaces, and yet it is as pure as the day that God made it. It is beautiful to think that these are only images of God's great pity for the race. Our sins, they are like the Thames, but, mind you, they shall be swallowed up—lost in the depths of the sea, to be remembered against us no more. Thou our sins have been going up to heaven through the generations, yet, though thy sins are as crimson, they shall be as wool, as white as snow (see Is. 1:18).

810 Blotted Pages

John Maynard was a student in an old-time country schoolhouse. Most of the year he had drifted carelessly along, but in midwinter some kind words from his teacher encouraged him to take a new start, and he became a distinctly different boy and made up for his earlier faults. At the closing examination he performed well, to the great joy of his father and mother, who were present. But the copy-books used through the year were all laid on a table for the visitors to look at; and John remembered that his copy-book, fair enough in its latter pages, had been a dreary mass of blots and bad work before. He watched his mother looking over those books, and his heart was sick. But she seemed, to his surprise, quite pleased with what she saw, and called his father to look with her; and afterward John

found that his kind teacher had thoughtfully torn out all those bad, blotted leaves, and made his copybook begin where he started to do better. To all who would forsake sin God offers a new chance and promise to blot out all old sin and make the record begin with the new start.

811 Grief at Sin

John Bunyan's wife having, after several previous applications to different judges, made a specially importunate appeal to the court justices for the release of her husband from Bedford jail, and being again unsuccessful, said: "I remember that though I was somewhat timorous at my first entrance into the chamber, yet, before I went out, I could not but break forth into tears, not so much because they were so hard-hearted against me and my husband, but to think what a sad account such poor creatures will have to give at the coming of the Lord, when they shall then answer for all things whatsoever they have done in the body, whether it be good or whether it be bad."

812 Repulsive Sin

"For he (God) hath made him to be sin for us, who knew no sin; that we might be made the righteousness of God in him" (2 Cor. 5:21).

A Christian once told his pastor: "I am very sorry that I cannot always attend church, for the Story of God is dear to my heart. I was blind as a brute that knows nothing at all. I have lived in awful wicked-ness without thinking that it was wicked. But when I heard God's Word, I said, 'What is this? My Lord and God who deserves no punishment goes and allows Himself to be punished for me, sheds His blood and dies for me!'

"In the light of this, everything I have done up to this time is repulsive and worthy of the greatest punishment, since He had tasted the bitter death that I should have suffered. Everything that I have done now appears repulsive to me, and I long to be made free of these things, and to know the forgiveness of all my sins."

Is this not what all of us need to understand more clearly? Do we not need to view sin from Calvary's vantage point? None who will ponder the revealed truth of God, that is, how Christ took our sins in His own body on the tree, can ever think kindly of sin in any form. It is there that we learn to hate what God hates, and to love what He loves. God grant us Calvary hearts!

813 The Sore Spot

"And when he is come, he will reprove the world of sin, and of righteousness, and of judgment." (John 16:8).

Very often a man will hear a hundred good things in a sermon, but there may be one thing that strikes him as being a little out of place. At such times he will go home and sit down at the table and talk right out before all his children, magnifying that one wrong thing, and forget

all the hundred good things his pastor has spoken. That is the way of criticism.

But when a man has broken his arm, the surgeon must find out the exact location of the fracture. He feels along the arm and presses gently with his fingers. "Is it there?" "No." "Is it there?" "No." Presently when the surgeon does touch one other spot, the patient cries, "Ouch!" He has found the broken part, and it hurts.

So it is one thing to hear a man preach about another man's sin, and to say, "That is splendid; just what those people need to hear!" But let the preacher touch upon some sin in their own life, some sore spot, as it were. Let him declare as did Nathan before David, saying, "Thou art the man!" Then it is they rebel, criticize and blame the preacher for saying the wrong thing, or for speaking out of turn.

814 The Deceitfulness of Sin

"But exhort one another daily, while it is called today; lest any of you be hardened through the deceitfulness of sin" (Heb. 3:13).

There is an insect that has a very close resemblance to the bumblebee, but which is a terrible enemy to it. Because of its likeness, it sometimes finds its way in a fraudulent manner into the bee's nest, and there deposits its eggs. But when these eggs are hatched the larvae devour those of the bee. It comes in as a friend and helper, but turns out to be a devouring enemy. Such is the secret sin harbored in the heart. It eats away the vitals of the spiritual life, and effectually destroys the power of growth and usefulness. It is all the more dangerous when it comes in the likeness of a friend and helper in the work of the Lord. Beware of the deceitfulness of sin!

815 Black Mail

"Ye adulterers and adulteresses, know ye not that the friendship of the world is enmity with God? whosoever therefore will be a friend of the world is the enemy of God" (James 4:4).

In the North of Scotland, and in the time of Rob Roy, wealthy farmers used to pay regularly what was known as black mail—so much corn or money given annually to powerful robbers for their good will and protection. If Christians are to maintain friendship with the world and ungodliness, it will be only on the "black mail" principle, that is, by sacrificing so much of their good for the encouragement of another's evil. He that is the friend of the world must become an enemy of God.

816 The Debts of Sin

A young man came to me with a strange question. He had recently been converted, and for a number of weeks had been leading a most exemplary Christian life. Before he became a Christian he was a slave to strong drink, and the question which he put to me was this: "What shall I do with the debts which I

owe to saloon keepers? I owe accounts at three saloons where I was trusted for liquor before my conversion." My answer without hesitation was: "Pay them, by all means." While this man ought never to have gone near the saloon, yet the only honest way for him to proceed now is to carefully save up his money and pay off these rum debts of sinfulness. There is many an afterclap to sin. It leaves many a scar that long years will not wear out. If those who are dallying and playing with it could only see what a long arm it has, they would stop their recklessness at once.

817 Beware of Insignificant Dissipations

Red-headed woodpeckers have destroyed during two years a carload of poles which supported the wires of the Kansas City and Independence electric lines. The busy little birds bore into the poles, and scoop out a cavity, where they lay their eggs and raise their young. In this way the poles are weakened so that they break under the weight of the wires. The wood of the poles is soft white cedar, and is easily penetrated by the sharp bills of the woodpeckers. The supports of the wires last usually ten years, but because of the nest-making of these little birds they have to be replaced at the end of the second year at a cost of $15 apiece. One year scores of the red-headed pests were shot by the employees of the electric railway company. There are many little sins and evil habits that seem insignificant which, however, eat into the character and breed a nestful of kindred habits, until the whole character is weakened by the honeycombing of those insidious sins.

818 Sin and Selfishness

God calls on us in the plainest language to work with Him. Only our sin and our selfishness stand in the way. When we can renounce these and turn to Him with all our hearts, the barrier is broken that stood between us.

819 Seeing Our Sin

The coming of the Son of God made a sin possible that was not possible before; light reveals darkness. There used to be people in Central Africa who never dreamed that they were black until they saw the face of a white man, and there are people who never knew they were sinful until they saw the face of Jesus Christ in all its whiteness and purity.

820 Sinner or Saint

Travelers in China relate that at the criminal courts there are two large books. The names of those who are judged innocent are written in the "Book of Life," and those guilty in the "Book of Death." No name can be in both books at the same time. Neither can your name be in the Lamb's Book of Life while you are under condemnation, nor need you have fear of death and judgment if you are His.

821 Difficulties a Blessing

One man, a golf enthusiast, was telling another man how hard it was, on a certain course, to drive the ball over a ditch that lay between the tee and the green. "Why don't they fill up the ditch?" asked the second man.

An old lady was watching a game of tennis, and saw how often the ball was driven against the net. "Why don't they take down the net?" she asked.

It is hard for many to comprehend the value of obstacles, of hazards, of hindrances. They cannot understand the joys of the chase. They never entered into the delight of overcoming.

If the time ever comes when all our ditches are filled, all our nets taken down, life will be too tame to live. Let us praise God daily for the hurdles in the way, face them cheerily, and over them with a shout!

—Aesop Jones

822 Almost Saved

I have seen in a picture sailors that had escaped from the wreck of a ship growing weary and weary and wearier. At last they touch the sand with their toes and begin to hope that they can creep upon the shore; when just with failing strength they are landing, up comes a wolf-wave behind them and sweeps them back with the undertow out to sea again. So sometimes are men longing for goodness and hoping for somebody to help them; and temptations come running in after them to sweep them out.

823 Overcoming Sin

Henry W. Crossley says: "I have heard of a young fellow who was in the habit of betting. He felt he was on the way to destruction, but the gambling passion was too strong to be resisted. He told his Sunday-school teacher that he had given up many bad habits, but that from this one he did not feel able to escape." "Were you always with me," he said, "I might manage it." "I cannot always be with you," replied the teacher; "but when and where do you gamble?" "Oh! every day at the dinner hour, at one o'clock." "Well," said the teacher, "every day, as the clock strikes one, I will pray for you." The young fellow came after a day or two, and said: "I shall bet no more. Yesterday I tried to go to the old place, but could not. I thought what a shame it was that you should be praying for me, and that I should be gambling at a public house, and *I could not do it!*" Let us in times of strong temptations hear our Lord, saying, "I have prayed for thee," and surely all sin will become loathsome to us.

824 Beginning of Evil

There is a factory in France where spiderwebs are regularly cultivated, and of the delicate fibers ropes for balloons for military purposes are constantly made. It seems almost incredible that so frail a thing can, by multiplying, be made into a

strong rope, strong enough to strangle a man; yet so it is. Cobwebs can now literally become cables. Sinful thoughts, shadowy and filmy at the first, may become so strong by constant indulgence that the strong cords of avarice, lust, and hate may at last bind the soul to its utter undoing. Beware of the beginnings of evil.

825 Plausible Disguises of Sin

It is said that a few years ago a detachment of forty Russian soldiers—part of an advanced guard of reconnoiters—crossed the river Yalu in Korea to an island in the middle of the river, and there changed their costume, so that they might appear as civilian settlers instead of military invaders. This is said to have been one of the many features of the invasion of Korea, compelling the eventual strife between Japan and Russia in the Russo-Japanese War. So sin and error often come in friendly guise, when their intention is very aggressive and destructive. We need much Divine wisdom to recognize the cunning devices of our enemies.

826 The One Antidote for Sin

A French surgeon, Dr. Calmette, professes to have found an infallible remedy for snake bites. It is a preparation having for its basis a salt of gold. One injection under the skin removes fatal results, and subsequent injections produce a perfect cure. There is only one antidote for all the virus of sin that has come from the "old Serpent the devil."

Jesus Christ can alone contain its ravages in our soul, His Blood cleanses from all sin.

827 Weighted Wings

Once when I was in Switzerland I saw an eagle, a splendid bird, but it was chained to a rock. It had some twenty or thirty feet of chain attached to its legs, and to an iron bolt in the rock. There was the king of birds, meant to soar into heaven, chained to earth. That is the life of multitudes of believers. Are you allowing business, are you allowing the cares of the world, are you allowing the flesh to chain you down, so that you cannot rise?

—Banner

828 Sweet Poison

A little boy, when his mother was out, got a chair and climbed up to a shelf in the closet to see if there was anything nice. He saw a small white paper parcel. He opened it. It was filled with white powder. The boy tasted it and found it sweet; he took more and then put it up again. His mother came back. The boy soon fell ill, and complained to his mother. She asked what he had eaten. He told her he had "tasted some of that sweet sugar in the closet."

"Oh, my boy, it is poison; it will kill you!" she exclaimed. The doctor was sent for, and the boy's life was saved. But that boy never forgot that what is sweet may be poison. So with sin. Something we like much may be wrong; but if it is wrong it is sin—it is death.

Take care what books you read.

They may contain sweet poison. They may injure your mind and your character and your life. They may wreck your happiness and your usefulness.

829 Sinful Self

Any man who is good for anything, if he is always thinking about himself, will come to think himself good for nothing very soon. It is only a fool who can bear to look at himself all day long without disgust. And so the first thing for a man to do, who wants to use his best powers at their best, is to get rid of self-consciousness, to stop thinking about himself and how he is working, altogether.

—Phillips Brooks

830 Hiding Sins

Sins unconfessed and not set straight are hindering a mighty work of God in many a man and woman today. David tried not confessing his sins to God, and we know the misery he experienced. He says in the thirty-second psalm, "When I kept silence, my bones waxed old through my roaring all the day long. For day and night thy hand was heavy upon me." At last he came to his senses: he confessed his transgressions, and the Lord forgave the iniquity of his sin. Then God worked mightily in David, and the thirty-second psalm and the fifty-first psalm, and many another psalms that have comforted and edified the children of God for nearly three thousand years, are the result.

—R. A. Torrey

831 Sin Conquered

Adam and Eve lost the paradise, in which the Creator placed them, by sinning. Satan tempted them, and gained a temporary triumph. But in the fullness of time the Redeemer conquers Satan, and for the redeemed, believing in Him, is prepared another and a better paradise, with the tree of life for its inhabitants, and with no tempter there. There shall be not two human beings, but "a great multitude that no man can number."

—John Hall

832 Clothes Do Not Make the Man

The program committee for a national barbers' convention devised a graphic means of demonstrating the effectiveness of their profession. They found a social derelict on skid row with long, dirty hair. His face was unshaven and his clothes were ragged and filthy. His body reeked with odors of cheap liquor and filth.

The barbers cleaned him up. They gave him a bath, shampoo, shave, haircut and a manicure. They liberally sprinkled talcum powder on him and added spicy cologne. He was dressed in a new suit and was presented before the convention as a changed man. He certainly looked the part. However, within a week the man was back on skid row, back in the gutter, back in his former pattern of living. The barbers altered his appearance, but their tonsorial services had not changed his inward nature."

Anyone can spend a bit of money and put a man in a new suit, but it takes being clothed with the Spirit of the Lord to put a new man in that suit! *"Therefore, if anyone is in Christ, he is a new creation; the old has gone, the new has come!"* (2 Cor. 5:17 NIV).

—Norman Bales

833 Abortion Myths

Myth #1: Abortion is only legal through the first trimester.

Fact: Due to the radical scope of Roe v. Wade and Doe v. Bolton, U.S. Supreme Court decisions, abortion is legal through all nine months of pregnancy.

Fact: More than 85,800 abortions take place every year in the United States after the 13th week of pregnancy.*

Myth #2: Women need abortion for health reasons.

Fact: An Alan Guttmacher Institute survey found that nearly one-half of women obtaining abortions said they used no means to control conception during the month they got pregnant.

Fact: Only 7 percent of all abortions are done for the mother's physical or psychological health. Rape and incest are cited as reasons for less than 1 percent of all abortions.

Fact: Nationally, 77.8 percent of women obtaining abortions are unmarried. The statistics strongly suggest abortion is used as birth control.*

Myth #3: No one knows when human life begins.

Fact: The California Medical Association referred to "the scientific fact, which everyone really knows, that human life begins at conception and is continuous whether intra- or extra-uterine until death."

Myth #4: Abortion is an unfortunate necessity and doesn't happen often.

Fact: More than 1.5 million abortions took place during 1992 in the United States.*

Myth #5: We need abortion to reduce child abuse. Wanted children will not become abused children.

Fact: Abortion has done nothing to reduce child abuse. Statistics show the overall change from 1976 to 1992 has been a growth of 331 percent in child abuse cases in the United States.*

Myth #6: The typical abortive woman is a poor, minority teen.

Fact: more than one-half of women getting abortions are between the ages of 20-29, and statistics show nearly two-thirds of abortions are performed on white women.*

*According to the most recent statistics from the U.S. Department of Health and Human Services Centers for Disease Control and Prevention.

—Right to Life Michigan

Soul

834 Seeking Souls

Sportsmen must not stop at home and wait for the birds to come and be shot at; neither must fishermen throw their nets inside their boats and hope to take many fish. Traders go to the markets; they follow their customers, and go out after business if it will not come to them; and so must we.

—C. H. Spurgeon

835 Cleansing the Soul

While walking down a street one day, I passed a store where a man on the pavement was washing the large plate-glass shop window. There was one soiled spot which defied efforts to remove it. After rubbing hard at it, using much soap and water, and failing to remove it, he found out the trouble. "It's on the inside," he called out to someone in the store. Many are striving to cleanse the soul from its stains. They wash it with tears of sorrow; they scrub it with the soap of good resolves; they rub it with the chamois of morality, but still the consciousness of it is not removed. The trouble is, "It's on the inside." Nothing but the blood of Jesus, applied by the mighty hand of the Holy Spirit, can cleanse the inside, for there God's Spirit alone can reach.

836 A Restored Soul

The Rev. John Newton, the fame of whose righteousness fills all Christendom, while a profligate sailor on shipboard, in his dream thought that a being approached him and gave him a very beautiful ring, and put it upon his finger, and said to him, "As long as you wear that ring you will be prospered; if you lose that ring you will be ruined." In the same dream another personage appeared, and by a strange infatuation persuaded John Newton to throw that ring overboard, and it sank into the sea. Then the mountains in sight were full of fire and the air was lurid with consuming wrath. While John Newton was repenting of his folly in having thrown overboard the treasure, another personage came through the dream, and told John Newton he would plunge into the sea and bring the ring up if he desired it. He plunged into the sea and brought it up, and said to John Newton, "Here is that gem, but I think I will keep it for you, lest you lose it again"; and John Newton consented, and all the fire went out of the mountains, and all the signs of lurid wrath disappeared from the air. John Newton said that he saw in his dream that that valuable

gem was his soul, and that the being who persuaded him to throw it overboard was Satan, and that the One who plunged in and restored that gem, keeping it for him, was Christ. That dream makes one of the most wonderful chapters in the life of that most wonderful man.

837 Soul-Treasures

Down deep in the sea some of the most beautiful things of earth are hidden. Now and then there are rocking storms that wash the very bottom, and roll on shore a shell that is but a specimen of thousands and thousands of exquisite forms and tints which defy the palette of the painter. But not the things that grow in the sea or in the wilderness are so beautiful or so numerous as those that grow in the secrecy of the souls of those who have been touched by the divine life; and though you can measure a man's outer life, only God can measure his inward life.

838 Soul Creation

Because the soul is evolved in the process of evolution with the body, according to the method and design of God, it is not necessary to infer that God is not the creator of the soul as well as of the body. An architect builds me a house, and he sends for the workmen, and they dig the cellar; but he never touches a spade. He sends for the stonemason, who brings out from the quarry the foundation stones, and puts them up; but the architect never touches them. He sends for the brickmaker who makes a million bricks, but the architect never touches the clay. He sends for the carpenter, the plasterer and other workmen; and they do the work in their individual departments; and by and by the house is completed. Did the architect build that house, or did he not?

839 Body Nourishing Soul

When you put beans, or seeds of any leguminous plant, into the ground, there come up great coarse leaves; and the stem feeds on them till the plant is able to organize other leaves; it sucks out of them the food which it needs till they have served their purpose; and then they shrink and die. It would seem as though the soul, like some rare plant, had stored in the body such materials that while the body was perishing the soul was filled with the nutriment that was provided for it through the body.

Spiritual

840 Spiritual Vision

A young man living in New York, whose eyes had been troubling him, consulted an optometrist.

"What you want to do," said the specialist, "is to take a trip every day on the ferry, or in New Jersey, Long Island—any place where you can see long distances. Look up and down the river, across the fields, or, if it comes to the worst, go to the top of a skyscraper, and scan the horizon from that point. The idea is to get distance. You can use your eyes a great deal and always at close range. You can't use them any other way in town. Even when not reading and writing, the vision is limited by small rooms and narrow streets. No matter in what direction you look, there is a blank wall not far away to shut off the sight."

Even so it is true in the matter of our spiritual vision. The reason so many of us do not understand the things of God better is because we do not get distance. We confine truth, we limit the divine to what we know—to what is immediately about us. Get out and get "distance."

841 Revivals Commence with the Few

Begin with a part of the Church instead of attempting to move the whole mass together. Those of us who were country boys know how impossible it is to make a fire out of green logs alone; but if we can get some dry sticks kindled around and underneath these green logs, we can make a very hot fire with them. Don't begin your revival by trying to rouse the whole unseasoned mass of Church members, but begin with a few of the most spiritual, and from these work out towards the others. Lyman Beecher said, in answer to the question, How can we promote a revival in the Church? "First get revived yourself, then get some brother Church member revived, and the work has begun." That is practical wisdom.

—A. J. Gordon

842 Seek and Ye Shall Find

Some men remind me of a poor immigrant who was discovered walking on the tracks of a railroad in New Jersey. On his back he carried a huge bulk and as he trudged on, worn and weary, he resembled Bunyan's pilgrim with his burden. In passing a station an agent ordered him off the track, reminding him that he was liable to arrest for trespassing. The man demurred and produced a railroad ticket good for passage from Jersey City to Scranton. The agent looked at him in amazement and asked why he was

walking when he might ride. The stranger replied that he thought the ticket gave him only the privilege of walking over the road. His right was explained to him and the tired man with delight boarded the first train for his destination. Surely the angels must look with wonderment at the thousands who trudge along, anxious and careworn, bearing life's burdens without divine help and future hope, for every soul carries in the conscience the ticket of divine promise: "Acquaint now thyself with Him, and be at peace; thereby good shall come unto thee" (Job 22:21).

843 Sign of Sonship

An old man living on a gentleman's estate in Glamorganshire, used to go to the chapel along the gentleman's private walk, because he saved a considerable distance by going that way. Some unkind neighbor told the gentleman, who was a magistrate, about it. One day, when the poor old man was going to the house of God, he met him on his private walk, and said:

"What right have you on this path?"

"No right at all, sir," he answered; "but I thought you wouldn't mind an old man who has lived on your estate so many years going this way to the house of God, especially as it's so far the other way."

"Give me your stick!" said he sternly.

The trembling old saint gave him his stick, not knowing what to expect next. Then to his surprise, the gentleman, with a kind smile and in the gentlest tones, said to him, as he gave him in return his own walking-stick mounted with gold and bearing his own crest:

"Here, my good man, when anyone asks you again what right you have this way, show them this, and tell them I gave it to you!"

That was what the father did to his returned prodigal son. He put a ring on his finger. It was a sign of sonship which he could show to anyone who might tell him he had no right there.

844 God's Humble Agents

There lived in a poor village a girl of sixteen. She was never more than six months at school, but she thirsted for knowledge. She almost learned by heart the few books within her reach, and then turned to study the Bible. The result was conversion, and with the experience of forgiveness, a great desire to serve her Savior. She thought of her brothers, and read to them, over and over again, the Bible lessons she had learned herself. She had heard of Sabbath schools, and determined to establish one for her scattered neighbors. Her father permitting the use of the kitchen, it was soon filled, the old and middle-aged coming for instruction as well as the young. Years passed, and in place of scores, hundreds were seen in that school every Sabbath. A neat church, too, grew up beside the old kitchen. That teacher has gone to her rest, but her work continues. One brother, who learned the truth from her lips, de-

voted himself to the ministry; others are useful Christians, and one of her scholars became a foreign missionary.

845 Need of Spiritual Life

That is a splendid appeal of St. Paul, "If ye then be risen with Christ, seek those things which are above" (Col. 3:1). One may be very much alive in every other department of his being, and yet share no spiritual life with Jesus Christ. Dr. C. A. Berry, of Wolverhampton, England, has given utterance to this striking sentence: "It is possible to be intellectually great, ethically enthusiastic, and spiritually dead."

846 Losing Spiritual Treasure Through Worldliness

Christ declares that where one's treasure is there the heart will be also. We cannot at the same time serve God and Mammon. Many times, without intending it, the Christian loses the sweetest treasure of his spiritual life by being drawn away by the things of the world. A young lady in Kansas City lost the gold ring which had been given to her by her husband at the time they became engaged. She advertised for the trinket, and offered rewards greatly in excess of its value, but with no result. Some time after another lady went into a store and commenced to try on kid gloves. Her surprise may be imagined when, in removing a glove from her hand, she found a strange gold ring upon one of her fingers.

The ring was engraved "From Willis to Emma," and was at once recognized as the one lost by her friend, who had been trying on gloves in the same store, and left the ring in the glove when withdrawing her hand.

847 Power of Spirituality

God has not given us vast learning to solve all the problems, or unfailing wisdom to direct all the wanderings of our brothers' lives; but He has given to every one of us the power to be spiritual, and by our spirituality to lift and enlarge and enlighten the lives we touch.

—Phillips Brooks

848 The Spirit of God

Unless the Spirit of God be upon us, we have no might from within and no means from without to rely upon. Wait upon the Lord, beloved, and seek strength from Him alone. There cannot come out of you what has not been put into you. You must receive and then give out.

—C. H. Spurgeon

849 Eyes Opened

A Christian worker in Arizona tells of a fierce looking cowboy who came to him asking for copies of Mark's Gospel, and who told him this story: "I went to San Francisco and threw away much money in rough revelry. I slept late after a night of dissipation. When I awoke I saw a little Book on the table near my bed: the Gospel of Mark. I angrily threw it on the floor. I did the same thing the second morning.

Awaking the third morning, I saw that same little Book. This time I took it with me to a nearby park and began to examine it. I spent the day reading it. I heard the Son of God say to a leper, 'Be thou clean' (1:41). I heard him say to a paralytic, 'Thy sins be forgiven thee' (2:5, 9). I heard him commend the widow for her mite (12:43). I saw him take little children in his arms and bless them. I heard him say, 'Couldst thou not watch one hour?' (14:37). I saw him die. It broke my heart and changed my life. I am a different man. Now, Stranger, I spend much time giving away copies of the Gospel of Mark."

850 A Spiritual Temple

Years ago there was discovered in Jerusalem a deep cavern close by the Damascus Gate, and those who have explored it have come to the conclusion that it is the spot from which the stones were taken to build the glorious Temple of Solomon. It was there that the hammering and the cutting were done. It was there that the stones were shaped, and from thence, by some process that we do not now understand, they were brought from their deep grave, and separately placed in position upon Mount Zion. The blocks of stone were taken one by one out of the bowels of the earth and out of darkness, and then carried by mighty power to the temple walls, until, when the last stone was cut out and placed in position, with shoutings of "grace unto it," the whole building was complete. This forms a beautiful illustration of the way in which the Lord builds His spiritual temple. The Spirit of God goes into the deep black quarry of fallen nature, and there hews out the hidden stones, and by His own almighty power bears them to the foundation stone and places them in a living temple to go no more out forever.

851 The Power of the Spirit

Mr. Spurgeon once preached what in his judgment was one of his poorest sermons. He stammered and floundered, and when he got through felt that it had been a complete failure. He was greatly humiliated, and when he got home he fell on his knees and said, "Lord, God, thou canst do something with nothing. Bless that poor sermon." And all through the week he would utter that prayer. He would wake up in the night and pray about it. He determined that the next Sunday he would redeem himself by preaching a great sermon. Sure enough, the next Sunday the sermon went off beautifully. At the close, the people crowded about him and covered him with praise. Spurgeon went home pleased with himself, and that night he slept like a baby. But he said to himself, "I'll watch the results of those two sermons." What were they? From the one that had seemed a failure he was able to trace forty-one conversions. And from that magnificent sermon he was unable to discover that a single soul was saved. Spur-

geon's explanation was that the Spirit of God used the one and did not use the other. We can do nothing without the Spirit who "helpeth our infirmities" (Rom. 8:26).

852 A Wise Answer

A young woman in Scotland, in the days of persecution in that land, one Sunday was on her way to a place of worship, when she was met by a company of hostile cavalry, and required by its commander to make known her destination. At this crisis this promise presented itself to her mind, namely, "It shall be given you at that hour what you ought to answer" (see Matt. 10:19); and she put up a silent prayer that the Spirit of God would put the right words into her mouth. In a moment these words suggested themselves and she uttered them as suggested: "I am going to my Father's house. My Elder Brother has died; His will is to be read today, and I have an interest in it." The commander bid her go on her way, expressing the hope that she would find a rich portion left to herself.

853 Social and Spiritual Life

A man builds him a house two stories high; but money fails, and he does not put on any roof. What is he going to do now? Live in it? He cannot live in it. Until somebody can put a roof on it, and close it in, it is not good to live in. Honesty, kindness and neighborliness are good things. Care for the laws of life is a very good thing. If this was all of our life, if these external and bodily relationships represented the sum total of all our experience, all that we should want would be morality. But we live again. We live in a populous realm more crowded with entities and realities than that which we see. We are living in this world conformably to the world. It is very well as far as the world is concerned; but we are not of this world only. Man, a creature of two worlds, must conform to the necessary laws of this, and also to the laws of that other which is higher, and more important to his spiritual and intellectual manhood.

854 Filled with the Spirit

Suppose we saw an enemy sitting down before a granite fort, and they told us they intended to batter it down. We might ask them "How?" They point to a cannon ball. "Well, but there is no power in that. It is heavy, but not more than half-a-hundred, or perhaps a hundred weight. If all the men in the army hurled it against the fort they would make no impression." They say, "No; but look at the cannon." "Well, there is no power in that. A child may ride upon it, a bird may perch in its mouth. It is a machine, and nothing more." "But look at the powder!" "Well, there is no power in that. A child may spill it, a sparrow may peck it." Yet this powerless powder and powerless ball are put into the powerless cannon; one spark of fire enters it and then, in the twinkling of an eye, that powder is a flash of lightning, and that ball a thunderbolt, which smites as if it had been

sent from heaven." It is yours, then, to forge the cannon, to mold the ball, to make the powder, and to lay the charge ready for the sudden flash.

855 "The Fruit of the Spirit"

A Christian has been renewed and enlightened by the Spirit. He may be expected to walk in the light, no more doing the deeds of darkness. This is acceptable to the Lord; and to those so walking God gives usefulness. They set an example; they witness for God; they show that the fear of God purifies heart and life. But this is not done in their own wisdom or power. It is "the fruit of the Spirit" (Gal. 5:22; Eph. 5:9). Would we be good, righteous, true? Then let the Spirit work within us. Let us be led and guided by this divine Counselor. Walk in the Spirit.

856 For God's Indwelling

In this mixture of good and evil which we call man, this motley and medley which we call human character, it is the good and not the evil which is the foundation color of the whole. Man is a son of God on whom the devil has laid his hand, not a child of the devil whom God is trying to steal.

The great truth of redemption, the great idea of salvation, is that the realm belongs to truth, that the lie is everywhere and always an intruder and a foe. He came in, therefore he may be driven out. When he is driven out, and man is purely man, then man is saved. It is the

glory and the preciousness of the first mysterious, poetic chapters of Genesis that they are radiant all through their sadness with that truth.

857 The Strength of our Life

There are hours of mental darkness and depression for us in this sin-laden world. What shall we do? Resort to fiction, fashion, or forgetfulness produced by the wine-cup and the like? No; let us look up. The Lord is our light. There are times of fear and apprehension; but He is our salvation. We are sometimes painfully conscious of our weakness in presence of many hostile forces, from Satan, the world, and our own remaining and selfish love of sin. But let us not be afraid. He is the strength of our life. Reader, are you leaning on Him?

858 Dwelling in Safety

To learn what it is to be a genuine Christian, and why such a Christian does not go to wreck amid all the temptations of the present evil world, we need only go to our Bibles. In the thirty-third chapter of Isaiah we light, for example, on this grand description of the righteous man: "He shall dwell on high: his place of defense shall be the munitions of rocks: bread shall be given him; his waters shall be sure." Every word of this is worth studying; it tells the secret of spiritual strength and security, and simply because there is a divine support and a divine supply.

859 In the Dark

Have you ever felt like you were "in the dark"?

The lights finally went back on on November 10, 1966. The night before, nine states in the Northeastern U.S. experienced the greatest power failure in history.

The newspapers read, "Most traffic signals gave out; intersections jammed. Skyscraper elevators halted between floors. As of midnight, untold numbers were still trapped in them. Operating rooms went dark. Airplanes circled darkened landing strips." While most adults were paralyzed, one child would later write, "It was dark! We had popcorn in the fireplace! It was fun!"

Your Creator describes everyone who doesn't walk with him as "being in darkness." You can be in constant illumination from external sources, but if you are not wired to God through His Son, Jesus Christ, you are living in an unending spiritual power failure. The Bible says, *"God is light; in him there is no darkness at all. If we claim to have fellowship with him yet walk in the darkness, we lie and do not live by the truth"* (1 John 1:5, 6 NIV). Jesus is the "Ultimate Power Source" that will guarantee that you will never be "in the dark" again!

Remember: Light up your life by plugging into Jesus Christ.

Reflections

Stewardship

860 Giving to God

Dr. Adam Clarke once preached on the words, "Let him that is athirst come. And whosoever will, let him take of the water of life freely" (Rev. 22:17). At the conclusion of the discourse he announced a collection. "How can you, Doctor," asked a lady afterwards, "connect the freeness of the water of life with the collection at the close?" "Oh, madam," answered the wise preacher. "God gives the water without money and without price; but you must pay for the waterworks, for the pipes, and the pitchers which convey the water to your neighborhood." Remember, you pay nothing to God; you are charged nothing for the water; but you cannot have convenient chapels to sit in without paying for them, nor a regular ministry to urge the water on your acceptance, without making a suitable provision for its support.

861 Be Consistent

A gentleman canvassing for an important benevolent enterprise was about to call upon a certain wealthy professor of religion who was more devout than generous. Ignorant of this fact, he asked his last contributor how much he thought the man would give. "I don't know," was the reply. "If you could hear him pray, you'd think he would give all he is worth." The collector called on the rich man, and to his surprise received a flat refusal. As he was taking his leave, it occurred to him to repeat what he had been told. "I asked a man," said he, "how much you would probably give, and he replied, 'If you could hear that man pray, you'd think he would give all he is worth.'" The rich man's head dropped, and his eyes filled with tears. He took out his pocket-book and handed his visitor a liberal contribution.

862 Giving and Praying

A venerable clergyman, once entered a meeting in behalf of foreign missions, just as the collectors of the offering were taking their seats. The chairman of the meeting requested him to lead in prayer. The old gentleman stood, hesitatingly, as if he had not heard the request. It was repeated in a louder voice; but there was no response. It was, however, that Mr. Sewall was fumbling in his pockets, and presently he produced a piece of money, which he deposited in the contribution box. The chairman, thinking he had not been understood, said loudly, "I didn't ask you to give, Fa-

ther Sewall; I asked you to pray."
"Oh, yes," he replied, "I heard you, but I can't pray till I have given something."

863 Miserly Christians

A man was once asked for a donation for some church purpose, but excused himself by saying: "I'm fattening a calf, and when it's fat, I'll give the proceeds." The same excuse was given three times over in response to appeals. One day he was approaching church a little late, and heard the choir singing, "The half has never yet been told," and thought, in the distance, the words were, "The calf has never yet been sold." Conscience stricken, he sold the calf, and gave the proceeds to the church.

864 The Perils of Prosperity

"What is the value of this estate?" said a gentleman to another with whom he was riding, as they passed a fine mansion surrounded by fair and fertile fields. "I don't know what it is valued at; I know what it cost its late possessor." "How much?" "His soul. Early in life, he professed faith in Christ, and obtained a subordinate position in a mercantile establishment. He continued to maintain a reputable religious profession till he became a partner in the firm. Then he gave less attention to religion, and more and more to business; and the care of this world choked the Word. He became exceedingly rich in money, but so poor and miserly in soul that none would have suspected he had ever been

religious. At length he purchased this large estate, built a costly mansion, and then sickened and died. Just before he died he remarked: "My prosperity has been my ruin."

865 Living Thief

Dr. Lorimer once asked a man why he did not join the church. The reply was that the dying thief did not join the church, and he was saved. "Well," said the minister, "if you do not belong to a church, you help to support missions, of course?" "No," said the man. "The dying thief did not help missions, and wasn't he saved?" "Yes," said Dr. Lorimer, "I suppose he was, but you must remember that he was a dying thief, whereas you are a living one."

866 Unconscious Service

A touching story is told in the Kentucky hills of a little heroine who was left motherless at the age of eight. Her father was poor, and there were four children younger than she. She tried to care for them all and for the home. To do it all, she had to be up very early in the morning and to work very late at night. No wonder that at the age of thirteen her strength was all exhausted. As she lay dying a neighbor talked with her. The little face was troubled, "It isn't that I'm afraid to die," she said, "for I am not. But I'm so ashamed." "Ashamed of what?" the neighbor asked in surprise. "Why, it's this way," she explained. "You know how it's been with us since mamma died. I've been so busy, I've never done any-

thing for Jesus, and when I get to Heaven and meet Him, I shall be so ashamed! Oh, what can I tell Him?" With difficulty the neighbor kept back her sobs. Taking the little caloused, work-scarred hands in her own, she answered: "I wouldn't tell Him anything, dear. Just show Him your hands."

867 Where Are Your Treasures?

A miser in Chicago was so suspicious of everybody that he would not trust his money in the bank, but buried it in his cellar. One night some thieves broke into the cellar and dug up every inch of sand and dirt until they found his box of gold and carried it away. The poor old fellow was nearly crazy over his loss. But the old man has many people following his example in the care of priceless treasures. How many there are who are laying away all their treasures in the sand and dirt of this earthly cellar, when heaven's strong vaults are offered to us for their safekeeping. Jesus says: "Lay not up for yourselves treasures upon earth, where moth and rust doth corrupt, and where thieves break through and steal; but lay up for yourselves treasures in heaven, where neither moth nor rust doth corrupt, and where thieves do not break through nor steal; for where your treasure is, there will your heart be also" (Matt. 6:19–21).

868 An Example of Stewardship

"I was born with music in my system. I knew musical scores instinctively before I knew my ABC's. It was a gift of Providence. I did not acquire it. So I do not even deserve thanks for music. Music is too sacred to be sold. And the outrageous prices the musical celebrities charge today truly are a crime against society. I never look upon the money I earn as my own. It is public money. It is only a fund entrusted to my care for proper disbursement. I am constantly endeavoring to reduce my needs to the minimum. I feel morally guilty in ordering a costly meal, for it deprives someone else of a slice of bread—some child, perhaps, of a bottle of milk. My beloved wife feels exactly the same way about these things as I do. You know what I eat; you know what I wear. In all these years of my so-called success in music, we have not built a home for ourselves. Between it and us stand all the homeless in the world."

—Fritz Kreisler

869 Unprepared for Offering

A little boy, sitting next to a lady in church, noticed that she had nothing for the collection plate. His own collection was in his hand; but as the collector approached, the little fellow seemed greatly disturbed because his seatmate seemed entirely unprepared for the offering. When the steward got within a few pews' distance he handed over his silver piece to the lady, as he whispered in her ear: "Take this, and I'll get under the seat till he goes by." Such sensitive souls as this boy are exceedingly rare.

870 The Best Gift

A rich man was down at the water front awaiting the departure of an ocean liner. He was joined by an acquaintance, who said to him, "You seem to be much pleased about something." "Yes," said the rich man, "I do feel unusually good today. Do you see that vessel at anchor in the North River? Well, I have on that vessel ten thousand dollars worth of equipment for a hospital in China, and I just came down to see the vessel safely off." "Well, that is interesting, and I am glad you made that gift," said the friend. "But you know I also have a gift on that ship. My only daughter is on that vessel, going to China to give her life as a missionary." The wealthy man looked touchingly into the eyes of his friend and exclaimed, "My dear brother, I feel as though I have given nothing as I think of what this sacrifice means to you!"

Temptation

871 Temptation Resisted

Luther said in his own pithy way: "I cannot keep birds from flying over my head, but I can keep them from building their nests under my hat." We cannot keep Satan from plying us with evil suggestions, but we can keep from responding to them. Our Lord was sorely assailed of him, but He could declare that Satan, "hath nothing *in* me" (John 14:30).

872 No Room in the Inn

There was an old saint in days past—such a one, we can imagine, as was the Venerable Bede in the midst of his young students—who lived a life of such purity and serenity that his younger comrades marveled. The wonder grew upon them so greatly that at length they resolved to approach the master, and ask to be told the secret of this purity, this peace. They came one day, and said: "Father, we are harassed with many temptations, which appeal to us so often and so strongly that they give us no rest. You seem to be untroubled by these things, and we would learn the secret. Do not the temptations that harass our souls appeal to you? Do they never come knocking at the door of your heart?" The old man listened, and smiled, and said: "My children, I do know something of the things of which you speak. The temptations that trouble you do come, making their appeal to me. But, when these temptations knock at the door of my heart, I answer, "The place is occupied.""

873 Suffocating the Soul

Not long ago, in the wall of an old castle in Italy where some repairs were being made, the workmen found a relic that told a tale of ancient barbarity and crime. Some baron of the old days put an enemy in a little niche in the wall, just large enough to hold a man, and then set the masons at work building the wall around him. Slowly the masonry crept up, as stone was laid on stone, until at last it arose and left the man standing there in his living tomb. "Ah," you say, "such horrible forms of torture were only possible in days of darkness, when men exercised their ingenuity inventing new modes of cruelty." Shall I tell you of something worse that is modern? A man starts out to build a structure, which he calls "Success." Slowly, as the years pass, he walls in his soul. Duty calls, and he answers, "I cannot sacrifice my interests for you." Pity pleads, and he says: "I really cannot afford to do

340

anything for you." Righteousness rings out with its prophetic demands, and he says: "It will injure the stock market if I join in these agitations." Day by day, year by year, every lofty ideal, every summons of sympathy, every project of truth, every purpose of purity, finds him making the same old excuse: "Beware of going too far!" "Keep your eye on the main chance!" "Look out for number one!" "Be just good enough to gain your ends!" "Use men, use your city, use the world to advance those plans of material prosperity and commercial power that minister to your own self-aggrandizement!" So he builds his living tomb. So he suffocates his soul.

—Rev. George H. Ferris

874 Temptation Resisted

Wrong has seldom looked more like right than in the case of a soldier whose story was told in an American paper.

He was in the General Hospital in Washington with a wounded foot, and still far from healed, when he heard that his wife was very ill and wanted to see him. He obtained a furlough and the necessary transportation papers, which would permit his journey home. On the way home his papers were stolen from his pocket, so that he became liable to be seized as a deserter, and was, besides, without sufficient money for continuing his journey. As he got out of the train at Philadelphia with a very sad heart, he trod on something which, when picked up, he found to be a wrapper containing the furlough and transportation papers of another man. A comrade, who knew his distress, promptly advised him to use them as his own. "You found them," he said. "None of the conductors know your name; it is your only chance of getting home at all. You are a fool if you don't." But the man had Christian principles, and he remembered, too, that the sick wife whom he was so anxious to see had said to him when he started for the war, "Let me hear that you are killed, or that you have died by the way, rather than let me hear that you have ever done what is wrong. I am willing to give you up for your country, only don't lose your principles."

He thought, too, of his praying mother; and he felt he dared not go home and look them in the face unless he went in an honest way. So he said to his comrade, "Never! never will I go home under a false name." Then he hobbled round, sought out the owner, and gave him his papers, and went thence to the rooms of the Sanitary Commission and told his troubles. Friends were found who telegraphed to Washington to get word that a furlough and transportation paper had been furnished him, so that the adjutant general could give him a certificate to this effect. The relief agent gave him ten dollars and tickets to different hotels, where he could be taken kind care of along the way without cost. And thus he reached his own home in comfort and with a good conscience.

875 Avoiding Temptation

Andrew Fuller, after his conversion at sixteen years of age, felt that he could no longer participate in the rough merrymaking indulged in on holidays by the young people of his town. So he tells us: "Whenever a feast or holiday occurred, instead of sitting at home with myself, I went to a neighboring village to visit some Christian friend and returned when all was over. By this step I was delivered from those mental participations in folly which had given me so much uneasiness. Thus the seasons of temptation became to me times of refreshing from the presence of the Lord."

876 The Devil Can Wait

"Be sober, be vigilant; because your adversary, the devil, as a roaring lion, walketh about seeking whom he may devour" (1 Pet. 5:8).

There is a story told of an old Christian slave in the South whose master was an infidel. One day the master went duck-hunting with his slave, and turning on him suddenly said: "How is it, Tom, that the devil never tempts me, and always worries you? Why should he tempt a Christian more than an infidel?"

Before the slave could find an answer, a flock of ducks came within shooting distance, and the master fired into them. He then directed the slave to make haste to secure the wounded birds first, and let those that were dead wait until last. When the slave returned to his mater he had found his answer.

"You see, master, I reckon it is this way about the devil. He thinks I am only a poor wounded soul that he wants to make sure of first, but you are surely his, and so you can wait!"

Perhaps the slave's master thought he was getting a little too personal in his remark, but until a man is truly born again through faith in Christ, the devil can wait to expend any special attention on him. It is the men made alive by the Spirit of God whom he has to hound and harass in order to draw them away from Christ.

877 Fighting Temptation

A believer's watchfulness is like that of a soldier. A sentinel posted on the walls, when he discerns a hostile party advancing, does not attempt to make head against them himself, but informs his commanding officer of the enemy's approach, and leaves him to take the proper measures against the foe. So the Christian does not attempt to fight temptation in his own strength; his watchfulness lies in observing its approach, and in telling God of it by prayer.

878 Steadiness under Temptation

If one looks out upon New York harbor, after an eastern storm, he will see it covered with craft, that brood upon its surface in flocks like wild fowl; nor can the eye, at a distance, tell why they hold their places, swinging but a little way with the changing tide, facing the wind obstinately and refusing to be

blown away. Every one is rooted by its anchor.

If men are found in life much tempted and yet firm in principle, there is an anchor somewhere. It may be a sweetheart, or a sister, or a mother, a wife, a father, or an old teacher. People anchor each other.

879 Fighting for Victory

There will come a world where there will be no temptation—a garden with no serpent, a city with no sin. The harvest day will come, and the wheat be gathered safe into the Master's barn. It will be very sweet and glorious. Our tired hearts rest on the promises with peaceful delight. But that time is not yet. Here are our tempted lives, and here, right in the midst of us, stands our tempted Savior. If we are men, we shall meet temptation as He met it, in the strength of the God who is the Father of whom all men are children. Every temptation that attacks us attacked Him, and was conquered. We are fighting against a defeated enemy. We are struggling for a victory which is already won. That may be our strength and assurance as we recall, whenever our struggle becomes hottest and most trying, the wonderful and blessed day when Jesus was "led up of the Spirit into the wilderness to be tempted of the devil."

880 Watch and Pray

Our Lord's temptation makes us see that temptation is not sin, nor does it necessarily involve sin. Christ was sinless, and yet tempted; therefore it is possible for man to be tempted, and yet sinless. Now so many of us, the moment we are strongly tempted, seem to fall into a sort of demoralized condition, as if our innocence were over, as if the charm were broken and we were already sinners; and so we too often give ourselves up easily to the sin. To any soul in such a state what could we say but this: "Look up and see the truth in Jesus; do you not see it there? To be tempted is not wicked, is not shameful, is not unworthy even of Him. It is the lot—in one view it is even the glory—of humanity. Sin does not begin, and shame does not begin, until the will gives way—until you yield to temptation. Stand guard over that will, resist temptation, and then to have been tempted shall be to you what it was to your Savior—a glory and a crown, a part of your history worthy to be written with thanksgiving in the Book of Life, as His is written in His book of life." Is not this the strength and courage that many a soul needs?

—Phillips Brooks

Tests and Trials

881 Trained to Endure

"Look at that vessel in the midst of the storm; see how the wild waves show their white teeth as if laughing at all the efforts of the sailors to keep it from sinking. It will weather the storm, say the sailors, if the mast will only hold out. Where did it grow? On the very heights of the stormy hills. That mast will weather the storm, for it is itself the child of storms." So God prepares His heroes on the heights, among storms and winter, and in much suffering. But they have grown strong and resistful as the result of it, and they will never fail, however fierce the fight. They have endured hardness in the beginning, and shall now prove they are "strong in the Lord, and in the power of His might" (Eph. 6:10).

882 Suffering and Song

It is said of Jenny Lind that when Goldschmidt first heard her sing, somebody said, as he walked out of the opera house, "Goldschmidt, how did you like her singing?" He said: "Well, there was a harshness about her voice that needs toning down. If I could marry that woman, break her heart and crush her feelings, then she could sing." And it is said that afterwards when he did marry her and broke her heart and crushed her feelings, Jenny Lind sang with the sweetest voice ever listened to; so sweet that the angels of God would almost rush to the parapets of heaven to catch the strains.

—J. Wilbur Chapman

883 Tried and True

When a founder has cast his bell he does not at once put it into the steeple, but tries it with the hammer, and beats it on every side, to see if there be a flaw. So when Christ converts a man he does not at once convey him to heaven, but suffers him to be beaten upon by many temptations and afflictions, and then exalts him to his crown. As snow is of itself cold, yet warms and refreshes the earth, so afflictions, though in themselves grievous, keep the Christian's soul warm and make it fruitful.

884 Use of Troubles

"When in Amsterdam, Holland, last summer," says a traveler, "I was much interested in a visit we made to a place then famous for polishing diamonds. We saw the men engaged in the work. When a diamond is found it is rough and dark like a common pebble. It takes a long time to polish it, and it is very hard work. It is held by means of a

piece of metal close to the surface of a large wheel, which is kept going around. Fine diamond dust is put on this wheel, nothing else being hard enough to polish the diamond. And this work is kept on for months and sometimes for several years before it is finished. And if a diamond is intended for a king, then the greater time and trouble are spent upon it." Jesus calls His people His jewels. To fit them for beautifying His crown, they must be polished like diamonds, and He makes use of the troubles He sends to polish His jewels.

885 Riding to a Fall

In Rochester, New York, there is a little picture hanging in an art gallery which represents a young man riding very swiftly on a horse. Out in front of him is floating what seems to be an angel, holding in her hands a crown. The young man is reaching out his hands to get the crown. He is trampling under his feet flowers and helpless children. He almost touches the crown, but just one more leap of the horse and he will go over the precipice in front of him. Suppose he does reach the crown, he will have it in his hands only for a moment, and then he is lost. That is the way it is with many who are bound to have pleasure, whether they have to sin in obtaining it or not.

886 False Emphasis

It is said that a soldier who enlisted in the American Civil War took along his kit of watchmaker's tools, and while they were in camp he did considerable business. But one day when the order came to strike tents and prepare for battle, he looked around his tent in dismay, and exclaimed: "Why, I can't possibly go, for I have twelve watches to repair, which I have promised by Saturday night." The man had forgotten what he had enlisted for. The soldiers of the King of kings sometimes seem to forget what they enlisted for.

887 Keep the Rudder True

In ancient heroic story there is one figure of which I often think. It is the figure of the old pilot who was sailing his boat in the crisis of a storm on the great tempestuous Aegean Sea, and in his extremity he was seen to stand erect and cry, in his old pagan way: "Father Neptune, you may sink me if you will, or you may save me if you will, but whatever happens I will keep my rudder true." Everyone can say that. It is not for us to decide our own destinies. It is not for us to say we shall not be overwhelmed by certain storms; it is not for us to say we shall never go under. We do not know how hard the trial is yet to be. But this we can say: "Sink me if you will, or save me if you will, but whatever happens I will never drift, I will steer straight, I will keep my rudder true." By God's grace everyone can do that.

888 Use of Affliction

Li Cha Mi, a Chinese preacher, was nearly killed by robbers dur-

ing the violence against foreigners, in 1872. At a subsequent conference, he said: "You have all heard of my sufferings during the past few months. I wish to say that these sufferings were very slight. It was easy to endure pain when I could feel that I bore it for Christ. It is wonderful—I cannot explain it. When attacked by the robbers and beaten almost to death, I felt no pain. Their blows did not seem to hurt me at all. Everything was bright and glorious. Heaven seemed to open, and I thought I saw Jesus waiting to receive me. It was beautiful. I have no words to describe it. Since that time I seem to be a new man. I now know what it is to 'love not the world.' My affections are set on things above. Persecutions trouble me not. I forget all my sorrows when I think of Jesus. I call nothing on earth my own. I find that times of trial are best for me. When all is quiet and prosperous, I grow careless and yield to temptation, but when persecutions come, then I fly to Christ. The fiercer the trial, the better it is for my soul."

889 Affliction Profitable

Thomas Fuller wrote in reference to his own sufferings in the Civil War: "I have observed that towns which have been casually burnt, have been built again, more beautifully than before; mud walls afterwards made of stone; and roofs, formerly but thatched, after advanced to be tiled. The Apostle tells me that I must not think it strange concerning the fiery trial which is to happen unto me. May I likewise prove improved by it. Let my renewed soul, which grows out of the ashes of the old man, be a more pious fabric and stronger structure; so shall affliction be my advantage."

890 Whose Servant Are You?

The hardships and trials of Paul's life were lifted out of the lowly and the commonplace because he looked upon them all as so many acts of service for Christ, whom he loved. Love is an easy taskmaster. To have endured hardship and imprisonment for Nero's sake, or as his prisoner, would have galled Paul to the very quick; but when he was in Nero's dungeon for Christ's sake, it was a very different matter. The way to make our lives romantic and splendid is to give ourselves in such complete devotion to Christ that the hard things of life will be endured in the spirit of love for his dear sake.

891 Tests and Trials Sent by God

Temptation is that which puts to the test. Trials sent by God do this. A test is never employed for the purpose of injury. A weight is attached to a rope, not to break, but to prove it. Pressure is applied to a boiler, not to burst it, but to certify its power of resistance. The testing process here confers no strength. But when a sailor has to navigate his ship under a heavy gale and in a difficult channel, or when a general has to fight against a superior force and on disadvantageous ground, skill and courage are

not only tested, but improved. The test has brought experience, and by practice is every faculty perfected. So, faith grows stronger by exercise, and patience by the enduring of sorrow. Thus alone it was that "God did tempt Abraham" (Gen. 22:1).

892 Thorn in the Flesh

A man met a little fellow on the road carrying a basket of blackberries, and said to him, "Sammy, where did you get such nice berries?" "Over there, sir, in the briers!" "Won't your mother be glad to see you come home with a basket of such nice, ripe fruit?" "Yes sir," said Sammy, "she always seems glad when I hold up the berries, and I don't tell her anything about the briers in my feet." The man rode on. Sammy's remark had given him a lesson, and he resolved that henceforth he would try and hold up the berries and say nothing about the briers.

893 Perfected in Suffering

The great musician, Beethoven, had always a great horror of deafness, and his feelings may be imagined when he found that he was becoming "hard of hearing." When the first symptoms of the infirmity became apparent, he became the prey of an anxiety bordering on despair. Doctors were consulted, and the Royal Library at Berlin possesses a collection of ear trumpets and similar instruments which he made in the vain hope of assisting his weakening sense. But the deafness increased until at last he conversed only by means of writing. Yet it was after he was dead to all sense of sound around him that Beethoven wrote his grandest music. Out of a calamity came forth sweet music.

894 Stepping Stones

The bone that is broken is stronger, they tell us, at the point of junction, when it heals and grows again, than it ever was before. And it may well be that a faith that has made experience of falling and restoration has learned a depth of self-distrust, a firmness of confidence in Christ, a warmth of grateful love which it would never otherwise have experienced.

—Alexander Maclaren

895 Duty and Pleasure

I heard sometime since of an optometrist who was very fond of cricket. but he had given it up, much as he enjoyed it, for he found that it affected the delicacy of his touch; and for the sake of those whom he sought to relieve he sanctified himself and set himself apart. That is what we want—that there shall come into our lives a force that prompts us always to be at our best and ready for service, a tree that is always in leaf and in bloom and laden with its fruit, like the orange tree, where the beauty of the blossom meets with its fragrance the mellow glory of the fruit.

—Mark Guy Pearse

896 Blessings Hidden

There is a beautiful figure in one of Wordsworth's poems of a bird

that is swept from Norway by a storm. And it battles against the storm with desperate effort, eager to wing back again to Norway. But all is vain, and so at last it yields, thinking that the gale will carry it to death—and the gale carries it to sunny England, with its green meadows and its forest glades. Ah, how many of us have been like that little voyager, fretting and fighting against the will of God! And we thought that life could never be the same again when we were carried seaward by the storm. Until at last, finding all was useless perhaps, and yielding to the winds that "bloweth where it listeth" (John 3:8), we have been carried to a land that was far richer, where there were green pastures and still waters.

—G. H. Morrison

897 The Trials That Strengthen Character

For a long time the tanners who handled the hides of Western steers were puzzled by the fact that one side of the hide was usually perceptibly thicker and heavier than the other. A thoughtful cowboy who was visiting an Eastern tannery was told of the fact and accounted for it in the following way: Every steer is branded on one of its flanks with its owner's particular device. The branding produces a painful burn, and it is several days before the hide entirely heals. While the burn is healing the steer naturally takes all possible precautions to favor the sore side, and, therefore, lies down with the branded flank uppermost. A few

days suffice to form the habit of lying only on the unbranded side. This, of course, protects one side from the biting winds of winter, and at the same time interferes more or less with the circulation of the blood and the normal development of the tissue. The other side, on the contrary, exposed to every wind and with perfect circulation, becomes thick, tough, and healthy. The same thing is strongly in evidence in human character. It is on the sides of our nature where we have winced under the branding-iron of trial that we become strong and able to overcome all difficulty. We should thank God for the trials and afflictions that make nobler men and women of us.

898 The Test of Real Life

An old schoolmaster said one day to a minister who had come to examine his school: "I believe the children know the catechism word for word." "But do they understand it— that is the question?" said the minister. The schoolmaster merely bowed respectfully in reply, and the examination began. A little boy had repeated the fifth commandment, "Honor thy father and they mother," and he was requested to explain it.

Instead of trying to do so, he said, almost in a whisper, his face covered with blushes: "Yesterday I showed some strange gentlemen over the hill. The sharp stones cut my feet, and the gentlemen saw they were bleeding, and they gave me some money to buy me shoes. I gave the money to my mother,

for she had no shoes either, and I thought I could go barefoot better than she could."

The boy passed. He had stood the test of life. That is the real test of all our knowledge and our fame.

899 Transfigured Sorrow

It is instructive to know how it is supposed the pearl is formed. A grain of sand, or some foreign substance, getting entrance within the shell of an oyster, hurts its sensitive body, which, having no power to expel the cause of pain, covers it with a secretion, and by degrees rounds off all sharp angles, molds it into a sphere, and finishes it with a polished surface. Thus it accepts the inevitable presence as a part of its life, and when it dies yields up, shaped and perfected, a perfect gem, lovely with the tints of the skies, a jewel whose worth is far beyond the pain that gave it existence.

God often introduces into human lives some element of discomfort, unrest, or suffering—a thorn in the flesh that cannot be plucked out, a burden that must be borne, a daily cross not to be laid down. Some souls thus dealt with chafe against the trial; they contend with it till their sensibilities are lacerated by its cruel edges, and their hearts become morbid and bitter. They make its presence one long perpetual pain and poison. Others, recognizing the trial as Heaven-sent, and therefore not to be escaped, accept it, not with joy, indeed, but with meekness; and though it press hard and sharply, they wear it with a sweet patience that, day by day, enables them to carry it more easily. It even becomes the source of an inward development, the growth of a grace which at the last proves to be the crowning, adorning attribute of their character, the especial quality which, rounded out to perfect symmetry, reflects the beauty of heaven.

900 Quietly Wait

Trials come on us here. Tempests threaten us on the voyage of life. Our spirits become restless. We look right and left, up and down, for a solution of hard problems that perplex us. Dear reader, bear with and carry out one suggestion. Think how your heavenly Father has cared for you hitherto. Consider, is He unequal to the work of carrying you on? Has He ceased to be all-wise, all-powerful? Has He taken back the promise that all things shall work together for your good? No. Then carry to Him your present difficulty; and says Jeremiah, "it is good that a man should both hope and quietly wait for the salvation of the Lord."

901 Not My Will

Jesus was the Son of God, the same in substance with the Father, His equal in power and in glory. But He condescended to be God's "righteous servant," and His own words express the submission of His will to the Father's. If the divine Redeemer speaks and feels thus, how submissive to God ought

we to be! Illness may prostrate us, death may bereave us, poverty may try us, the tears of the widowed or of the fatherless may flow from our eyes; but let us aim at having the same mind in us that was in Christ, and the divine Father will carry us through, and give us the victory at length.

902 Clear Shining after Rain

In almost every Christian's experience come times of despondency and gloom, when there seems to be a depletion of the spiritual life, when the fountains that used to burst and sing with water are grown dry, when love is loveless and hope hopeless, and enthusiasm so utterly dead and buried that it is hard to believe that it ever lived. At such times there is nothing for us to do but hold with eager hands to the bare, rocky truths of our religion, as a shipwrecked man hangs to a strong, rugged cliff when the great retiring wave and all the little eddies all together are trying to sweep him back into the deep. Then when the tide turns, and we can hold ourselves lightly where we once had to hang heavily, when faith grows easy, and God and Christ and responsibility and eternity are once more the glory and delight of happy days and peaceful nights, then certainly there is something new in them—a new color, a new warmth. The soul has caught a new idea of God's love when it has not only been fed but rescued by Him.

903 Strength in Weakness

There is something very beautiful to me in the truth that suffering, rightly used, is not a cramping, binding, restricting of the human soul, but a setting of it free. It is not a violation of the natural order; it is only a more or less violent breaking open of some abnormal state that the natural order may be resumed. It is the opening of a cage door. It is the breaking in of a prison wall. This is the thought of those fine old lines of an early English poet—

The soul's dark cottage,
 battered and decayed,
Lets in new light through chinks
 that time has made,
Stronger by weakness, wiser
 men become
As they draw near to their
 eternal home.

904 Bearing Right On

One of the worst evils brought by the sin of discouragement is that we are tempted to stop when we are just on the eve of realized success, and almost in sight of the richest blessings. Up near the summit of Mount Washington I once saw a cairn of stones, to mark the spot where a poor girl perished from exposure and heart failure on a cold night. She and her father had rashly attempted to ascend the mountain without a guide and they had become lost, and had sat down bewildered when the chilling darkness of the autumnal night came on. The next morning the distracted father discovered that a very short dis-

tance more would have brought him in sight of the lights from the windows of the "Tiptop" cabin! Here is a bit of a parable to illustrate how those who are doing not rash things but wise things may be tempted to lose heart, and to relax their efforts when they are almost in sight of success. God puts dark hours before dawn to test faith; hard fields are the very ones that ought not to be abandoned.

Thankfulness

905 Elementary

Are you impressed by seventy-five cent words?

It's the day after Thanksgiving and your wife has gone off to the mall to second-mortgage the homestead. You've got the day off, but the turkey looks unappetizing, the football games are over, so you've discovered this book.

After reading a bit of this material you may be unimpressed with its content, which consists mostly of two bit words conveying pedestrian concepts and simple theology. You are not at all like simple-minded Winnie-the-Pooh who said, "I am a bear of very little brain, and long words bother me." After all, you are well educated. You see yourself in the same class as William F. Buckley.

Broadcaster Michael Guido once attributed the success of his ministry to: "I keep my message on the level of a third grade student." And the communicator God chose to write much of the New Testament, the Apostle Paul, said this, *"For Christ did not send me to baptize, but to preach the gospel—not with words of human wisdom, lest the cross of Christ be emptied of its power"* (1 Cor. 1:17 NIV). Sometimes less is more.

Reflections

906 Light My Fire

Do you still have an inner fire burning deep inside of you?

There was something different about Arlington Cemetery on November 26, 1963. The Washington, D.C. burial ground was poignantly illuminated by the "eternal flame" of President John Kennedy's grave.

The past three days had been surreal for most Americans. No matter what side of the political aisle you sat on, the unbelievability of this assassination attached itself to you. A solemn funeral procession, a composed yet grief-stricken wife, and a saluting three-year-old brought tears to the hardest of human exteriors. And finally, the "eternal flame" would remind us always—of a "difficult day to forget" in November of '63.

Obviously, this "eternal flame" must be regularly fueled to continue burning. And at some point, in the temporary scenario for this planet, it will be extinguished forever. Unlike that flame, if you personally know the eternal God, you can say with the Psalmist: *"You, O Lord, keep my lamp burning"* (Psalm 18:28). God cannot only fuel your inner fire during this life, but also insure that it will burn brightly throughout eternity. Praise God!

Reflections

907 Shallow Water Gratitude

Too many of us are low-voiced and shallow-streamed in our gratitude. We are like the boy who had been swimming in a tiny pond, and who was taken for the first time to the ocean. His little bathing-suit was put on him, and he was asked to wade in.

But he looked aghast at the vast blue expanse, and shrank back.

"Why don't you take a dip?" urged his mother.

"Because," he said with a great deal of dignity, "I don't think this was made for little boys; it was made for big ships."

We have either got to get into deeper water with our expressions of gratitude or else admit that we don't know how to swim.

908 A Great Giver

A king who wished to express his affection for a private soldier of his army gave him a richly jeweled cup, his own cup. The soldier stepping forth to receive the gift exclaimed shamefacedly, "This is too great a gift for me to receive." "It is not too great for me to give," the king replied.

God is a great giver. Let us be great in giving thanks.

909 The Thanksgiving Cure

Thanksgiving season ought to be a great time for curing people of a certain disease of which I have read. The disease is called amnesia.

This disease is a comparatively rare affliction—fortunately so. Its main feature is forgetfulness. There are cases on record in which people have forgotten their own names, the date of their births, their family relations; in a word, cases in which memory had become a complete blank and the past was utterly blotted out.

Facts have been published concerning a minister's son who disappeared from an army training camp, was hunted for as a deserter, and later turned up as an unnamed man on one of the transports sent back from a military hospital. He had found the longing to be at the front too strong to resist, had apparently re-enlisted under another name, was sent to the firing line, was wounded in the head and when consciousness was restored, he had lost all memory of the past. His name was found to be an assumed one and he was unable to tell who he was or where he came from. His former life had become a complete blank and, when his parents recognized him as their long lost son he did not give the first sign of recognition and knew none of his former friends or acquaintances.

Such is amnesia. Physically it is, fortunately, a rare disease, but spiritually it is not rare. Not in vain does the psalmist call upon his soul, *"And forget not all His benefits."* Kipling has, as the refrain of his immortal "Recessional," the words, "Lest we forget, lest we forget."

Ingratitude is nothing but a form of spiritual amnesia. It stands for a voluntary or involuntary blotting

out of the memory of the past. The mind is no longer sensitive to past benefits bestowed. It is as if these things had never been. And thus ingratitude becomes a spiritual menace. God's own people are very apt to suffer from this disease and we forget past mercies in the face of present emergencies, as if they had never been.

910 Savor the Morsel

Are you so blessed that small gifts are inconsequential to you?

Well, it's another fourth Thursday in November. How many does that make for you? Today if you asked the person on the street what one word comes to mind when Thanksgiving Day is mentioned, you would probably hear words like: football, turkey, sales, holiday, and fall. Like most holidays, the initial reason for the celebration has been brushed aside or totally forgotten.

The problem is that most of us have more than we need. We have overlooked our need to be grateful for everything both great and small. Think of a time in your life when a single letter or gift was very precious to you. Can you remember a happier, less-well-off time in your life when a single morsel of food seemed like an entire smorgasbord?

An ancient prophet asked the question: *"Who despises the day of small things?"* (Zech. 4:10 NIV). If the answer is "you," apply this inspiration from your gracious Creator: *"Give thanks in all circumstances, for this is God's will for*

you in Christ Jesus" (1 Thess. 5:18 NIV). Pray this Thanksgiving Day for a continuous and all-encompassing thankful spirit.

Remember: No blessing is too "small" not to merit a "big" thanks to God

Reflections

911 Gratitude for Redemption

A few months before the death of Robert Louis Stevenson, certain Samoan chiefs whom he had befriended while they were under imprisonment for political causes, and whose release he had been instrumental in producing, testified their gratitude by building an important piece of road leading to Mr. Stevenson's Samoan country house, Vailima. At a corner of the road there was erected a notice, prepared by the chiefs and bearing their names, which reads:

"The Road of the Loving Heart. Remembering the great love of his highness, Tusitala, and his loving care when we were in prison and sore distressed, we have prepared him an enduring present, this road which we have dug to last forever."

912 Thankfulness

There was once a good king in Spain called Alfonso XII. Now it came to the ears of this king that the pages at his court forgot to ask God's blessing on their daily meals, and he determined to rebuke them. He invited them to a banquet which they all attended. The table was spread with every kind of good

food, and the boys ate with evident relish; but not one of them remembered to ask God's blessing on the food.

During the feast a beggar entered, dirty and ill-clad. He seated himself at the royal table and ate and drank to his heart's content. At first the pages were amazed, and they expected that the king would order him away. But Alfonso said never a word.

When the beggar had finished he rose and left without a word of thanks. Then the boys could keep silence no longer, "What a despicably mean fellow!" they cried. But the king silenced them, and in clear, calm tones he said, "Boys, bolder and more audacious than this beggar have you all been. Every day you sit down to a table supplied by the bounty of your Heavenly Father, yet you ask not His blessing nor express to Him your gratitude.

913 Thanksgiving

The first New England Thanksgiving was celebrated less than a year after the Plymouth colonists had settled in the new land of Massachusetts Bay Colony. The first dreadful winter in the colony had killed nearly half of its members. But new hope emerged in the summer of 1621 when the corn harvest brought rejoicing. Governor William Bradford decreed that a three-day feast be held beginning on December 13, 1621. Thus came about a Thanksgiving Day set aside for the special purpose of prayer as well as celebration.

The custom of Thanksgiving Day spread from Plymouth to other new England colonies. During the Revolutionary War, eight special days of thanks were observed for victories and deliverance from perilous times. On November 26, 1789, President George Washington issued a general proclamation for a day of thanks. For many years there was no regular national Thanksgiving Day in the United States until President Lincoln in 1863 proclaimed the last Thursday in November as "A day of thanksgiving and praise to our beneficent Father." As one studies early American history it becomes obvious that our early settlers and forefathers expressed their "thanksgiving" and their "gratitude" to God daily rather than once a year. As a nation we need to go back to the pilgrims' fine art of gratitude toward God!

914 1 in 10

Is there someone in the course of your life you have forgotten to thank?

Thanksgiving is not far away. We can hardly wait for the holiday from work so we can labor at the cornucopia of digestible delights. Yet, folks are still waiting for your thanksgiving to them.

Twenty centuries ago, Jesus, the Son of God, was walking through the human experience. One day, close to Jerusalem, he ran across ten lepers. The nationality of the entire group is unclear, but we know one of them was a despised Samaritan. Recognizing Jesus, perhaps only as a healer, they called to

him, "Jesus, Master, have pity on us!" Jesus simply said, "*Go show yourself to the priests.*" Miraculously, on their way, they were totally healed. But sadly, only the Samaritan returned: "*He threw himself at Jesus' feet and thanked him*" (Luke 17:16 NIV).

Take this week and survey your life. Ask God to bring instances to your mind when you completely forgot to thank some benefactor. Maybe it was a small favor. Perhaps you were just one of a group to which the gift was given. Make an effort to thank at least one person you failed to thank earlier. That one will be surprised, delighted—and thankful.

Remember: Why don't you be the "one" in ten who is always grateful.

Reflections

915 Going Under

How many times in your life has God rescued you?

Last November, Coast Guard rescuers lowered their helicopter basket and pulled in a drowning family of four.

A man was taking his family from Norfolk, Virginia to Bermuda. Normally, it was a short and pleasant excursion. But he failed to notice Tropical Storm Gordon descending upon his path. They endured 19 hours of 20-foot waves and 50-mph winds. Their sailboat was tossed like a toy. Many of those hours were spent in prayer for survival.

When it was over, did they thank the one who answered their prayers? Surely they thanked the Coast Guard, and most probably the medics who tended to them on shore. But what about their Ultimate Rescuer? The Bible describes such a scene with: "*He rescued them from the grave. Let them give thanks to the Lord for his unfailing love*" (Ps. 107:20, 21 NIV). Are you quick to thank God for the hundreds of times He has rescued you? No matter what method or person became God's instrument for your deliverance, God was the "Conclusive Liberator." Thank Him, right now!

Remember: When you forget to thank God, you "miss the boat."

Reflections

Tongue

916 Influence over the Young

It is related of Sir Robert Peel that to his last days he could never go into a room without a look of nervousness, without trembling, and in presence of Royalty he was like a shy, awkward country lad, not knowing what to do with his hands, and shuffling his feet in a curious and painful way. The explanation given is, that as a lad at Harrow School he had been terribly bullied and worried. His schoolmates fastened on to his awkward little ways and so teased and mocked him, and this fastened on his soul, and he never did overcome it. The great Primer Minister was scarred and marred by these early cruelties. What need for care in early training that the result in after life may be blessing, and not bane!

917 Speech Guarded

"A perverse tongue falleth into mischief." Professor Amos R. Wells says: "Sometimes a mountain avalanche is so delicately poised that the vibration of a voice will bring it down. Many an avalanche of sorrow has been brought down by a hasty word." Carelessness in word and action may result in the shipwreck not only of one but of many lives.

918 A Fatal Blunder

An elderly gentleman recently related that when he was a young man he was on one occasion out with a party camping. They were mostly young fellows, but one or two were middle-aged men. One evening as they sat around the fire, a story that one of the older men told suggested to my friend a vulgar comment, to which he gave utterance before he thought twice. He could have bitten his tongue off the next instant. The older man simply looked straight at him for a moment across the fire, and he knew that he was judged by that remark. After a year or two had passed the young man's name was mentioned for a position which was very desirable and which he seemed likely to secure, but the man who had been disgusted at his vulgar comment was one of the three to decide it, and at his suggestion the young man was defeated. He afterward found other work and made a fair success of life, but he regretted as long as he lived giving utterance to that one vulgar, impure comment. The story is a striking illustration of Christ's word, "I say unto you, That every idle word that men shall speak, they shall give account thereof in the day of judgment" (Matt. 12:36)

919 Power of the Tongue

The tongue is the expression of our inward states of mind, and so, its reach is immense. It can rise to the very highest themes of spirituality, and all experiences therein. It can be the minister of love. It can be an instructor through imagination. It can give knowledge. It can give encouragement, cheer, consolation. It can bind up wounds. It can salve them and soothe them. Or, it may be the instrument of wrath, ignoble appetites and passions. For the mischief that it can do, for the malignity that it can express, it has no rival. For the transcendent beauty which it may exhibit, for the comfort and knowledge which it may minister, it also has no rival. The pen works for a longer period, but the pen is dry. The tongue is a living force. It adds to the mere enunciation of any theme or feeling that electric impulse which every man carries with him. The pen has no blood; the tongue has much. We do well to take heed of it.

920 The Tongue at Home

A great many persons who are just in many things are unjust in speaking. A great many men who are cautious in their demeanor abroad, at home and in their own household are heedless, and even rash. There are Christian heads of families who shoot across the table from day to day words which stir up the worst feelings that men can have. Many children are brought up in the midst of provocations and quarrels. Many and many a household has no free chimney which carries away the smoke of these conflicts, and the smoke falls down, leaving harm where it rests; and there is a settled condition of unhappiness as the result.

Treasure

921 Treasure Unreceived

A nobleman once gave a celebrated actress a Bible, telling her at the same time that there was a treasure in it. She, thinking he meant religion, laid the Bible aside. She died, and all she had was sold. The person who bought the Bible, on turning over its leaves, found a note for $2,500 in it. Poor creature! Had she read the book, she might not only have found the note, but the "pearl of great price."

922 The Heart Following the Treasure

Dr. Theodore Cuyler tells a very interesting story from his own pastoral experience of how our interest is increased where we have placed our treasure or our service. He says: "When my Brooklyn church, in the days of its infancy, was building the present sanctuary the funds ran short. The Civil War had just broken out, and almost every new church enterprise came to a standstill. On a certain Sabbath I made a fervent appeal for help, and a visitor from New York heard the plea, and went home and spoke of it at his boarding house table. At the table was a bright young lady who supported her widowed mother by her earnings as a teacher. I had once rendered the young lady some trifling service, which I had quite forgotten, but she had not. The next day she came over to Brooklyn and told me how sorry she was that my church was in such straits. She was not a Christian and had never given anything to any religious object, but felt desirous to contribute her 'mite,' and slipped into my hand a piece of paper containing a coin, which I put into my pocket with a word of sincere thanks. After she had gone I opened the paper and found that it contained a fifty-dollar California gold-piece! I immediately sent her word that she must take it back, for I knew that she could not afford to give such a sum. But she wrote me that this, her first gift, had already afforded her such delight that she could not allow it to be returned. On the following Sunday I told the story of the gold-piece, and it fired the congregation with fresh enthusiasm, and brought in such contributions of funds as tided us over into deeper waters. The young lady herself determined to follow up her gift by coming over to our chapel every Sunday, and was soon converted and became a happy member of Christ's flock."

923 The Wagon Lady

Margaret Siders died at the age of 92. The last twenty years she was a

familiar figure seen daily in the downtown area of Shreveport, LA. She pulled a little wagon through the streets, sifting through the trash for edibles and discarded clothing. She had lived alone in a small tin house since her husband's death six years earlier. Her body was being kept at the Caddo Parish morgue because no one had agreed to pay for her burial.

Aren't you saddened when you read stories like this? I know I am. I'm saddened when I think of her loneliness. Her mate was gone, and she apparently didn't have anyone in the world. She didn't have anyone in life or anyone to mourn her death. I'm saddened when I think of her lifestyle. What an image she burns, pulling her wagon from trash can to trash can. A smile would come across her face when she'd discover an edible or wearable treasure. Then she would go home to her humble abode. How do you feel when you think of her loneliness...her life...her death? But wait, there's more to her story.

When authorities entered her home, looking for clues of next of kin, they also made an interesting discovery. Police Detective Bettye Brookings had befriended Mrs. Siders and shared with the other officers a suspicion she had. "When you go in, keep your eyes open.

You are looking for more than a name and a phone number." She led the group in and went room to room, but it was in the bedroom where rumor became a reality. Bettye reached inside a hole that had been cut in the mattress and pulled out some books—bank books. The figures showed that the "wagon lady" had about $250,000 in four local banks, and possibly more in another account. Now, how do you feel once you've read the full story? What emotions come to mind when you consider how she chose to live when she possessed so much more? How do you explain the enigma of Margaret Siders?

Before you come down too hard on Mrs. Siders, does her story remind you of your own? No, not literally. I'm not talking about something that can be revealed in a bank book; however, another book does come to mind. Do you live your life in light of what you possess? Or do you live in denial? Does your spiritual life reflect more rumor than reality?

How do you feel when you consider one who chooses to live an impoverished life when treasures are possessed? Sadness still comes to mind.

—Dwaine Powell
The Friendly Visitor
(Abridged)

Trust

924 A Better Answer

A young man went away from home to embark in a modest enterprise. His capital was small, but it represented the earnings of many years. He had won the esteem of his employer, and, as he was about to leave, the merchant said to him, "Don, if you ever get into a tight place, let me know of it. I will be glad to help you." For awhile the young man prospered; then came a misfortune. This was followed by others in such rapid succession that he began to see before him bankruptcy and ruin. He thought of his old employer, and at last resolved to write to him and ask for help. He had not the courage to ask for the whole amount, but hoped the small sum he asked for would enable him to somehow retrieve his fortunes. He waited eagerly for an answer, but no answer came. He knew that the merchant was at home, and that he was not a man who ever procrastinated about what he intended to do. Don's heart grew sick. Tomorrow his creditors would seize upon his goods. There seemed to be no way of escape. As he sat wrapped in his gloomy thoughts, the door opened and his old employer stood before him.

"My boy," he said, "I received your letter, and while you said you wanted money, I made up my mind that you needed me. I have been to see your creditors, and they understand that my entire fortune is behind you."

His friend had kept his promise, but he had answered in a way that the petitioner had not dared to hope. Brother, if your Lord has given you exceeding great and previous promises, do not allow yourself to fear that he will not fulfill them. God doesn't always give his loved ones what they ask, but he never fails to supply their needs.

925 The Patient Sufferer

A few years ago there lived in a village a little girl who was cruelly persecuted in her own home, because she was a Christian. She struggled on bravely, seeking her strength from God, going regularly to Holy communion, and rejoicing that she was a partaker of Christ's sufferings. The struggle was too much for her poor weak frame, but He willed it so. One day the Angel of Death came for her suddenly. She had fought the good fight, she had kept the Faith, she had witnessed a good confession before her witnesses at home, and finally her sufferings were ended. When they came to take off the clothes from her poor dead body, they

found a piece of paper sewn inside the front of her dress, and on it was written, 'He opened not His mouth' (Is. 53:7; Acts 8:32).

926 The Little Russian Boy's Letter to God

Years ago, a government official living at St. Petersburg died in utter destitution, leaving behind him, motherless, and without friend or relations, two little children, the one a boy of seven years of age, and the other a little toddling girl of three. Left in the house alone without money and without food, the little fellow did not know what to do to get food for his sister. At last, urged by the tears of the little one, he wrote on a piece of paper, 'Please, God, send me three copecks (a penny) to buy my little sister a roll"; then he hurried off to the nearest church to slip it into an alms-box, believing in his simplicity that the prayer would reach heaven through this medium. A priest passing by observed the child on tiptoe trying to thrust the paper in, and, taking the paper from him, read the message. Returning home with the child, he took the little ones to his house, and gave them food and clothing they so much needed. On the following Sunday he preached a sermon on charity, in which he mentioned this touching little incident, and afterwards went around the church with a plate. When the offerings were counted, it was found that the congregation had given 150 ruble's, a large amount of money for that time.

927 Survivalist

Do you believe in the survival of the fittest?

On December 8, 1903, British philosopher and railway engineer, Herbert Spencer transitioned into eternity unable to survive the clutches of death. It was a little ironic, given the fact that he was the evolutionist who coined the phrase, "survival of the fittest."

Spencer believed: "the great law of nature is the constant action of forces which tend to change all forms from the simple to the complex." The more complex the species, the greater the chance of survival. Obviously, he never read or perhaps just didn't believe his own Creator's account of the development of all life.

Our egos love to trust in our innate strength, intellect and determination to survive. But God's plan for mankind had nothing to do with superiority. He wanted us to totally trust him. The Apostle Paul grasped this truth when he said, *"I will boast all the more gladly about my weaknesses, so that Christ's power may rest on me. For when I am weak, then I am strong"* (2 Cor. 12:9, 10 NIV). If you want to survive eternal death, take the word of your Creator, not a derailed philosopher.

Remember: God believes in the "survival of the weakest."

Reflections

928 Misguided Trust Can Be Dangerous

I read about a photographer for a national magazine who was as-

signed to "shoot" one of those big Western forest fires. He was told that a small plane would be waiting to fly him over the fire.

When he got to the airport, sure enough, he found a little Cessna waiting. He jumped in with his equipment and yelled, "Let's go!" The pilot, the plane, and the photographer were soon in the air.

"Fly over the north side of the fire and make several low passes," the photographer shouted.

"Why?" the nervous pilot asked.

"Because I'm going to take pictures! I'm a photographer, and photographers take pictures," was the reply.

After a long pause, the pilot tensely asked, "You mean, you're not the instructor?"

The pilot and the photographer both trusted someone to do something they could not do. Luckily, in this case, thanks to communication by the air traffic control, they were able to get back to the airport.

In life, trust is often put in places, people, and things that are not worthy of such trust. People have entrusted friends, advice columnists, talk shows, spouses, organizations, and a host of other people and things–even their own feelings–to direct them. Unfortunately, many people do not learn until it is too late that their trust has been misguided and misplaced. Many of the decisions lead not to safety but to destruction!

Jesus warned, "*Beware of false prophets, which come to you in sheep's clothing, but inwardly they are ravening wolves*" (Matt. 7:15) and "*if the blind lead the blind, both shall fall into the ditch*" (Matt. 15:14).

Our authority should be in God and His Word and not in preachers, friends, relatives and others. People can knowingly or unknowingly deceive others. God's Word is the only safe guide.

—John Denney

929 Allegiance Confirmed

When Queen Victoria of England reigned as Empress of India, the Maharajah of Punjab was a little boy. To show his allegiance, he sent her a magnificent diamond. It became one of the crown jewels and was safely kept in the Tower of London. When he became a man, he went to London to pay his respects to the Queen. The young man asked the Queen if he could see the diamond. The precious jewel was brought in and presented before the Indian prince. Then, taking the diamond and kneeling before the Queen, he said with deep emotion, "Madam, I gave you this jewel when I was too young to know what I was doing. I want to give it again, in the fullness of my strength, with all my heart, and affection, and gratitude, now and forever, fully realizing all that I do."

At this special season of the year, let us think of how we should surrender our lives and allegiances to Christ alone. As he gave all to save us, we must give Him our all in return.

—John R. Brokhoff
From: *This You Can Believe*

930 I Can Sleep at Night

A farmer needed a hired man. After trying several workers, who all failed to meet his standards, the farmer began to feel desperate.

Then another worker applied for the job. The farmer asked him, "What qualifies you for this job?"

The man answered, "I can sleep at night."

That didn't sound too promising, but since he was desperate, the farmer hired the newcomer.

That night there was a terrific thunderstorm. The farmer awoke, ran to the hired man's room and tried to arouse him. He could not.

Muttering to himself something like, "I'll take care of him in the morning," the farmer went outside into the night and the driving rain. He found the barn doors securely closed, the hay stack well covered and the tractor put away in the shed. There was nothing he could do but return to the house and go back to bed. Then he understood why his new hired man had said, "I can sleep at night."

Isn't it comforting to know that when we have prepared ourselves for Jesus' coming by faithfully doing the things the Lord has made clear to us, he will take care of those things beyond our control?

—John Van Schepen
Family Newsletter

931 I Will Come Back

A father took his daughter swimming. Both were good swimmers, but after a while the water got a little rough and the father was not sure his daughter could make it to the shore. "I will go to the shore for help. You are able to float on your back all day. Don't worry, I will come back for you."

As soon as the father reached the shore, he enlisted many people to help. They went in boats looking for his daughter. After four hours they found her floating on her back. She was not afraid. Her rescuers congratulated her. The little girl said, "But why were you so worried? I wasn't afraid at all because my daddy told me that he was going to come back for me and I believed him. I floated on my back as he told me to do and waited for him. I fully expected him to come back for me. I never had any doubt about it."

Neither should we have any doubt whatsoever in regard to the promise of the Lord Jesus Christ who said, *"Let not your hearts be troubled. . . . I go to prepare a place for you and if I go and prepare a place for you, I will come again, and receive you unto myself: that where I am, there you may be also"* (John 14:1–3).

No matter how stormy life is, trust Jesus' promise that He is coming back.

932 Strength in Numbers

During the Russian invasion of Romania in 1941, a Romanian soldier, Ana Gheorghe, became separated from his company. As he tried to find

his way to the assembly point which had been designated for such a contingency, he came upon a broad grassy clearing which he would have to cross. There was no sight nor sound to indicate the presence of an enemy, but menace seemed to fill the air. How he wished for the presence of some of his fellow soldiers!

Stiffening his resolve, he began his dash across the meadow—only to see a Russian soldier suddenly materialize out of the grass, his rifle already aimed at him. Fear conquered training, as Gheorghe fell to his knees, then buried his face in his hands and began to pray.

As he prayed feverishly, he waited for the touch of the Russian's rifle, and the searing impact of the bullet which would end his life. But the touch was delayed, though he sensed the near approach of his enemy. Gheorghe opened his eyes, and saw the Russian soldier kneeling in front of him, his gun on the ground. The Russian was also praying.

Neither understood a word the other spoke, except for "Alleluia...amen." They tearfully embraced, then they walked quickly to opposite sides of the clearing.

"I learned a great lesson from our meeting in the grass," Gheorghe later told an American relative. "There is indeed strength in numbers, but the number needed for the greatest strength of all is two."

From an article by
Daniel Christiansen, an
American relative,
in *Moody Magazine*, Feb. 1990.

933 The Other Side

A major disaster occurred in England's mines some years ago which took the lives of 40 miners. Loved ones gathered around the entrance of the mines, agonizing for a word of hope. Someone asked Bishop Edward Stanley to speak a word of encouragement to those families, and this is what he said:

"We stand today in the face of mystery, but I want to tell you about something I have at home. It is a bookmark, embroidered in silk by my mother and given to me many years ago. On one side, the threads are crossed and recrossed in wild confusion, and looking at it you would think it had been done by someone with no idea of what he was doing. But when I turn it over I see the words that are beautifully worked in silken threads, 'God Is Love.'

"Now we are looking at this tragedy from one side, and it does not make sense. Some day, we shall be permitted to read its meaning from the other side.

"Meanwhile, let us wait and trust."

—A. P. Bailey
Sparks

934 In Jesus I'm Safe Evermore

Over a hundred years ago, a sixteen-year-old lad was singing happily at his work on his father's fishing boat. Some time before, he had given his heart to the Lord Jesus and confessed Him as his

Savior. He loved to sing of Him and His precious love. Now, he was singing:

I've anchored my soul in the
 haven of rest,
I'll sail the wide seas no more;
The tempest may sweep o'er the
 wild stormy deep;
In Jesus I'm safe evermore.

Just as he finished singing the last line, "In Jesus I'm safe evermore," the heavy sail swung round, knocking him overboard, and he disappeared without trace. After searching in vain, the father, sad at heart, turned the vessel round and headed back to the port where the family were staying for the summer months. The poor mother was grief-stricken. Although the family members were filled with sorrow, their hearts were comforted that they sorrowed not as those who have no hope; the Word of God assuring them that He will bring with Him those who have fallen asleep through Jesus at the coming of the Lord Jesus for His own (1 Thess. 4:13–18).

What, dear reader, is your hope? If on the things of this life only, death ends all that. Have you fled for refuge to lay hold of the hope set before us, which we have as anchor of the soul, both secure and firm? Have you trusted in the finished work of Jesus on the cross and His precious shed blood? Oh! Lay hold of this blessed hope so that you too can sing, "In Jesus I'm safe evermore."

From: *The Fisherman's
Gospel Manual*
Chapter Two, London

Truth

935 Truth Vindicated

At the funeral of a man, who was very generous and loving, but ungodly and dissipated, I felt unwilling to make a funeral address that should be untrue to my convictions of the truth of the Word of God. Accordingly I spoke to the businessmen, present in very large numbers, who had been his companions, about the folly of neglecting the soul even for the sake of worldly profit. They had expected to hear a eulogy of the dead, and get comfort in their own ungodliness, and were much incensed. One of them cursed and swore that he would provide in his will that I should never officiate at his funeral. Shortly after, God smote him with incurable disease, and for many months he lingered in great agony, and died. He would send for me and cling to me like a child, confess to me his sinful life, and beg me to pray for him and with him. Before his death he wrote me a letter with a trembling hand—a letter that is to me as precious as gold. In it he says: "Be always honest and true with men; tell them the truth, and even those who at the time may take offense, will afterward stand by you and approve your course." When he came to look into the great hereafter, he wanted no shallow quicksand of flattering falsehood on which to rest his feet. There comes a time when every man wants to know the truth.

936 Jesus is Truth Personalized

Jesus said: "I am the Truth—the Way to the Truth and the Life of the Truth." It is not enough to say that Jesus speaks the Truth or brings the Truth. The fact is that Jesus is the Truth. He is the Truth personalized. If we wish to know the truth we must get to know Christ. When we know Christ we know everything that is worth knowing. If we see Christ, we shall see God. "If ye had known Me ye should have known My Father also." If we learn of Christ we shall know what sin is and what righteousness is and what salvation is and the means of salvation. We shall understand eternal life if we know Christ. "This is eternal life, to know Thee, the only true God and Jesus Christ Whom Thou hast sent" (John 17:3). All we need to know about the Church and the judgment and the future we shall understand in the teaching of our Lord.

937 Emptiness of Unbelief

Unbelief is the most unmanly thing that a man can boast of—not believing in truth, in all the great

thoughts that belong to the universe, in men, in women, in virtue, in heroism. To rest in unbelief is to be like a tenement house that is abandoned by the tenant, and given up to the rats and vermin. The emptiest, poorest, most unmanly of all conditions, is that of a man without belief in anything.

938 *"In the Heavenly Places"*

If we want to live more than ordinarily spiritual lives as Christian men, it is necessary that we be great feeders upon the Word of God, which is not only quick, but powerful. De Quincey divided all literature into the literature of knowledge and literature of power. This is pre-eminently the literature of power. "If ye abide in me, and my words abide in you, ye shall ask what ye will, and it shall be done unto you" (John 15:7). And still further, we might make this additional statement: that without spiritual Bible study, other spiritual helps may often lead us into danger, and ultimately they may be abandoned. Take the matter of meditation: without the Bible, meditation may lead a man to morbid introspection. Secret prayer is not a monologue, but is a dialogue.

Unbelief

939 Lost Thoughts

At death a man sees all those thoughts which were not spent upon God to be fruitless. A Scythian captain having, for a draught of water, yielded up a city, cried out: "What have I lost? What have I betrayed?" So will it be with that man when he comes to die who hath spent all his meditations upon the world; he will say: "What have I lost? What have I betrayed? I have lost Heaven, I have betrayed my soul." Should not the consideration of this fix our minds upon the thoughts of God and glory? All other meditations are fruitless; like a piece of ground which has much cost laid out upon it, but it yields no crop.

940 Love of Darkness

When the Bastille was about to be destroyed a prisoner was brought out, who had long been lying in one of its gloomy cells. Instead of joyfully welcoming his liberty, he entreated that he might be taken back to his dungeon. It was so long since he had seen the light that his eye could not endure the light of the sun. Besides this, his friends were all dead, he had no home, and his limbs refused to move. His chief desire now was that he might die in the dark prison where so long he had been a captive.

941 Too Respectable for Hell

A wealthy merchant of Philadelphia, who would not listen to the gospel message in health, sent for me at his death-bed. I told him: "I have nothing now to tell you. You are a sinner, and here is a Savior. Do you feel your guilt, and will you take a Savior?" "No. There must be some better place than hell for a man of my respectability."

Unity

942 *Faith That Saves*

"In an English town," says Dr. A. C. Dixon, "a report got out that the bank was about to fail. Five hundred people ran for their deposits on the same day. The pastor of the dissenting Church in the town was invited by the bank directors to meet them. They said to him, 'Sir, if these people press us to the wall, they will lose their money. If they don't press us, we will pay every dollar.' The pastor said, 'I will help you; I have some money, and I trust you.' He went home, got his money, came to the bank door, and, standing on the step, said, 'Friends, you all know me; I have been living here twenty-five years, and I believe in this bank. Here are three hundred pounds that I am going to deposit. I believe that the bank is good.' In less than thirty minutes every one of those people had dispersed, and the bank was saved by faith. Unbelief as to that bank was about to ruin it. The moment faith was implanted, the bank was saved. Railroads are saved by faith. Steamboats are saved by faith. Your business, friend, is saved by faith. Every good thing on earth is saved by faith. And when the infidel rails at the religion of Jesus Christ because we are saved by faith, he is railing at every institution this country holds dear."

943 *The Double Fence*

Church unity is fine as an idea, but it is another thing entirely when we deal with application. I read this story recently, and it illustrates my point well:

"Between two farms near Valleyview, Alberta, you can find two parallel fences, only two feet apart, running one-half mile. Two farmers, Paul and Oscar, had a disagreement that erupted into a feud. Paul wanted to build a fence and split the cost, but Oscar refused. Since he wanted to keep cattle on his land, Paul built the fence anyway.

"After the fence was completed, Oscar said to Paul, 'I see we have a fence.' 'What do you mean, 'We?' Paul asked. 'I had the property surveyed and built the fence two feet into my land,' Paul continued. 'Some of my land is outside the fence, and if I see your cows trespassing, I'll shoot them.' Oscar knew Paul was serious, so when he eventually chose to use his land next to Paul's for pasture, he was forced to build a fence two feet away."

Unity in practice is time-consuming, costly, distracting and difficult at best to attain. It means

sacrificing our preferences and desires. So why bother? Before Jesus was arrested, he prayed, *"I have given them the glory that you gave me, that they may be one as we are one: I in them and you in me. May they be brought to complete unity to let the world know that you sent me and have loved them even as you have loved me"* (John 17:22, 23 NIV).

Unity in practice is sometimes painful, and it does mean we must sometimes give up our preferences, tastes and traditions. So why bother? To fulfill our mission to make disciples for our God, who sacrificed His Son to remove our sin and bring us back to a covenant relationship with Him!

—Mike Wittl
Old Union Reminder

944 The Cats of Killkenny

A well-known limerick conveys a message very pertinent to all of us in the Lord's Body. It speaks of two cats, each of which had an overrated opinion of itself. The arrogance of these two felines ultimately led to the demise of both.

There once were two cats of
 Killkenny.
Each thought there was one cat
 too many.
They fought and they spit,
They clawed and they bit,
Till instead of two cats there
 weren't any!

How many times have we seen the saga of the Killkenny cats played out in the Lord's church with the same tragic results? An arrogant, self-righteous attitude displaying itself in religious bigotry is a shame upon our Prince of Peace who lived, died and rose again that we **all** might be *ONE*. To spit and fight, claw and bite, in our efforts to be "top cat" is only to invite our own ultimate destruction.

Immediately after stating that "through love" we are to "serve one another," and that the whole Law is summed up in one word, *"You shall love your neighbor as yourself,"* the apostle Paul says, *"But if you bite and devour one another, take care lest you be consumed by one another"* (Gal. 5:13–15 NASB). This is good advice not only for feisty felines, but for cantankerous Christians as well.

—Al Maxey
The Aloha Spirit

Will

945 Content in His Will

"For we know that all things work together for good to them that love God, to them who are called according to his purpose" (Rom. 8:28)

A farmer and a king unite to teach us the secret of contentment in God's will. The farmer who had been sick was being visited by his pastor. "How are you getting along?" asked the minister. "Just as I would have it, pastor," he answered. "But how must I understand this?" asked the preacher. "Do you wish sickness for yourself?" "No," said the farmer, "but what God wills that I also will. If it is God's will that I should be sick now; then it is my will, too. If it be His will that I die now, then it is my will, too. Should He will that I get well again, then I will it, too. *Everything is placed in His hands, let Him deal with me as it pleases Him."*

The King, Christian III, of Denmark, when exceedingly sick, and without the medicine to cure him, laughingly asked: "Where are we now, who are accustomed to being called the great ones, when we are so utterly cast down by a fever? On account of what are we so proud? Even when we are adorned with all manner of human righteousness, we still bring nothing to God but a heap of sin. Therefore let us seek refuge in the Son of God, and accept His righteousness by true faith. This will lead us to eternal life."

It is this double confession of our nothingness combined with a humble confession and committal of ourselves to God through Christ that brings us any contentment.

946 Thy Will, Not Mine

A young girl, who had struggled with the question of submission to God, said: "I could see easily enough that making God's way my way was very different from submitting just because I had to do it, or because I felt that it was my duty. I was on the way down to Miss Howland's to see about having my new dress made. I had some notion of how I wanted it to look, but when I showed her the materials she told me how it ought to be made and trimmed, and it wasn't the least bit as I had planned. I didn't altogether understand her, but I fell right in with her plan and was perfectly satisfied to have her go ahead with it. Now, it is just because I know Miss Howland so well, and we are in such perfect sympathy on questions of color, etc., that I am at rest in letting her work it out, though I don't know just how she is going to do it.

She knows what suits me better than I know myself. And it seemed to me," dropping her voice a little, "that we ought to be just that way with God."

If our hearts are in harmony, we will be able to say that His will is ours, even when we don't know what it is. He knows what is suited to us better than we can possibly know.

947 Go or Send

A young woman who, while poor herself, had many rich, influential friends and relatives, felt that she ought to devote her life to working among the neglected classes in one of our large cities. Her friends tried to turn her from her purpose. They ridiculed her, and told her that she simply wanted to do something sensational. A servant girl in the family where the young woman made her home, heard of it. She was ignorant and poor, but she was a Christian. One night, when her work was done, she went timidly to the young woman's door and tapped for admission. "I just wanted to tell you to go," she said simply; "I've always wanted to, but I can't. I hope you will go in my place." The would-be missionary had been just on the point of giving up, but this message saved her. "Yes, I will go," she said, joyful tears running down her cheeks. "I will go in your stead, for God will know and I know that it was you who sent me."

948 Hearken and Do

Every true prayer has its background and its foreground. The foreground of prayer is the intense, immediate desire for a certain blessing which seems to be absolutely necessary for the soul to have; the background of prayer is the quiet, earnest desire that the will of God, whatever it may be, should be done. What a picture is the perfect prayer of Jesus in Gethsemane! In front burns the strong desire to escape death and to live; but behind there stands, calm and strong, the craving of the whole life for the doing of the will of God.

—Phillips Brooks

Wisdom

949 True Wisdom

If we are wise with the true wisdom of souls, our first need of patience sends us to God to ask for it. We seek a refuge from disquietude in His peace: our haunting weakness drives us back upon His strength, till presently we find that our incapacity, with God's help, is stronger far than our most complete energy without it, and that, with the thorn still fretting the flesh, we can do all things through Him that strengthens us (Phil. 4:13).

950 God's Wisdom Seen in Nature

Somewhere I have met the incident of one, whose mind was hung about by atheistic doubts, walking in the woods and reading. As he read he came upon the sentence from Plato, "God always geometrizes." Just then he noticed a simple white flower blooming at his feet. He plucked it, and carefully began to count its petals; there were five. He counted the stamens; there were five. He counted the divisions at the flower's base; there were five. Then interested in the discovery, he set himself to computing the mathematical chances against the probability of the appearance of a flower set about with this fiveness by a merely unintelligent happening. *They were as a hundred and twenty-five to one.* But here was another flower of the same sort, and then another, and then another, whitening the fields, thousands of them and every one gripped by just this fiveness—no more no less. No wonder that he exclaimed: "Bloom on, little flowers, you have a God, and I have a God; the God that made these flowers made me."

951 Search for Divine Wisdom

Tell men that a new lode has been found in some gulch or cannon, tell men that some Black Hills country is open for the digging of more gold; and all the armies cannot keep the emigrants from streaming thither from every quarter through the plains. Suffering from weariness and from hunger, and in the face of a thousand scalping dangers they will hunt for that gold. Tell men that in the mountains there are precious stones—opals, rubies, sapphires and the like—and how they will explore and explode the hills for them! And though but one in a thousand can gain them, yet each one of the thousand will think that he is to be the favored one.

Now, we are told in the Word of God that this understanding of Him

374

is more precious than rubies; that silver and gold are as nothing to it; and that we are to search for God, to seek after him, as for hidden treasures—as men search for the dearest objects of their desires.

952 Wise Renunciation

The "Swedish Nightingale," Jenny Lind, left the stage, for no apparent reason, when money and applause and fame were pouring in upon her. Some time after, an English friend found her sitting by the sea, with a Lutheran Bible on her knee, looking out at the glory of the Sunset. As they talked together the friend asked, "Madame Goldschmidt, how is it that you ever came to abandon the stage at the very height of your success?" "When every day" came the quiet answer, "It made me understand less of this—(laying a finger on the Bible)—and nothing at all of that—(pointing to the sunset)— what else could I do?" We may pay too high a price for the best that the world can give. What shall it profit a man if he gain the whole world and lose his own soul as the price for doing it?"

953 Evil Communications

Forsake dangerous associations. Health is not contagious, but sickness is. We quarantine yellow fever to keep it out of the country, but we do not bring in health or quarantine it. Sin is catching; holiness is not. Be very careful to whom you give the key of your heart. Look out! This association, with us imitative creatures, has a tremendous influence on a man's or a woman's Christian character. Lot bought real estate down near Sodom; pitched his tent over against Sodom. Then he moved into Sodom, and pretty soon Sodom moved into him. The angel put a hand on his shoulder, and said, "Escape for thy life . . . lest thou be consumed" (Gen. 19:17). That is the only way for any one to get out of dangerous associations in business, in politics, or anything else. Christians, the moment you find that you are in any associations that harm and poison your piety, escape out of that place as quickly as Lot deserted Sodom, for there is no safety in remaining there.

954 Blessed Are The Hungry

Thorwaldsen worked long and with earnest enthusiasm upon his statue of the Christ; but when at last it was completed, a deep sadness settled over him. When asked the reason for this, he replied, "This is the first of my works with which I have ever felt satisfied. Till now my ideal has always been far beyond what I could execute; but it is no longer so. I shall never have a great idea again." Satisfaction with his work was to him the sure indication that he had reached his best achievement. He would grow no more, because there was no longing in his soul for anything better. He recognized this, and hence his pain of heart.

In all life this law applies. Hunger is a mark of health, and the lack of appetite proclaims disease. The cessation of the desire for knowledge

shows that intellectual growth has ended. So, in spiritual life, dissatisfaction is the token of health. "Blessed are they which do hunger and thirst after righteousness" (Matt. 5:6).

—J. R. Miller

955 Put On Christ

You never can drive out the uncleanness of evil thoughts except by pouring in the clean wholesomeness of the thoughts of Christ. Have you made Christ for any length of time the one object of your thoughts? Try it, you people who want to break loose from the shackles that you know are keeping you away from the great blessing of God and from the pure sweetness of His free and holy life. What else is there to think about that is worth anything, compared with Him? All treasures of wisdom and knowledge are hidden in Him. How it must grieve Him, who, though He was rich, yet for our sakes became poor, to see us filling our minds with passing things, worthless things, dying after the fashion of the world, while Christ is crowded away into some bare and paltry place in our lives!

956 One Man's Folly

A rich man failed in business. He gathered up the fragments of his wrecked fortune and had in all a few thousand dollars. He determined to go to the West and start anew. He took his money and purchased a motor home, furnishing it in the most luxurious style, and stocking it with provisions for his journey. In this sumptuous vehicle he traveled to his destination. At length he stepped from the door of his motor home and only then thought for the first time of his great folly. He had used all his money in getting to his new home, and now had nothing with which to begin life there. This incident illustrates the foolishness of those who think only of this life and make no provision for eternity.

Witness

957 *Witnessing for Christ*

A few years ago two young men, who had been much like David and Jonathan from their boyhood days to their college days, and from that time until they were lawyers together in a certain city, went down to the dock of the *White Star* steamer. One of them was to go on a long journey around the world. They were utterly unlike in one thing only; one was a Christian, and the other, though not a skeptic, had delayed this question. During the entire train ride the Christian man said: "I will speak to him when we get down to the Fifth Avenue hotel." He did not. When they stood on the dock, "I will speak a word when we are going down the gangplank." He did not. "I will spring up on the rail of the pier, just as the ship is swinging off, and speak then." He did not. The great ship turned her head out into the stream, and the two parted, and he had not said his word of Christian warning. Only a year and a half later, halfway around the globe that lost friend ran out of time and September did not come after August for him. And now, in his beautiful library, that living man sits and looks up at his dead friend's picture, and talks to him, and says: "O Jonathan, my friend, I ask you to be a Christian! I pray you to be a Christian!" But the picture upon the wall makes no reply. The lamp burned till midnight and went out. If you have a word of warning to say to your friend, you had better say it now.

958 *Useless Consuls*

A young New York businessman who has been making a tour of the West Indies in search of information as to trade conditions and possibilities in that region, complains that he could not get the slightest assistance from the United States consuls. This was not because they were unwilling to assist him, but because they were entirely unfit for their positions. He often found the Stars and Stripes flying over the door of a man who could not speak a word of the language of the people among whom he lived, and knew nothing about the commerce or resources of the island where he represented the United States. Every Christian is under obligation to represent Jesus Christ to those who do not know him. Many times those who bear his name fail to properly make him known because of their ignorance. If we are going to make our Christianity of value to others, we must be not only earnest, but intelligent Christians ourselves. We should study to know

Christ more perfectly, not only for our own comfort, but that we may be able to make our knowledge a blessing to others.

959 A Chain of Good Deeds

A miner who had come back from the Klondike had made a unique gold watch-chain, composed of splendid nuggets taken from a mine in the newly discovered gold-fields in Alaska. A newspaper reporter, writing of it, said that wherever this miner went this striking chain of nuggets made him a walking advertisement for the Klondike, and aroused a desire in other men to go there. The sincere disciple of Jesus Christ who seizes every opportunity to do Christlike deeds is forming a chain of nuggets far more precious. Wherever he goes the imagination of men is aroused, and their desires awakened to know the Christ who makes such deeds possible. This is what Christ meant when he said: "Let your light so shine before men that they may see your good works and glorify your Father which is in heaven."

960 Paul on the Witness Stand

Paul thought his Christian experience was by far the most powerful argument he could give to the truth of the Christian religion. When he was brought before King Agrippa, instead of undertaking to defend himself by some great oration, or some strong legal argument, which he was well able to make, he simply told his experience of how Christ revealed Himself to him on the road to Damascus, and how ever afterward he had been obedient to the heavenly vision, and had gone on this new way rejoicing. The gospel in us is the most powerful we can speak to the people whom we wish to win.

961 Witnesses—Standing

At an open-air meeting in Liverpool, a skeptic gave a strong address against Christianity to a large audience and at the close said, "If any man here can say a single word in favor of Jesus Christ, let him come out and say it." Not a man moved. The silence became oppressive. Then two young girls arose, walked hand in hand, as if moved by the Holy Spirit, up to the speaker and said, "We can't speak, but we will sing for Christ," and they sang with great power, "Stand up, stand up for Jesus." When the song ceased, every head was uncovered, all were deeply moved, some were sobbing, and the crowd quietly went away, apparently with no thought of the skeptic's words. Can you stand with God against the blasphemies, against sneers, against temptations to dishonesty, against bribery in subtle form, against flattery, against persecution?

962 A Good Witness

J. D. Brash came to Manchester. His mother came to live with him, and while attending the church in which he was minister, gave her heart to God. Her son asked her to

attend his society class, but her Scottish reserve made her insist upon a promise being given by him that he would never call upon her to speak. To this he assented, but said that he would tell the story of her conversion. At the first class meeting he began to tell the story, but he had not traveled far before his mother very excitedly said, "You are not telling it right, Jack," and forthwith speedily poured forth the story of her newfound love. He often told this to prove that when the most timid soul is aglow with love, there is something which makes it claim a share in the spiritual conversation of the class meeting.

—James Hastings

963 Consider Your Influence

A little girl strolled into Bible class one morning. Her hands were dirty, her dress was soiled, and there was a curious dirty ring around her mouth. Her teacher asked her how she had gotten so dirty so early in the morning. She explained that on her way to Bible school, a neighbor boy asked her to blow up his wading pool. She blew and blew until she had enough air to make the rubber wall stand up. Then, the boy picked up the hose and started filling the pool.

The little girl asked him why he didn't come to Bible school with her. He told her, "No, I want to play in my pool." Then, with her pretty blue eyes looking straight toward the teacher, the girl said, "I pulled the stopper out of the air hole and let the air out so the pool would go down, because if he didn't come to Bible school with me, I didn't want God to blame me for it!"

As you consider the influence your life has on another, could God ever blame you for their conduct? *"A little leaven leaveneth the whole lump"* (Gal. 5:9).

—Olden Cook

964 Your Influence as a Teenager

Even before his outstanding years as Harding's quarterback, Tom Ed Gooden was noted by the *Arkansas Gazette* as being the best high school quarterback in his district. The paper ran a picture of Tom Ed with the caption, "Not on Wednesday." It seems that another school had tried to schedule a game with his team, Carlisle, AR, on Wednesday evening. But his coach replied that they couldn't do it. The coach said, "My quarterback is a church member and he goes to church on Wednesday nights. He won't miss for any reason, and I can't win without him.

Teenagers, whether you like it or not, your life is a walking sermon! Your good deeds and faithfulness to the Lord must be obeyed by all. Jesus once described this tremendous influence as *"the light of the world"* and *"city on a hill"* (Matt. 5:14). And as Paul penned his first letter to young Timothy he emphasized the influence of youth by exhorting him to be *"...an example of the believers, in word, in conversation, in charity, in spirit, in faith, in purity"* (1 Tim. 4:12). By

your godly life, you can lead others to the Lord.

Of course, the opposite is true, also. Unfaithfulness to Christ suggests to your friends that there is no difference between the Christian life and living without God. After all, if you see the same movies, use the same language, tell the same jokes, dress the same way, listen to the same music, and so on, what's the difference?

Your obedience to Christ must be conditioned primarily upon your life for Him. It must be so great it leaves us no choice (2 Cor. 5:14) but to follow Him. And it must reflect an inner yearning to seek first the kingdom and righteousness of God (Matt. 6:33). But as you consider the questions of drinking, sexual morality, attendance at services, involvement in church activities, smoking, etc., be sure to remember that your decisions will go beyond your life. They will be deeply felt in the lives and destinies of others.

Witnessing

965 *Fishing for Men*

There is a very beautiful fishing story which is related in the fifth chapter of St. Luke's Gospel, where Jesus had been preaching from the deck of Peter's little fishing boat, and after the sermon was over He said to Peter, Let's go a-fishing; and Peter replied that they had been out all night and had not been able to find anything. But perhaps noticing the disappointed look on Christ's face, he continued: "Nevertheless, at thy word, I will let down the net." They had a great catch that day, and took more fish than they could carry to the shore in two boats. It is the great business of the church to fish for men. We are Christ's fishermen, and we should ever be watchful for indications from Him as to opportunities for winning souls.

966 *Workers—Unknown*

A commercial traveler, named Rigby, was compelled to spend a weekend every quarter in Edinburgh. He always worshiped in Dr. Alexander Whyte's church and always tried to persuade some other visitor to accompany him. On one occasion, having taken a Roman Catholic traveler there who thereby accepted Christ, he called on Dr. Whyte to tell him of the conversion. The doctor then asked his name, and on being told that it was Rigby, he exclaimed: "Why, you are the man I've been looking for for years!" He then went to his study and returned with a bundle of letters from which he read such extracts as these: "I was spending a weekend in Edinburgh some weeks ago, and a fellow commercial traveler named Rigby invited me to accompany him to St. George's. The message of that service changed my life." "I am a young man, and the other day I came to hear you preach at the invitation of a man called Rigby, and in that service I decided to dedicate my life to Christ." Dr. Whyte went on to say that twelve of the letters were from young men, of whom four had since entered the ministry.

967 *A Fearless Witness*

Robley D. Evans will scarcely go down in fame as a diplomat; but in all his stirring career, remarks the *New York Sun*, he never rendered a greater service to this country than during that trying time in the harbor of Valparaiso when his little gunboat, the Yorktown, was the sole representative of our naval power in Chilean waters. Insult after insult was coolly heaped upon the young captain's hot-tempered head,

and diplomacy was needed. Evans lay in the harbor with nine Chilean war vessels about him. The Chileans were celebrating some independence day or other with fireworks and searchlight drills. The white beams from the Chilean vessels had an impudent way of swinging occasionally on the little Yorktown, where she lay within machine-gun range of the Chilean cruisers. As the cruiser Cochrane fired her salute she let off a flight of war-rockets, and one of the heavy bombs barely missed the Yorktown. "I at once hoisted a large American flag," read Evans' log, "and turned both my searchlights on it, so that if anyone really wanted to hit me he could know just where I was. I was determined if trouble came there should be no ground for saying we had accidentally been struck in the dark. When the searchlights a few minutes later lighted us up they showed the crew of the Yorktown standing at their quarters and the guns all ready for business." No more rockets came our way.

968 Redemption— Discovering

Some time ago an evangelist, traveling on the cars, was singing to himself the song, "I've been Redeemed." A fellow passenger, hearing, joined him in the son. After singing, the evangelist put the question to the stranger, "Have you been redeemed?" "Yes, praise the Lord," was the answer. "May I ask you how long since?" "About nineteen hundred years ago," came the reply.

The astonished evangelist echoed in surprise, "Nineteen hundred years ago?" "Yes," was the reply, "but I'm sorry that it's not more than a year that I've known it."

969 Winning Souls

Over the door of a church in Scotland are carved the three Hebrew words translated in our Bible, "He that winneth souls is wise" (Prov. 11:30). They were put there as an indication of the object of the church's existence, and also in the hope that some Jews passing by might see them, and come in to worship the God of Abraham. Dr. Bonar preached from these words on the day on which the church was opened, explaining that "winning" was the word used to describe a hunter stalking game, and reminding "soul-winners" that their work must be done in a wise way. "How carefully David prepared to meet Goliath! He chose five smooth stones out of the brook. He did not assume that one would be lying by his hand when he needed it. Never go to the Lord's work with meager preparation."

—James Hastings

970 Is Your Light Turned on?

"Let your light shine before men, that they may see your good deeds, and glorify your Father in heaven" (Matt. 5:16).

Ted Engstrom, in *The Pursuit of Excellence*, tells of one day when he was cleaning his desk, and found a flashlight which had not been used for over a year.

Trying the switch, he couldn't get it to light. He unscrewed the top, and shook the flashlight, but the batteries wouldn't budge. Then suddenly, after a quick shake and a knock against his arm, the batteries came loose and went clattering to the floor. What a mess! Battery acid had corroded the inside of the flashlight.

Ted was disgusted. The batteries were new when he put the flashlight into the warm, dry drawer. That was the problem! Batteries are meant to be used; not hidden away!

It's the same with us. Our faith is not meant to be stored away! It is intended to be shown everyday in our life. In the midst of difficult and trying situations, like the flashlight, we are to let our light shine.

The Visitor

971 Practical Discipleship

Basically, God is looking for us to serve Him in three ways: as a wife (bride of Christ), as a worker, and as a witness.

Wife-The good wife comes from the fact that Christians are the bride of Christ. Christ expects His bride to be pure (avoid the things of the world that would defile us) and chaste (not flirting with the world or running after other loves). That's easy to understand. These are the same things you want of your husband or wife.

When we violate God's rules in marriage we come to the big "D's" (and I don't mean Dallas!)—disgrace, disease, debt, dishonor, and divorce.

Worker—a good worker is someone who comes to work on time every day; gives an honest day's work for an honest day's pay; and does his job without complaining. These are simple ideas that should apply to your place of employment as well as your place of worship.

Witness—Witnessing is not throwing someone in a corner and making them believe as you believe. Witnessing is simply telling people the difference Christ has made in your life. Sharing answered prayers should be as natural as sharing an exciting news item from the newspaper. Sharing your love for Christ should be as easy as sharing your devotion to the Gamecocks or the Tigers. It's simple to witness when Christ is the main focus of your life.

As Charles Templeton puts it, "Christianity does not remove you from the world and its problems; it makes you fit to live in it, triumphantly and usefully." Are you fit to live and ready to die?

972 "Are All the Children in?"

There is an old story about a devout mother, who had a large and busy family. This family, composed mostly of boys, lived in the country; and in most seasons of the year that meant the children were constantly out of doors, coming and going about their work or play—checking in at mealtimes, but off again at full speed afterwards.

But as twilight drew its curtains across the end of each day, the mother would begin to count her brood, concerned when not all

could be found within the shelter of the home. "Are all the children in?" she would ask her oldest son. And as the darkness grew, so did her anxiety if any were missing. "Not all in? Go! Ring the bell again!" she would exclaim. She could not rest easy until she was assured that all were safe within.

I told that story at my mother's funeral, years ago—for she was just such a mother, and I knew it had been her concern for years that all her children be gathered safe against the night, within the bosom of the Savior she so loved.

"Are all the children in?" This is the abiding concern of every godly mother, and every godly father. Though sons and daughters may grow up, move away, and have families of their own; still across the years, and spreading to number also grandchildren and even great-grandchildren, the call continues: "Are all the children in?"

—Ted Kyle

Works and Service

973 Moral Adaptability

A Moravian missionary once went to the West Indies, to preach to the slaves. He found it impossible for him to carry out his design so long as he bore to them the relation of a mere missionary. They were driven into the field very early in the morning, and returned late at night with scarcely strength enough to roll themselves into their cabins, and in no condition to be profited by instruction. They were savage toward all of the race and rank of their masters. He determined to reach the slaves by becoming himself a slave. He was sold, that he might have the privilege of working by their sides, and preaching to them as he worked with them. Do you suppose the master or the pastor could have touched the hearts of those miserable slaves as did that man who placed himself in their condition, and went among them, and lived as they lived, suffered as they suffered, toiled as they toiled, that he might carry the gospel to them? This missionary was but following the example of the Lord Jesus Christ, who took on Him the nature of men, came among them, and lived as they lived, that He might save them from their sins.

—H. W. Beecher

974 This Man Cared

"I looked on my right hand, and beheld, but there was no man that would know me: refuge failed me; no man cared for my soul" (Ps. 142:4).

It is to be feared that some Christians are idle because they have no concern for the needs of folk around them.

Over half a century ago there was a young surgeon beginning his practice in the city of London. He soon became interested in a rescue mission down in the slums, and went there after evening office hours. One night after the meeting was over, he discovered a ragged little boy lying asleep on one of the benches near the fire. The doctor gently woke him and told him it was time to go home. But the lad replied he had no home. Therefore the doctor took the lad to his own home and after they had eaten he asked: "Are there any other boys in London like yourself?"

"Lots of them," said the boy.

"Will you show me some?" asked the doctor.

"Let's go," said the child.

Soon after midnight they started treading their way through the streets and alleys and byways till they came to a wretched coal shed.

"There's some of 'em in there," said the lad. The doctor entered and lit a match. Not a lad was to be seen. He thought he had been misled, but his boy-guide was not at all abashed. "Cops have been after 'em. They are up on the roof."

So they climbed up the rickety shed to the top. There lay thirteen little homeless boys, cuddled close together on the tin roof in a vain attempt to keep warm. There in the darkness looking down at those sleeping waifs, the young doctor saw the vision of one of the greatest lives of service ever lived in this generation.

That young man was Dr. Bernardo, the founder of those homes for "nobody's children" which at one time stretched like a line of lighthouses across the British Empire. It is said that some ten thousand British fighting men in World War I came from these homes.

Surely this is a demonstration that there is service for all who have nurtured a concern for the souls of those perishing around them.

975 He Doeth the Works

"... but the Father that dwelleth in me, He doeth the works" (John 14:10).

A famous organist came to the intermission of his recital. It was in the days of organs requiring a hand pumper. So in joy the organ-pumper remarked, "We are giving them a fine recital today."

The organist looked up in disgust saying with a stinging retort,

"Please, sir, I am giving this recital!"

The organ-pumper was chagrined. The second half of the contest began when suddenly the organ was without a sound. The audience wondered what had happened. The organist knew. He went back stage and humbly apologized to the old pumper.

"You are right, sir, it is *we*, and not *I*." Then the exquisite concert proceeded. The "we" could do what the "I" cannot. The Father must work in us; and we must recognize our work as a joint effort with our blessed Lord.

The apostle Paul expressed it in these words, "We are laborers together with God. . ." (1 Cor. 3:9).

976 The Time is Short

In a certain factory, where each man was required to finish so much work in a given length of time, bells were rung at intervals to remind the men just how much time they had left.

"The men work better when they realize that the day is slipping away from them," the manager explained.

The same thing is true of us concerning spiritual things. We need often to be reminded that "the time is short." "The night cometh when no man can work" (John 9:4). We work better when we realize that the day is slipping away from us.

977 Double Service

"You are always working," I exclaimed, as I entered the office of a business friend. "How many hours do you work each day?" "Twenty-

four," he replied with a smile. Then more seriously, "I became interested in missions and determined to go to China, but my father died and his business was in such a state that no outsider could carry it on. My mother, sisters, and younger brother were dependent upon the profits of the house, so I was obliged to remain here. I then took the support of a native preacher in China as my substitute. In that way I work twenty-four hours a day, for my representative there is working while I sleep."

This man is like the angels in heaven, "serving day and night."

978 Light Giving

A young man who had heard the gospel accepted Christ. A little while after this, a Christian teacher asked him: "What have you done for Christ since you believed?" He replied: "Oh, I'm a learner." "Well," said the questioner, "when you light a candle do you light it to make the candle more comfortable, or to have it give light?" He replied, "To give light." "Do you expect it to give light after it is half burned, or when you first light it?" He replied, "As soon as I light it." "Very well," was the reply, "go thou and do likewise; begin at once." Shortly after there were fifty more Christians in town as a result of the man's work.

979 Personal Work

A deacon in a certain Congregational church in Boston, many years ago said to himself, "I cannot speak in prayer meeting. I cannot do many other things in Christian service, but I can put two extra plates on my dinner table every Sunday and invite two young men who are away from home to break bread with me." He went along doing that for more than thirty years. He became acquainted with a great company of young men who were attending that church, and many of them became Christians through his personal influence. When he died he was buried in Andover, thirty miles from Boston, and because he was a well-known merchant, a special train was chartered to convey the funeral party. It was made known that any of his friends among the young men who had become Christians through his influence would be welcomed in a special car set aside for them. And a hundred and fifty of them came and packed that car from end to end in honor of the memory of the man who had preached to them the gospel of the extra dinner plate.

980 Service in Little Things

A story is told in some annals of the Roundtable of a knight who set forth to find the Holy Grail. Forth from the castle rode the knight filled with his lofty purpose, having no eyes nor care for the common things about him and giving no heed to the gray-beard beggar that lay asking alms close to his door. Forth he went and began to do many wonderful works. His sword wrought prodigies of valor, in gloomy woods by robbers' strongholds, in wild mountains.

But he never saw the holy vision, the reward of God's true knight. Then, spirit-broken, he gave up the quest as hopeless and rode homeward wearily. He came with head hung down and eyes that looked upon the ground. "Not for me, not for me," he muttered, "is the holy vision," Then, as he came through the gates he caught sight of the beggar. "Ah, now shalt thou be helped, old man," cried the knight, "for I must content myself with such small acts of pity." He sprang from his horse; he laid aside spear and crested shield and bent over the beggar tending his wounds. He bade his servants bring him bread and wine and himself saw that all his wants were supplied. And lo! as he turned there floated before him the wondrous vision—he saw the Holy Grail.

981 Work and Pray

A squall caught a party of tourists on a lake in Scotland and threatened to capsize their boat. When it seemed that the crisis had really come, the largest and strongest man in the party, in a state of intense fear, said, "Let us pray." "No, no, my man!" shouted the bluff old boatman; "let the little man pray. You take the oar."

982 Use the Abilities that God Has Given You

On the subject of the parable of the talents in Matthew 25, J. R. Miller writes:

"It would not do for all to be great—to be five-talented. If all the soldiers were fit for generals, who would make up the rank and file? If all church members were eloquent preachers, who would do the countless little, quiet services that need to be done? If all men and women were great poets, who would write the prose? There is need for far more common people than great brilliant ones. One Niagara is enough for a continent, but there is need for thousands of little springs and rivulets. A few great men are enough for a generation, but there is work for millions of common folks. So this diversity of gifts is part of the divine plan. The world needs more people of average ability than it needs of the extraordinary sort, and so we are always sure of being in good company. Lincoln said "God must love the common people, for He made so many of them. People who are very great must feel lonesome, for there are so very few of them."

983 Try Not To Be Seen

There is a picture which shows a hand holding up a cross. The person is not seen—only the hand. It is good to be a hand that holds up the cross. It is good to be a voice that proclaims the Christ. We would all do well to keep ourselves out of sight and get people to look upon Christ. Too many of us want people to see us, and so project our own personality that we hide the vision of the Christ that we ought to exalt and honor. We want people to see us, to hear and admire what we say, to love us and honor us. But what can we do for them? What can the

teacher do for her scholars in their sinfulness and need? What can the preacher do for those who are in penitence and sorrow? We would better hide ourselves away and get people to see Christ. It is enough for us to seek to be only a voice, speaking out clearly to tell men of Christ, while we ourselves remain unseen and unknown. It is enough for us to speak our word or sing our song and pass out of sight, while the word we speak and the song we sing live to bless the world.

984 Ashamed to Die

"Are you afraid to die?" asked a visitor of a man who lay on his deathbed, one who had lived a prodigal's life, returning to Christ only in time to die. The man was now grieving, and his friend said to him, "Why, you are not afraid to die are you?" "No," said the dying man, "I am not afraid to die; but I am ashamed to die. God has done so much for me, and I have done nothing at all for Him."

Worldliness

985 When Brothers Quarreled

I knew of two brothers who had a quarrel. The mother could not reconcile them. She could not sleep. Her prayers went up night after night. One of the sons saw how she felt and was sorry for her, so he bought a costly gift and took it to her. "I don't want any gift," she said; "I want you to be reconciled to your brother." God doesn't want your gifts until you are reconciled.

986 Form Without Power

Representative Norris, of Nebraska, was on a streetcar one Sunday morning when there entered a white-haired woman, a man of about thirty and a well-dressed young woman. The conversation soon made it apparent that the young man and his mother were from a farm, and that they were visiting Washington for the first time. He was starting home, leaving her to visit longer with the young woman, who was her daughter. When the brother arose a little later to say goodbye at the point where he was to leave the car, his mother threw her arms around his neck, and stood for some moments delivering a motherly message, while the conductor waited patiently with his hand on the bell-cord. Embarrassed, the son still held his arm about his mother's waist.

"Start the car!" called out a man in a silk hat. "It's church-time now. Why can't people do this sort of thing before they start for church?" he grumbled.

It had gone far enough for Mr. Norris. "Young man," he said to the one who was now the center of all eyes, "you just take all the time you want to say goodbye to your mother. You don't know when you will say it to her for the last time. And if any of these people are so worried over their sins that they must hurry to church, why, they might get down on their knees right here and pray."

987 Copying Imperfections

A gentleman had a lovely Chinese plaque with curious raised figures upon it. One day it fell from the wall on which it was hung, and was cracked right across the middle. Soon after, the gentleman sent to China for six more of these valuable plates, and to ensure an exact match, sent his broken plate as a copy. To his intense astonishment, when six months later he received the six plates, and his injured one, he found the Chinese had so faith-

fully followed his copy, that each new one had a crack right across it. If we imitate even the best of men, we are apt to copy their imperfections, but if we follow Jesus and take Him as our example, we are sure of a perfect pattern.

988 Ruined by Companions

A young lady was so very strongly moved under the pleading of the gospel that she often wept. Her pastor watched her with interest, to see her brought to Christ. After a time, not seeing her in church, he inquired concerning her of her mother. That lady was a widow, and she replied, weeping: "Ah, sir, I fear my daughter has met with companions who are leading her sadly astray."

The pastor did his best to restore the girl to right paths. His efforts were vain. She had given her heart to folly, and would no longer listen to the voice of duty. Not many weeks elapsed before this young woman, while busy over her sewing, suddenly dropped her needle, and exclaimed: "Oh, I am dying!"

The inhabitants of the house placed her on the bed. Looking wildly about her, she said: "I see heaven and hell before me. *I can't get to heaven, for* HELL IS IN MY WAY!" These were her last words.

989 Unused Wealth

After many weeks, during which his family, aided by the police, searched for him, a wealthy man of Ithaca, New York, was located at a poorhouse in New London, Connecticut. He had wandered away from home suffering from mental trouble, and, in spite of the efforts that were made, had entirely eluded his friends. While they were searching for him, desiring to bring him back again to his home of comfort and luxury, he was living in a poorhouse. How many people there are like that. Christ has purchased for them an inheritance of untold wealth. But while the Savior is seeking after them to bring them into the rich enjoyment of this peace and comfort, they are living in the poorhouse of worldliness. It is necessary to get such people to "look up" and behold the spiritual treasures before it is possible *to lift them up* out of their self-imposed poverty.

990 Would You Let Jesus In?

"And when he was come near, he beheld the city and wept over it" (Luke 19:41).

Tonight I heard on the same newscast that 1) another black church had been torched—this time in North Carolina; and 2) that a black youth and his two white friends (who had invited him to "youth night" services at their church) were sent home by men in the church...no reason given except that "youth night services have been canceled," though other young people continued their activities at the church facility after the trio were driven home in the church van.

The first incident is another grave danger signal of a sick society. The second is a signal of a sick church. I believe both caused our Savior to weep afresh, as He wept over Jerusalem. And I have to wonder if there are not many churches in which our Lord Himself would not be welcome. He was, remember, a Jew. Many churches warmly welcome Jews...but how many churches would not?

Would Arabs be genuinely welcome in your church? Would Hispanics? Would African-Americans? Would the homeless? Would the marginally-intelligent? Would Jesus?

What in the world have we done to Christianity, if we have so domesticated it that we can be comfortable in associating only with those just like ourselves?

There is an evil spirit abroad in our land—a spirit of meanness and arrogance masquerading as Christianity—preying upon our culture and our land. Not all of it is in the uniforms of neo-Nazis and the Ku Klux Klan. Some of it wears business suits and wouldn't miss a Sunday service for anything.

And Jesus still weeps.

—Ted Kyle
(Abridged)

Worship

991 Complete Consecration

A Connecticut farmer came to a well-known clergyman, saying that the people in his neighborhood had built a new meeting-house, and that they wanted this clergyman to come and dedicate it. The clergyman, accustomed to participate in dedicatory services where different clergymen took different parts of the service, inquired:

"What part do you want me to take in the dedication?"

The farmer, thinking that this question applied to the part of the building to be included in the dedication, replied:

"Why, the whole thing! Take it all in, from underpinning to steeple."

That man wanted the building to be wholly sanctified as a temple of God, and that all at once. "Know ye not that ye are the temple of God, and that the Spirit of God dwelleth in you?" (1 Cor. 3:16).

992 Family Worship

Richard Knill, who had the advantage of a mother who prayed for him and with him as a boy, but forgot her counsels when he went from home as an apprentice, has given us the story of his conversion as follows: "When at Mr. Evans', I came down night and morning to family prayer. This was a new and strange scene to me. I had never been present at family prayer in my life. The first night that I was in this good man's house, about nine o'-clock, he rang the bell, and his shop-men and servants all came into the parlor and sat down. I looked with surprise, and wondered what was coming next. When all were seated, he opened the Bible and read a portion, and thus let God speak to his household. They then arose and fell upon their knees. The sight overpowered me. I trembled—I almost fainted. At last I kneeled down too. I thought of my past life; I thought of my present position; I thought: 'Can such a guilty creature be saved?' "

This was the beginning of the spiritual life of a modern apostle.

993 The Need of Worship

In a recent magazine article, a pastor stated clearly the fact that at his best man longs to worship some power above him. And it is this capacity for worship which is the measure of man's self-culture and the test of his character. It is the touchstone by which to test the ideal nature of the individual and the trend of a whole civilization. A man may be a source of beneficence, he may be a reservoir of practical social effort;

he may through the power which he possesses, and therefore the influence which he wields, make himself the object of universal acclaim. And yet there is something intensely distorted in his character if he feels not by some impulse of humility the desire to worship the Maker, whose creation he is. For otherwise the deepest fact in his experience is not a sense of responsibility to a higher authority, but rather a complacent self-reliance and self-sufficiency. In every act of worship, however crude and mistaken, there was some liberating influence, through which man was led away from his egoism, and experienced the restraint to his power and the quickening inspiration to his stirring virtue. And today it is the same ability to acknowledge the existence of an Infinite Perfect—beside whom our brightest virtues pale, and to whom we stretch out our hands in reverence and worship—that is the salt that protects the health of the soul and gives to life an unfailing, because a never completely realized, purpose.

994 Value of United Worship

At a meeting of the Board of Overseers of Harvard College a proposition was made to absolve the students from daily attendance at Chapel. After a number of younger men had argued in its favor, Ralph Waldo Emerson spoke, "Religious worship is the most important single function of the life of any people. I derived more benefit from the Chapel service when I was in College than from any, perhaps from all, other exercises which I attended. When I am in Europe I go on every occasion to join in the religious service of the people of the town in which I am. For this reason I should be sorry to see the attendance at Chapel made to vary with the wishes at the moment of the young men." After this no one cared to speak, and as long as he lived, compulsory attendance was maintained.

995 Motivation

What is your motivation for attending church today?

You say, "Well, it's the Sabbath and we're supposed to keep it holy." Actually, it's not the Sabbath. Today is the first day of the week. It is the day the early Christians chose instead of the Sabbath to worship Jesus Christ.

"You're right, the day has changed," you interject, "but it's still one of the Ten Commandments." Did you know that because of Jesus Christ's death and resurrection, *"he forgave us all our sins, having canceled the written code, with its regulations"*? The *Living Bible* adds, "So don't let anyone criticize you...for not celebrating...Sabbaths. For those were only temporary rules that ended when Christ came. He brought a new order."

We worship God on Sunday because over the past twenty centuries it has become customary. But there is a higher reason—"Christ's love compels us" to worship God in unity. The writer of Hebrews probably said it best when he wrote: *"Since we are receiving a king-*

dom that cannot be shaken, let us be thankful, and so worship God acceptably with reverence and awe (Heb. 12:28)."

996 *There's a Bear Behind You!*

The park ranger was leading a group of hikers to a lookout tower in Yellowstone National Park. Along the way he pointed out some of the famous sites in the park. He was so intent on the stories he was telling, that he paid no attention when his two-way radio received a message. He turned it down. Later they stopped to look at some flowers and view some of the birds in nearby trees. Once again his radio distracted the ranger, so this time he turned it off.

As the group neared the lookout tower they were met by a nearly breathless ranger who asked why the guide hadn't responded to the messages on his radio. From their viewpoint, high in the tower, some other rangers had observed a large grizzly bear stalking the group. They had been trying desperately to warn the hikers.

Many times we are so involved in personal activities and pursuits in this life, we don't pay attention to the voice of God trying to get through to us. Sometimes we turn down the volume. Sometimes we don't pay attention. Sometimes we even turn Him off.

If God is trying to get through to us, we can be sure it is for a good reason.

The Messenger via *The Visitor*

997 *The Story of the Praying Hands*

For years people have admired the art masterpiece known as *The Praying Hands*. Behind this work of art is a fascinating story of love and sacrifice.

In the late fifteenth century two struggling young art students, Albrecht Durer and Franz Knigstein, worked as laborers to earn money for their art studies. But the work was long and hard and it left them little time to study art.

Finally they agreed to draw lots and let the loser support them both while the winner continued to study. Albrecht won, but he agreed to support Franz after achieving success so his friend could finish his studies.

After becoming successful, Albrecht sought out Franz to keep his bargain. But he soon discovered the enormous sacrifice his friend had made. As Franz had worked at hard labor, his fingers had become twisted and stiff. His long, slender fingers and sensitive hands had been ruined for life. He could no longer manage the delicate brush strokes so necessary for executing fine paintings. But in spite of the price he had paid, Franz was not bitter. He was happy that his friend Albrecht had attained success.

One day Albrecht saw his loyal friend kneeling, his rough hands entwined in silent prayer. Albrecht quickly sketched the hands, later using the rough sketch to create

his masterpiece known as *The Praying Hands*.

998 Is Your Heart Reserved for Christ Only?

It is related that once when Queen Victoria was in the Highlands, she stopped at the cottage of a poor woman, sitting for a few minutes in an old armchair. When the party was leaving, one of the number told the old woman who her visitor was. She was awed by the thought of the honor which had been hers, and taking up the old chair, she carried it into the spare room, saying, "No one shall ever sit in that chair again, because my queen sat in it." How much more sacredly should we keep from other occupancy the place in our heart where Christ has been received as Guest! How is it, just now, in your heart? Is there any need for Christ to come with His whip of cords to drive out the traders, the sellers of cattle and doves, and the moneychangers?

—J. R. Miller

999 Great Expectations

Have you ever received a blessing that exceeded your expectations?

In 1995, Atlanta Braves' star pitcher Greg Maddux received an unprecedented fourth consecutive Cy Young award. The Cy Young is given to the outstanding pitcher in each league. He is only the second pitcher to win four of the awards, but the only one to win them consecutively. Bravo, Bravo!

Following the presentation of his third Cy Young award, Maddux reflected, "It's very exciting! You always set goals, but to win a Cy Young, or three of them, was never a goal. Anytime you exceed your expectations, it's more gratifying."

Christians ought to be the most excited inhabitants of this planet. Not only are they headed for an eternal heaven with the Creator of the universe, but that Creator promises unbelievable benefits—right now. He inspired this promise: *"No eye has seen, no ear has heard, no mind has conceived what God has prepared for those who love him"* (1 Cor. 2:9). Can you handle it? Give your devotion to your omnipotent and exceedingly gracious heavenly Father and watch the fireworks begin. You've never seen anything quite like it!

Remember: Expectations are greatly enhanced by a thankful spirit.

Reflections

1000 Give It Up

To whom would you be willing to swear undying allegiance?

During the Crimean War between Russia and Britain's allies, the "Charge of the Light Brigade" took place in 1854. British confusion was at the core of this disaster. Out of approximately 600 British cavalrymen, 247 were either killed or wounded by Russian troops. Later, though, Britain would be the victor in the Crimea.

After the dust had settled, British poet, Alfred Lord Tennyson would

describe the allegiance of those soldiers with these words:

> Theirs not to make reply,
> Theirs not to reason why,
> Theirs but to do and die:
> Into the valley of death
> Rode the six hundred.

Unswerving consecration was and still is the foundation of military campaigns.

Are you that devoted to your Lord and Savior? Jesus once said, *"If anyone comes to me and does not hate...even his own life...he cannot be my disciple"* (Luke 14:26). Later, the Apostle Paul would make this request: *"I urge you, brothers, in view of God's mercy, to offer your bodies as living sacrifices...this is your spiritual act of worship."* Are you willing?

Remember: God sees your mediocre life and says, "Give it up, I've got something better."

Reflections

1001 Are You a Functioning Member?

As we all grow older we feel the pains that creep into our once strong and fluid joints. Our hands hurt when they do their work. Our knees creak when we stoop down. Our backs and necks are sore when we sleep wrong. The ailments we suffer from are seemingly endless.

We are aware of those faulty parts, are we not? When we have a pain in any portion of the body we tend to focus on that area. We aren't so mindful of the hundreds of other parts that don't hurt. We do that because we go to the aid of the weakest members. They need the attention, or at least they demand it. The spiritual implications of these thoughts are many.

Paul, in describing the role of the church's relationship with its Head, Christ, said, "From whom the whole body fitly joined together and compacted by that which every joint supplieth, according to the effectual working in the measure of every part, maketh increase of the body unto the edifying of itself in love" (Eph. 4:16). As the church, the body of Christ (Eph. 1:22f), functions to serve the head, it acts as a unit made up of many members (1 Cor. 12:27). Each part functions on its own, up to its own ability, yet, all the parts function together in harmony to produce all proper reflections of the Head. This places each member in a position to strive for personal spiritual excellence, as well as for all to work with each other towards the ultimate goal of glorifying Christ.

Christian Messenger

General Index

Notes: Numbers refer to specific illustrations, not to pages. Entries in boldface type refer to chapter titles and subtitles within the book

abiding 160
accepted Christ 473, 741, 777
accepted the Savior 776
accepted time 273, 758
action and reward 780
actions speak 207
Adams, Moody 142
Admonition **1–6**
advertisement 187
advice 17, 27, 271
affection 416
afflictions 883
Africa 208, 335
after-service 144
Age **7–8**
aged Christians 8
Alexander 8
alive in Christ 876
all night prayer 625
alpha and omega 725
amnesia 909
anchor 330
anchored in Christ 878
anecdote 280
Anglican Bishop 32
answered prayer 639
antiseptic 498
apostles 497
application 548
aptitude 19
Arlington Cemetery 906
Armenian girl 126

arms of Jesus 480
artist 83
atmosphere 24
Atonement **9–11**
Attitude **12–33**
Augustine 113
authorship 61
Babcock, M. D. 705
backsliding 507
Baghdad 693
banks of Arno 94
baptism 40
barber 392
Barnes, Albert 709
barometers 368
battlefield 348
be our best 895
be ready 614
beauty of heaven 899
Beecher, Dr. Henry Ward 262, 676, 712, 973
Beethoven 893
before creation 454
beggar 83
believe Him 95
believe in God 196
believing truth 340
Bernard, Dr. 974
besetting sin 756
best gift 393
best required 242
Bethany 133
Bible **34–70**, 342, 554, 921
Bible half-read 52
Bible reading 43
Bibles 38

biblical relationship 600
biblical self-respect 598
bitterness 379
Blake, J. M. 714
blank check 334
blessed fellowship 111
blessed hope 934
blessedness 638
blessing 458
blessing given 166
blessing received 166
blessings 458, 648
blood of Christ 728, 752
blotted out sin 490
bold faith 239
Booth, Evangeline 409
Boston, MA 30
boulder 33
Bradford, Gov. William 913
bravest soldier 376
briers 892
British prisoner 399
broken heart 577
Brooks, Phillips 130, 266, 292, 360,
 435, 437, 464, 483,
 509, 604, 609, 637,
 665, 847, 880
brotherhood 110
Brown University 523
Browning, Elizabeth Barrett 142
Buckley, William F. 905
bugler 397
Bunyan, John 99, 185, 673
burdened prayer 719
burdens 694
Burr, Aaron 271
busy life 238
butterfly wings 427
cabin-boy 370
calculations 404
calm weather 426
Calvary 812
Cambridge University 157
Canadian Frenchmen 769

captain 326
Carey, William 99
Chambersburg, PA 675
changed life 849
Chapman, J. Wilbur 127, 232, 274,
 278, 304, 334, 348,
 399, 540, 614,
 628, 670, 694,
 742, 807, 882
Chapman, Steve & Annie 355
Character 7, 71–78, 240, 368
Charlie's sake 127
chastened 160
Chicago, IL 495
child's faith 324
child's love 488
children 184
Chinese Christian 124, 260
choice 243, 695
choose carefully 174
Christ 79–143
Christ child 94
Christ is love 483
Christ's list 699
Christ's saints 107
Christ's way 591
Christ-like love 579
Christian 69, 144–185
Christian character 163
Christian experience 960
Christian girl 925
Christian graces 206
Christian growth 365
Christian home 356
Christian household 54
Christian life 4, 269, 283
Christian Living 186–196
Christian minister 293
Christian name 691
Christian truth 295
Christian walk 198
Christianity 197–209
Christina 87
Christlike 596

Christlike deeds	959
Christmas	14
Church	60, **210–230**, 410
Cicero	267
circumstances	172, 243, 413
City Hall	235
Civil War	18, 237
commentators	671
Commitment	**231–243**
companions	368
companionship	583
compass	57
Compassion	15, **244–254**, 869
compassion lacking	563
Complaining	**255–256**
condemn	288
confess transgressions	830
confiding faith	637
conquered alone	134
conscience	181
consecration	335
contentment	186
contrite heart	366
conversion	116, 325, 643, 734, 753, 992
converted lad	155
counterculture	178
Countess of Huntingdon	109
courage	509
court pages	912
Creator	327, 455
creeping Christians	154
criticism	813
Crosby, Fanny	590
cross	11, 395
cross of Christ	735
crown	81
cry of distress	418
curiosity	214
Cuyler, Theodore	325, 922
Czar Alexander I	363
damaged vessel	426
danger signals	990
day and night	977
day of grace	731
days of grief	138
Death	**257–268**, 441, 779
debt	121, 373
Decisions	**269-279**, 462, 690
deep significance	585
deny oneself	793
depend on Him	790
designs of God	838
destruction	282
devout farmer	350
Dickens, Charles	349
dinner plate	979
disaster	933
Discernment	**280–288**
disciples	426
Discipline	**289–292**
disciplined purpose	290
discontentment	186
displeasure	29
dissatisfaction	186
dissatisfied	52
distinguished guest	79
diversity of gifts	982
divine evidence	202
divine promise	842
Divine Providence	452
divine support	858
divinity of Christ	95
do likewise	978
Doctrine	**293–295**
double life	678
doubt	6
Doyle, Sir Arthur Conan	11
Drummond, Henry	103, 672
Dublin	122
Duke of Clarence	91
Duke of Wellington	168, 615
Duty	147, 266, **296–299**, 537
Dyer, John	708
dying	259
dying thief	865
earthquake	258
educating	28

Edwardson, Isaac 165
effectual manner 17
elbow-touch 361
Embert, Eliza 364
Emerson, Ralph Waldo 994
emperor 371
Emperor Napoleon 326
encouragement 619
endeavors 746
endless bliss 460
enduring present 911
enemies 375
enemy 567
energy 409
England 404
enter in 462
enterprise 409
enthusiasm 409
errand boy 30
escape 953
essence 204
eternal flame 906
eternal life 197
eternal loss 268
eucalyptus tree 395
Everlasting God 330
evidence of God 427
evolutionist 927
exaltation 516
Example 102, **300-302**, 661
executed 379
experience 452
experiment 236
extraordinary 642
Faith 25, **303–342**, 360,
 891, 902, 970
faith and hope 568
faithful 605, 774
faithful witness 774, 966
faithfulness 599
false doctrine 294
false lights 282
familiar expression 513
Family **343–357**

father 289, 416
Father's face 602
father's hand 445
Father's house 173
Fear **358-361**
feed on the Word 938
fellow-feeling 120
fellowman 546
Fellowship 157, 217,
 362–369, 665
fervency 621
fervent prayer 325
Finney, Charles 144
fire 495
five barley loaves 135
focus 971
forebodings 360
foreign missions 384
forgiven 376
Forgiveness 374, **370–379**, 393
found waiting 623
foundation 356
fragrance 549
France 63
friends 580
friendship 294, 985
frozen crew 210
fruit 469
fruitful 510
gain the world 268
Galilee 108
Garibaldi 80
gave all 747
gave lives 769
gave substance 697
General Longstreet 784
generosity 542
gentlemen 30
Gettysburg, battle of 784
Gettysburg, PA 12
gift 922
give 682, 862
give-up 791
Giving **380-394**

giving thanks 908
Gladstone, William 588
glorify God 338
go and tell 100
God **395–458**
God forgives 490
God hates sin 802
God inspired 342
God knows 946
God measures 837
God never fails 924
God's blessing 494
God's call 397
God's child 564
God's Church 453
God's enemy 815
God's gift 417
God's grace 148
God's help 949
God's judgment 677
God's love 420, 514
God's plan 450
God's presence 446
God's promises 700
God's service 434
God's Spirit 835
God's universe 403
God's Word 66, 215, 404
God-centered 22
God-ordained 655
good conscience 874
good for something 738
Good Shepherd 118
Gordon, A. J. 841
Gospel 501, 509
Governor Stewart 370
Grace **459–464**
grace of God 459
graduate 345
grandest music 893
Grant, Ulysses S. 280
grateful love 894
gratitude 413, 912
gravitation 115

great anxiety 434
great gain 449
great loss 449
greatest enemy 526
green pastures 896
grieved 492
grounded 182
Growth **465–473**, 888
guard against 439
guilty conscience 529
habit 272
hand 428
hand of God 406, 445
happiness 20
hardened heart 742
Harmann, John 348
harmony 354
Harper's Ferry 239
Harvard University 403
hasty word 917
Hawthorne, Nathaniel 87, 597
Haydn 400
He knocks 137
He's coming 139
heard and obeyed 744
heart 998
heart attitude 653
heathen bell 757
Heaven 26, 475, 400, 474, **474–488**, 941
Hebrews 327
helpfulness 165
Henry, Matthew 425
hidden faith 652
hidden treasure 951
high ideals 28
highest grace 698
Highlands 91
Highlands of Scotland 757
hired 53
His likeness 414
holy living 510
Holy One 492
Holy Spirit 44, 59, 130,

215, **489–512**, 832

Holy trinity	508
"Home, Sweet Home"	558
homeward bound	478
honor	696
honoring God	354
Hope	26, **513–514**
Hosanna	133
hospitality	178
hours of joy	138
Hughes, Charles E.	796
human affairs	201
humble confidence	765
humble man	868
humble service	603
Humility	**515–517**
humor	355
hunger	954
Huss, John	337
Hypocrisy	**518–519**
ignorance	338
immorality	41
impure comment	918
Indian Prince	929
infallible way	164
infinite	459
inspiration	676
instant prayer	641
instruments of mercy	103
intemperance	220
intercede	736
intercession	629, 631
inward decay	532
Jacob	67
Jansen, Dan	189
Jefferson, Thomas	48
Jens, Haven	358
Jesus and Paul	670
Jesus' method	100
Jewell, J. H.	514
job-searching	53
joy	180
joyful surprise	562
judge	373

Judgment	448, **520–537**
judgment day	536
Judson, Adoniram	640
Kearns, Robert	195
Keft, Felix	703
kennel dogs	126
Kindness	29, **538–553**
king	415
King Agrippa	960
King Alfonso XII	912
King of Sweden	87
Knill, Richard	374
knowing God	433
Knowledge	**554–556**
Kreisler, Fritz	868
Kyle, Ted	972, 990
lack of concern	255
lasting blessing	386
laughing	355
lawful right	256
learn of Him	88
Lee, Gen. Robert E.	18, 237
less is more	905
lesson	33
Lewis, C. S.	664
life and death	267
lifeguard	418
life in Christ	190
life of sin	269
lifting power	572
lighthouse keeper	156
Lincoln, Abraham	302, 311, 698, 795, 882, 952
Lind, Jenny	919
living force	919
living sermon	207
living temple	850
living the truth	340
living waters	51
Livingstone, David	260, 384
Lloyd-George, David	247
London	129
loneliness	446
lonely life	923

long campaign	361		713, 954, 982, 998
looking to Jesus	722	mind in Christ	901
Lord's side	191	miracle cleansing	504
Lord's teaching	936	missionary	278, 358
Lord's work	515	mockery	364
lost but found	720	Moffat, Robert	335
Louis XII	375	monarch	363
Love	**557–596**	money	279
love and hope	541	Moody and Sankey	672
love and sacrifice	997	Moody, D. L.	99, 148, 235, 254,
love and trust	560		322, 495, 536, 577,
love letter	56		579, 608, 624, 688,
love of Jesus	566		707, 768, 770, 791
loved ones	480	moral qualities	206
loving service	386	moral sensibility	262
loving-kindness	557	moral sleep	152
loyalty to God	942	moral worth	679
Luther, Martin	170, 763	morality	41
Lutheran Bible	952	More, Hannah	710
Lyle, Elsie	119	Morrison, G. H.	896
MacDonald, George	406, 711	Moses	434
Maclaren, Alexander	13, 164,	Moses' rod	135
	501, 894	mother	381
made beautiful	466	mother and step-mother	311
magnetic force	496	mother's God	748
man overboard	250	mothers	343
many honors	345	motto	350
Marriage	**597–600**	muddy pools	51
martyr	337	Müller, George	647
McKenzie, Alexander	338	Murray, Andrew	623
McKinley, William	15	music	2
meagerness	664	Muslim	145
measured time	192	name preserved	237
medal	345	Napier, Sir William	315
meditate	45, 939	Napoleon	527
memorize	381	natural man	287
Merriman, Henry Seton	78	new heart	439
message	392	New Hebrides Chieftain	68
method	435	new life	452, 783
Meyer, F. B.	172, 241,	new nature	438
	457, 459, 504	new standards	22
Miller, J. R.	135, 137, 138, 242,	New Testament	54, 65, 349
	268, 354, 376, 386,	New York	3
	539, 586, 589, 648,	New York City	53

newfound love 962
Newton, John 836
noble heart 18
noble heroes 299
Norwegian explorer 696
not afraid 984
nurse 379
oath 537
Obedience 336, **601–612**
old power 497
Old Testament 65
omniscient 285
one convert 208
one leaf 508
one saved many 234
open profession 277
opinion 15
opportunity 147
others 408
others first 570
our hearts 526
our salvation 857
our work 242
overcoming 821
own destinies 887
parachute 718
pardon 370
pardoned troops 371
Paris 116
Parker, Joseph 671
passport 551
past and future 626
pastor 392
Pastors **613–620**
patience 195, 635
patience and trust 555
pay attention 996
Payne, John Howard 558
peace 180, 425
peace promised 205
Pearl of Salvation 761
peasant 363
Peel, Sir Robert 916
penitent servant 627

Pentateuch 39
Pentecost 128
Pentecost, George F. 750
perfect pattern 987
perfection 441
perfectly content 675
perspective 189
Pierson, A. T. 131, 647
Pilgrim fathers 150
Pilgrim's Progress 673
place of blessing 576
pleasure 56
poor child 372
Port-au-Prince 258
power 38, 47, 211, 317, 435
power of God 50
"Power Source" 859
practical wisdom 841
pray about it 877
pray and wait 640
pray ardently 823
pray in faith 136
Prayer **621–669**
prayer rewarded 222
praying 632, 773
praying people 222, 618
praying widow 155
Preaching **670–690**
preference 940
preparations 73
prepared people 476
prepared place 476
prescription 233
pressure 407
Pride **691–693**
Prince George 91
Princess Elizabeth 275
Princeton College 198
Priorities **694–699**
prisoner 373
problems 292
promise to Israel 701
promised Mother 278

Promises 700–701
prophecy 213
propitiation 9
prospered 453
protection 413, 644
protest 220
proverb 20
Proverbs 69
public schools 70
purifying 122
purpose 435, 647
quality 45
Queen Victoria 46, 81, 929
Queen's Palace 372
Queenstown harbor 330
questionable 411
quiet home 344
Quotes 702–716
rare roses 372
reach and redeem 514
read and pray 667
real test 898
reality 782
reason 341
reception 232
recognize evil 518
reconciliation 437
red crosses 375
Redeemer 398, 831
redeeming mercy 686
refining influence 501
refining silver 122
reflecting Christ 128
reformer 170
regularity 256
rejoice 763
relation to Christ 469
religion 150, 364
renewed soul 889
repent 185, 767
Repentance 717–727
reputation 240
rescued 399
reserve 457

resist temptation 880
responsiveness 438
resurrection glory 264
reunion 173
reverence 515
revival 155
riches 211, 864
right now 273
righteous actions 342
rightly used 903
Roman prince 94
Roman youth 113
Romania 932
ruin 864
Russia 371
Russian history 275
sacred volume 48
sacrifice 649, 870
sacrificial life 238
sages and prophets 65
saintly conduct 13
Salvation 398, 420, **728–783**
Satan 39, **784–788**
saved by example 300
saved by Faith 775
saved by grace 680
saving grace 321
Savior 437
Savior's love 587
science professor 523
Scripture 62
Scriptures 47
search 34
second-mile 540
secrecy 73
secret 814
seek and accept 945
seek and save 760
seek to save 118
Self 789–801
self-consecration 366
self-contained 182
sermon on charity 926
servant of servants 108

serve the Lord	86
service	866
Shamrock	129
sheep	254
shelter	522
shepherd	254
Siders, Margaret	923
silence	73
Sin	**802–833**
sin settled	724
sin-bearer	10
sincerity	662
sinful folly	524
singing	755
single person	668
skeptical hearer	674
slave	973
slave trade	369
slept	156
small acts	980
smallest gift	248
smile	12
Smith, George	208
Smith, Gypsy	766, 773
sold the calf	863
soldier	326, 415
solemn words	669
Solomon's proverb	201
some churches	214
Son of God	547
Soul	437, **834–839**
"soul travels"	622
soul-lethargy	152
sound warning	613
Spanish gunboat	214
Spanish-American War	397
speech	71
speech defects	768
speedily rescued	759
Spencer, Herbert	927
spirit of Christ	119
Spirit of God	137, 851
spirit of Love	390
Spiritual	**840–859**

spiritual blessing	511
spiritual duties	336
spiritual excellence	1001
spiritual lesson	589
spiritual sight	59
spiritual treasures	989
spiritual winter	264
Spurgeon, C. H.	1, 10, 25, 93, 105, 110, 220, 275, 277, 316, 412, 451, 475, 494, 522, 689, 692, 704, 720, 728, 751, 764, 765, 772, 786, 834, 848
St. Petersburg	926
stand with God	961
Stevenson, Robert Louis	911
Stewardship	**860–870**
stiff gale	426
Stoll, Scott	78
stony natures	215
stormy hills	881
strength	595
strife	475
strong and able	897
study Christ	131
submit	450
suffering	105
suitable provision	860
Sunday-sickness	226
supplication	659
support	628
Supreme Court	70
sweet communion	365
sweet consciousness	381
swept overboard	934
Swift, Dean	706
"switch-key"	589
take heed	786
taking a stand	357
talking loud	650
Talmage	7
team	19
telegraph operator	404

temple of God	991	Truett, George W.	285, 748
Temptation	**871–880**	**Trust**	25, 327, **924–934**
temptations	439, 822	trust God	154
tempted Savior	879	trusted counselor	316
Ten Commandments	70	**Truth**	34, **935–938**
tender spirit	390	turn from sin	727
tender-hearted	545	turned away	79
tendons	427	**Unbelief**	338, **939–941**
terrific gale	156	understanding	44
test of faith	904	unguarded speech	280
Testaments	37	unholiness	507
Tests and Trials	**881–904**	**Unity**	**942–944**
thankful spirit	999	universal blessing	163
Thankfulness	**905–915**	unlimited resources	334
the Word	341	unmeasured time	192
theme	645	unopened letters	142
therapeutic	20	unprepared	257
things	408	unruly soldier	376
think of Christ	159	unselfishness	244
thoughtfulness	552	unshakable	446
threads of faith	306	unspeakable peace	762
three-day feast	913	uplifting	550
time invested	231	urgent prayer	624
time is now	770	useful Christians	844
times of refreshment	875	V-chip	357
to every creature	615	valiant deeds	110
to the point	683	value of prayer	630
tolerance for truth	230	vengeance	522
Tongue	**916–920**	verses or chapters	64
too busy	409	vessel wrecked	234
too late	274, 270, 474,	Voltaire	42
	733, 764, 941	wait and trust	933
Torrey, R. A.	39, 800, 830	waiting	416
touchstone	993	"walking sermon"	964
tract[s]	37, 374, 754	walking stick	843
transformation	464	warned	448
transformed life	203, 749	Waterloo	527
treacherous	817	Watt, James	231
Treasure	5, 72, **921–923**	Webster, Daniel	62, 204
tree of shame	395	Welsh girl	259
trial	511	Wesley, Charles	746
true church	224	Wesley, John	225, 320, 369, 682
true servant	434	West Point	531
true yoke-fellow	111	Westminster Abbey	32, 216

whaling vessel	210
Whitefield, George	642, 687
Wilberforce, William	369, 747
Will	**945–948**
willing to wait	611
winepress	134
winning souls	575, 965
Wisdom	29, 518, 825, **949–956**
without limit	101
without religion	257
Witness	**957–964**
Witnessing	157, **965–972**
won a convert	119
Word of God	465
words and works	594
Works and Service	**973–984**
Worldliness	**985–990**
Worship	**991–1002**
X-rays	202
yoke	103
young boy	47
youth	28
Zion	63

Scripture Index

Note: Numbers refer to specific illustrations, not to pages.

Genesis
2:24 — 600
ch. 15 — 599
18:19 — 179
19:17 — 953

Exodus
10:26 — 701
14:14 — 126

Numbers
23:24 — 220
32:23 — 529

Deuteronomy
30:19 — 70

Joshua
24:15 — 191, 690

1 Samuel
1:11 — 629
1:28 — 179

1 Kings
6:7 — 73

2 Kings
5:1–3 — 179
ch. 9 — 248

2 Chronicles
7:14 — 70

Nehemiah
7:1, 2 — 179

Job
22:21 — 842

Psalms
1:1, 2 — 45
16:8 — 408
18:28 — 906
23:1 — 334
23:4 — 361
27:10 — 573
33:13, 15 — 160
41:9 — 108
46:1, 2 — 699
50:15 — 435
51:7 — 781
71:3 — 666
90:2 — 454
91:1 — 755
100:3 — 612
103:13 — 573
107:20, 21 — 915
119:18 — 59
139:8 — 514
139:9, 10 — 445
142:4 — 974

Proverbs
10:19 — 174
11:17 — 394
11:24 — 385
16:25 — 445

17:22	20
18:24	110
19:2	517
22:6	69
25:17	666
27:17	369
31:28	619

Ecclesiastes
8:11	439
9:3	439

Isaiah
1:18	675, 809
40:30, 31	194
41:10	361
53:7	925
54:10	477
55:10, 11	40
60:1	758
63:5	134
66:1, 2	366

Jeremiah
9:23, 24	455
18:6	406

Ezekiel
33:3	448

Daniel
4:30	693
6:20	407

Micah
7:7	623

Zechariah
4:10	910

Malachi
3:2, 3	122

Matthew
4:17	727
5:6	954
5:8	781
5:14	964
5:16	156, 207, 970
5:44	567
6:3	78
6:6	638
6:14	393
6:19–21	867
6:33	277
7:2	699
7:8	656
7:15	928
7:22, 23	497
8:20	108
9:10	157
9:38	649
10:19	852
10:33	661
10:34–39	660
11:28	259
11:29	88
11:29, 30	111
12:35	159
12:36	918
13:4, 8	676
13:31, 32	194
13:45–49	761
15:14	928
15:22–28	624
16:18	60
16:24	793
18:11	109
22:36–40	447
23:27, 28	161
ch. 25	982
25:35–40	193
25:37	510

26:28	9	12:32	115, 572
27:42	569	13:18	108
		14:1–3	931
Mark		14:6	462
1:41	849	14:9	131
2:5, 9	849	14:10	975
8:35	696	15:7	938
8:36	268	15:18–20	660
11:25	379	16:8	813
12:43	849	16:22	699
14:37	849	17:3	58, 936
15:31	569	17:22, 23	943
		18:36	484
Luke			
2:51	179	**Acts**	
4:19	780	1:8	774
7:45, 46	24	7:59	260
8:10	656	8:32	925
9:23	793	ch. 9	269
9:24	696	9:6	799
9:58	108	11:24	179
10:2	631, 649	14:15	963
10:38, 39	179	16:30	799
12:16–21	279	16:31	330
14:26	1000	17:11	179
17:7–10	448	24:25	793
17:16	914	26:25	674
18:1	664		
18:13	404	**Romans**	
19:10	109, 587, 760	1:16	50, 158
19:41	990	5:1	699
		5:3	511, 660
John		5:17	459
1:29	404	5:20	514, 725
3:16	763	6:23	52
4:7, 10	108	7:9	470
4:14	464	8:13	498
9:4	976	8:17	691
10:5	106	8:18	486
10:4, 5	120, 173	8:26	851
10:10	609	8:28	945

10:13	112
12:12	195
13:13, 14	113

1 Corinthians

1:13	354
1:17	905
1:27, 28	450
2:3	179
2:9, 10	44
3:1	176
3:9	975
3:16	991
4:19	678
9:27	793
12:27	1001
ch. 13	660
13:3	381
15:33	368
15:53	611

2 Corinthians

1:10	675
1:34	792
5:1	162, 441, 801
5:14	964
5:17	197, 832
5:20	187
5:21	812
6:2	273, 758
6:14	364
6:33	964
8:5	384
12:7–11	660
12:9	464
12:9, 10	927

Galatians

2:20	9, 314
5:9	963
5:22	855

| 6:7 | 226 |
| 6:7, 8 | 471 |

Ephesians

1:7	404
1:22	1000
4:3	496
4:16	1000
4:32	394
5:9	855
6:10	881
6:14	55

Philippians

1:13	575
1:21	485
2:4	660
2:7	124
2:9–11	516
3:13, 14	487
4:6	136
4:7	413
4:8	501
4:13	699, 949
4:19	334

Colossians

| 3:13 | 450 |

1 Thessalonians

1:10	448
4:13–18	934
5:18	910
5:25	618

2 Thessalonians

| 3:1 | 618 |

1 Timothy

| 4:6 | 677 |
| 4:12 | 964 |

2 Timothy
1:5 311
1:12 236
2:15 69

Philemon
1:10 124

Hebrews
2:15 266
3:13 814
4:15 120
5:8 660
7:25 547
10:29 757
11:1 303
11:6 321
11:10 611
11:25 695
11:27 463
12:1 199
12:14 616
12:2, 3 486
12:28 995
13:5 699

James
2:17 342

2:19 342
4:2 630
4:4 815
5:16 629

1 Peter
1:5 50
1:18, 19 752
2:20 175
2:21 291
2:24 514
3:3, 4 699
5:1–5 612
5:8 876

1 John
1:3 365
1:5, 6 859
3:2 611
3:14 568
5:4 314, 660

Revelation
1:5, 6 792
3:15 678
ch. 20 177
21:18 611
22:17 860

Bibliography

Banks, Lewis Albert, ed. *Anecdotes and Morals: A Volume of Illustrations from Current Life.* New York, London: Funk and Wagnalls, 1899.

———. *Spurgeon's Illustrative Anecdotes.* New York, London: Funk and Wagnalls, 1906.

———. *Windows for Sermons.* New York, London: Funk and Wagnalls, 1902.

Beecher, Henry Ward. *A Treasury of Illustration.* Edited by John R. Howard and Truman J. Ellinwood. Introduction by Newell Dwight Hillis. New York, Chicago, Toronto: Fleming H. Revell, 1904.

Bomberger, J. H., ed. *Three Thousand Practical Illustrations in Religion and Morals.* Cleveland, OH: Central Publishing House, n.d.

Boteler, Mattie M., ed. *Side Windows or, Lights on Scripture Truths.* Cincinnati: Standard, 1901.

Ellis, J., ed. *Weapons for Workers.* London: Robert Scott, 1915.

Mackey, H. O., ed. *Helps for Speakers: Incidental and Illustrative for Pulpit, Class, and Platform.* London: Marshall Brothers, n.d.

Perren, C., ed. *Seed Corn for Sowers: Original and Selected Thoughts, Themes and Illustrations for Public Use and Private Study.* Glasgow, London, New York: Pickering & Inglis, Alfred Holness, D. T. Bass, n.d.

Pierson, Arthur T. *Seed Thoughts for Public Speakers.* New York, London: Funk and Wagnalls, 1916.

Shaw, W. Frank. *The Preacher's Promptuary of Anecdote.* London: Griffith, Farran, Okeden & Welsh, n.d.

Tinling, J. F. B., ed. *Fifteen Hundred Facts and Similes: For Sermons and Addresses.* London: Hodder and Stoughton, 1889.

Webb, Aquilla, ed. *1001 Illustrations for Pulpit and Platform.* Introduction by John F. Carson. New York, London: Harper & Bros., 1926.

_____. *One Thousand Evangelistic Illustrations.* Introduction by E. Y. Mullins. New York: George H. Doran, 1921.

_____. *One Thousand New Illustrations.* Introduction by James A. Barkley. New York, London: Harper & Bros., 1931.

Wright, J. C., ed. *Still Waters: Daily Readings for Every Day in the Year.* London, Edinburgh, New York: T. Nelson and Sons, n.d.